WALLACE The Segretary Complete Contractions Manual

Illustrated by **Graham Bleathman**Designed by **Lee Parsons**Written by **Derek Smith**

Edited by Wallace & Gromit using the EDIT-O-MATIC PRONTO PRINT (patents pending)

© and TM Aardman/Wallace & Gromit Limited 2010. All rights reserved.

Wallace and Gromit (word mark) and the characters "Wallace" and "Gromit" © and TM Aardman/Wallace & Gromit Limited.

Wallace & Gromit are characters created by Nick Park.

No part of this publication may be reproduced, stored in a retrieval system or transmitted, in any form or by any means, electronic, mechanical, photocopying, recording or otherwise, without prior permission in writing from the publisher.

October 2-013
Published in November 2010

A catalogue record for this book is available from the British Library

978 0 85733 411 4 ISBN 978 1 84425 958 8

Haynes Publishing, Sparkford, Yeovil, Somerset BA22 7JJ, UK Tel: +44 (0) 1963 442030 Fax: +44 (0) 1963 440001

E-mail: sales@haynes.co.uk Website: www.haynes.co.uk

Haynes North America, Inc., 861 Lawrence Drive, Newbury Park, California 91320, USA

Printed and bound in the USA by Odcombe Press LP

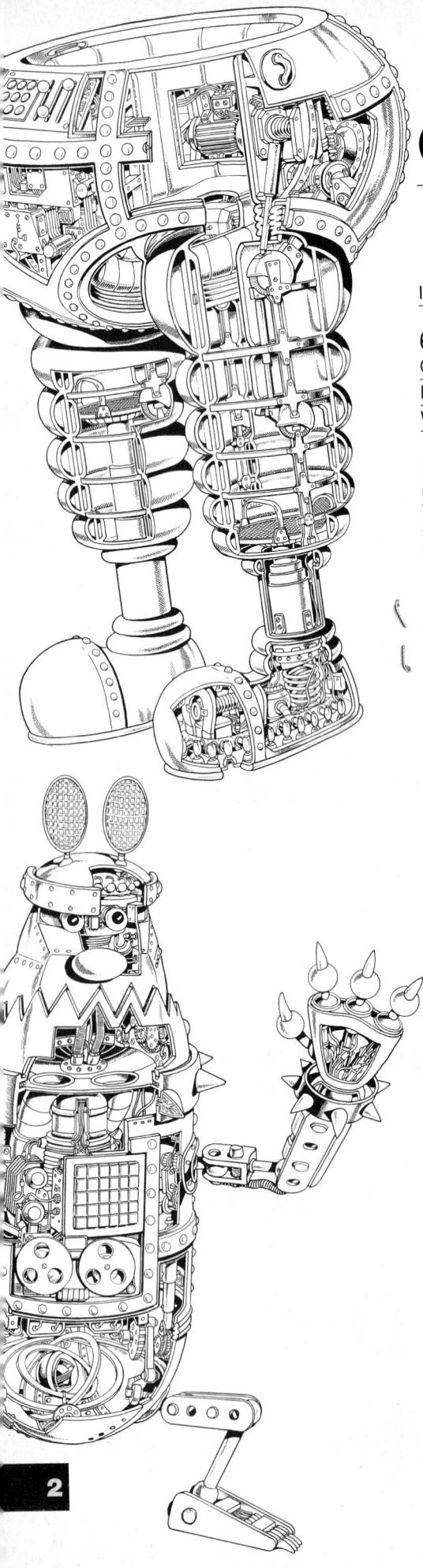

Contents Part 1

Introduction	Page	4
CO West Wallahy Street		
62 West Wallaby Street	Page	6
General description House cutaway	Page	8
Wallace's 'Wash 'n' Go' launch system	Page	10
Wallace's Wash in do launch system		
Bed Launcher	Page	12
General description	Page	14
Bed Launcher cutaway	Page	16
Auto Dresser cutaway	1 agc	
Rocket		40
General description	Page	18
Rocket cutaway	Page	20
Cooker cutaway	Page	22
Jam Ballista		
General description	Page	24
Jam Ballista cutaway	Page	26
Tachno Trougoro		
Techno Trousers General description	Page	28
Techno Trousers cutaway	Page	30
Techno Trousers – modifications by Feathers McGraw	Page	32
Techno nodolo modificación ay		
Porridge Cannon		00
General description	Page	36
Porridge Cannon cutaway	Page	38
Knit-O-Matic		
General description	Page	40
Knit-O-Matic cutaway	Page	42
Preston's Mutton-O-Matic		
General description	Page	46
Mutton-O-Matic cutaway	Page	48
Preston the Cyber Dog	Dogo	50
General description	Page	52
Preston cutaway	Page Page	54
Domesticated Preston cutaway	Page	34
Motorcycle & Sidecar		
General description	Page	56
Motorcycle & Sidecar cutaway	Page	58
Sidecar - Gromit's aeroplane modifications	Page	60

Contents

Austin A35 Van		
General description	Page	62
Austin A35 Van cutaway	Page	64
Top Bun Bakery		
General description	D	
Forklift truck cutaway	Page	68
TORRITE Truck Cutaway	Page	70
Autochef		
General description	Page	72
Autochef cutaway	Page	74
Dully Dua of Vast	and the second section of the second	
Bully-Proof Vest		
General description	Page	76
Bully-Proof Vest cutaway	Page	78
Christmas Card-O-Matic		
General description	Page	80
Christmas Card-O-Matic cutaway	Page	82
505.0		All land
525 Cracker Vac		
General description	Page	84
525 Cracker Vac cutaway	Page	86
Shopper 13		
General description	Dane	00
Shopper 13 cutaway	Page	88
Chopper to outaway	Page	90
Snoozatron		
General description	Page	92
Snoozatron cutaway	Page	94
Conservation		
Soccamatic		
General description	Page	96
Soccamatic cutaway	Page	98
Snowmanotron		
General description	Page	100
Snowmanotron cutaway	Page	102
Tellyscope		`
General description	Page	104
Tellyscope cutaway	Page	106
Turbo Diner		
General description	Page	108
Turbo Diner cutaway	Page	110
	. ~90	

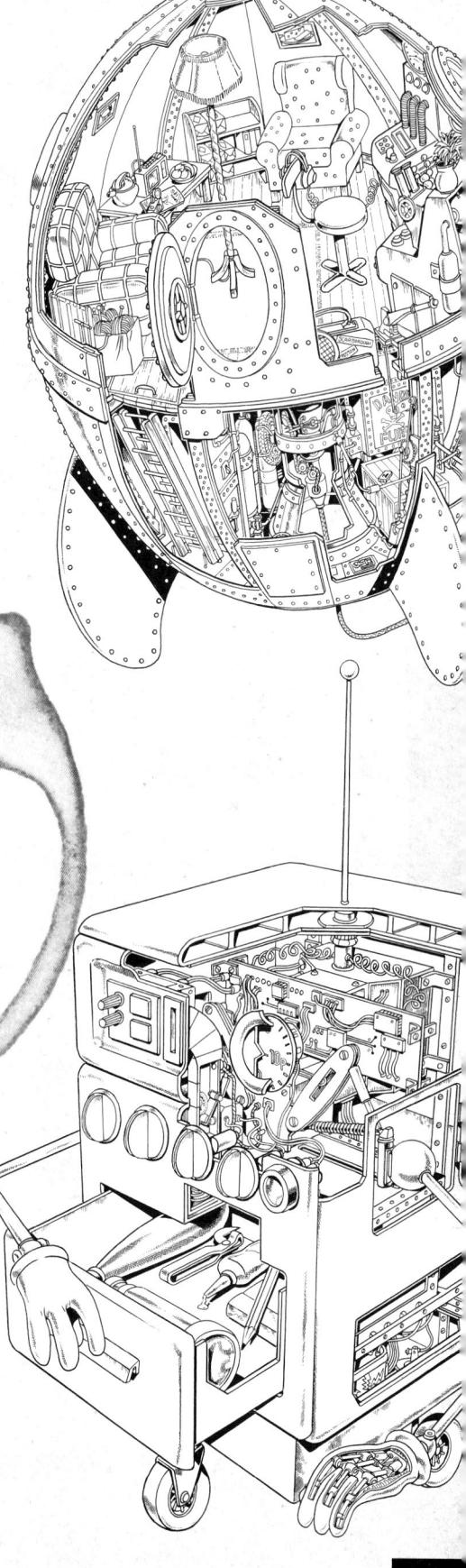

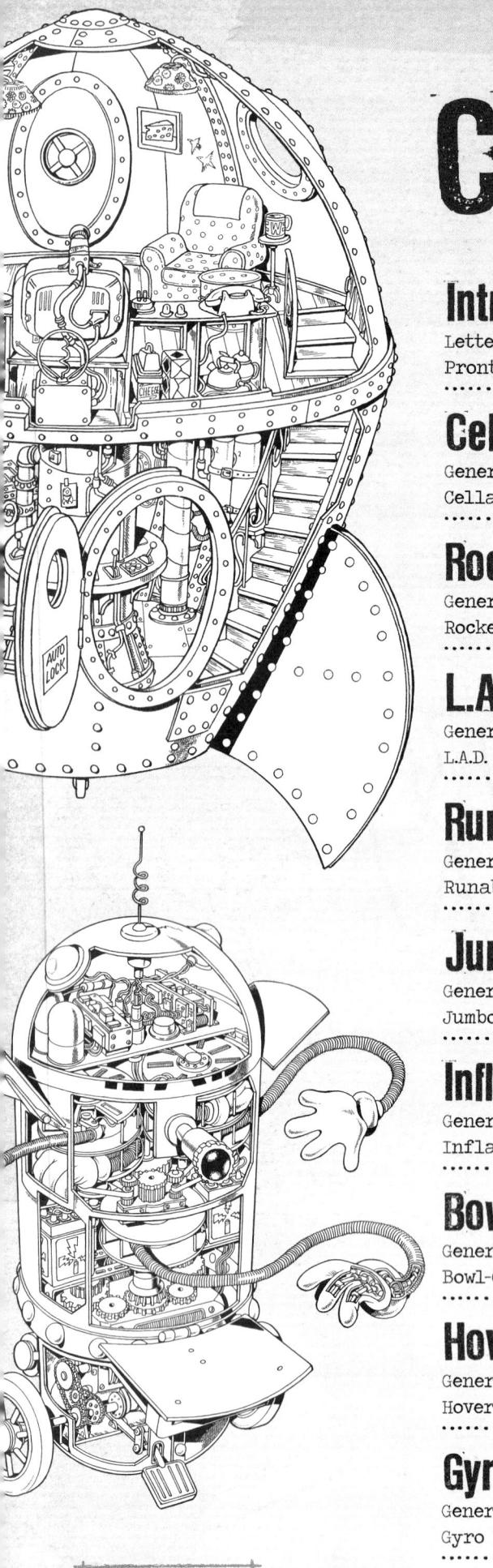

FOLIO

CONTENIS Part 2

Letter from Wallace Pronto Print cutaway

Cellar Studio

General description Cellar Studio cutaway

Rocket Mk-2

General description Rocket Mk-2 cutaway

14 122 14 122

16 124

General description L.A.D. cutaway

18 126

18 126 20 128

Runabout Steam Chair

General description Runabout Steam Chair cutaway **22** 130 22 130 24 132

Jumbo Generator

General description Jumbo Generator cutaway **26** 134 28 134 28/ 136

Inflatable Safety Suit

General description Inflatable Safety Suit cutaway 38 138 30 138

32 140

Bowl-0-Matic

General description Bowl-O-Matic cutaway 34142 34 142 36 144

Hover Wellies

General description Hover Wellies cutaway **36**146 38 146

Gyro Brolly

General description Gyro Brolly cutaway 42 150

40 148

Mk-1 Easy Iron General description Mk-1 Easy Iron cutaway	46 154 48 154 48 156	
Fuel & Drinks Dispenser General description Fuel & Drinks Dispenser cutaway	50 158 50 158 52 160	
Anti-Pesto Launch System General description Anti-Pesto Launch System cutaways	54 162 56 164	
Garden Exit System General description Garden Exit System cutaway	62 170 62 170 64 172	
Bun Vac 6000 General description Bun Vac 6000 cutaways	68 174 66 174 68 176	(FUEL)
Mind Manipulation—O—Matic General description Mind Manipulation-O-Matic cutaways	7 2 180 72 180 74 182	GALLONS
Austin A35 Van General description Austin A35 Van cutaway	78 186 78 186 80 188	DIESEL 4 STAR UNLEADED
Bed Launcher & Auto Dresser General description Bed Launcher & Auto Dresser cutaways	82 190 82 190 84 192	TEA
Pie Launcher General description Pie Launcher cutaway	28 196 ²⁸ 196 90 198	
Wallace Vision General description Wallace Vision cutaway	92 200 \$2 200 \$4 202	

Part 1

The Editor
Haynes Publishing Ltd
Sparkford
Somerset
BA22 7JJ

Wallace & Gromit

62 West Wallaby St, Up North, England

Dear Editor,

I can't tell you how delighted I was to receive the proofs for your new book in this morning's post. All in all, I think you've made a pretty good stab at it. And as for those drawings, they're absolutely cracking!

However, I hope you don't mind me taking the liberty of making a few judicious tweaks here and there. Actually, I've put the whole thing through my new 'EDIT-O-MATIC' machine, which should iron out a few bugs in the text. And design. And layout... To tell the truth, it's pretty much a new book altogether.

In fact, I'm sending you an exclusive preview of the plans for my invention - it's bound to bring this publishing game into the modern age! You could do worse than put your entire output through the works - just think of the improvements you could make at the flick of a switch. You'd hardly need to employ any real editors again!

Delighted to be of help, and can't wait to see the finished book!

Yours ever,

Wallow

Wallace

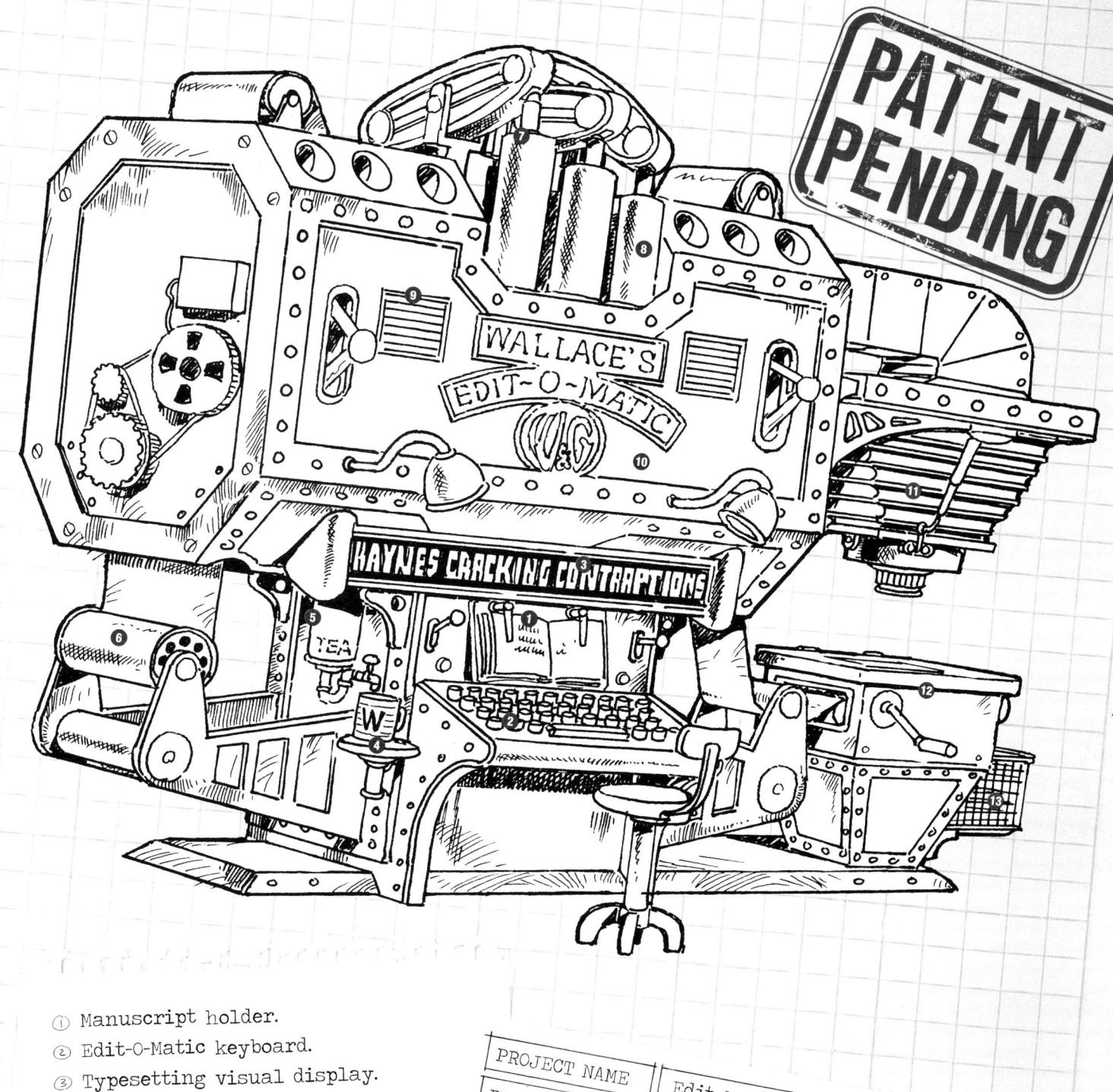

- 4 Mug of tea.
- 6 Tea urn.
- 6 Printing paper roll.
- Trinting ink pump.
- 3 Correction fluid pump.
- @ Cooling vents.
- Page layout mechanics housing.
- ① Flat bed process camera adds photos and drawings to page layouts.
- ② Pages are printed and trimmed, ready for binding.
- 3 Finished pages tray.

62 WEST WALLABY ST

Contents

General description	6
62 West Wallaby Street cutaway	8
The Wash 'n' Go launch system	10

General description

Wallace and Gromit live at 62 West Wallaby Street, in a spacious, double-fronted, semi-detached house. Downstairs there is an entrance hall, lounge, dining room, kitchen and pantry, and upstairs there are four bedrooms, one of which is used as a study, and a bathroom. Attached to the side of the house is a single garage, and there are attractive gardens front and rear.

Wallace is constantly inventing and many of his latest creations have been installed or put to use around the house. Over time these are often improved or replaced with new contraptions, and it's impossible to know what latest piece of ingenious machinery may be concealed behind a wall or above a ceiling.

Some of the more permanent (and more successful) contraptions include the Bed Launcher, which tips Wallace's bed and delivers him, via his trousers, to his chair at the breakfast table in the dining room below, where the Auto Dresser, Jam Ballista and Porridge Cannon are waiting ready to perform their duties each morning.

The 'Wash 'n' Go' launch system was devised when Wallace and Gromit started their window-cleaning

business, and provided fast access to their motorcycle and sidecar. The system was later modified for use with their Austin A35 Van.

Other contraptions are called into action as necessary, and these include the Tellyscope, the Autochef, the Turbo Diner, the Snoozatron and the 525 Cracker Vac. All of them are prototypes and all of them need those few final tweaks to make them perfect.

Most of Wallace's inventing takes place in the unusually large cellar beneath the house. It is here that some of his largest and most spectacular contraptions have been designed and built, including the Rocket and the Knit-O-Matic.

From the outside, 62 West Wallaby Street appears to be just an ordinary suburban house and never really changes. That was until Wallace and Gromit started their Top Bun Bakery business, providing a complete 'Dough to Door' service to their customers. They installed a traditional windmill on the roof and converted the entire house into a large-scale bakery.

In the future, we might see even more dramatic changes to the house as Wallace's ideas and inventions get bigger and better.

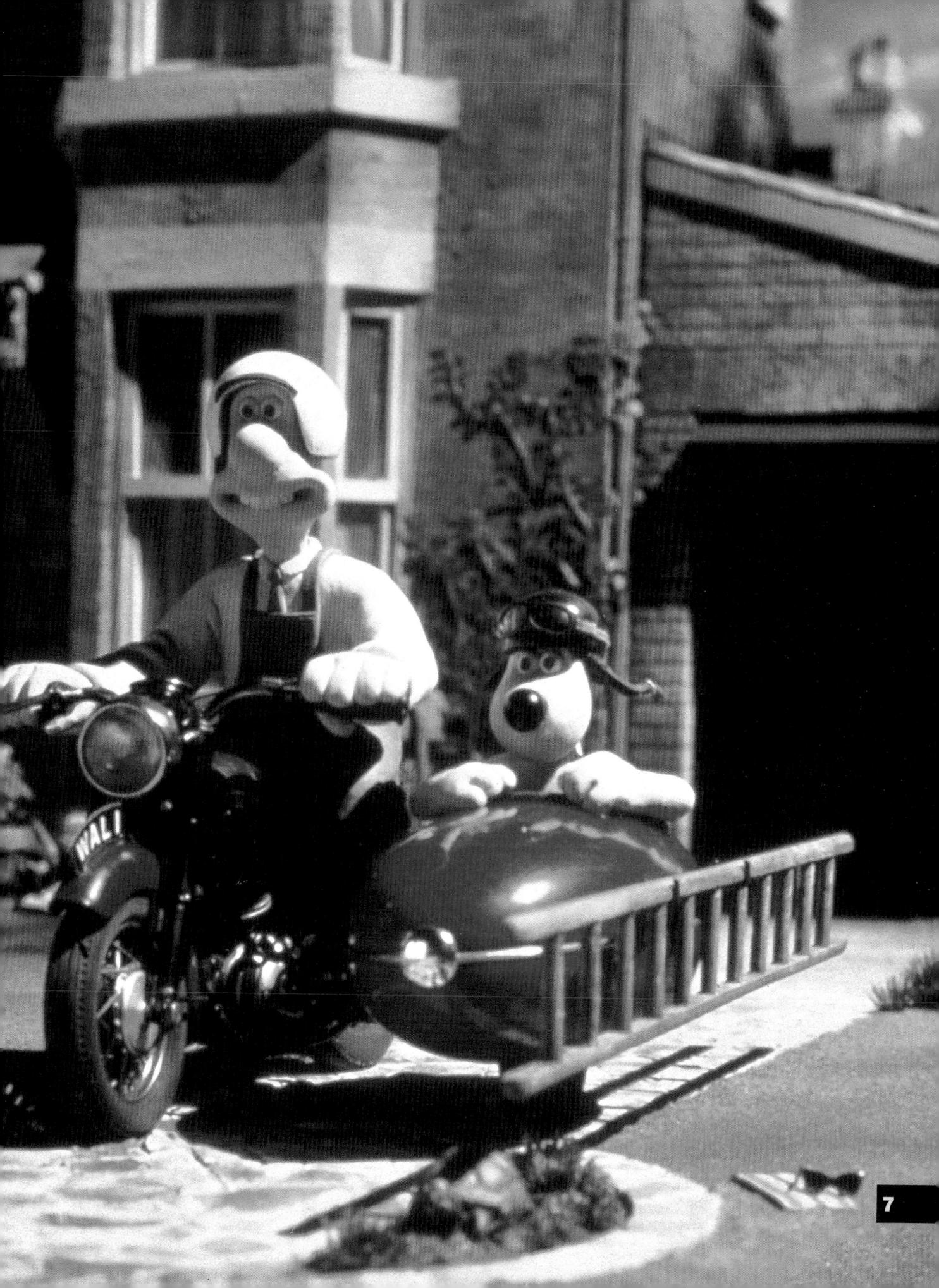

PROJECT NAME	
	62 West Wallaby Street
PURPOSE	Home of Wallace & Gromit
	and their workshop (cellar)
والمستروع والمستروع والمتراج والمتراوي والمتراوي والمتراوي والمتراوي والمتراوي والمتراوي والمتراوي والمتراوي	

62 West Wallaby Street cutaway

- Garden path, leading to front gate and West Wallaby Street
- 2 Two pints of milk delivered daily
- 6 Lounge
- Gromit's bedroom
- G Gromit's bed
- 6 Bookcase
- Study
- Wallace's bedroom
- Wallace's bedside alarm system control box
- Spare room (later redecorated and occupied by Gromit when Feathers McGraw takes his room)
- Spare bed
- Landing and stairwell
- Part of the roof of the neighbouring house
- Front door
- (1) Living room door
- Cellar and workshop where many of Wallace's inventions are created
- **1** Launch system activation lever
- Wallace's 'Wash-n-Go' job standby chair (shown in launch position)
- Hydraulic lift raises Wallace's chair through the study and into launch position
- Variable position launch chutes
- Launch chute control box and gearing
- 2 Ladder attachment system
- Spare ladder
- Motorcycle engine auto-start boot
- Overall suspension arms
- 29 Wallace's overalls
- Telescopic sponge deployment arm
- Garage cellar
- Motorcycle and sidecar
- Turntable
- 1 Hydraulic lift
- Revolving garden pond (shown in 'GO' position)

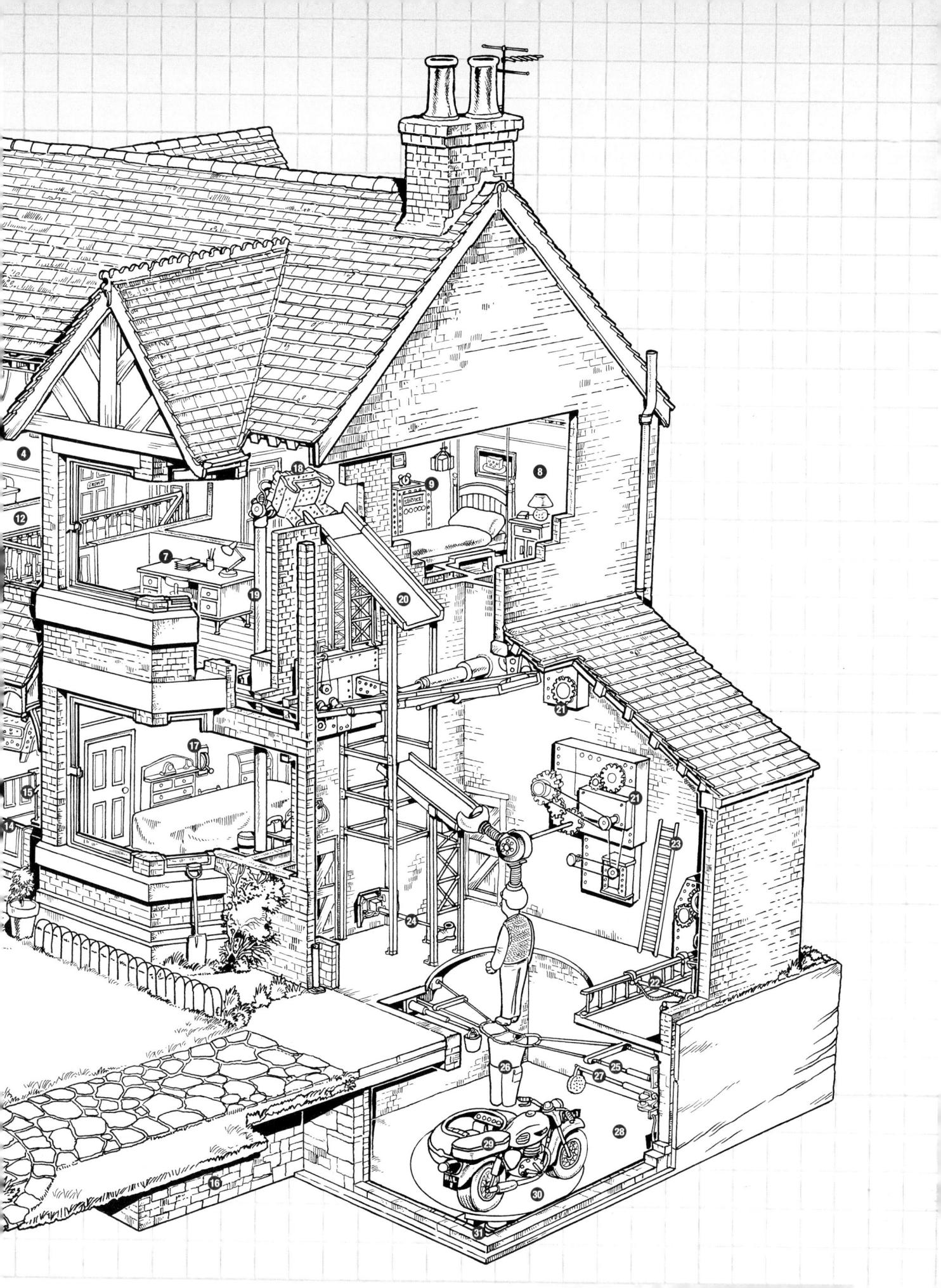

Wash 'n' Go launch system

ne of Wallace's more ambitious inventions is the Wash 'n' Go launch system, which was installed when he and Gromit started their rapidresponse window-cleaning business.

When a call is received from a distraught customer with dirty windows, they can be ready to go, along with all

necessary window-cleaning equipment in less than a minute.

Wallace waits at the ready in his standby armchair. When the launch system is activated, the chair is lifted up through a hatch in the ceiling of the dining room, into the study above by a hydraulic lift. The chair is then tipped

backwards and Wallace slides through the wall and down a series of chutes before being dressed in his overalls and delivered to his motorcycle and sidecar, which is automatically kick-started.

A ladder, sponge and bucket are then deployed and the Wash 'n' Go team are ready for action.

Launch sequence

- Once a call is received, Gromit pulls a lever, activating a hydraullic lift, which sends Wallace's standby chair (and Wallace) up into the study above.
- 2 The chair tips backwards and a painting on the wall flips down, allowing Wallace to descend through the hole in the wall.
- Wallace slides head-first down the chute until his head comes to rest on a cushion at the other end.
- This part of the chute tips down and Wallace continues his descent feet-first.

- When he reaches the end, the chute tips again, and Wallace slides head-first again towards an awaiting motorcycle helmet.
- With his head gripped firmly in the helmet, Wallace is rotated clockwise to a vertical position.
- Wallace is turned 90 degrees to face the back wall of the garage, still with his head gripped in the helmet.
- ① Descending to his motorcycle, Wallace is dropped into his overalls while telescopic arms pass him his bucket and sponge.
- Wallace lands on the motorcycle, which is raised to garage floor level. It then rotates through 180 degrees and Gromit hops into the sidecar, having walked through a door from the pantry.
- A ladder is attached to the sidecar by extending arms, and the auto-start boot kick-starts the motorcycle.
- The garage door slides up and over, and the motorcycle speeds over the garden pond – which revolves to reveal paving on the other side.

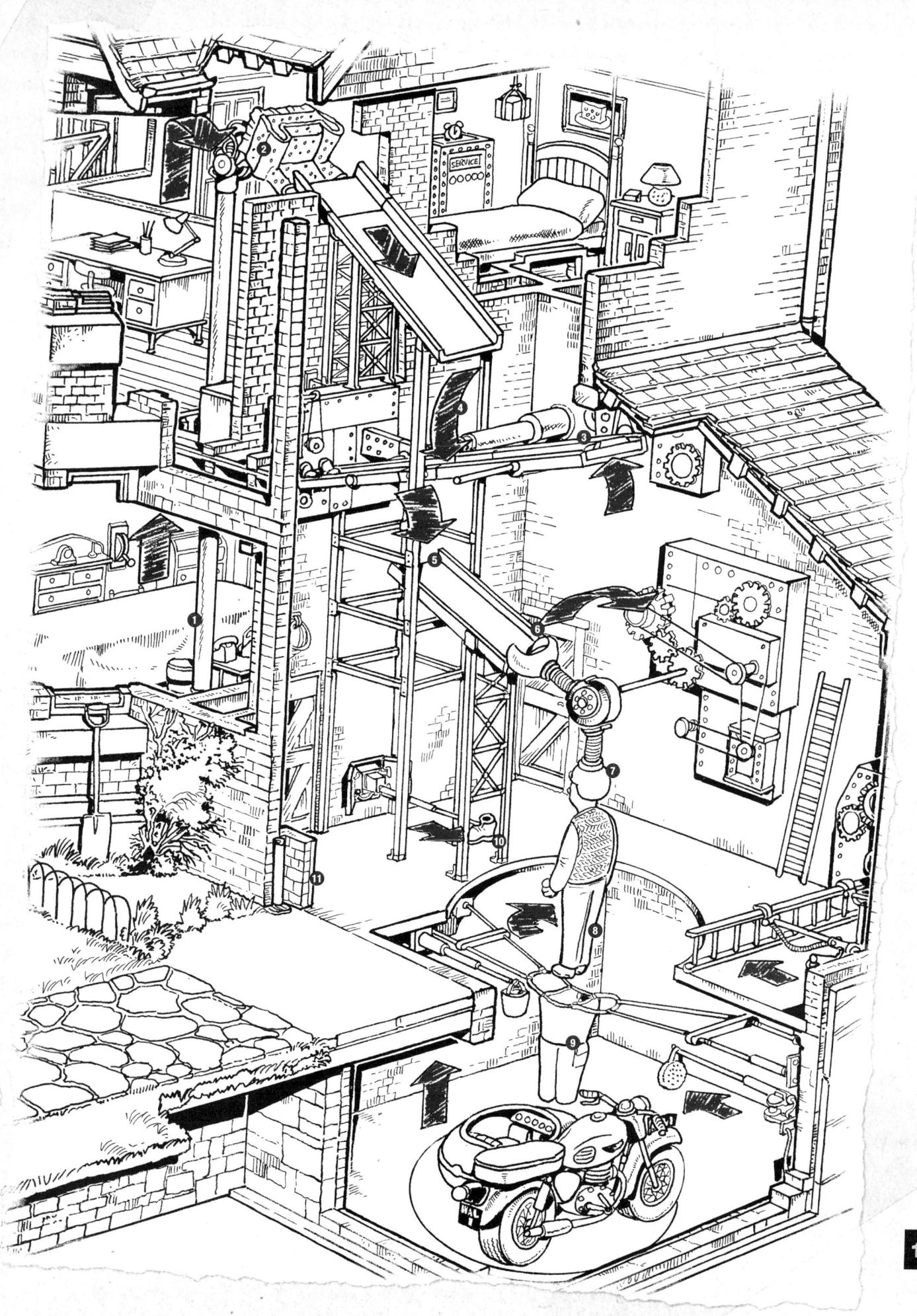

BED LAUNCHER

Contents

General description	12
Bed Launcher cutaway	14
Auto Dresser – General description	16
Auto Dresser cutaway	17

General description

The Bed Launcher provides the fastest possible means of getting Wallace out of his bed in the morning and to the breakfast table in the dining room, directly below his bedroom.

Wallace is woken by his alarm clock – although other devices may be employed if this doesn't work. He then uses the bedside pushbutton call system to tell Gromit, downstairs, what he wants, for example 'Breakfast'. This alerts Gromit, who throws a lever to activate the Bed Launcher.

The head end of the mattress is winched up by an electric motor, concealed above the ceiling, using a system of ropes and pulleys. The process is assisted by a counterweight, which falls down into the corner of the bedroom, pulling a rope and helping to lift the bed.

The arc made by the head end of the mattress is corrected by small slide wheels fitted at the foot end of the bed; this ensures that the winching ropes remain vertical during operation and increases the angle, and hence speed, of descent. The bedclothes are left untucked at the foot of the bed the night before so that Wallace can simply slide out once the mattress reaches the critical angle.

Simultaneously, a two-door hatch in the bedroom floor at the foot of the bed is opened by two rope winches. These are again operated by electric motors, this time mounted in the cavity between the floor of the bedroom and the ceiling of the room below.

Wallace slides out of the bed, through the hatch in the floor and straight into his trousers, which are suspended by their braces from four hooks located around the bottom edge of the hatch. This is a particularly ingenious part of the design since not only does it put on Wallace's trousers but it also helps to break his fall when he lands on his chair at the breakfast table in the room below.

As soon as Wallace lands on his chair, the Auto Dresser (see page 16 for full description) puts on the top half of his clothing (shirt, tie and tank top), while the sleeves are added by a separate device extending down from the ceiling.

The entire process takes a matter of seconds, which means that Wallace loses no time at the start of a busy day.

Further contraptions are then used to speed up or automate the serving of breakfast although none seem to work as effectively as the Bed Launcher.

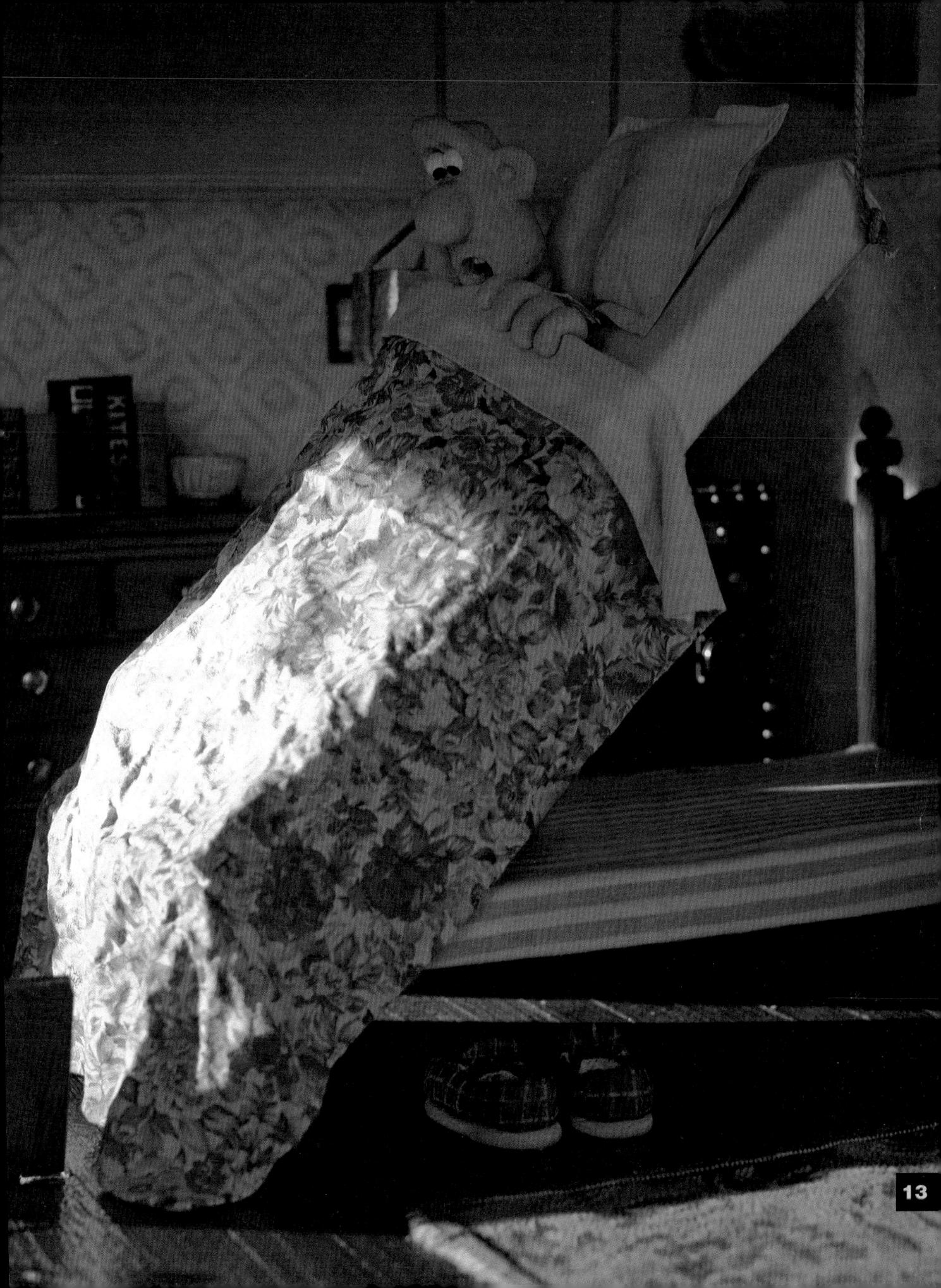

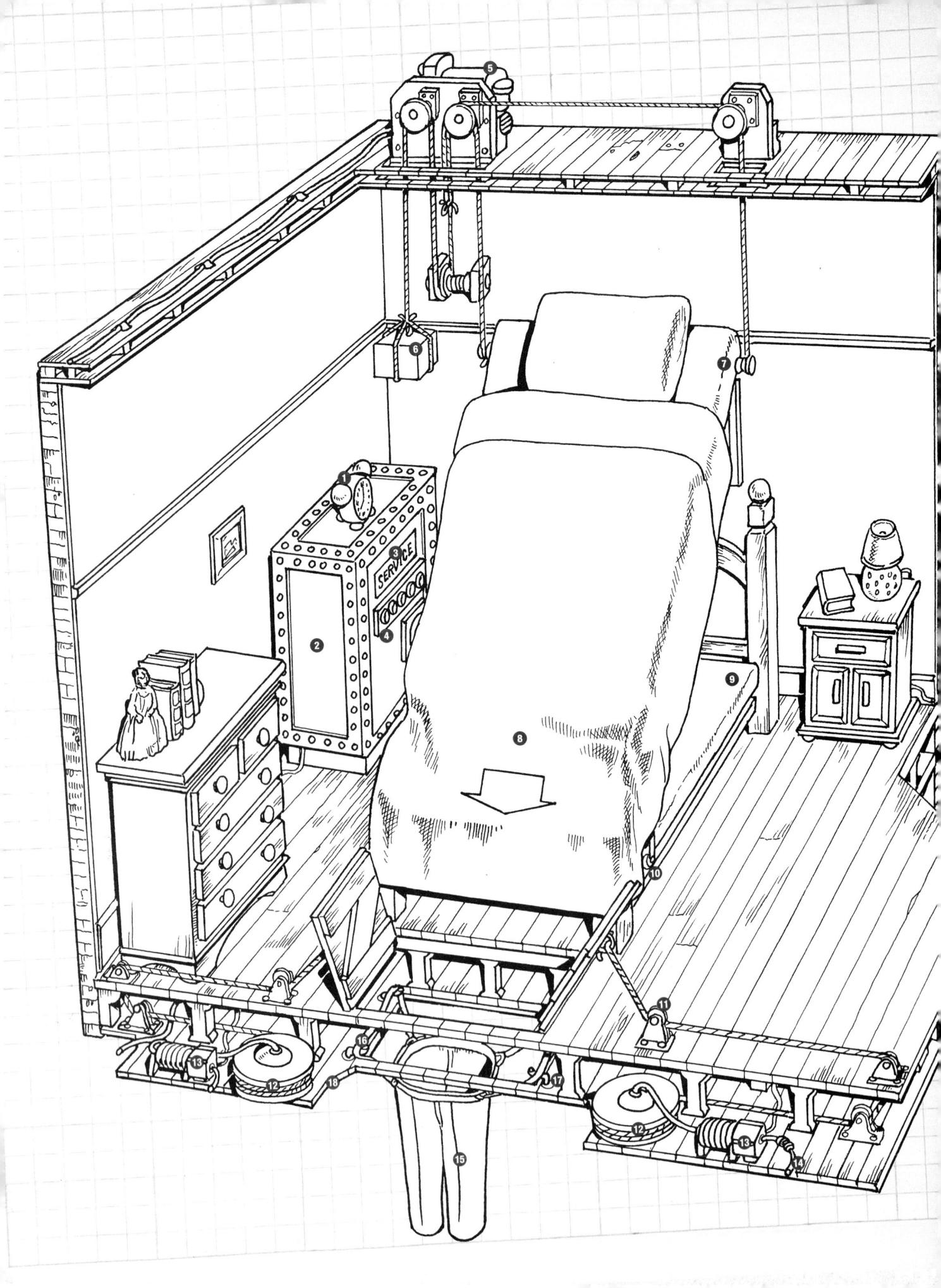

PROJECT NAME	Bed Launcher
PURPOSE	High-speed route from bed to breakfast via trousers

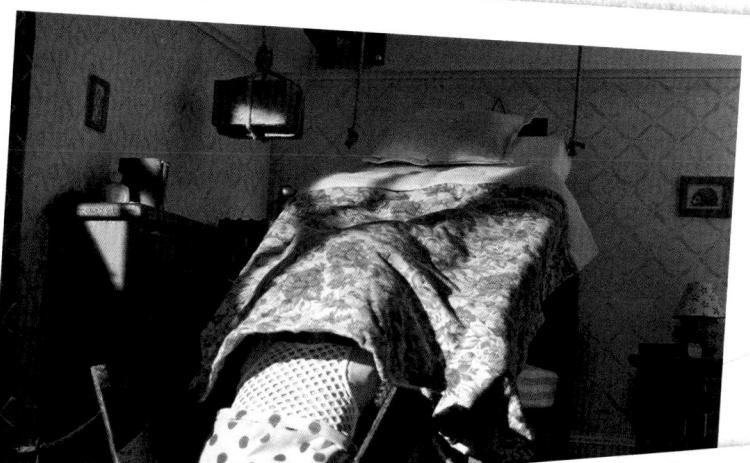

wallace slides out of bed and into his trousers...

Bed Launcher cutaway

- Alarm clock
- Bedside call system control box
- Visual display
- Control box function buttons
- 6 Mattress lift electric motor
- Mattress lift counterweight
- Strengthened bed mattress
- Blanket and eiderdown left untucked
- Sprung base of bed
- Mattress lift slide wheels allow foot end of mattress to slide back
- Tloor hatch pulleys and cord
- P Hatch cord winch reels
- 1 Hatch cord winch electric motor
- **1** Power cable
- Wallace's trousers
- Trouser braces placed on hooks the night before by Gromit
- One of four trouser brace hooks
- (B) Dining room ceiling

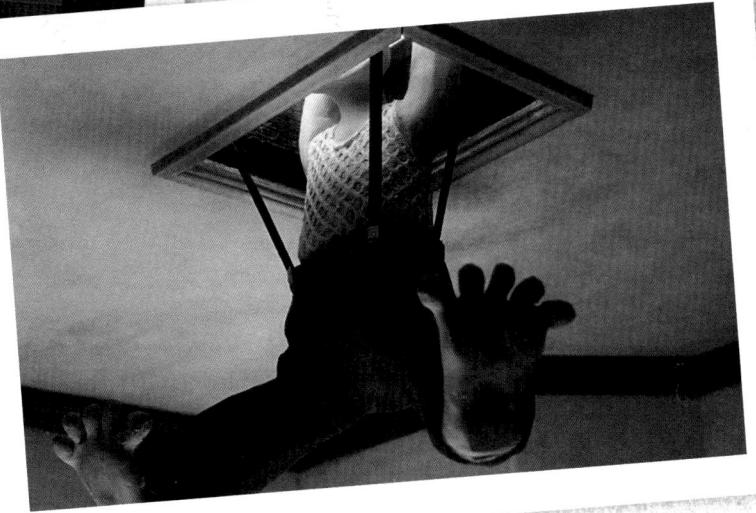

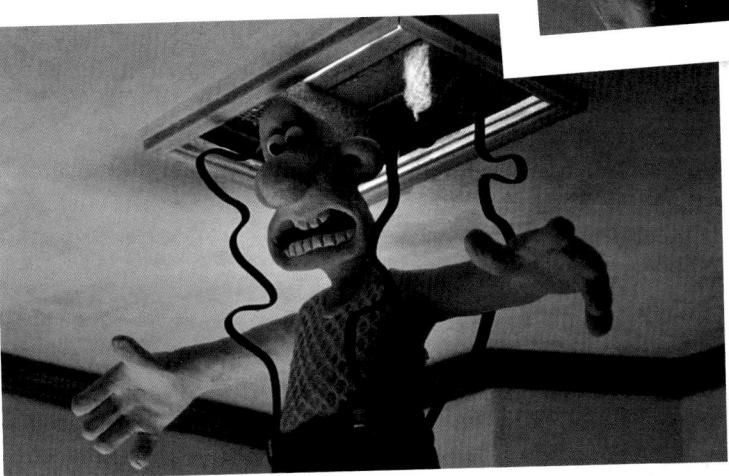

... which also help to break his fall.

Auto Dresser - General description

PROJECT NAME

PURPOSE

Auto Dresser

Automatic tank top, shirt and tie dressing machine

The Auto Dresser's primary function is to dress Wallace in his shirt and tank top each morning. This is normally performed at the breakfast table after Wallace has been dropped through the ceiling and into his trousers from the bedroom above by the Bed Launcher. Shirt sleeves are pulled on to Wallace's arms by a separate device, and then the Auto Dresser adds the rest of the shirt, tie and knitted tank top to complete his outfit for the day.

The tank top and shirt combination is held and stretched open by two tank top holding bows. These are mounted on hydraulically actuated arms that are articulated and have complete freedom of movement, which is essential for achieving a comfortable fit. The arms are mounted on the control dome. which is able to rotate on top of the upper section of the Auto Dresser's body. The upper section can be raised and lowered in order to reach up and pull the clothes down over Wallace's head; the upper section also houses the motor that controls the arms as well as the rotation of the control dome.

The Auto Dresser is controlled by a computer, which contains several different dressing programs, and the user can change program using a dial on the control box at the top of the unit. The computer, control box, hydraulic arm actuators and gearing are all contained within the control dome.

The lower section forms the base of

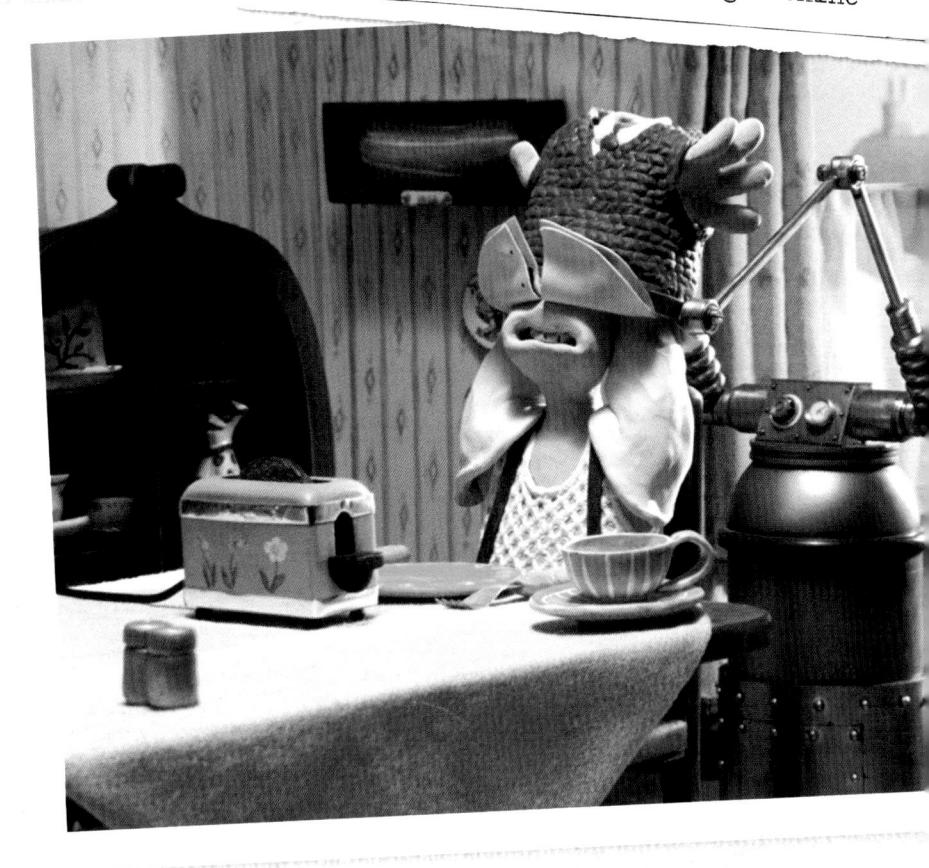

the Auto Dresser and contains the gearing to control the height of the upper section. The entire unit is mounted on caster wheels and driven by a second motor, also in the lower section, allowing it to move around the house as required by the current program. The Auto Dresser is also used in the cellar of

62 West Wallaby Street to assist in taking the latest item of knitwear produced by Wallace's Knit-O-Matic and putting it on the lucky recipient.

A hatch at the front of the lower casing allows access to the battery and for general maintenance of all internal components.

Auto Dresser cutaway

- Program dial
- Ocntrol box
- 3 Arm control circuit board
- O Good dress sensor dial
- Tank top holder bows place clothes over Wallace's head; sleeves are added by separate sleeve attachment device
- Tank top holder bow pivot
- Arm hydraulics incorporating wiring for adjustable tank top holder bows

- Computer controlling speed, direction and pre-programmed dressing functions.
- Arm movement gearing
- ® Rotating control dome
- 1 Rotation control gearing
- Control dome rotation ball bearings
- Top motor controls arms and rotation of control dome
- **(1)** Upper section maintenance key
- Spare adjustment key

- (in raised position)
- Upper section height adjustment gearing
- (B) Height adjustment guide slot
- (1) Guide rollers
- @ Lower section
- 2 Lower section maintenance hatch
- Lower motor drives wheels, steering and height adjustment
- **3** Battery
- Steering caster wheels driven by lower motor

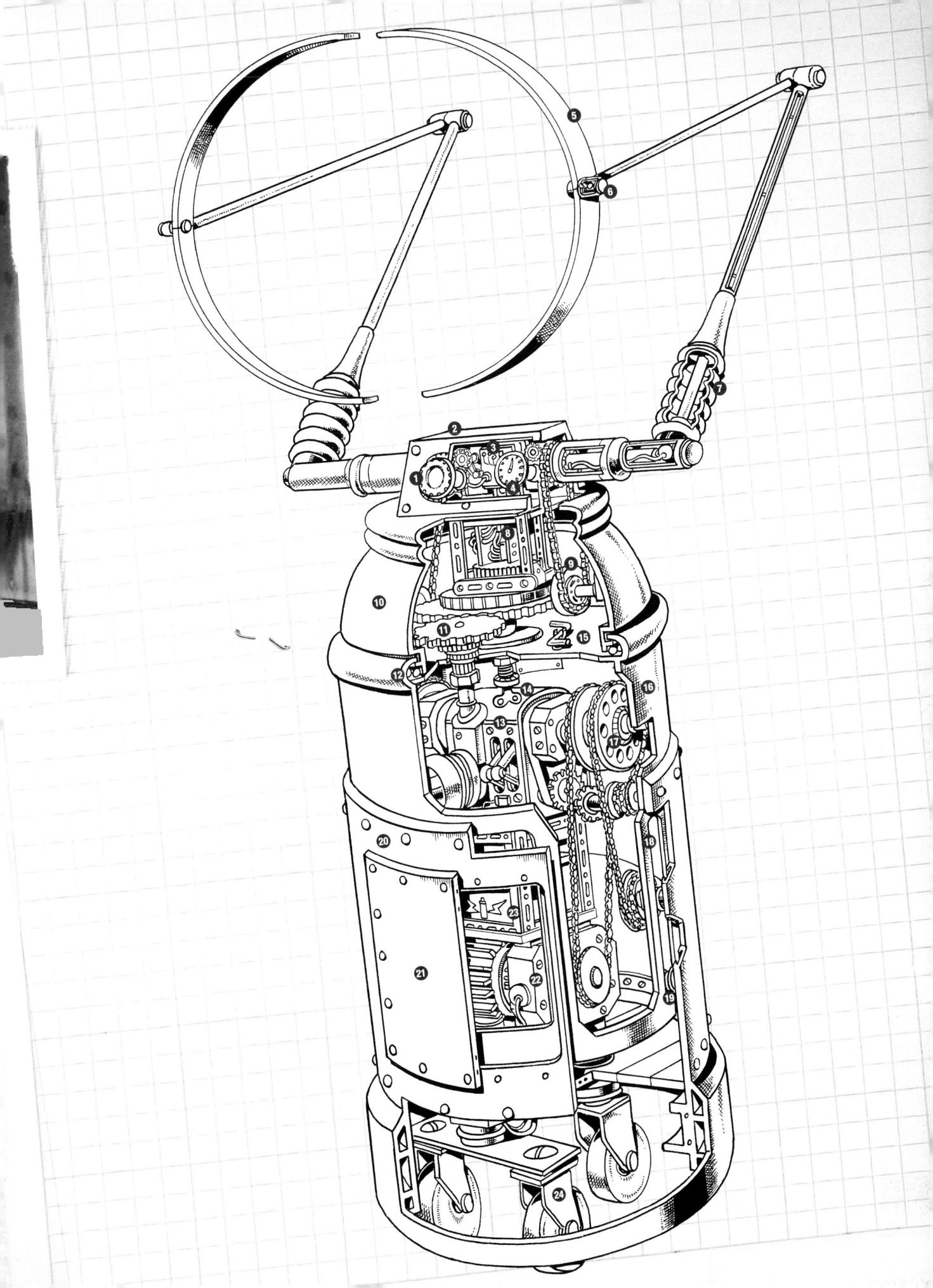

ROCKET

Contents

General description	18
Rocket cutaway	20
Cooker cutaway	22
Cooker – General description	23

General description

Wallace wants to go on holiday, and where is there plenty of cheese? The moon of course! Since the easiest way to get to the moon is by rocket, Wallace and Gromit set about building one in the basement. The result is very much a home-made contraption, but the design ensures that passenger comfort is high on the agenda and that nothing is left to chance.

The rocket is of riveted construction and braced by six stanchions spaced equally around the inside of the egg-shaped hull. The internal space is split roughly in half with the 'top' half being the passenger cabin/living room. The lower half is almost entirely filled with the rocket engine, fuel, water and air tanks, fuse reel, an access ladder and various other equipment.

Access to the pressurised cabin is via a hatch from the outside. An additional hatch in the floor of the cabin provides access to the engine room and, finally, the engine room may be accessed directly from the outside via a maintenance access panel.

The propulsion system is a bespoke jet engine using a unique method of ignition. This consists of a length of fuse fed down through the rocket nozzle and

lit from the outside. The fuse is continuous and stored on a reel next to the engine so that a length may be deployed for the next lift-off.

A single operator console, situated in the passenger cabin, contains all the switches, levers and buttons necessary for navigation, steering and control of the rocket's engine. Further equipment includes an external view-scope, engine monitor headphones, an electric kettle and a fitted toaster.

Other than the control systems, the passenger cabin contains two armchairs, which serve to cushion Wallace and Gromit from the forces of acceleration during lift-off and to provide a comfortable place to relax during the journey, along with a range of various other items of furniture and home comforts.

Rocket cutaway

- Hull support stanchion
- Cabin lighting
- Shelving for books and food supplies (mainly crackers for cheese)
- Gromit's acceleration/ relaxation chair
- 6 Headphones for monitoring engine
- 6 Control systems console seat
- Toaster
- Clock
- Observation porthole
- ® Rocket control systems console (operated by Gromit)
- External view-scope to monitor outside environment and to check altitude when landing
- Pot plant to reduce carbon dioxide in cabin
- (B) Console internal mechanics
- Console coolant tank

- Rocket thrust standby control lever (handbrake)
- 1 Fuel tank
- Tuel feed pipe
- Fuel distribution/regulation valve
- Rocket engine
- @ Ignition fuse: stored next to the rocket engine and fed through the nozzle
- a lanition fuse pulley system deploys an additional length of fuse for the return journey. However, it requires lighting from outside
- Mouse trap
- Begine room maintenance access panel
- 2 Ignition fuse cutter
- ② Ignition fuse storage reel: holds up to 50 yards of fuse for further lift-offs
- 25 Cabin air tanks

- Water tank (mainly for making tea)
- Engine room light switch
- Polding step ladder allowing access to Rocket from around level
- Ladder stowage compartment
- Stabilising fin (one of three)
- Access hatch to step ladder stowage compartment
- Pressurised cabin access hatch
- Knitting
- O Deckchair and spade
- Wallace's acceleration/ relaxation chair
- Observation porthole
- Kettle
- Camera
- 10 Holiday brochure
- Radio
- Bowl of fruit

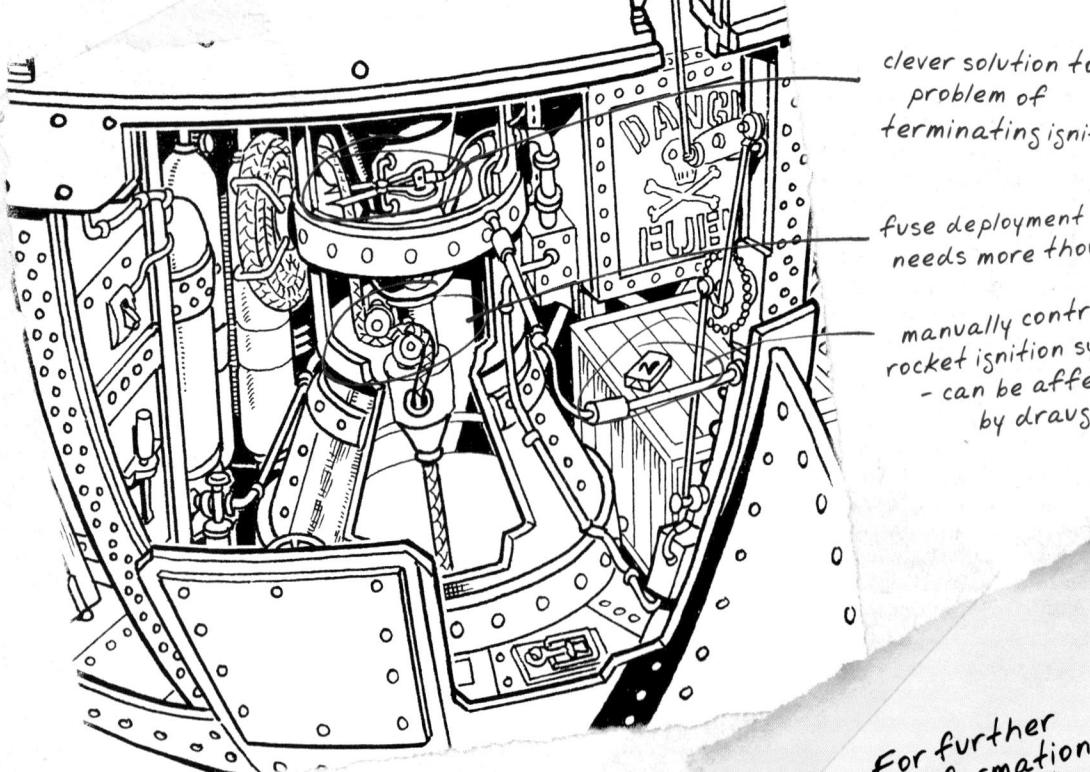

clever solution to the terminating ignition

needs more thought

manually controlled rocket isnition system - can be affected by draughts

For further on information on information field the Rocket's field the Rocket's see test please 23

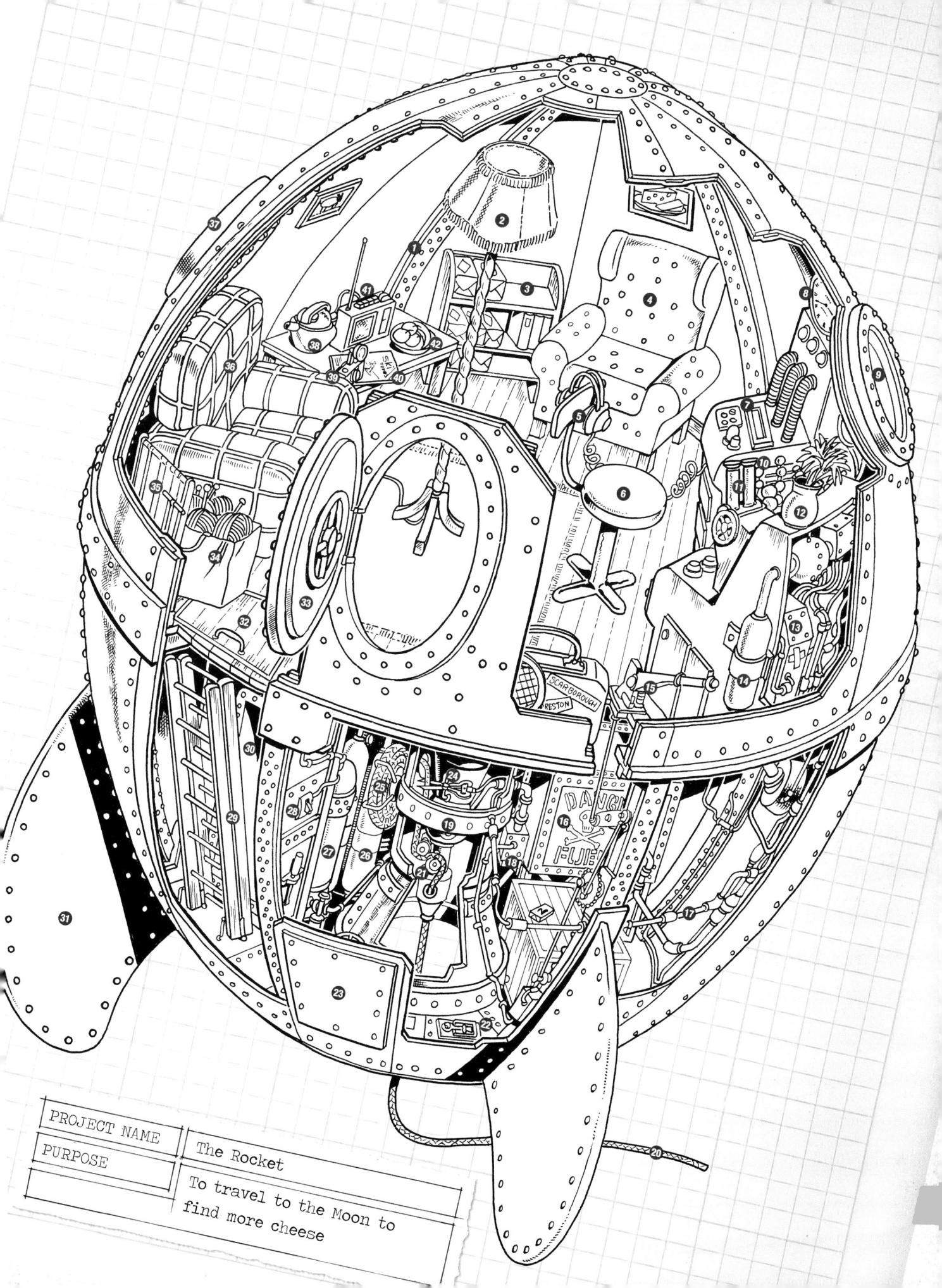

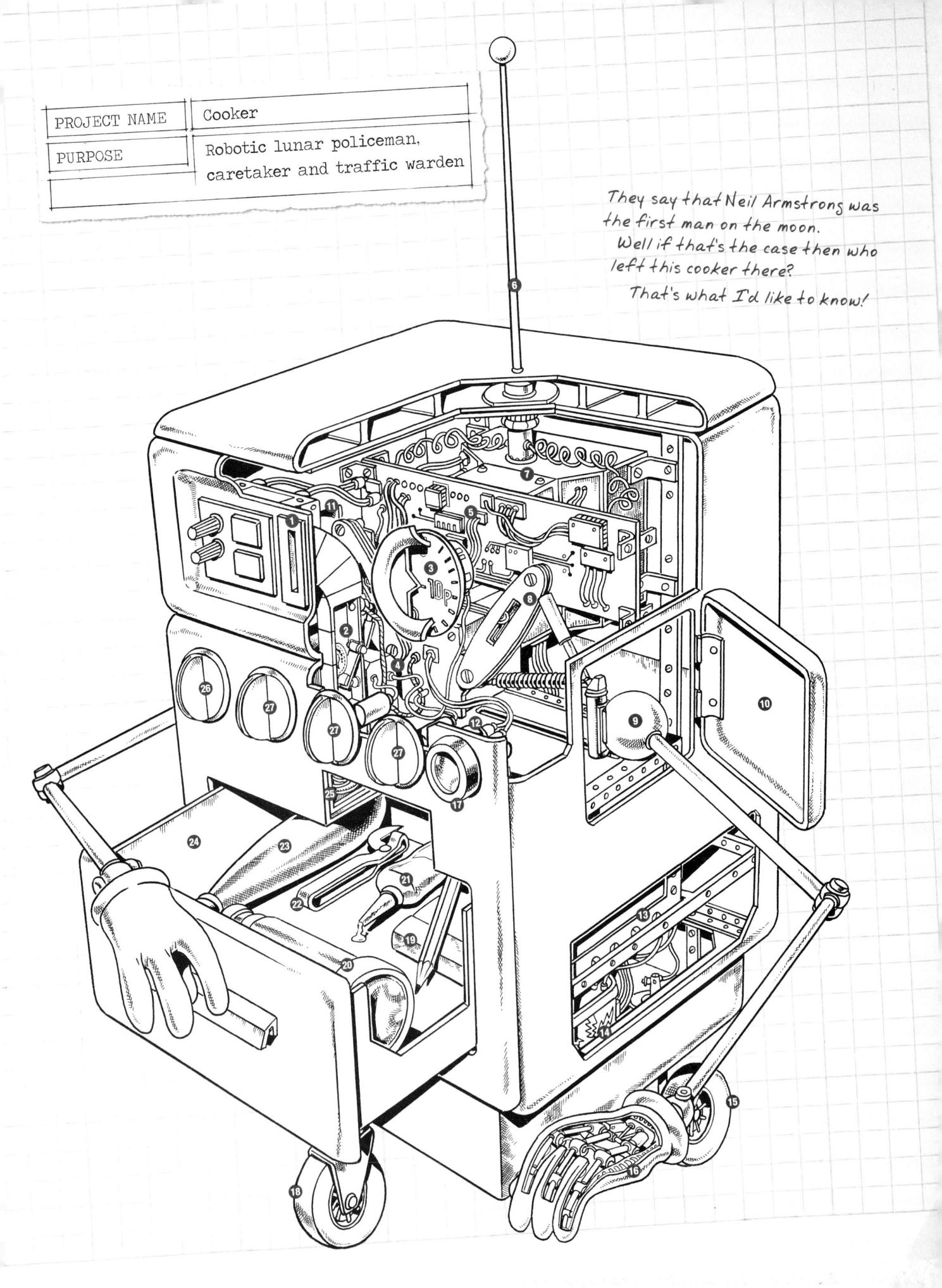

uring their trip to the moon to sample the 'lunar cheese', Wallace and Gromit discover a machine, which appears to be a domestic gas cooker mounted on trolley wheels with an antenna. The front cover houses a coin slot, into which Wallace inserts a coin, but nothing happens at first. However, as soon as Wallace and Gromit walk away, the coin mechanism operates and the machine comes alive.

Immediately, flaps in the side panels open to reveal robotic arms complete with articulated joints and hands. The Cooker begins to clear up the remains of Wallace and Gromit's picnic, but on finding one of their discarded holiday brochures about skiing its thought visualisation processor stirs into action and it begins to 'daydream'.

A drawer in the Cooker's lower casing provides storage for various

implements including a dustpan and brush, a notepad and pencil, a truncheon, a tin opener and a telescope, which it uses to search the landscape and discover Wallace and Gromit's Rocket (illegally parked and leaking oil). The Cooker gives the Rocket a parking ticket before searching again for the culprits, who it discovers tucking into more moon cheese. Racing across the moon surface, the Cooker grabs the truncheon from its drawer and is about to strike Wallace over the head when, fortunately, the coin-op mechanism times out and the machine comes to a sudden halt. Wallace takes the truncheon and inserts another coin into the Cooker. Once more the machine springs to life but realises that Wallace and Gromit are on their way back to the Rocket and Earth...

The Cooker reaches the Rocket before it can take off and gains entry through the lower hull using its tin opener. Unable to see in the dark, the Cooker strikes a match, causing an explosion and ignition of the Rocket's engine. The Cooker is thrown from the Rocket, but manages to tear off two strips from the steel hull. Although unable to travel to Earth, the Cooker fashions the steel strips into makeshift skis, which it uses to ski up and down the lunar landscape.

Cooker cutaway

- Coin slot. Inserting a coin activates timer-control mechanism
- 2 Memory activation solenoid, triggered by coin insertion
- Timer-controlled price display, linked to and triggered by Memory activation timer
- Memory activation timer
- Frimary functions circuit board: controls speed and direction of travel, arm movement and visual processing
- 6 Thought visualisation processor antenna
- Memory bank and thought processing circuits

- Arm control hydraulics: when not in use, the arms are retracted and stored behind the coin slot
- Left arm shoulder swivel joint extended to side hatch doorway to allow maximum movement
- 1 Left arm hatch
- Right arm hatch
- Visual processor linked to memory bank via primary functions circuit board
- Orawer housing (originally the main oven)
- **©** Battery
- Rear left wheel
- Control actuators

- **10** Visual processor camera lens
- Front steering wheel
- Motebook and pencil
- Telescope for long-distance visual enhancement
- Lunar surface instant repair kit (quick-drying glue)
- 2 Tin opener
- Anti lunar intruder device (truncheon)
- Main oven door replaced by drawer unit
- Used coin storage container
- Thought visualisation processor 'tuning' control knob
- Original oven control knobs (redundant)

JAM BALLISTA

Contents

General description	24
Jam Ballista cutaway	26

Watching the toast popup save me a crackinsidea

General description

he Jam Ballista is a relatively straightforward contraption, designed for one reason: to get jam on to a piece of toast the moment it pops out of the toaster. A toaster pop-up synchronisation terminal ensures that the operation is timed to perfection.

The device itself uses a dipping spoon, which is loaded with the user's jam of choice directly from the pot. This simple design means that there are no internal workings to become gummed up with jam.

The catapult spring is extended and held in tension by a jointed spar, located in the centre of the spring coils. The spar is extended by an activation motor operating via a rocker assembly in the base of the Jam Ballista. When the activation (or firing) button is pressed, the current to the motor is cut off, releasing the spar from its primed state and allowing the catapult spring to contract. The spoon pivots in the support structure and comes to a sudden stop as the lower end of the spar

lands on its shock-absorbing pad, causing the jam to be launched.

A dial on the control panel allows the user to pre-set the amount of tension loaded into the catapult spring, thereby allowing a degree of control over speed

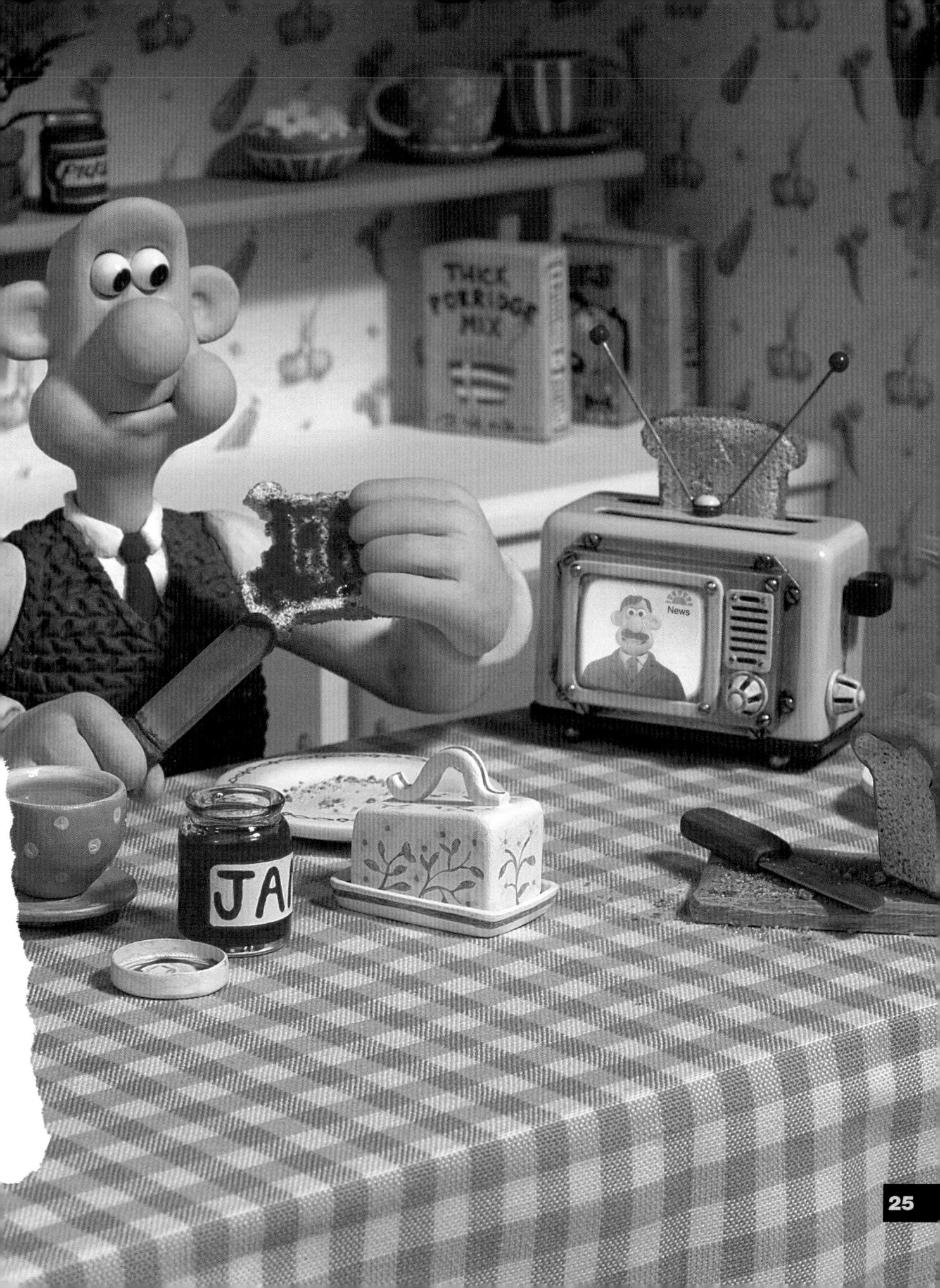

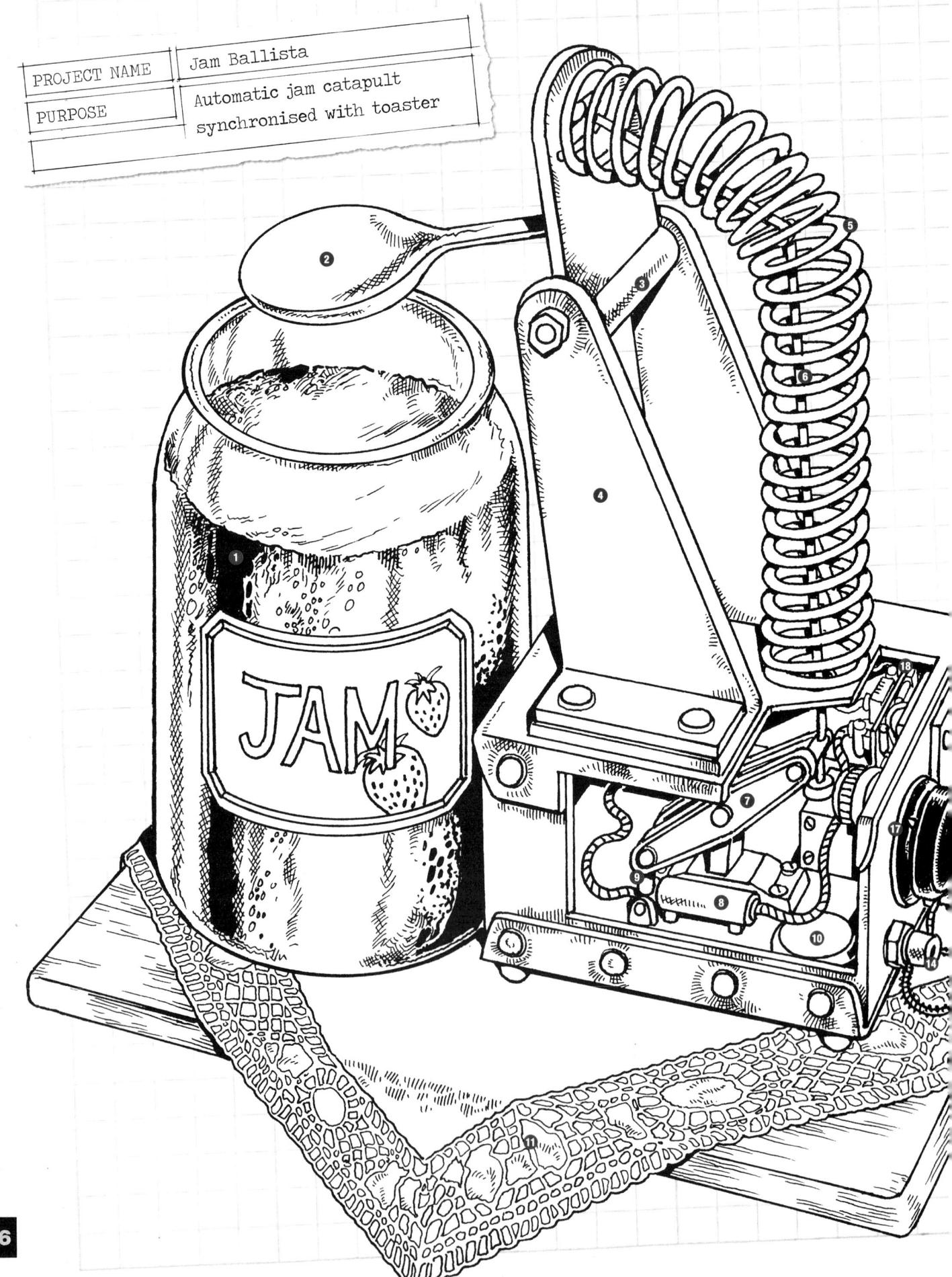

Jam Ballista cutaway Open pot of jam (strawberry shown but other flavours optional) 2 Jam dipping spoon Catapult pivot 4 Hardened steel support structure 6 Catapult spring 6 Spring extension spar Activation motor rocker Spring extension spar activation motor Spring tension sensor Spar shock-absorber landing pad 1 Doily to reduce vibration Activation (firing) button (B) Cable to activation button Toaster synchronisation terminal Toaster synchronisation cable **®** Power switches **©** Spring tension pre-set dial (B) Control circuitry

- EX-NASA

TECHNO TROUSERS

Contents

General description	28
Techno Trousers cutaway	30
Feathers McGraw modifications	32
Feathers McGraw controls cutaway	33
Diamond Grabber cutaway	34

General description

The Techno Trousers were designed by NASA to provide automated personal transport for astronauts during surface landings and other extravehicular activities, such as the repair of spacecraft. Not only are they fully automated, and controllable by remote, but they are also pre-programmable, which makes Wallace think that they will make the ideal dog-walking companion (and birthday present) for Gromit. Perhaps not surprisingly, Gromit isn't quite so impressed.

When used for transport, the operator (or 'pilot') sits on a padded saddle in the upper 'waist' section of the Techno Trousers. Each foot is located inside a leg of the device and secured to a foot platform by a toe clip. With the rise and fall of the legs, the foot platforms are also raised and lowered hydraulically to compensate, maintaining stability and maximising comfort for the pilot who experiences only a simple back-and-forth movement of the legs.

Among the Techno Trousers' many features are their ability to walk up vertical walls using switchable vacuum and magnetic field generators located in the soles of the integrated all-terrain boots. This system allows the boots to

cling to both metallic and non-metallic surfaces, permitting the Techno Trousers to scale virtually any obstacle, and even walk upside-down. This function proves extremely useful while Gromit redecorates his bedroom but also leads to trouble when the Techno Trousers fall into the wrong hands...

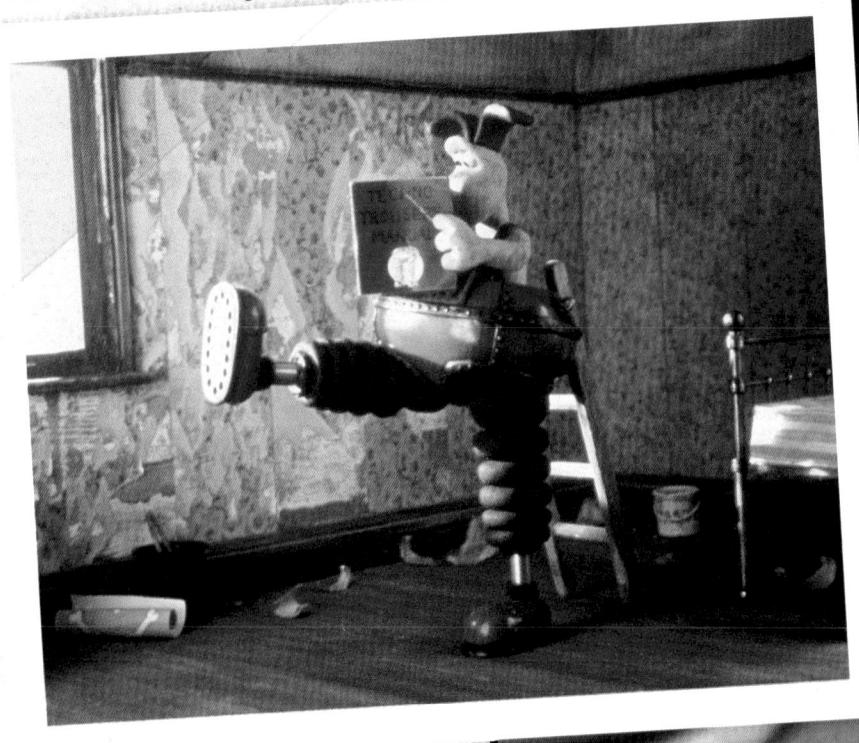

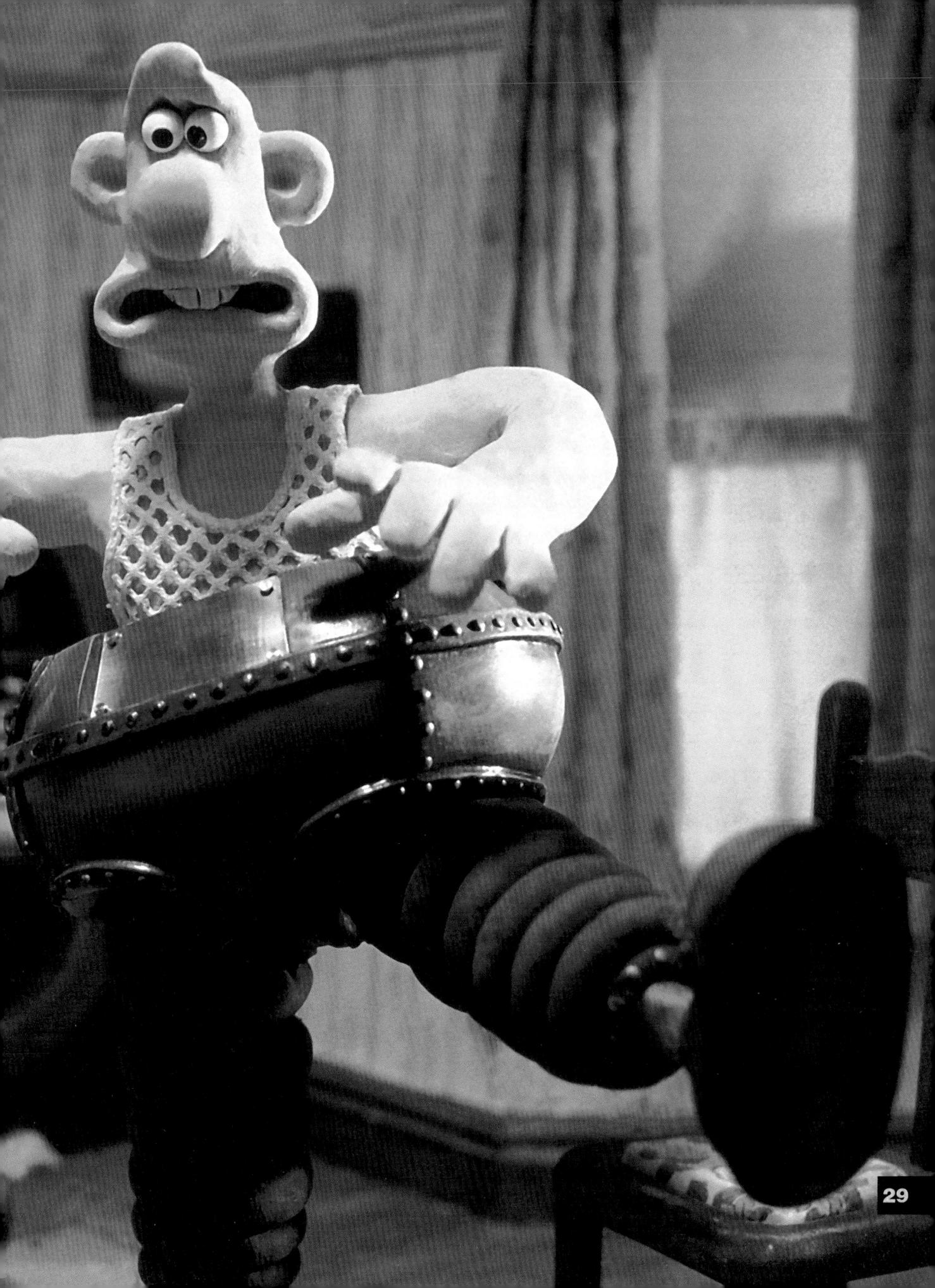

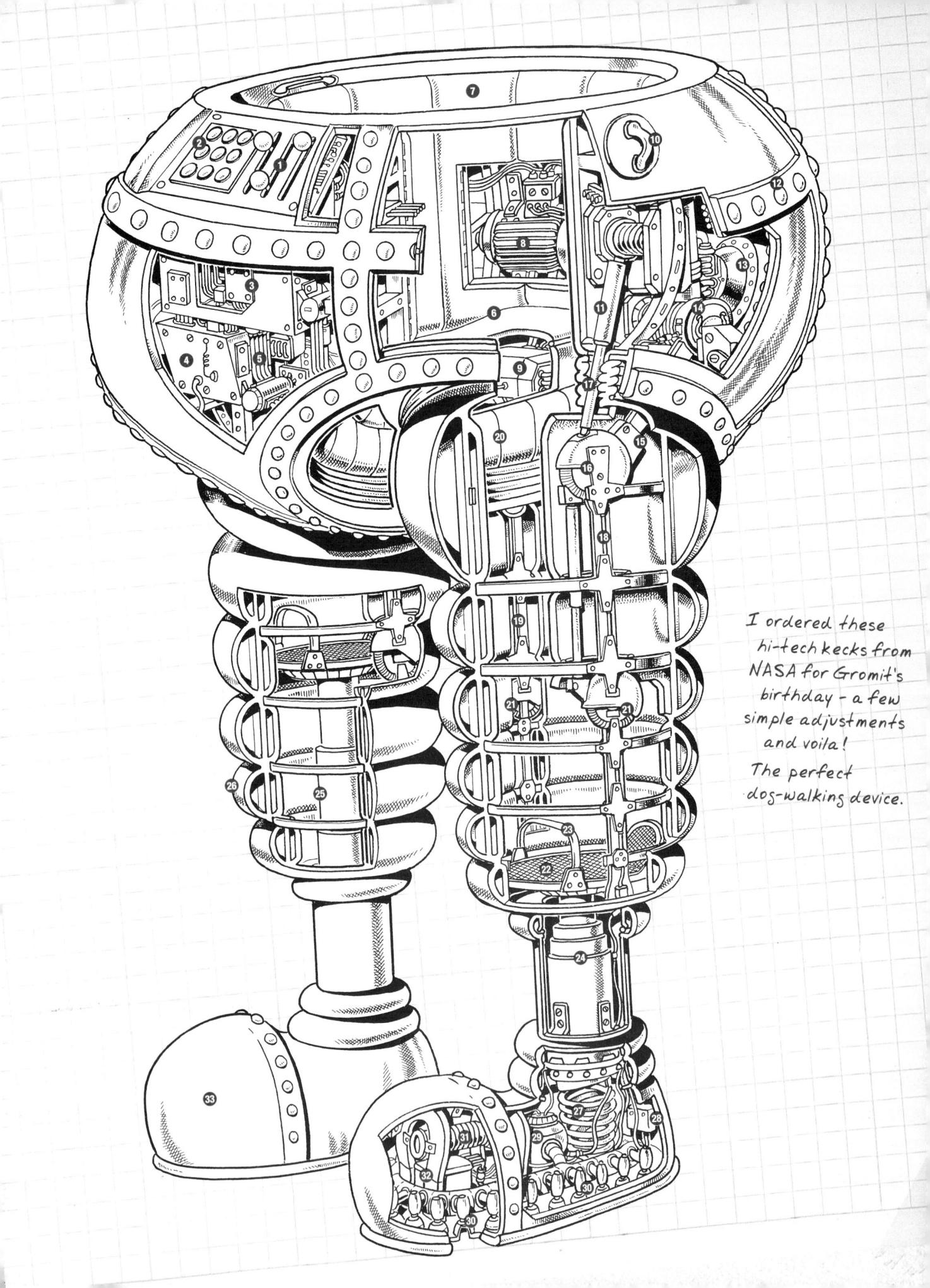

Techno Trousers cutaway

- Operator's controls (designed to be manipulated with spacesuit gloves)
- 2 Automatic pre-programming controls
- 3 Control system computer
- Remote-control receiver allows Techno Trousers to be controlled from a landing ship or base camp if operator is incapacitated
- Control lines to motors
- Operator's saddle and battery compartment cover
- Internal padding to cushion impact and movement
- Primary electric motor, powered by rechargeable battery or optional extension lead (top speed: 'Walk Factor 10')
- Rechargeable battery
- Techno Trousers port-side loading hook

- Forward/reverse leg movement actuator
- **®** NASA-grade rivets
- Rear external power supply and recharging socket
- Left leg secondary motor
- 1 Leg speed gearing module
- 180° hip motor
- Texible leg-joint seal
- Outer internal leg sub-frame
- 1 Inner internal leg sub-frame
- Plexible internal padding prevents operator's legs from chaffing
- Mee joint motors

 Output

 Description:

 Output

 Description:
- ② Operator's foot platform (fully compressed)
- Toe clip
- Poot clamp variable height adjustment hydraulics
- Operator's foot platform (fully extended)

- Flexible rubberised outer skin permits maximum leg movement and provides protection from inclement weather
- Footfall impact absorber
- Foot electronics crossover and junction box
- Switchable vacuum generator allows Techno Trousers to scale vertical surfaces and walk upside-down.
- Sole vacuum tubes
- Gravity field repulsor coil
- Localised field generator magnets allow boots to grip metallic surfaces
- 3 Armoured all-terrain boots

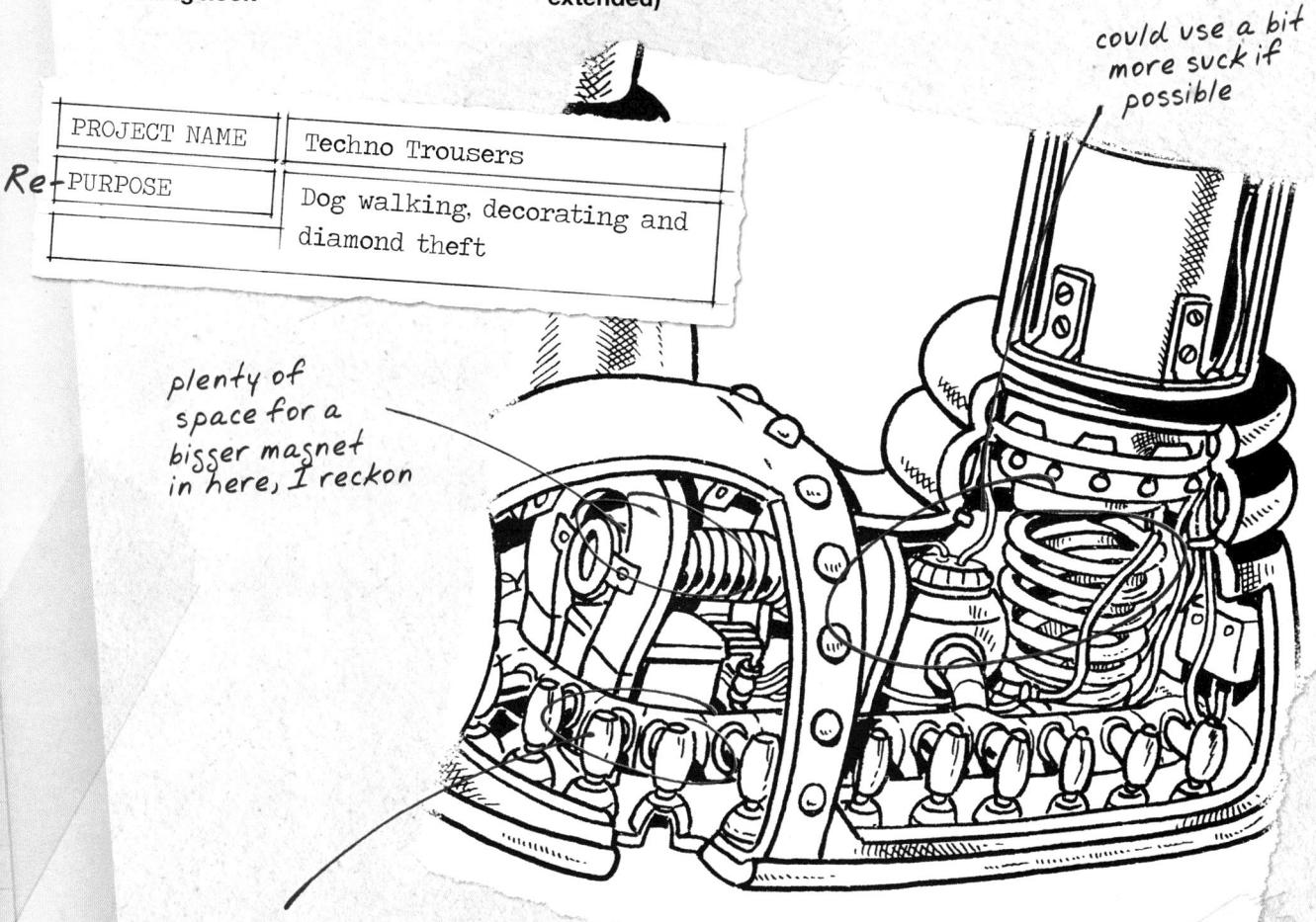

main vacuum tube soes all the way round the boot When notorious criminal Feathers McGraw rents a room at 62 West Wallaby Street, it doesn't take him long to realise the full potential of the Techno Trousers. He devises a cunning plan to steal a large and extremely precious diamond from the Town Museum using Wallace as his unwitting accomplice and the Techno Trousers with some special modifications of his own.

Firstly, the operator's controls on the front of the upper section are

removed and a tamper-proof panel cover is put in their place. This means that the Techno Trousers can now be controlled only via a new remotecontrol unit, which has been specially configured by Feathers McGraw.

Secondly, Wallace (by now exhausted and fast asleep after a long day of extensive 'testing') is fitted with a helmet in which is stowed a Diamond Grabber claw. This is operated (also by remote) while Wallace is hanging upside-down directly above the

diamond in the museum. The grabber claw is deployed through a pair of opening panels in the top of the helmet by a cable winch; it then grabs the diamond, retrieving it for Feathers McGraw who is waiting safely outside.

Meanwhile, Gromit discovers the true identity of the new lodger and confronts him upon his return to West Wallaby Street. Following a struggle, Feathers McGraw is finally captured and towed anonymously to the police station by the Techno Trousers.

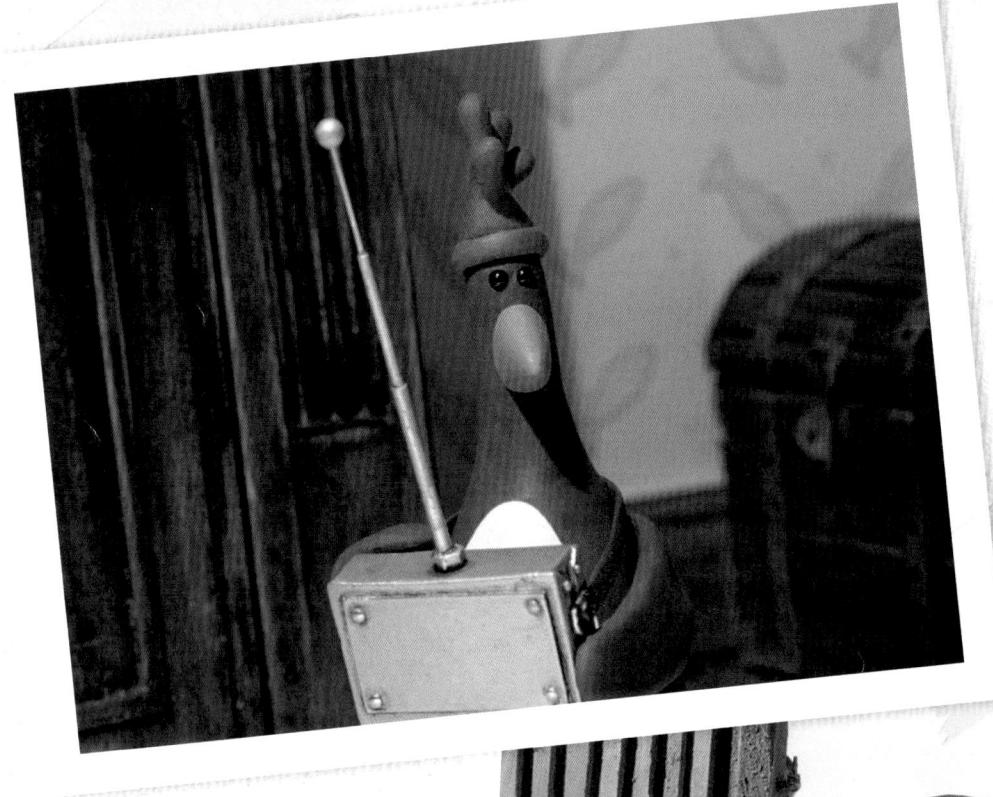

The scoundrel had been finkering and right under our noses fool

I had a very firing day in the WRONG trousers
Feathers McGraw controls cutaway

- Operator's control switches have been removed, and moved to the remote-control unit
- Pre-programming controls have been removed and rewired. All functions have been duplicated on the remote control reusing the original control switches
- Original computer memory store now rewired and reprogrammed

- New remote-control radio link
- Remote-control receiver has been overridden, with wiring re-routed to new remote-control radio link
- Re-routed control lines to motors
- Tamper-proof panel cover ensures that Techno Trousers can be controlled only via new remote control
- Safety braces (originally installed by Gromit)
- Remote-control unit
- Remote controls duplicate the disconnected operator's controls on the Techno Trousers
- Pre-programming control system transferred to, and reprogrammed by, the remote unit
- Neck strap

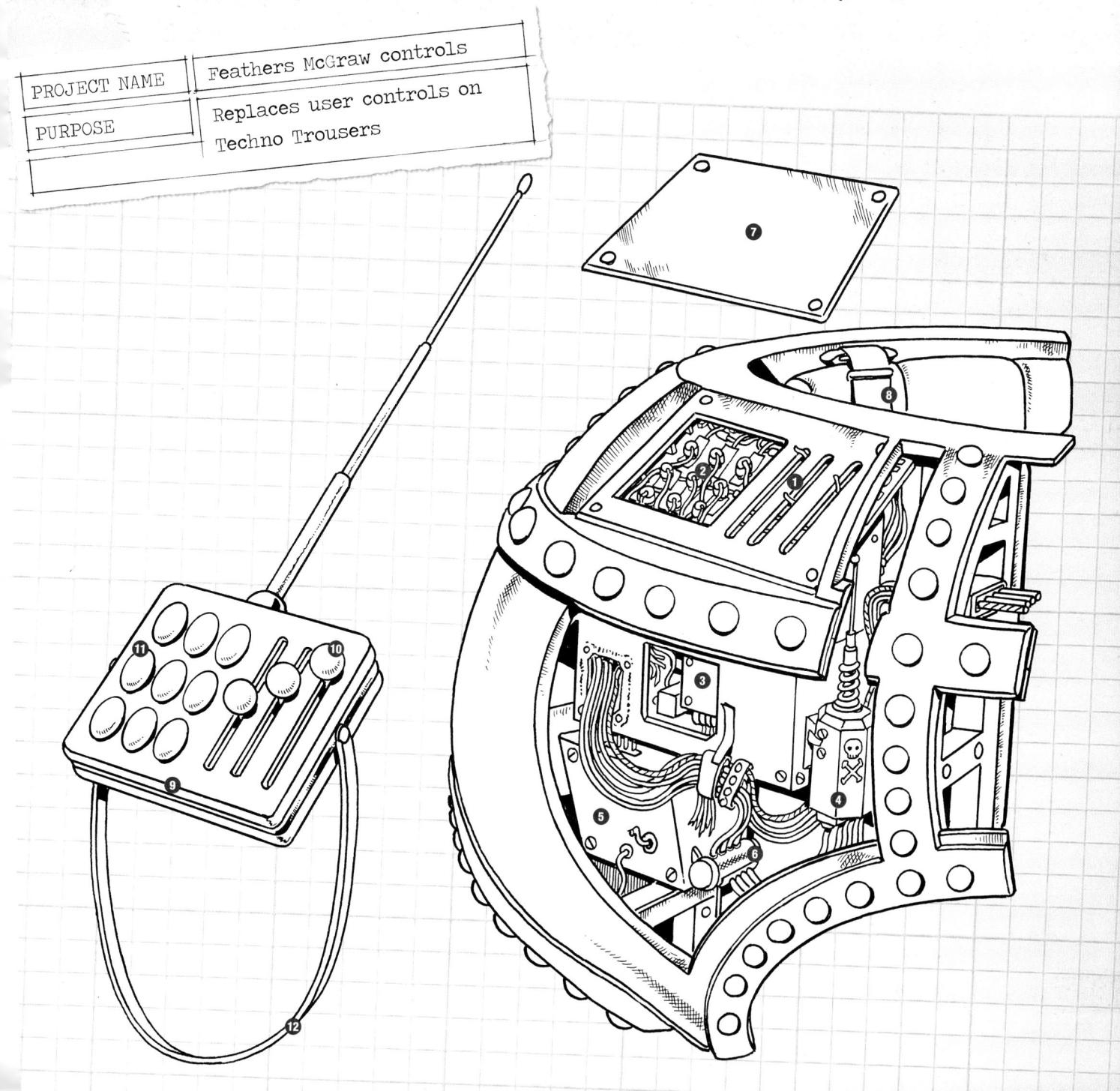

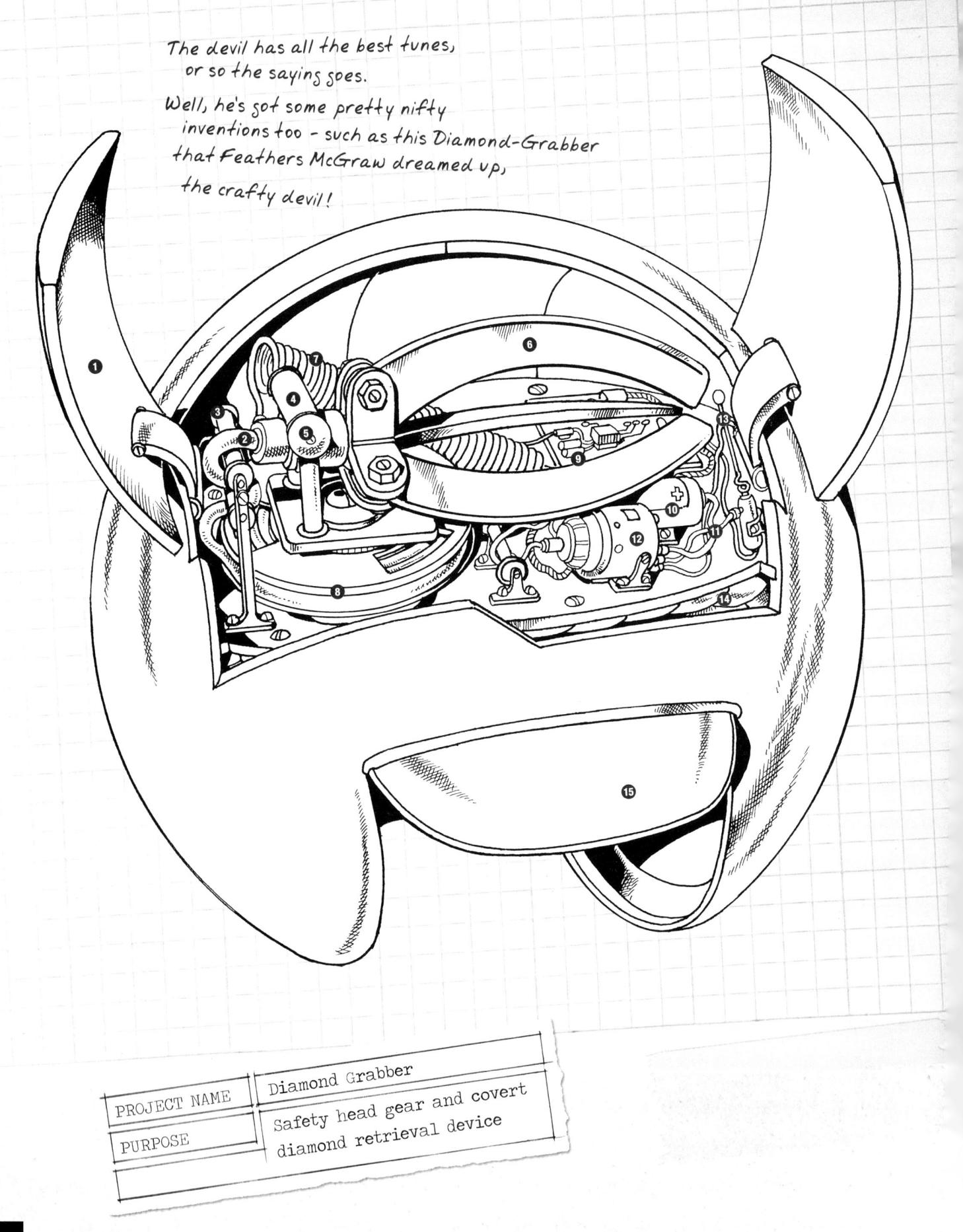

Diamond Grabber cutaway

- 1 Grabber deployment panel
- 2 High-strength grabber deployment cable
- 3 Cable deployment guide rollers
- O Clamp roller
- Retaining clamp and roller locks grabber inside the helmet when not in use, and ensures smooth deployment when grabber is activated
- Three-pronged diamond grabber shown in stowed position (best results are achieved when helmet is used upside-down)
- Grabber electronics control cable
- Cable spool rewinds grabber back into helmet after use
- Electronics and control circuit board

- Battery
- Deployment panel hinge control wiring
- **@** Electric motor
- Antenna links grabber to new Techno Trousers remote control
- Internal helmet comfort padding
- (B) Visor

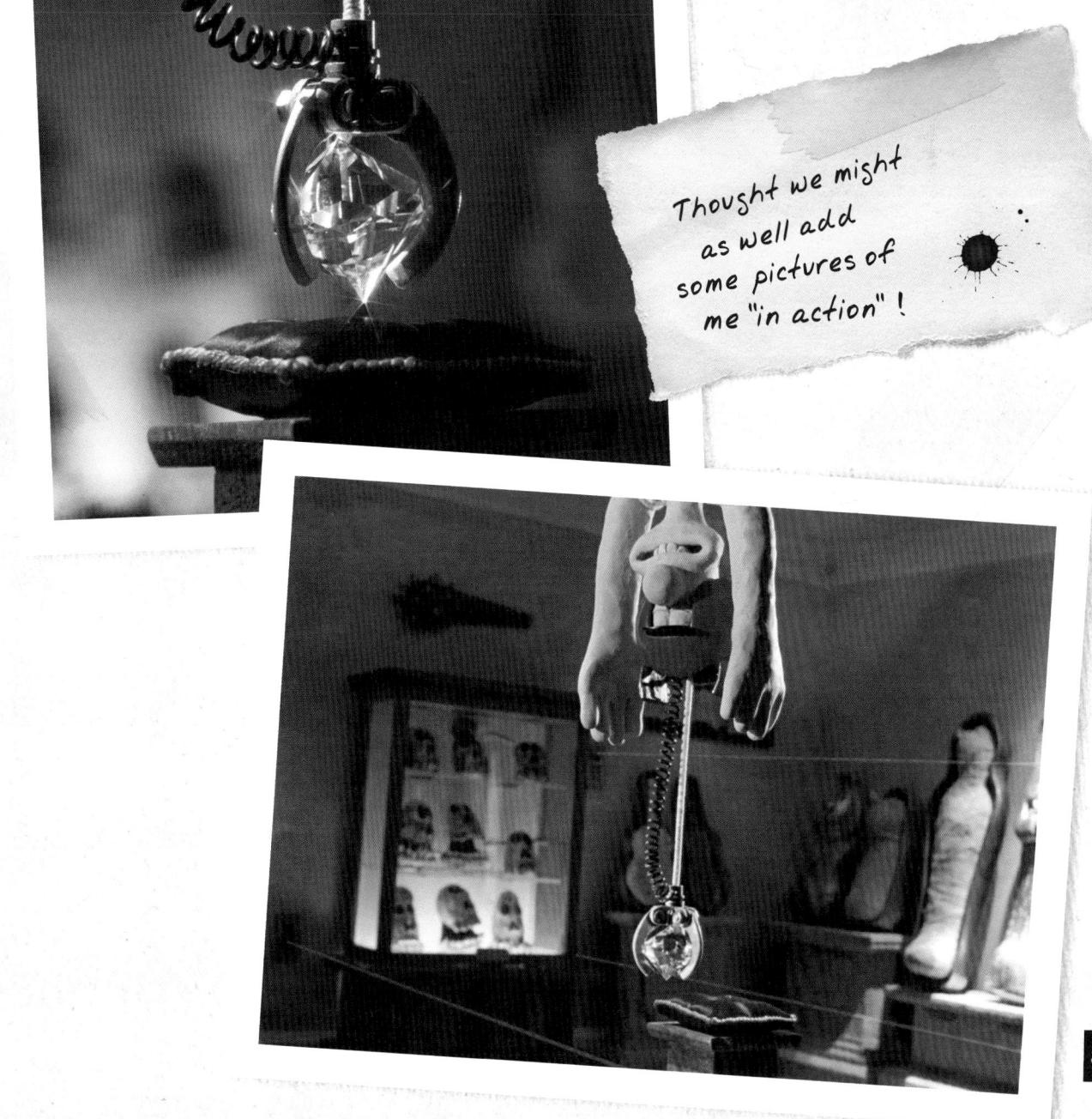

PORRIDGE CANNON

Contents

General description	36
Porridge Cannon cutaway	38

General description

t is probably best to think of this contraption as a high-powered air gun, which is designed to fire porridge either ready-mixed from a tank or made from dry porridge oats and water using the on-board mixer. The domestic version (shown here) is mounted on a substantial metal base unit. which is motorised and steerable to allow for convenient positioning at the breakfast table. A modified version, the 'Sud Cannon', is fitted to the sidecar of the motorbike and used for Wallace and Gromit's window-cleaning business (see page 56).

Ready-mixed or 'wet' porridge is stored in a tank, held high behind the cannon, from where it is drawn through a flexible pipe to the mixer and then into the porridge firing chamber. The chamber is then compressed by a high-pressure pneumatic ram, driven by air from a pump within the base unit. This compacts the porridge within the chamber and forces it from the barrel of the cannon at high speed. When used in 'automatic fire mode' this whole operation can be repeated several times a second and continue indefinitely (or until the porridge tank is empty).

A control panel on the front of the base unit features a master on/off switch together with various programming controls and status lights. These may be used to control the speed and aim of fire plus the consistency of the porridge itself. Finally, a remotecontrol start/stop button is connected by a cable to the porridge cannon for added convenience.

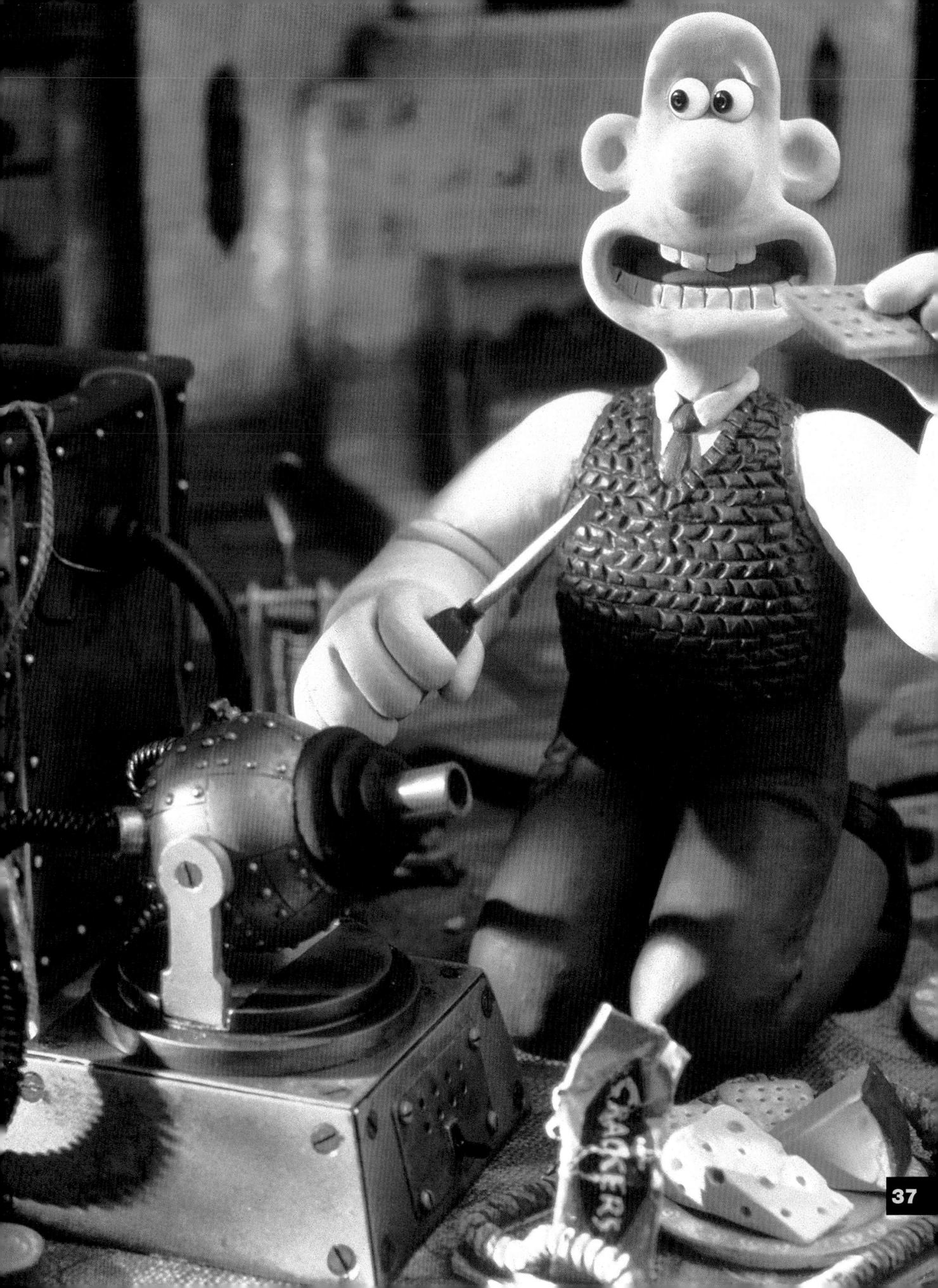

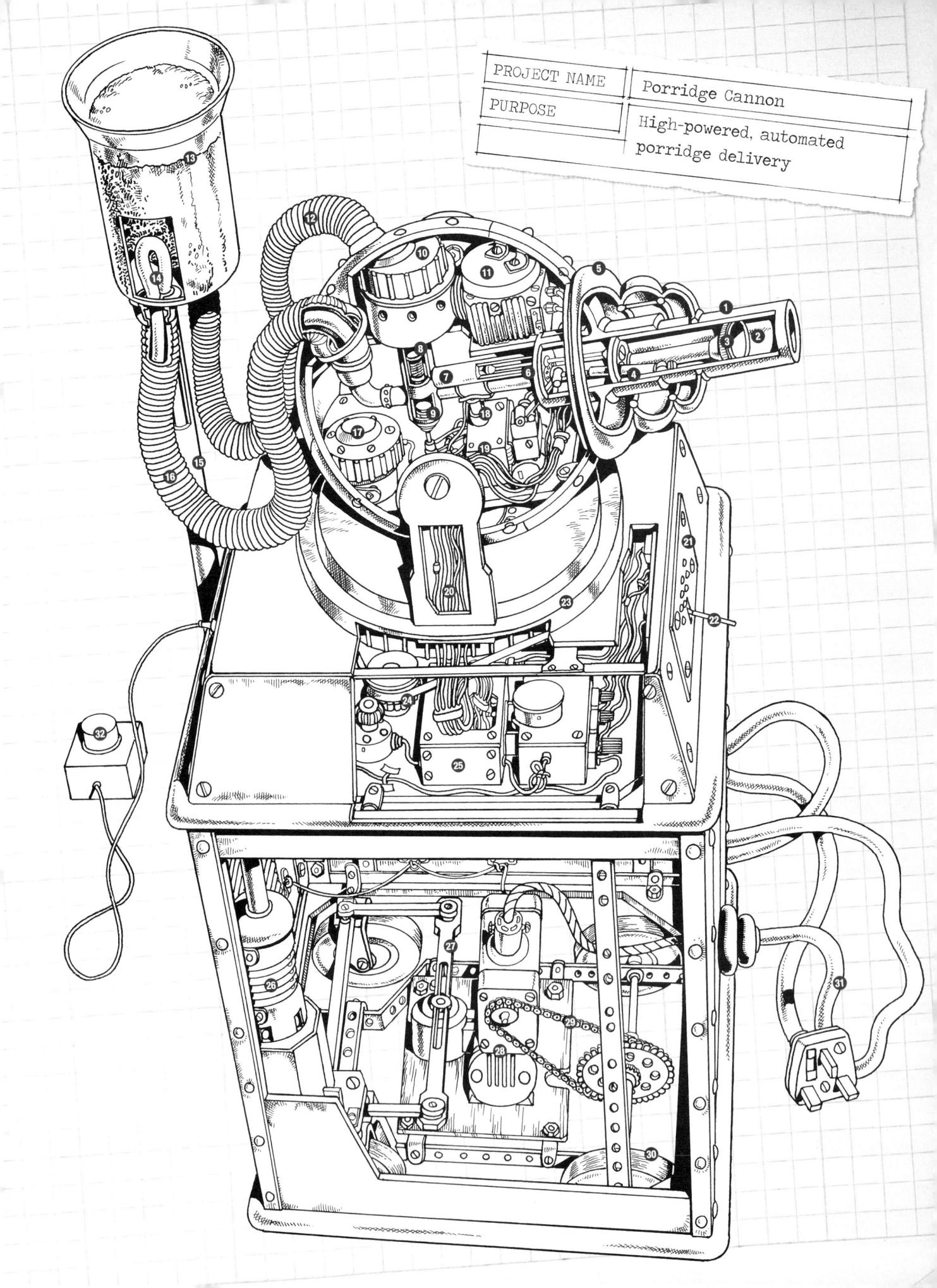

Porridge Cannon cutaway

- 1 Automatic cannon barrel pump
- 2 Porridge firing chamber
- O Porridge nozzle
- O Pneumatic ram
- Gannon barrel recoil dampener
- **6** Piston
- Air cylinder
- 8 Primary valve
- 9 Secondary valve
- Porridge mixer: ensures desired consistency with either readymixed or dried porridge
- **1** Mixer motor

- Porridge pipe
- Ready-mixed (wet) porridge tank
- Tlexible air pipe
- Air pipe and porridge container support stand
- Outer hose carries water to mixer
- Water pump: used when cannon is fitted to motorbike sidecar (see page 56)
- 18 Electrically controlled trigger
- Trigger control timer and motor
- **②** Control wiring

- ② Programming controls
- Master on/off switch
- Cannon turntable
- 2 Turntable drive belt
- (2) Control unit (programmable)
- **3** Air pump
- Steering control bar
- ② Dual electric motors operate wheels and air pump
- Pront-wheel chain drive
- 1 Drive wheels
- 1 Power cord and plug *
- Remote control start/stop button

* Shaun chewed the power cable so it's a bit iffy

Maybe just another couple of tweaks to the tarseting too

KNIT-O-MATIC

Contents

Seneral description	40
Knit-O-Matic cutaway	42

General description

The Knit-O-Matic is one of Wallace's greatest inventions and takes up almost the entire cellar below 62 West Wallaby Street. It is a completely automated machine for washing, drying and shearing sheep, spinning and dying the wool, and then using it to knit a garment. Putting it simply, a sheep goes in at one end and a knitted jumper comes out at the other end.

The sheep starts in the Auto Wash tub where it is gently scrubbed by two hydraulically operated washing sponges to remove all dirt and odours from the wool. An extendable suction tube is then lowered and the sheep is sucked up by a powerful fan to the Auto Dry, where it is dried by drying fans before being passed along the clean sheep duct to the next stage in the process. Although part of the full Knit-O-Matic, the Auto Wash and Auto Dry machines may be controlled separately by a control console, which is responsible only for these functions.

Now that the sheep is clean and dry, it is gravity-fed into the Auto Shaver unit via a vertical tube, where a soft landing is provided by an impact-reducing trampoline. Six articulated shearing arms each carry an electric

razor to ensure fast and efficient shearing of the sheep. As soon as the sheep is shorn it is ejected from the Auto Shaver unit via a duct in the side wall and out through an exit hatch. In the meantime, suction fans gather the shorn wool and pass it to the wool-processing drum (carding drum) where it is carded (straightened) ready for spinning. As the spinning cords exit the Auto Shaver they are dyed in a range of colours as required by the machine's current program.

The wool cords are then spun into yarn using an automated spinning machine from where it is fed into the Auto-knit machine, which can be programmed to create a range of fashionable knitwear.

The operator has overall control of the Knit-O-Matic using the main system control console. While wool dying, spinning and knitting functions can be programmed, a single dial is used to choose either a wash only for the sheep or a light, medium or close shave. Unfortunately, this variable-cut shaving control dial has proved to be somewhat unreliable, sometimes switching automatically to 'close shave' when the Knit-O-Matic develops a system fault.

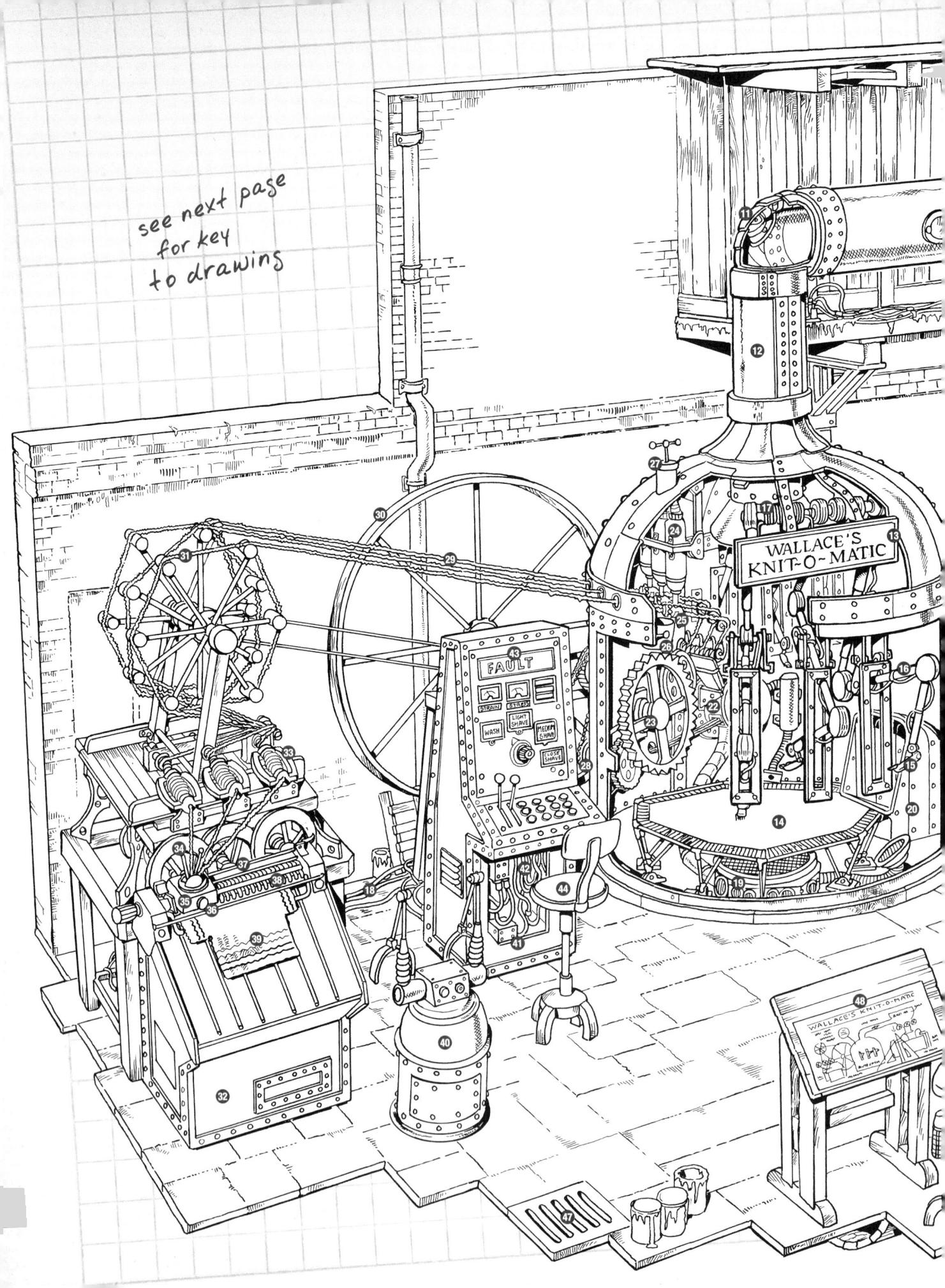

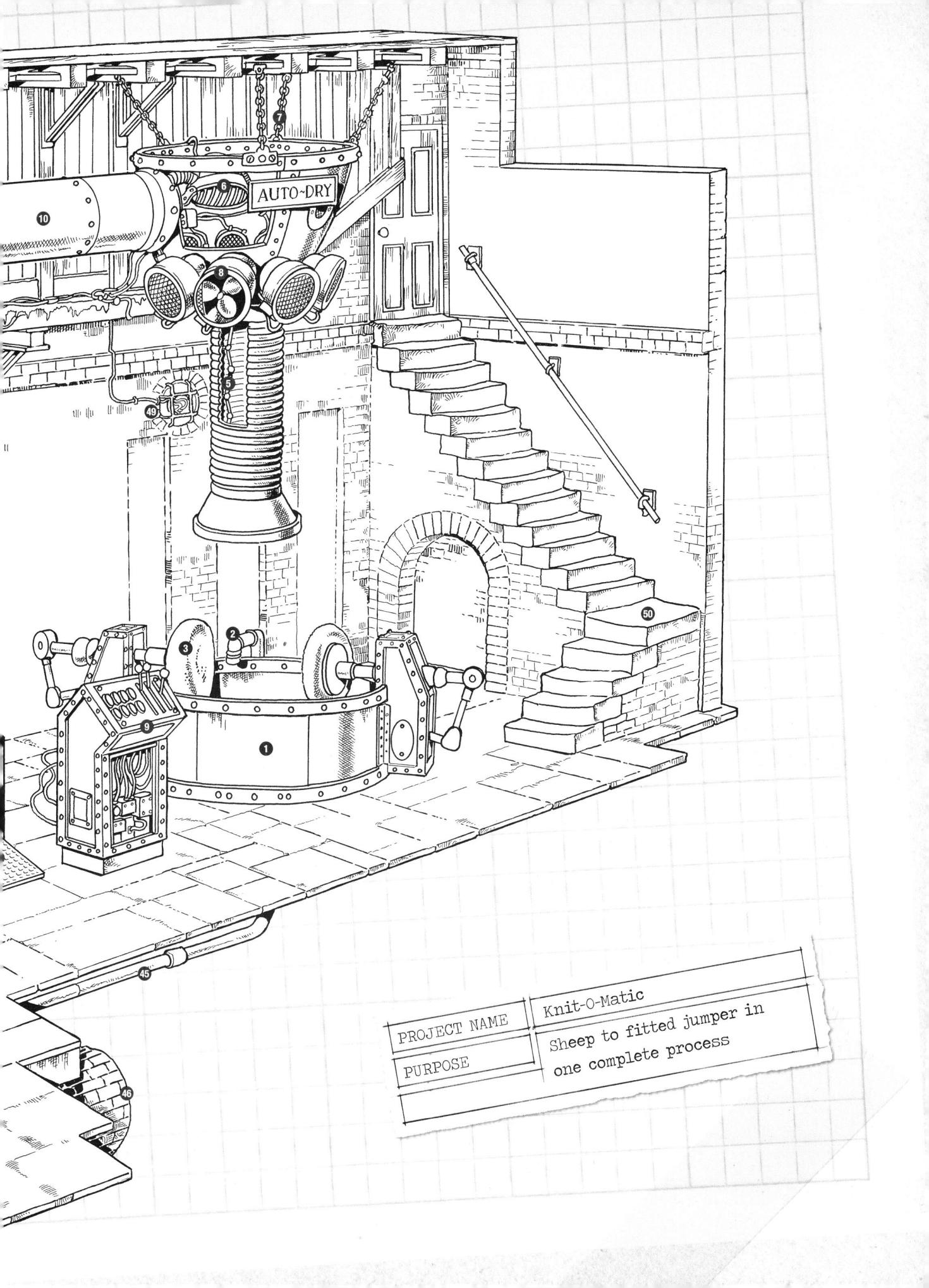

Knit-O-Matic cutaway

- Auto Wash tub
- 2 Fresh water pipe (flow controlled by console)
- Washing sponges mounted on hydraulic arms
- Suction tube
- Suction tube lowering mechanics
- O Powerful fan draws sheep up suction tube
- Auto Dry support chains
- O Drying fans
- Auto Wash and Auto Dry control console
- O Clean sheep duct
- Secondary suction fan draws sheep along clean sheep duct
- ② Auto Shaver duct (gravity assisted)
- Auto Shaver
- Impact reducer (trampoline) ensures no injury to sheep

- (B) Shearing razors
- Hydraulic shearing arm (six in total)
- The Shearing arm electric motors
- Wariable-cut shaving control dial
- Suction fans gather wool during shearing
- Shorn sheep exit duct
- 3 Shorn sheep exit hatch
- Wool-processing drum
- Cord spool gearing
- Refillable wool dye containers
- 3 Wool dye application tubes
- Bucket to catch excess dye spillage
- Wool dye refil cap and level indicator
- **3** Cord spool
- **49** Wool spinning cords
- Flywheel
- Auto-spinning wheel

- Auto-knit machine
- 3 Yarn cone winder
- Maintain the second of the
- Sknitting carriage
- Tension dial
- Carriage slide rail
- Flow combs
- Sknitted jumper
- Auto Dresser
- 4 Main system control console
- **@** Console system wiring
- System fault indicator
- Operator's chair
- Water pipe
- O Drainage system and sewer
- Drain cover allows water to drain into sewer to prevent cellar flooding
- Wallace's Knit-O-Matic plans
- Wiring junction box leading to main house wiring
- Stairs to ground floor of house

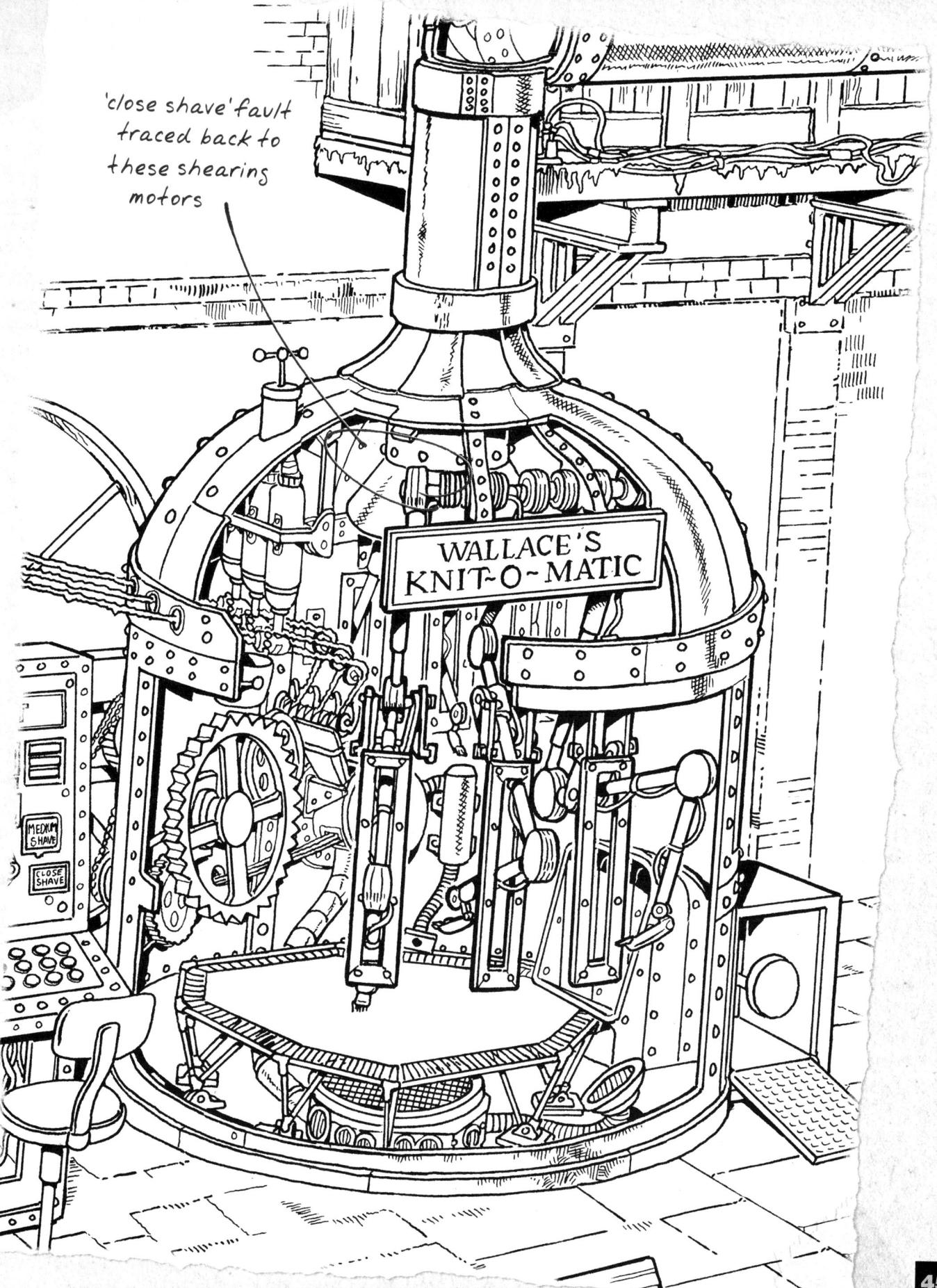

THE MUTTON-TIME-O-MATIC

Contents

General description	46
Mv+ton-O-Matic cutaway	48

Now steady on! This is a bit unsavoury. W

General description

Preston steals the plans to Wallace's Knit-O-Matic and decides to build his own version, but he adds a gruesome final stage to turn the sheep into dog food. Fortunately, Preston's plans are foiled through the heroic actions of Gromit and no living creatures are harmed by his new contraption, the ghastly Mutton-O-Matic. Even so, the machine itself is an accomplished piece of engineering and worthy of a technical description. Wallace's

Freshly shorn by the Knit-O-Matic, the sheep are shepherded into a holding pen. When the Mutton-O-Matic is activated, the pen is lifted by a hydraulic lifting ram, tipping the sheep on to a conveyor belt. The conveyor leads to two giant masher drums, which are fitted with hardened steel spikes. This is known as the 'primary stage' of the production process. The secondary stage involves a pair of piston-operated crushers, which compress the dog food and force it through the secondary stage filter. From there, it is sucked along a final duct and down a chute into dog food tins, which are on a moving conveyor.

Empty tins enter the machine and receive pre-glued 'Preston's Dog Food' labels from a heated applicator. After filling, the tins are fitted with lids before

being packed into a waiting crate, ready for dispatch.

The entire machine is powered by a large single-cylinder diesel engine running at a steady 200rpm. This drives the primary stage masher drums and secondary stage crusher pistons, along with the reciprocating pump for the final stage suction duct and both conveyor mechanisms.

I've sot patent pending on that! W

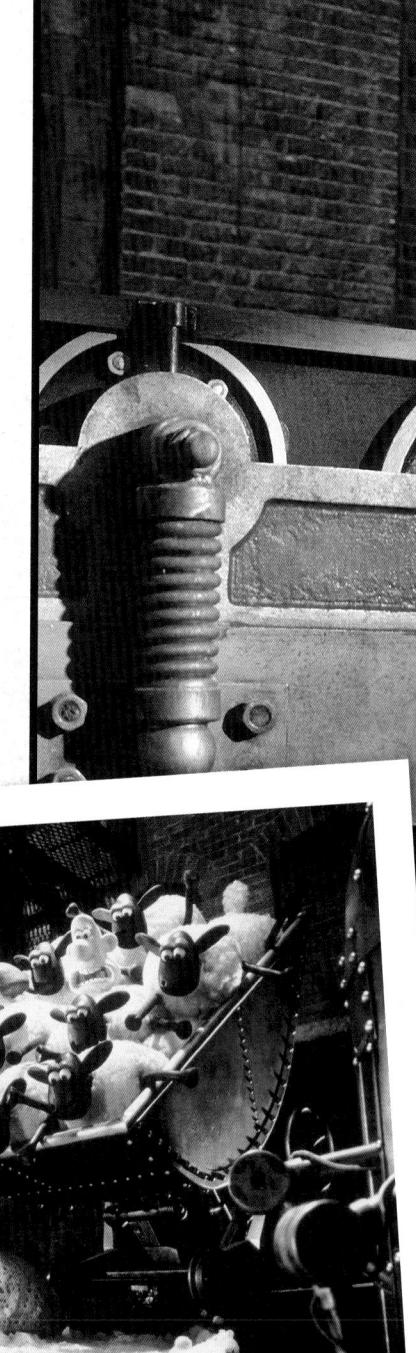

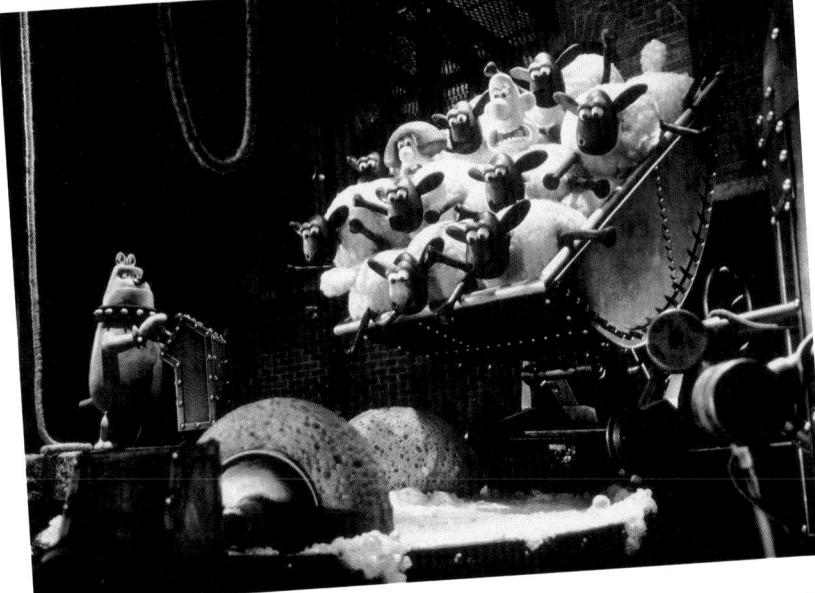

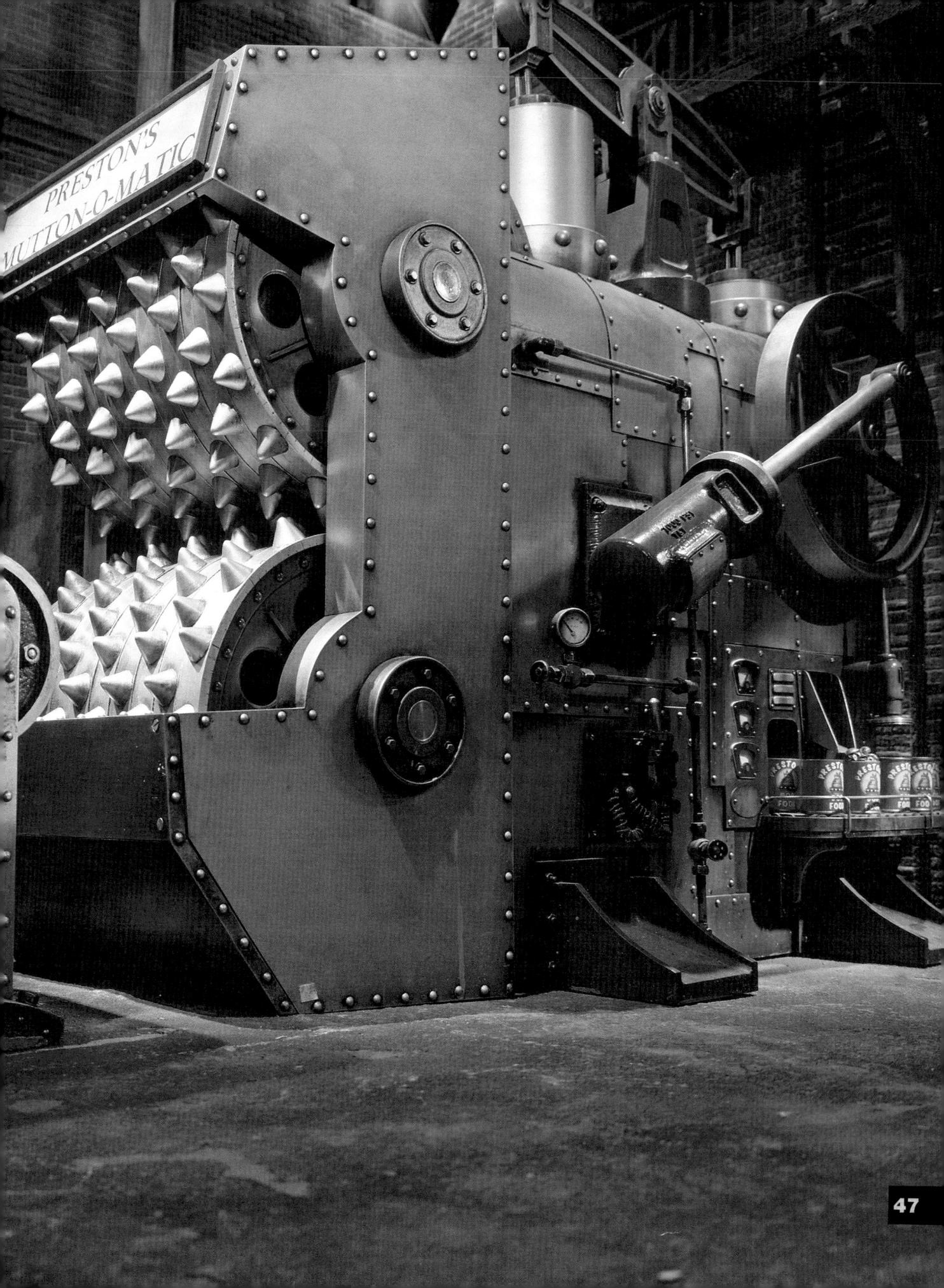

While Mutton-O-Matic cutaway

① Sheep holding pen (in elevated position)

Shirt of the Connect Society

- ② Hydraulic lifting ram
- 3 Conveyor belt
- (4) Conveyor belt rollers
- © Conveyor belt start-stop button
- @ Primary stage masher drum
- Frimary stage duct
- ® Secondary stage crusher foot
- @ Secondary stage crusher piston
- © Cantilever beam
- (1) Cantilever fulcrum
- ® Secondary stage filter
- 3 Waste chute
- @ 80 horsepower diesel engine
- ® Flywheel
- © Reciprocating suction pump
- (1) Final stage (dog food) suction duct
- ® Tin filling chute
- @ Dog food tin labels
- @ Heated label applicator
- ① Tin conveyor rollers
- @ Empty dog food tins
- @ Conveyor rollers pass tins under filling chute
- @ Tin lid applicator
- 3 Packing crate

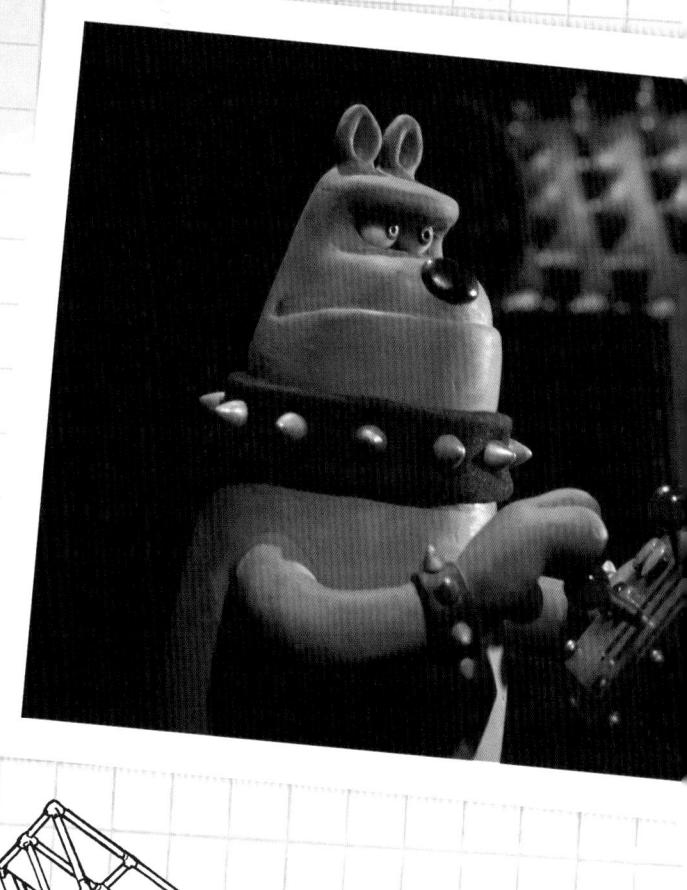

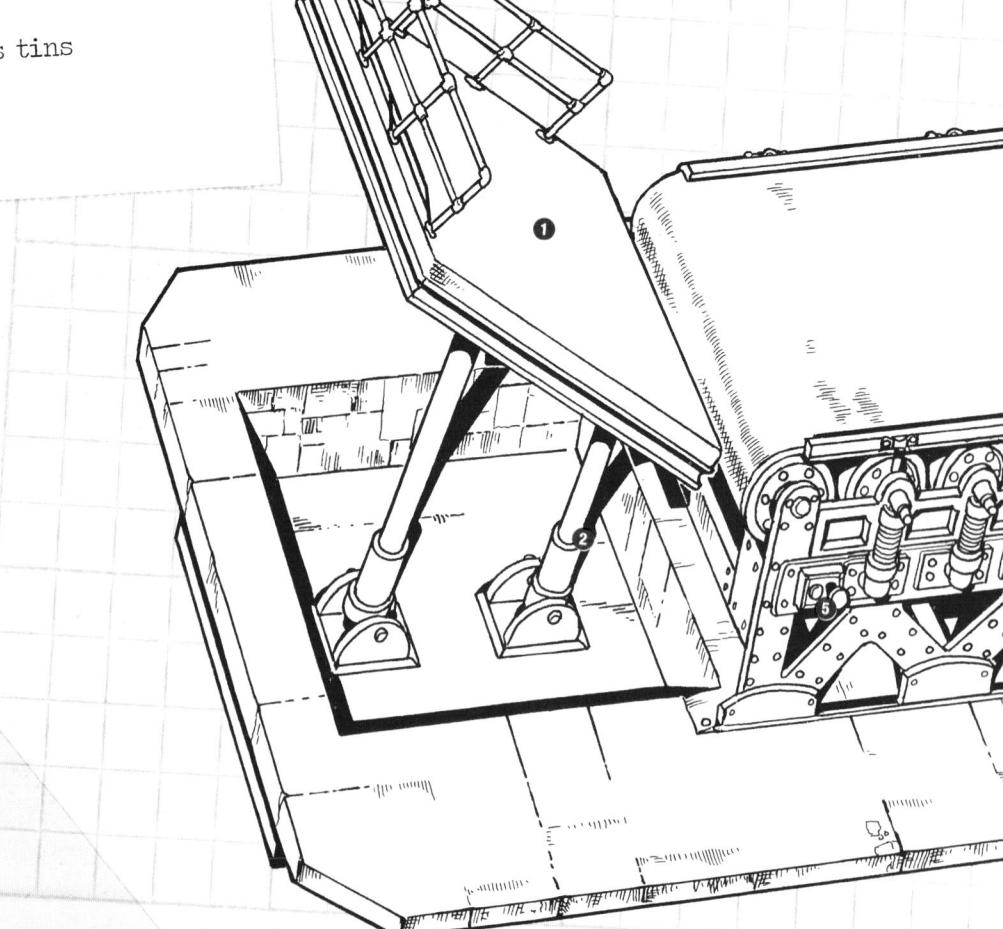

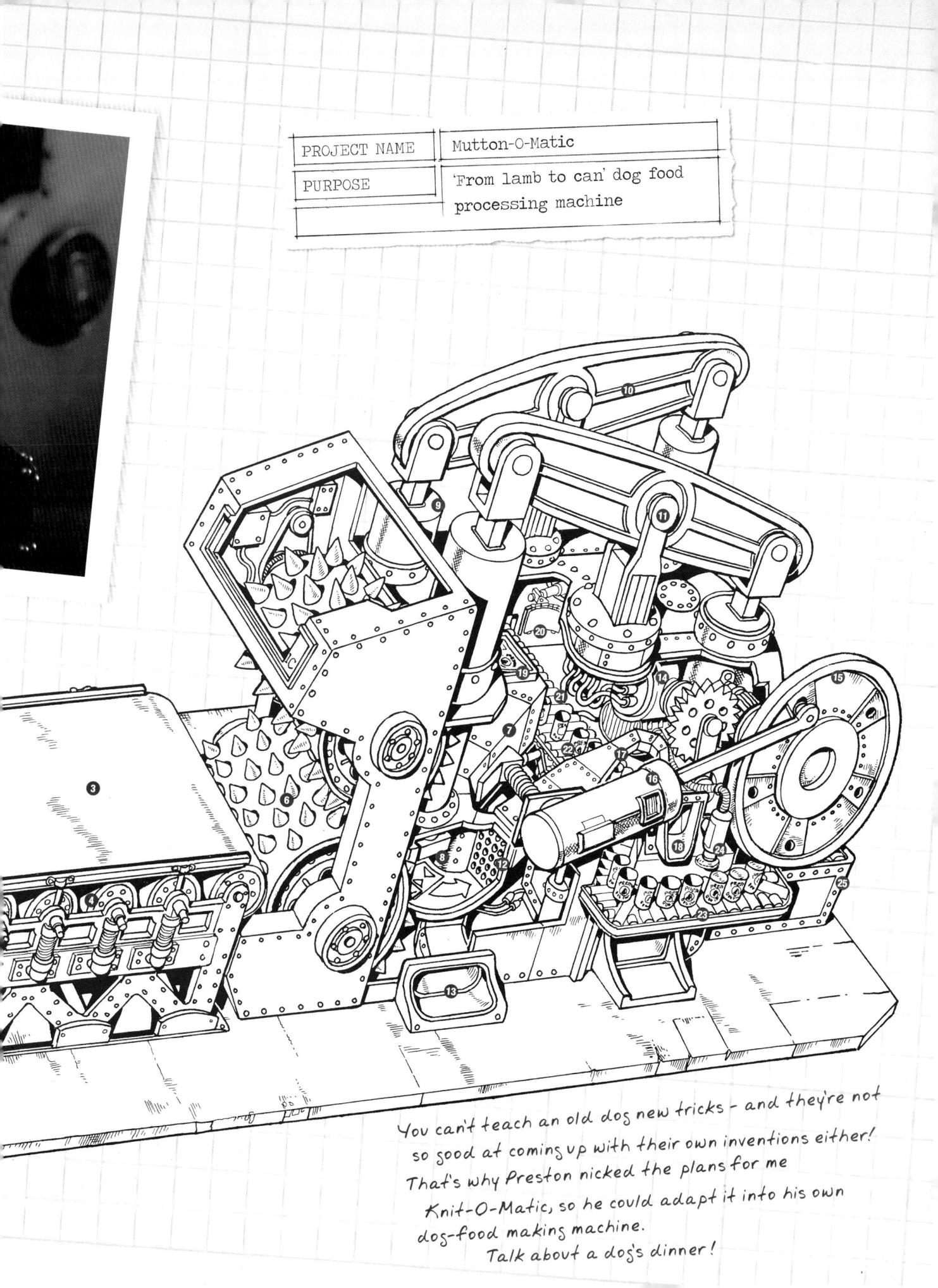

PRESTON THE CYBER DOG

Contents

General description	50	
Preston the Cyber Dog cutaway	53	
Domesticated Preston cutaway	54	

General description

When Wendolene Ramsbottom's father died he left her the family wool shop along with "debts and a few other things", namely Preston, a sophisticated cyber dog which he built to protect both his daughter and the business. Unfortunately, Preston carries out his programming with ruthless efficiency, even resorting to sheep rustling in order to supply the shop with wool.

Preston's body is built around a skeleton of high-strength titanium alloy. The skeleton, skull and internal mechanics and electronics are covered with artificial skin and fur so that, from the outside, Preston appears to be a normal dog. He is equipped with two stereoscopic cameras (eyes), two articulated unidirectional microphones (ears) and a multi-spectrum odour detection sensor (nose). He is also able to 'eat' like a real dog, with food being sucked down two tubes leading from his mouth to a small incinerator, located just below the neck.

All of Preston's movement is driven by a powerful electric motor, positioned centrally within the torso. Individual leg, paw and jaw movements are controlled via a series of pulleys, gears and cranks. A gyroscope fitted at the bottom of the torso works together with the unidirectional microphones to help maintain balance, especially when Preston is walking upright.

The main computer, housed in the chest area, provides overall control of Preston's functions, while memory and programming data is stored on magnetic tape.

Preston operates independently, and he can learn and adapt in order to protect himself, but he has been programmed with protocols to ensure that he never harms Wendolene or the family business. However, over time Preston's increased self-awareness begins to override his programming, with dramatic consequences.

After framing Gromit for the sheep rustling, Preston steals the plans for Wallace's Knit-O-Matic machine and builds his own version. However, having decided to go into the dog food business, he adds an extra stage of his own design: the Mutton-O-Matic (see page 46). This horrendous invention is a fully functioning prototype, and Preston's first victims are the sheep, including Shaun, together with Wallace and Wendolene.

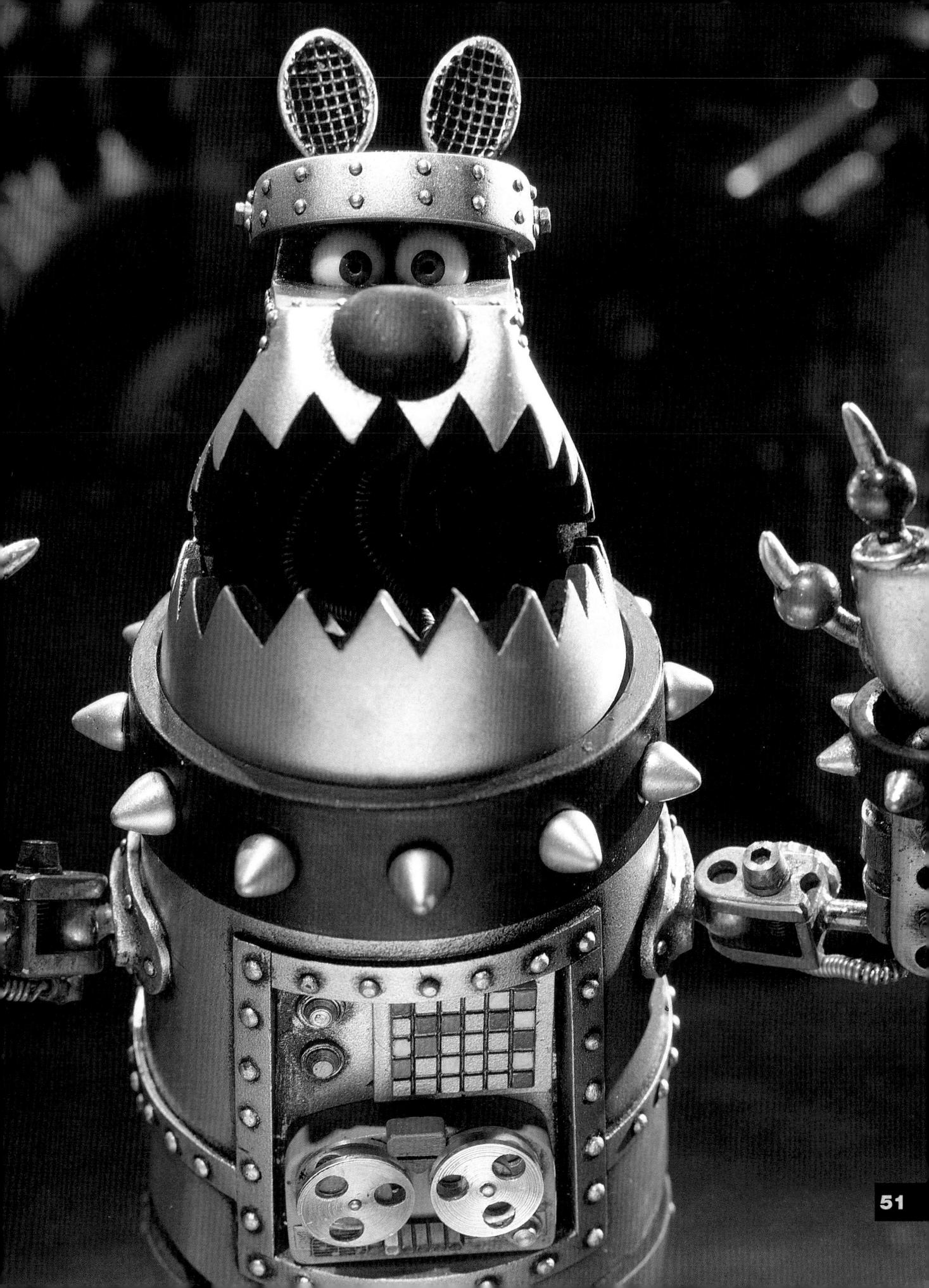

Preston the Cyber Dog cutaway

- While disguised as a real dog, food tubes suck food to a small incinerator for disposal
- 2 Incinerator located behind electric motor
- Incinerator vacuum pump powered by adjacent electric motor
- Main power switch (locked in 'On' position)
- Unidirectional microphones provide spatial awareness and help to maintain balance
- Independently suspended cameras provide stereoscopic vision
- Visual processing cortex
- Multi-spectrum ultra-sensitive odour detection system

- Power and data conduits connect audio and visual processors to computer
- **©** Electric motor
- Heat sink tubes built into collar spikes dissipate heat from motor
- 12 Jaw hinge mechanism
- Paw and claw grip control actuators
- 1 Titanium ultra-grip claws
- Left fore leg and paw control gearing
- Torso movement hydraulic jack
- The Left hind leg control gearing
- Multi-jointed hind legs support Preston's weight and provide most of the motive power
- Claws provide additional grip and balancing adjustments

- Right hind leg control gearing
- Gyroscope maintains robot's balance in upright position on hind legs
- Plexible torso joint seal
- Batteries
- Battery support stanchion
- Main computer and memory bank, programmed with self-awareness protocols that cannot be overridden
- Memory tape spool controls (locked to 'On' position and tamper-proof)
- Memory/programming tape spools
- ② Illuminated memory code programming controls

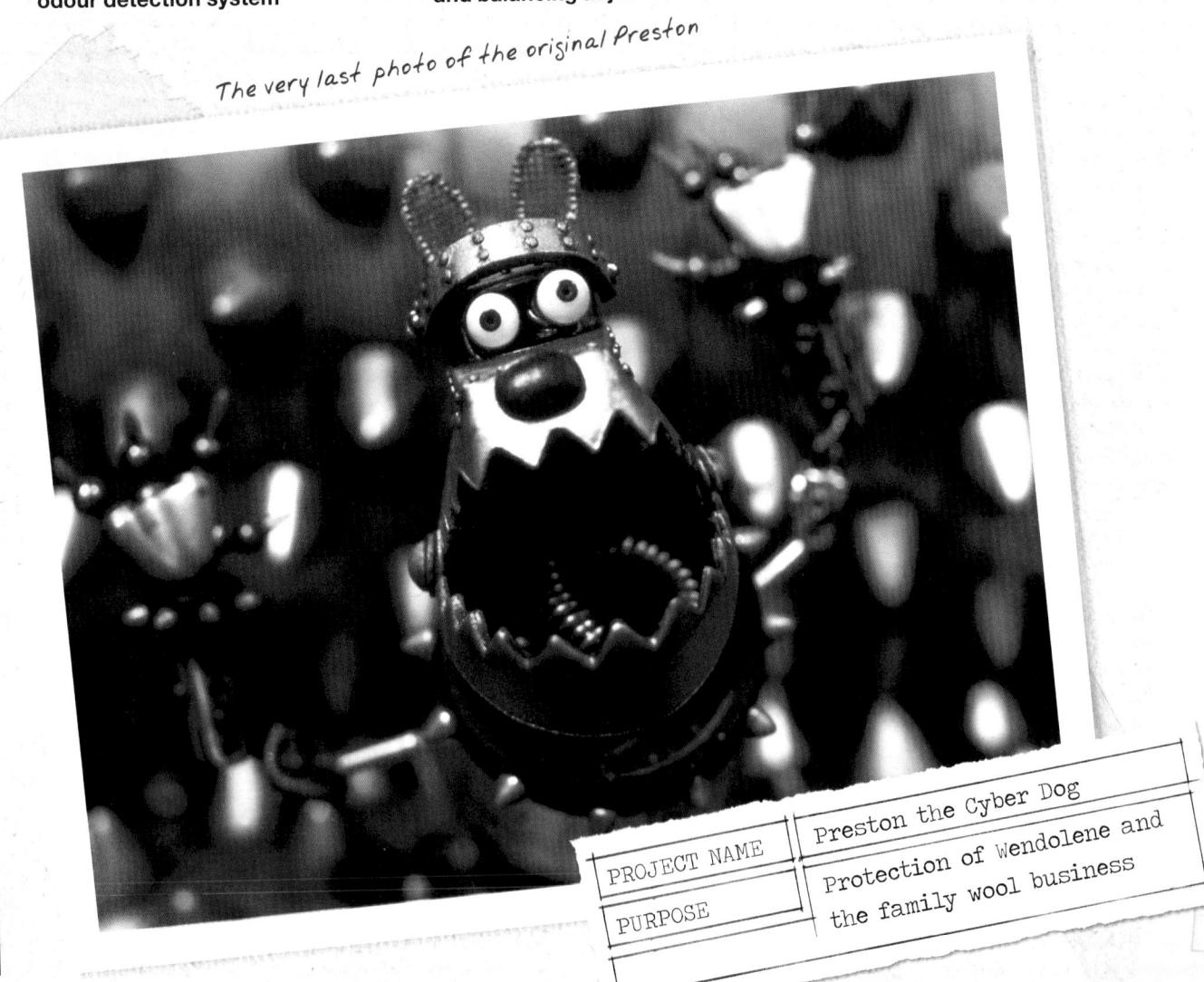

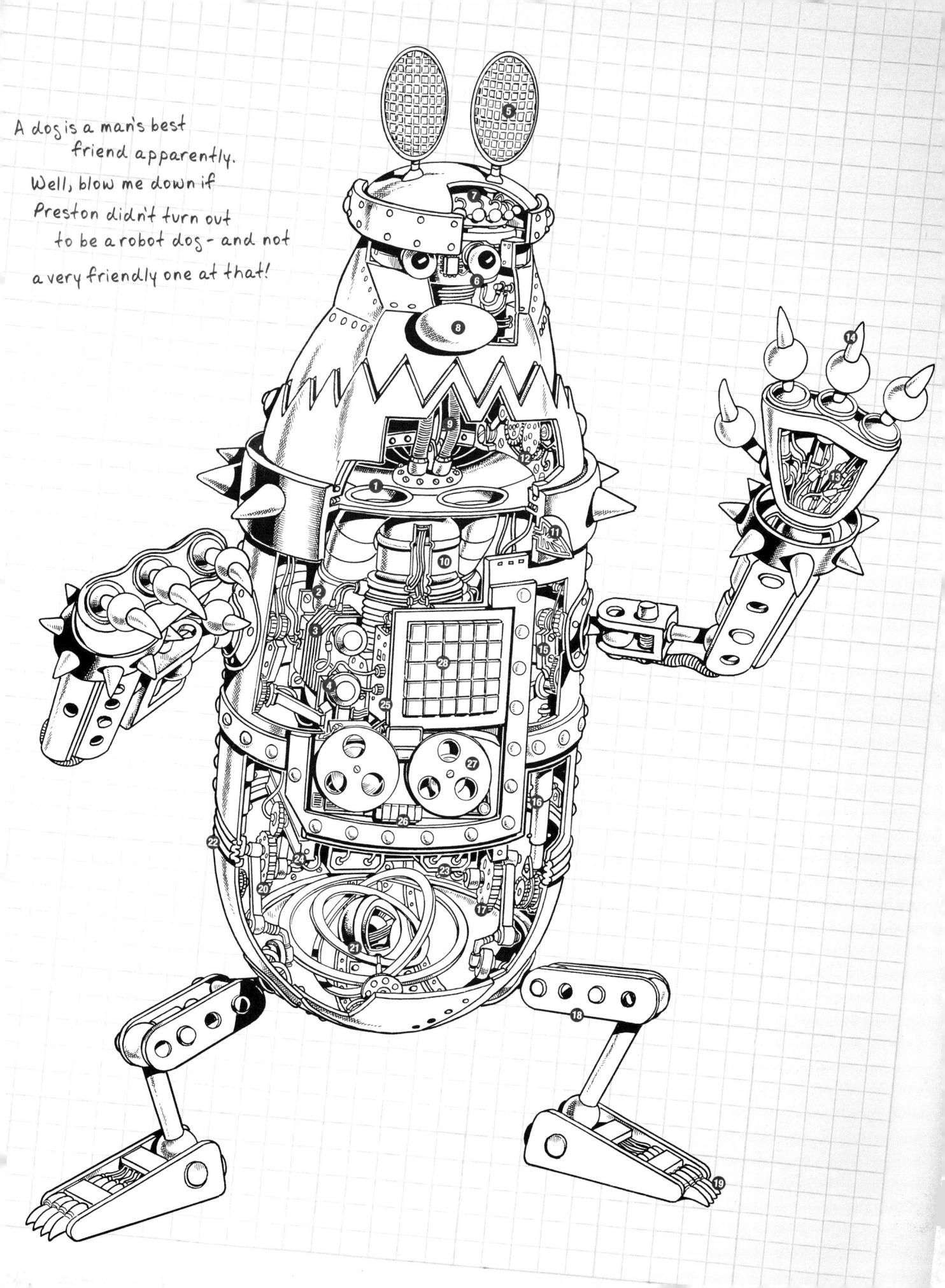

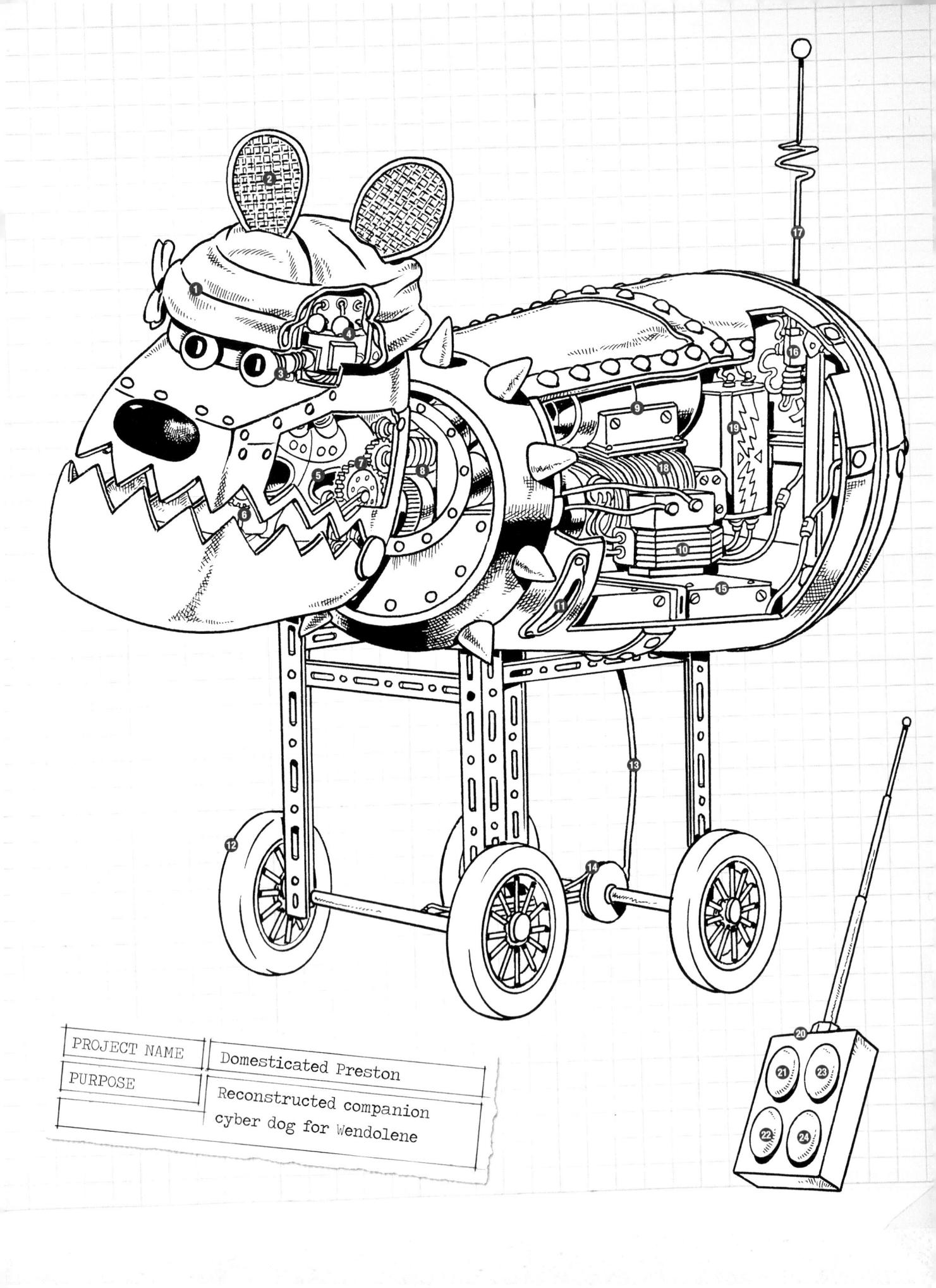

ollowing the dramatic events involving Preston and his Mutton-O-Matic machine, Wallace salvages what pieces he can find of the old Preston and uses them to build Wendolene a more friendly 'domesticated' cyber dog. A new body is constructed of riveted steel plate and attached to a simple trolley frame and wheels, allowing the new Preston to move around. The head is reshaped and the jaw fitted with an anti-bite mechanism. while the stereoscopic cameras and unidirectional microphones have been reused. A repair bandage around Preston's head also provides additional thermal insulation for the damaged circuitry inside. Most importantly, Preston has been reprogrammed with restricted self-awareness protocols, and he is now fully controlled by a hand-held remote unit which features a dedicated pre-programming override button, just in case...

Domesticated Preston cutaway

- Repair bandage and thermal insulation
- ② Unidirectional microphones
- 3 Reconditioned stereoscopic cameras
- Visual processing cortex
- Dog food suction pipes (redundant)
- 6 Anti-bite clamp
- Jaw hinge gearing
- O Power and data conduits connect audio and visual processors to main computer
- Incinerator (redundant)
- Incinerator vacuum pump (redundant)
- Original fore leg joint socket
- Prore and hind legs replaced with easy-to-control trolley frame

- B Rear-wheel drive power cord
- Speed and braking control regulator
- Reprogrammed control computer, now with restricted self-awareness protocols, which can be overridden by remote control
- ® Remote-control transceiver
- TRemote-control antenna
- Electric motor
- Battery
- @ Remote-control unit
- Forward/backward control
- 2 Pre-programming override
- Steering control: once for left; twice for right
- Start/stop button

Not a bad job, if I may say so

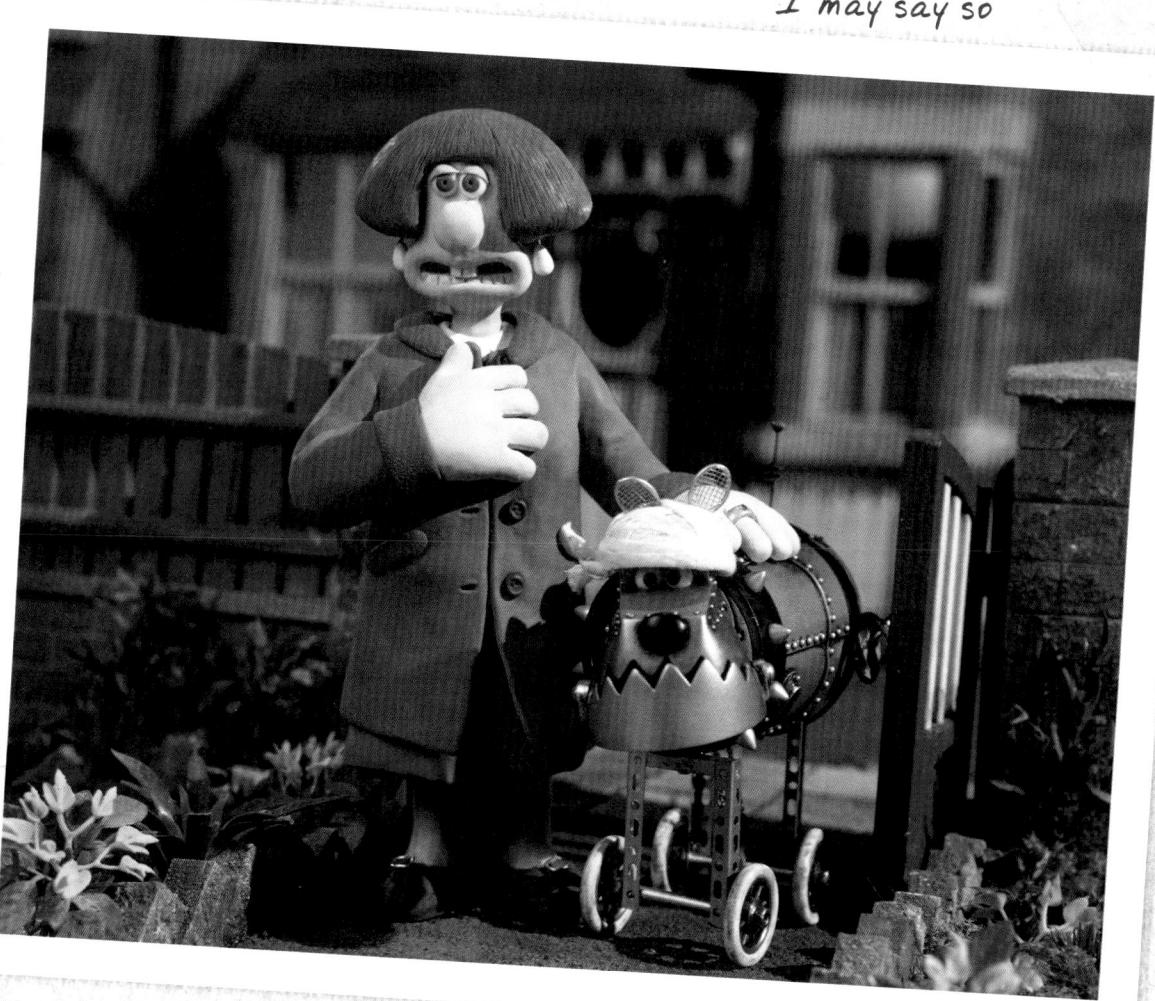

MOTORCYCLE & SIDECAR

Contents

General description	56
Motorcycle & Sidecar cutaway	58
Sidecar Plane	61

General description

Allace's motorcycle is based on a traditional British design by Triumph although it will be clear to the enthusiast that various modifications have been made over the years. Having said that, these are all fairly minor and appear to have no significant effect on its operation. The motorcycle is powered by a 350cc single-cylinder four-stroke engine, which drives the rear wheel via a four-speed manual gearbox and chain. Braking is by cable-operated drum brakes front and rear. Otherwise the motorcycle is conventional in nearly every respect.

Of far greater interest is the sidecar. which has undergone a number of significant modifications and contains two special features that are worth noting in particular. The first of these is its ability to transform into an aeroplane. This requires the sidecar to be separated from the motorcycle, before panels in the side and rear of the aluminium bodywork open to allow wings and a tailplane to be extended. In the nose of the sidecar, slightly offset to the right, is a compact 'aeromatic' petrol engine, which drives a propeller via a toothed belt. The propeller itself is stored with its blades folded within the nose of the sidecar but is deployed

instantly at the same time as the wings. The transformation from sidecar to aeroplane is activated by buttons on a control panel in front of the passenger/pilot, and the whole process takes less than a second – which proves to be not a moment too soon when the sidecar separates from the motorcycle by accident and Gromit finds himself plunging to the bottom of a 2,000ft drop.

Located behind the engine and propeller assembly is the sidecar's second special feature: the sud cannon. This is a modified version of the porridge cannon found at 62 West Wallaby Street and is used by Wallace and Gromit for their window-cleaning business. Dried detergent and water are stored in separate tanks and mixed together inside the sud cannon before being drawn into the cannon barrel. Compacted shots of high-density soap foam are then fired from the sidecar at ground level (usually by Wallace) while Gromit climbs the ladder to clean the windows. All other aspects of the sud cannon's operation are very similar to that of the porridge cannon in fact, during his attempts to stop Preston from rustling sheep, Gromit fills the sud cannon's detergent tank with extra-thick porridge mix. * see page 36

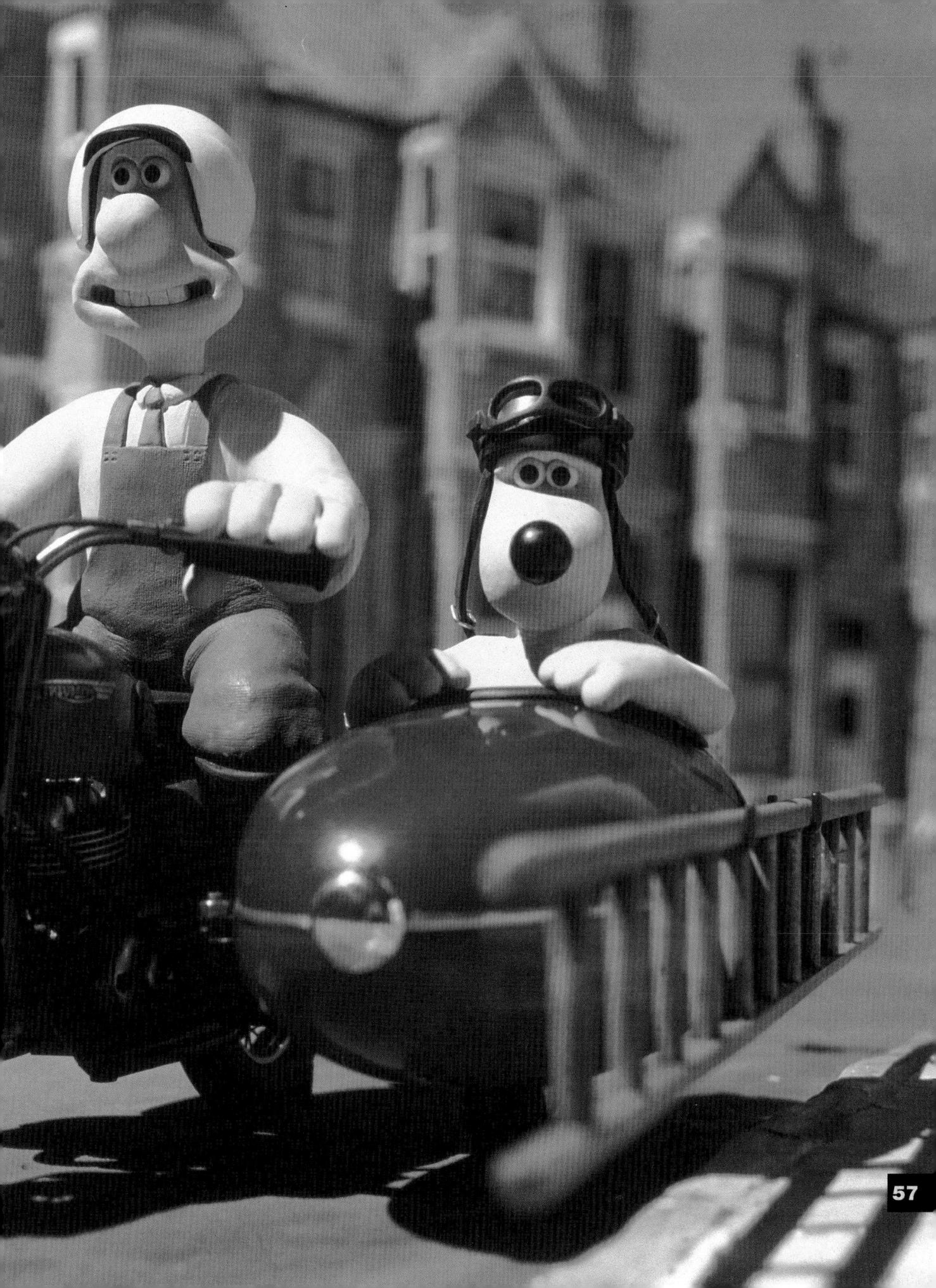

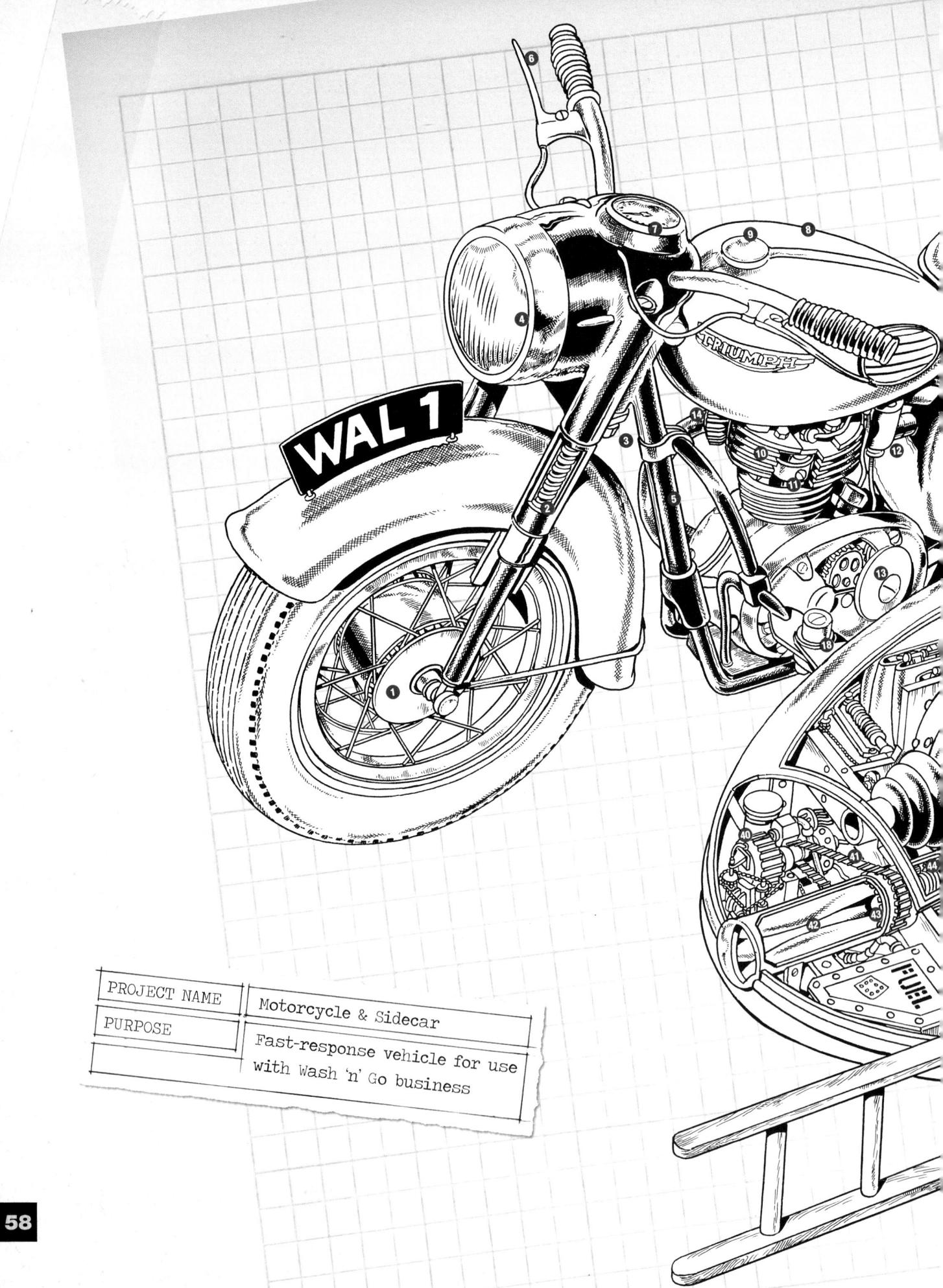

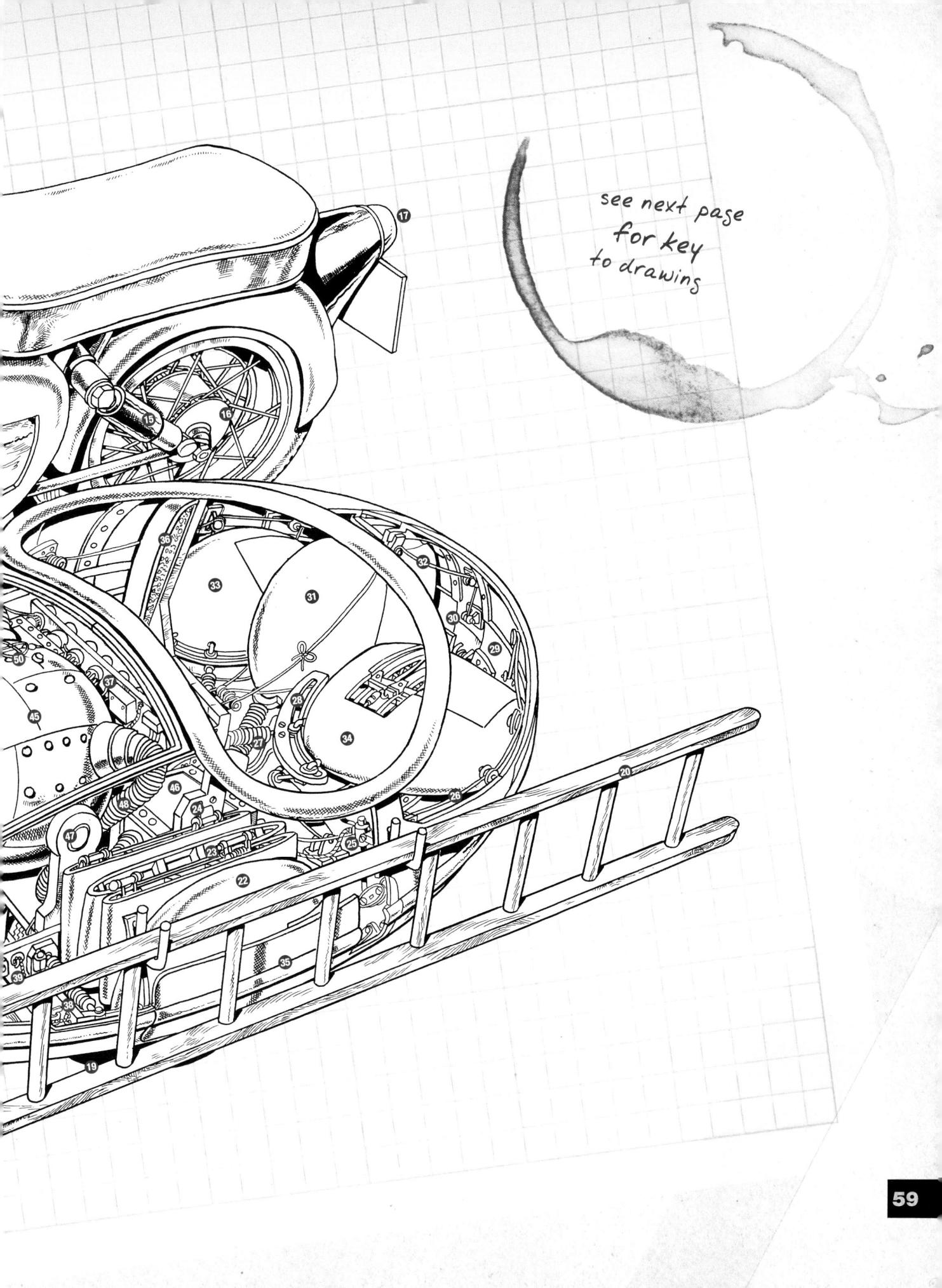

Motorcycle & Sidecar cutaway

- Front brake drum
- 2 Hydraulically damped front forks
- Steering head
- O Headlamp
- 5 All-welded tubular motorcycle frame
- 6 Front brake lever
- Speedometer
- Fuel tank
- 9 Fuel cap
- Single-cylinder four-stroke engine
- **©** Piston
- Carburettor
- (B) Gearbox
- Exhaust pipe
- 1 Rear suspension damper
- Rear brake

- Rear number plate
- Front sidecar securing bolt
- Sidecar wheel
- 4 High-window access device
- Retracted starboard wing
- Retracted port wing (folded in three sections)
- Wing fold operating link
- Wing spar attachment bolt
- Port wing panel actuator
- Wing panel control string
- Wing deployment spring
- Wing positioning slide
- Rear port wing panel
- Tailplane panel
- Tailplane
- Tailplane panel control strings
- 3 Starboard rear wing
- Port rear wing

- Port wing panel
- Sidecar/pilot's seat
- **Flight controls**
- Port wing deployment spring
- Wing deployment control string
- Aeromatic engine
- Propeller drive belt
- Three-blade propeller (shown retracted)
- Spring-loaded propeller hub
- Propeller hub spring
- Window-cleaning detergent cannon
- Dried detergent mix tank
- **1** Water tank
- Detergent tank to mixer pipe
- Cannon deployment hydraulics
- 5 Fold-down target finder

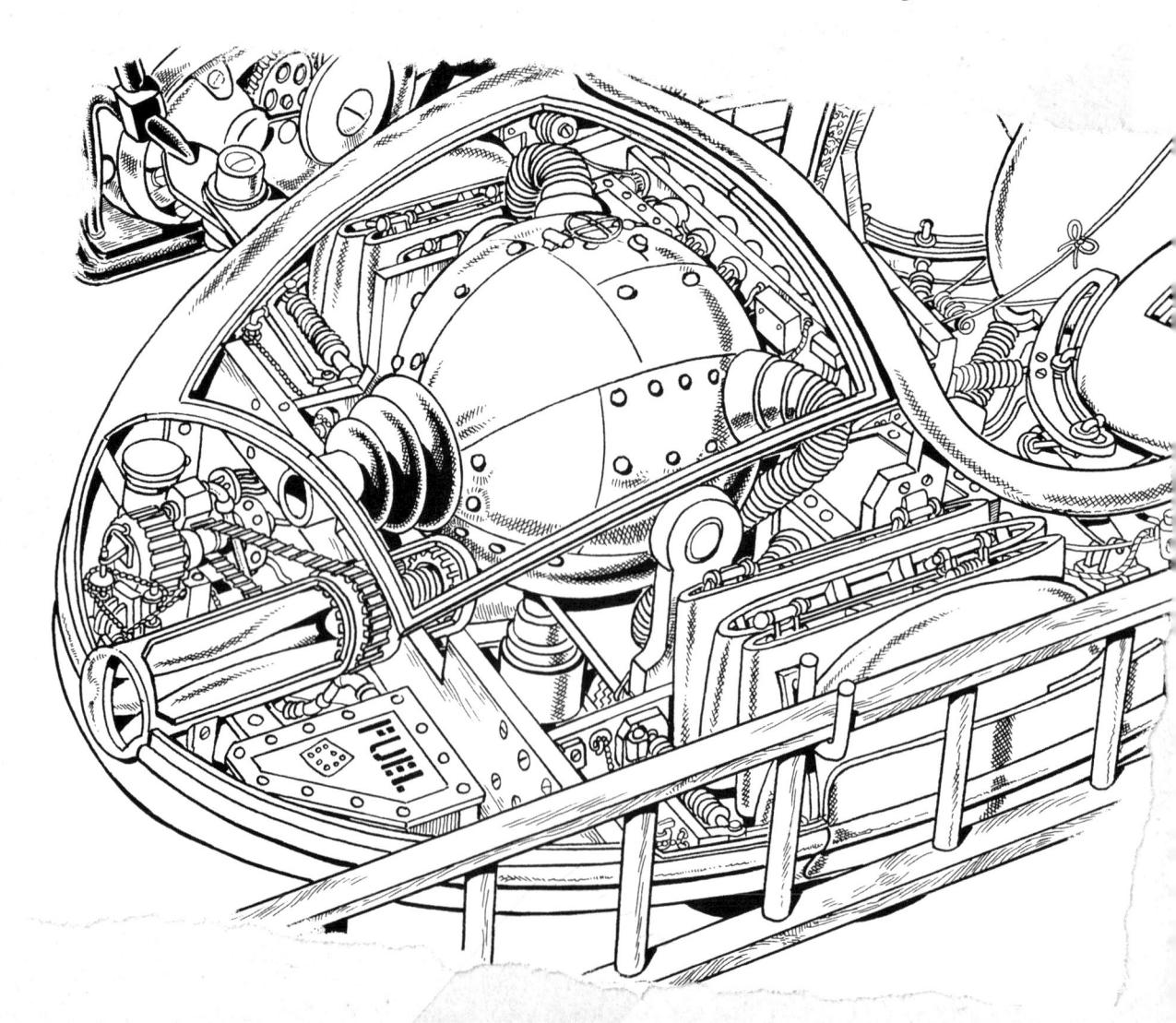

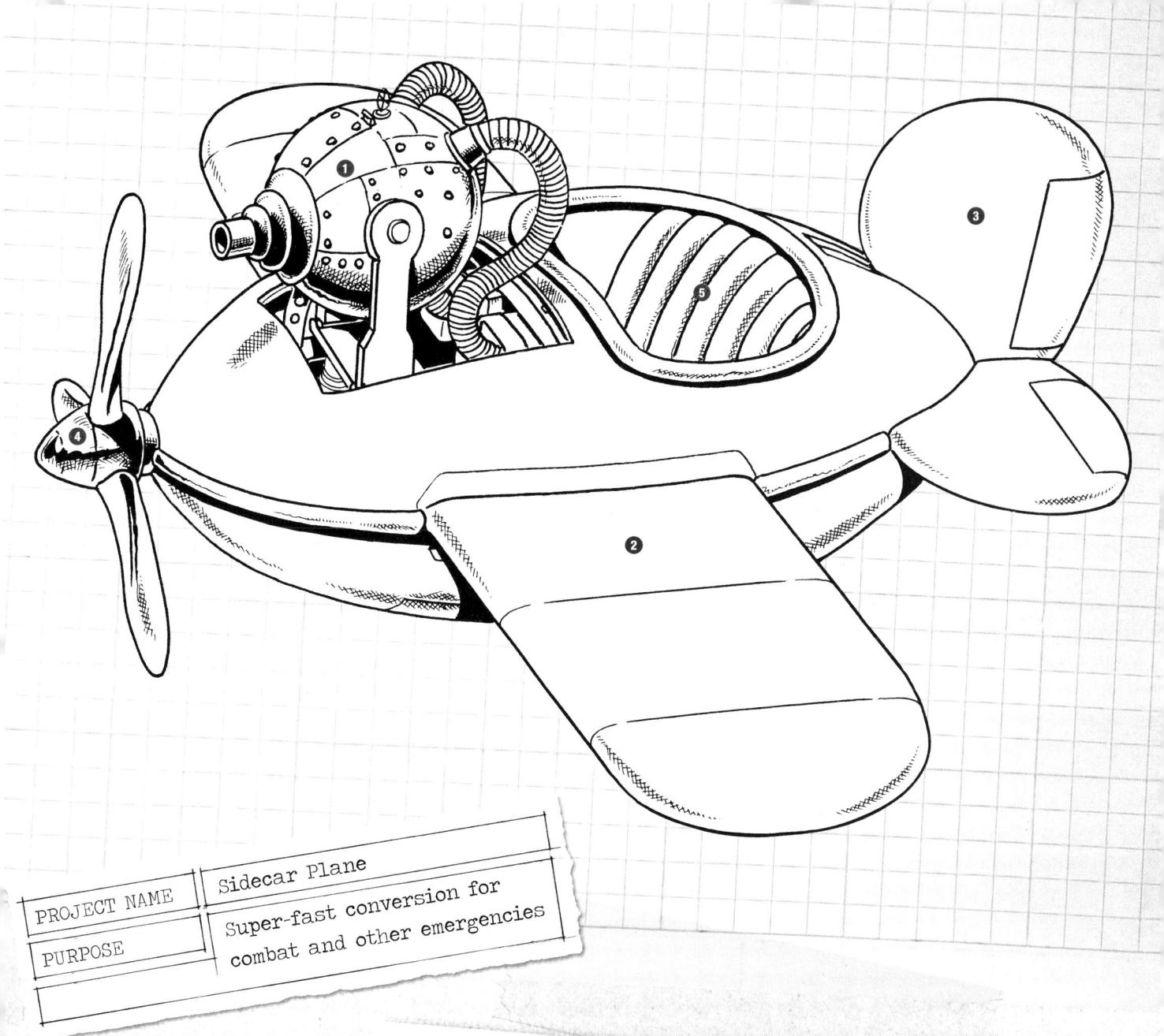

production or

- ① Sud cannon (deployed)
- ② Port wing
- 3 Tailplane
- ⑤ Propeller
- ③ Pilot's seat

AUSTIN A35 VAN

Contents

General description	62
Austin A35 Van cutaway	64

General description

Allace and Gromit are great fans of the Austin A35 Van and throughout their many adventures and various money-making enterprises they have used at least two such vehicles to provide reliable transport along with plenty of space to carry cargo and contraptions. Their latest van was built in 1965 and is still fitted with its original 1098cc, four-cylinder A-series engine and gearbox. It is shown here in the livery of the Top Bun bakery business, which Wallace and Gromit run from their home at 62 West Wallaby Street.

Although from the outside the van appears to be unmodified, it does, in fact, have a few special features. The most significant of these are the seats, which can be installed and removed via access hatches in the floor pan. The seats themselves are normally stored 'on standby' in the cellar below the garage. When it's time to make the busy morning delivery round, every second counts and the seats, along with the driver and passenger, are raised swiftly up through the garage floor and then through the floor of the van on hydraulic lifting rams. Once inside the cab, the clamps securing the seats to the hydraulic rams are released, and the rams withdraw back to the cellar while the hatches in the floor pan of the van are closed and the seats anchored in place.

In the cab, the steering wheel is normally positioned on the right-hand side but can be removed from the steering column and attached to a duplicate steering column on the lefthand side for continental driving. The swap-over can be achieved very quickly in the event of an emergency, where the driver must ask the passenger to "take the wheel". Beneath the radio unit in the centre of the dashboard is a slot-loading longplay (LP) record player, driven directly by the engine. This is a recent addition to the vehicle and was installed to replace the Auto-Burn P toaster fitted previously. A selection of LPs is stored in a record case built into the lower dashboard on the passenger side.

The rear of the van is fitted with a bread shelf transit frame, which is designed to carry removable bread shelves. These are loaded with bread fresh from the ovens at the Top Bun bakery, ready for dispatch early each morning.

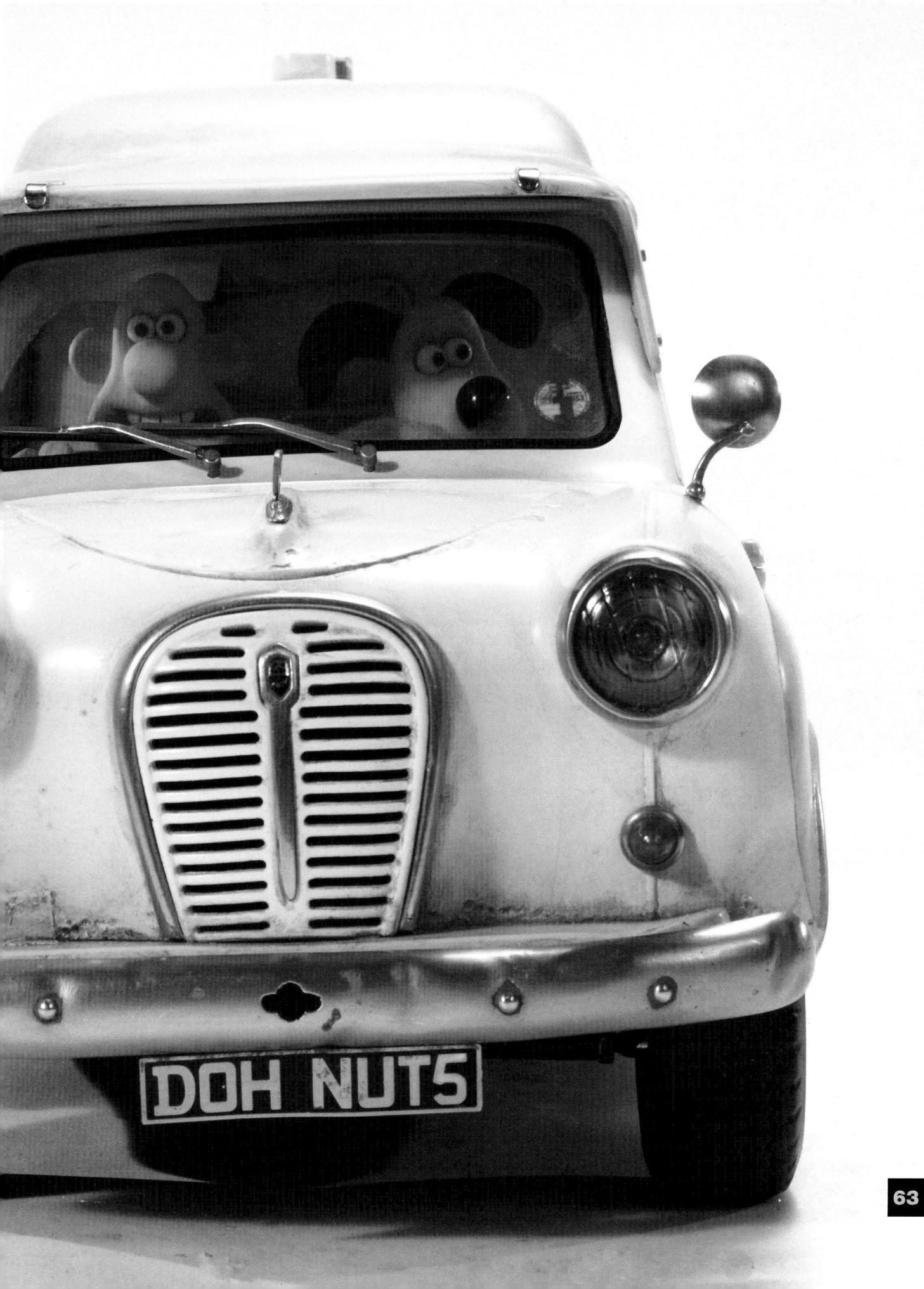

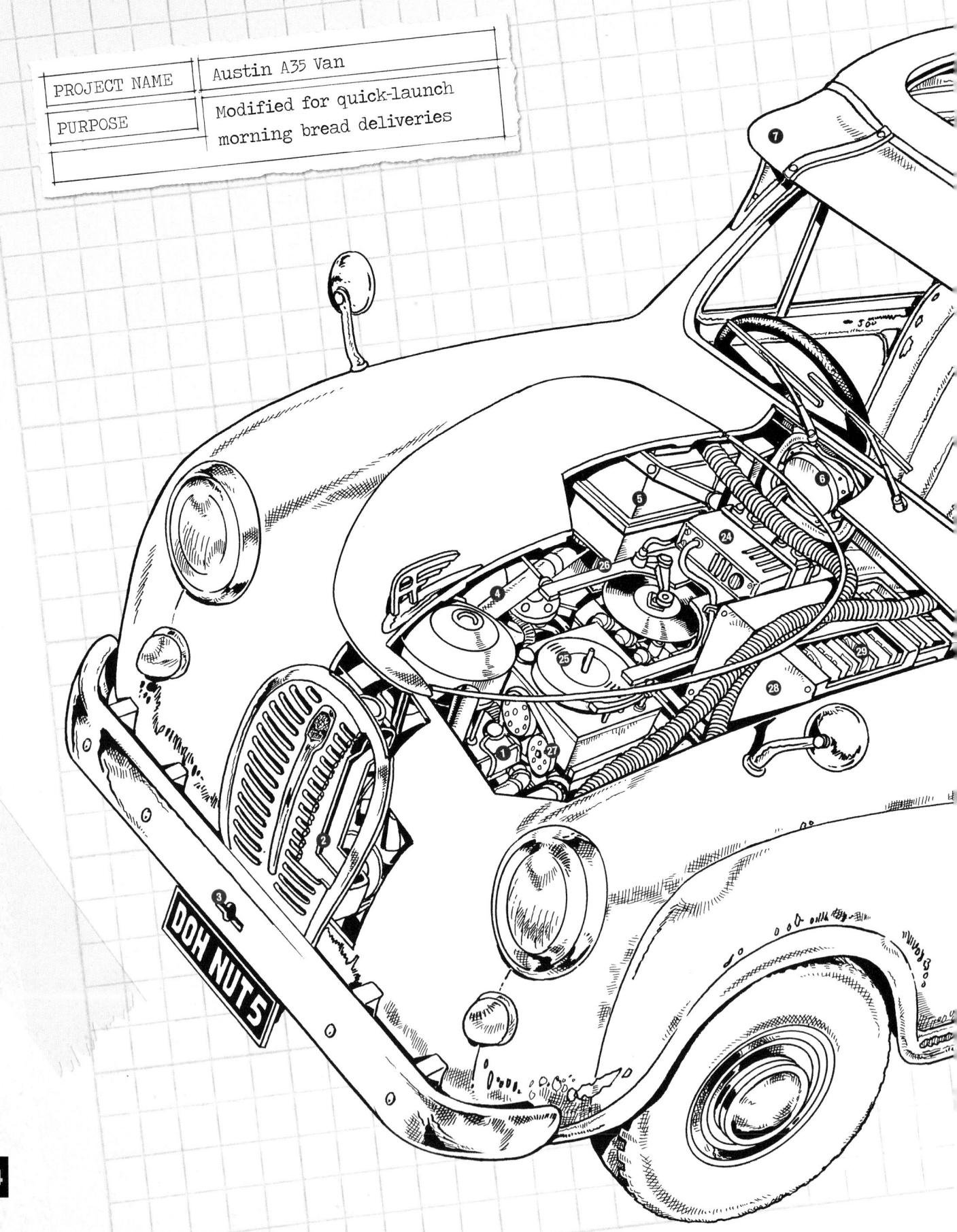

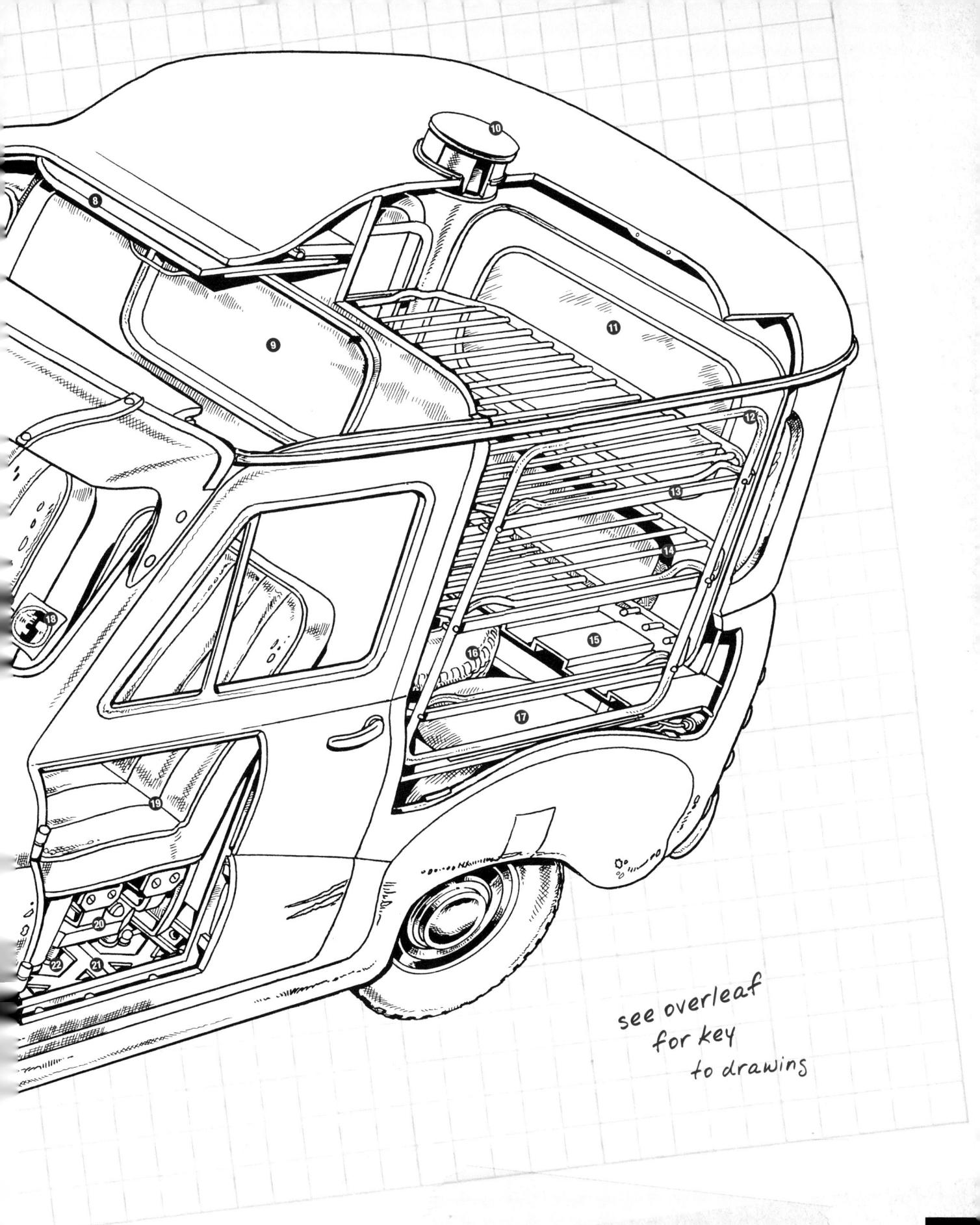

Austin A35 Van cutaway

- Engine
- Radiator
- Manual crank handle slot
- Right-hand drive steering column (duplicated on left for continental driving)
- **6** Battery
- Speedometer
- O Sun visor
- Sun roof (retracted to allow Wallace and Gromit to wear bakers' hats while delivering bread)
- Rear of cab 'bread-checking' window
- Ventilation fan
- Rear loading door

- P Bread shelf transit frame
- Transit frame shelf slide runners
- Adjustable and removable bread shelves
- Rear load floor
- Spare wheel
- 1 Inner wheel arch
- (I) Up-to-date tax disc
- Passenger seat (normally stored on hydraulic lift in cellar below garage of 62 West Wallaby Street)
- Strengthened passenger seat subframe
- Under-floor access hatch through which passenger enters van

- Passenger seat hydraulic lift clamps
- **3** Gear lever
- 2 Radio
- Single-speed vibration-damped auto-return record player
- Record player LP slot-loader
 (this was added to replace
 the Auto-Burn toaster
 located under radio)
- Record player driven directly from engine.
- Aluminium record-storage cabinet
- ② Cracking collection of longplaying records

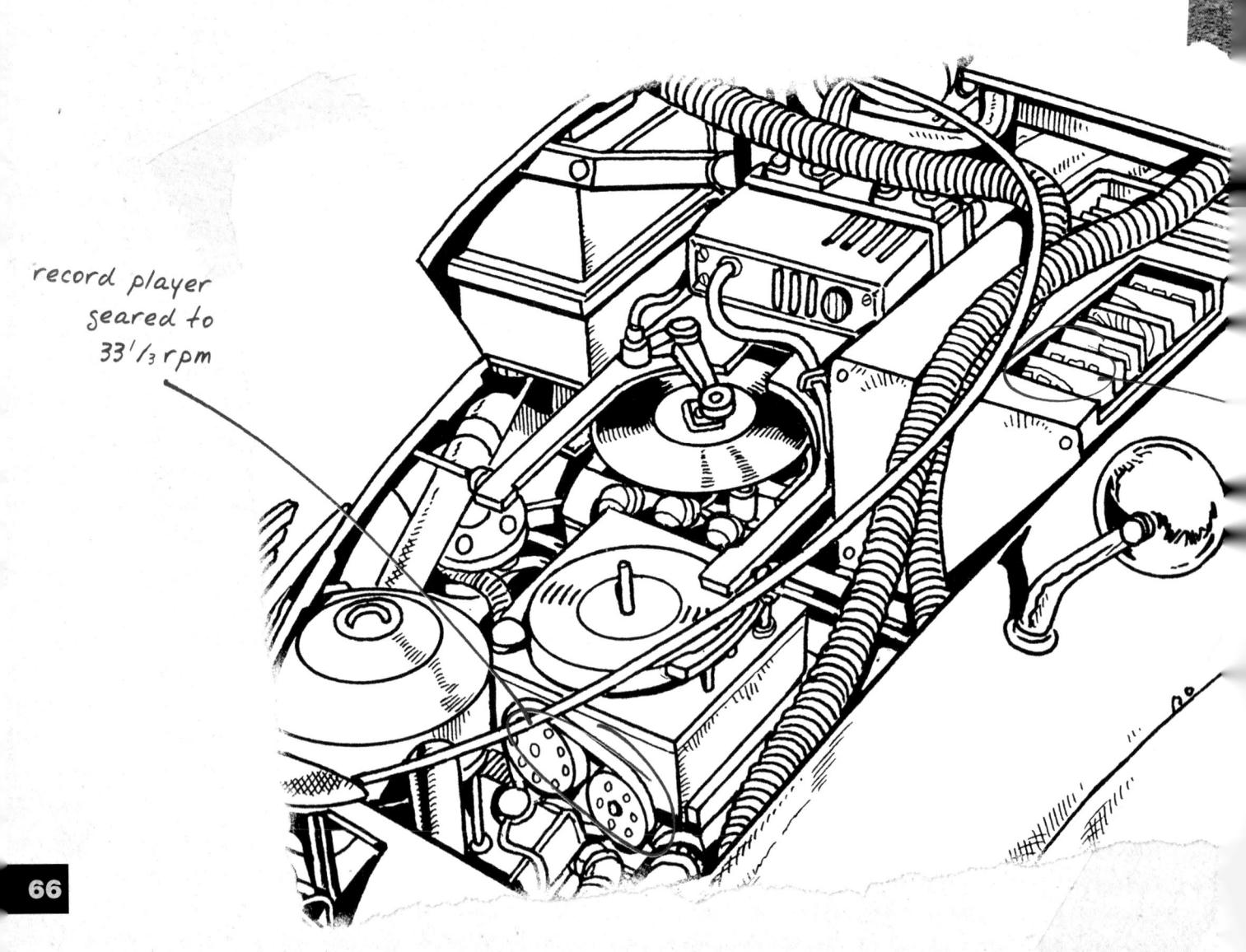

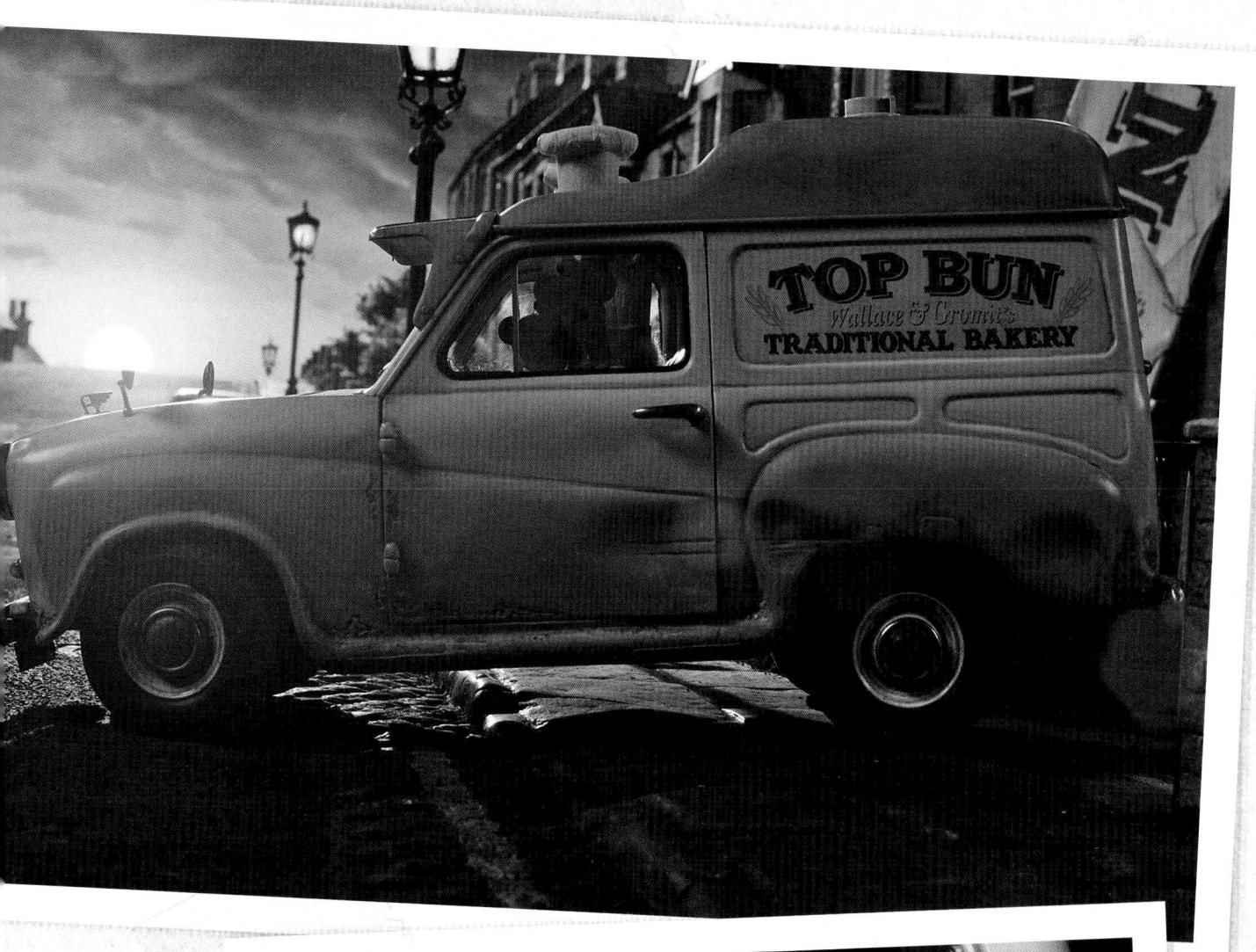

Gromit's record collection

TOP BUN BAKERY

Contents

General description	68	
Forklift truck cutaway	70	

General description

When Wallace and Gromit start their Top Bun bakery business, they carry out extensive modifications to the house at 62 West Wallaby Street. The most obvious of these is the traditional cloth-sail windmill, which is installed on the roof. This provides on-site milling of grain to make flour as well as power for the automated dough kneading machine, mixer, bread ovens and other bakery equipment.

The fast-response launch system, originally installed for Wallace and Gromit's Wash 'n' Go window-cleaning business, has been updated for use with the Top Bun delivery van (see Austin A35 Van, page 62).

The early-morning bread delivery round meant that a new 'GET-U-UP' system had to be devised to get Wallace out of bed at 5am and ready to leave as quickly as possible. A modified Bed Launcher now delivers Wallace directly to the delivery van, while on the way he is automatically dressed in his clothes and baker's hat. Once in the van, Wallace has his tea mug filled from a pump nozzle, which can also supply 4-star petrol, diesel, coffee and milk. The system is neat and efficient although the tea can be prone to a 'diesely aftertaste'.

Most of the various other contraptions found in the Top Bun bakery are dedicated to the breadmaking process, which is mostly automated. However, the forklift truck is one exception.

Although largely conventional in design and operation, the 'arms' of the forklift truck have been specially modified to include two highly articulated mechanical grabber hands. These are controlled by a pair of multiposition servos fitted either side of the mast. The grabber hands are able to grasp hot bread trays from the oven and load them directly into the back of the delivery van. Specially designed heat-resistant oven gloves are fitted over the grabber hands to protect them and to provide additional grip.

The forklift truck is powered by a petrol engine, which is fuelled by liquified petroleum gas (LPG) from a bottle mounted behind the operator. This can be replaced when empty to allow continuous operation since there is no need to wait while batteries are recharged. The vehicle is driven by the front wheels and steered by the rear wheels, this arrangement offering a good combination of traction, stability and manoeuvrability.

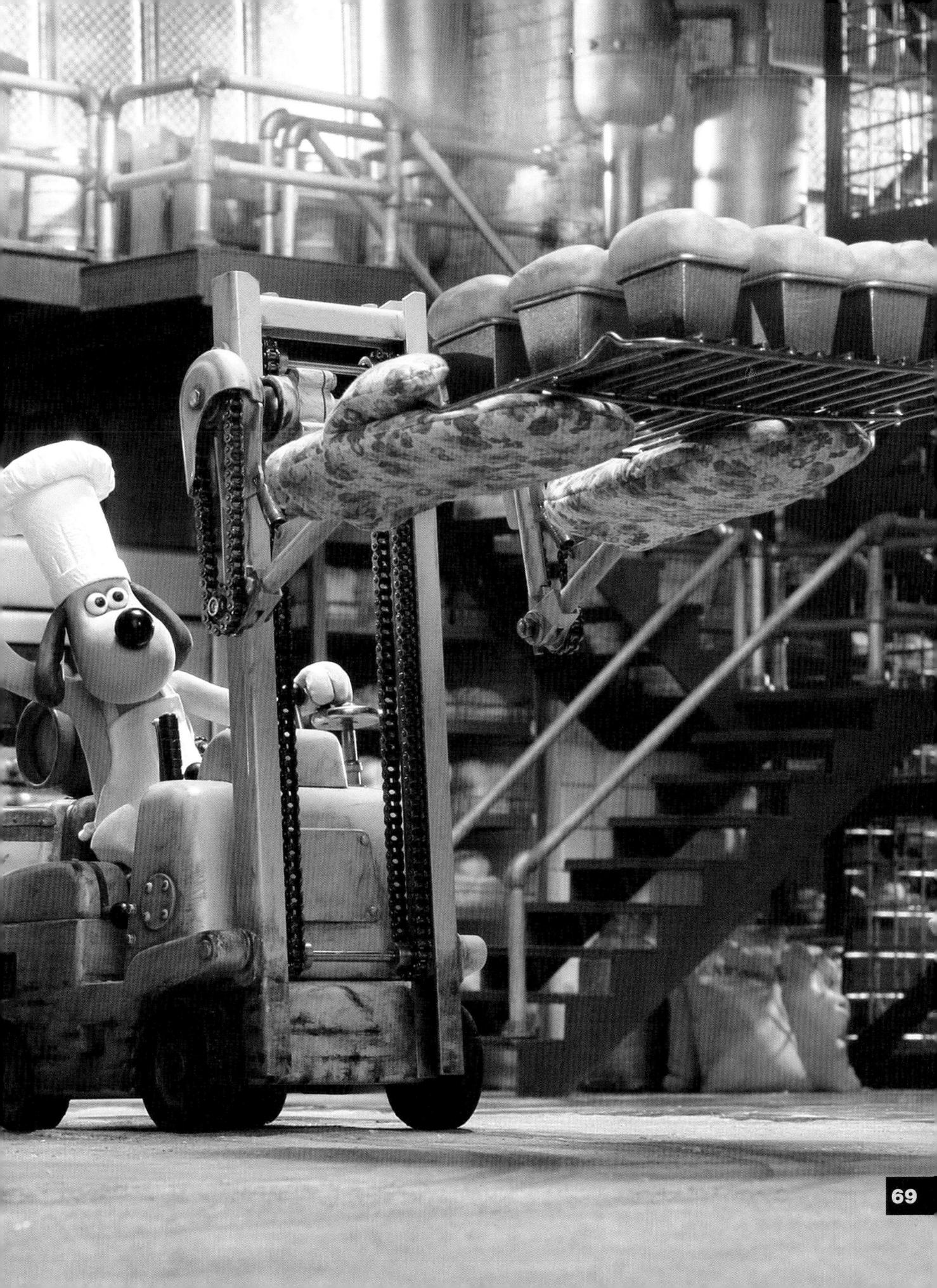

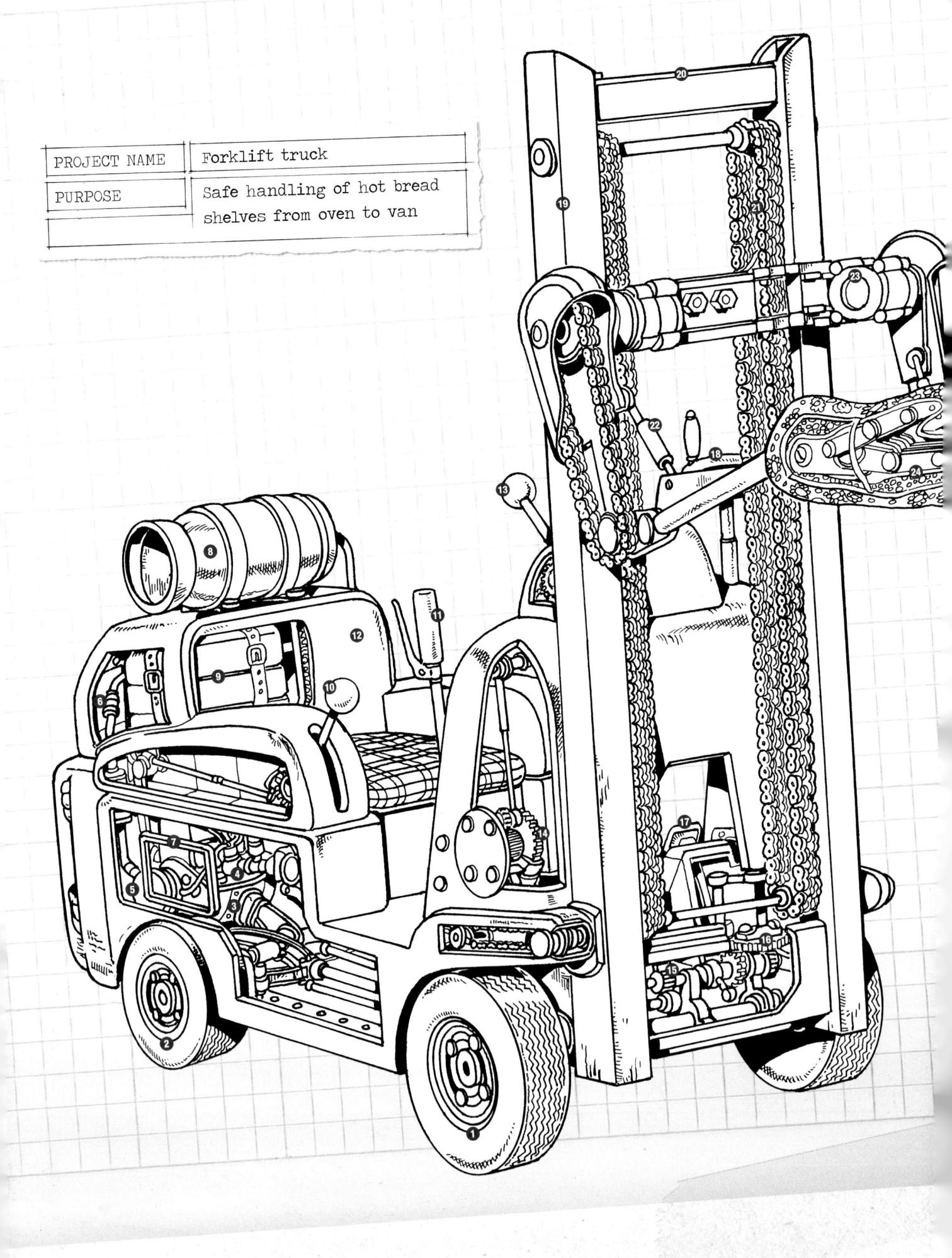

Forklift truck cutaway

- O Driving wheels
- Steering wheels
- **3** LPG engine
- O Fuel control valve
- 5 LPG regulator/vaporiser
- **6** Filter
- Ventilation grille
- 8 LPG fuel tank
- Ocunterweight
- Mandbrake lever
- Forward/reverse lever
- Padded seat for operator comfort
- ® Forklift controls

- Forklift control gearing
- **(b)** Drive gearing
- **6** Steering gear
- Accelerator pedal
- Steering wheel
- Mast
- **②** Crosshead
- 4 Lifting chains
- Lifting arm hydraulic ram
- Multi-position arm servos
- Toughened bread tray grips
- 4 Heat-resistant oven gloves
- 3 Bread tray

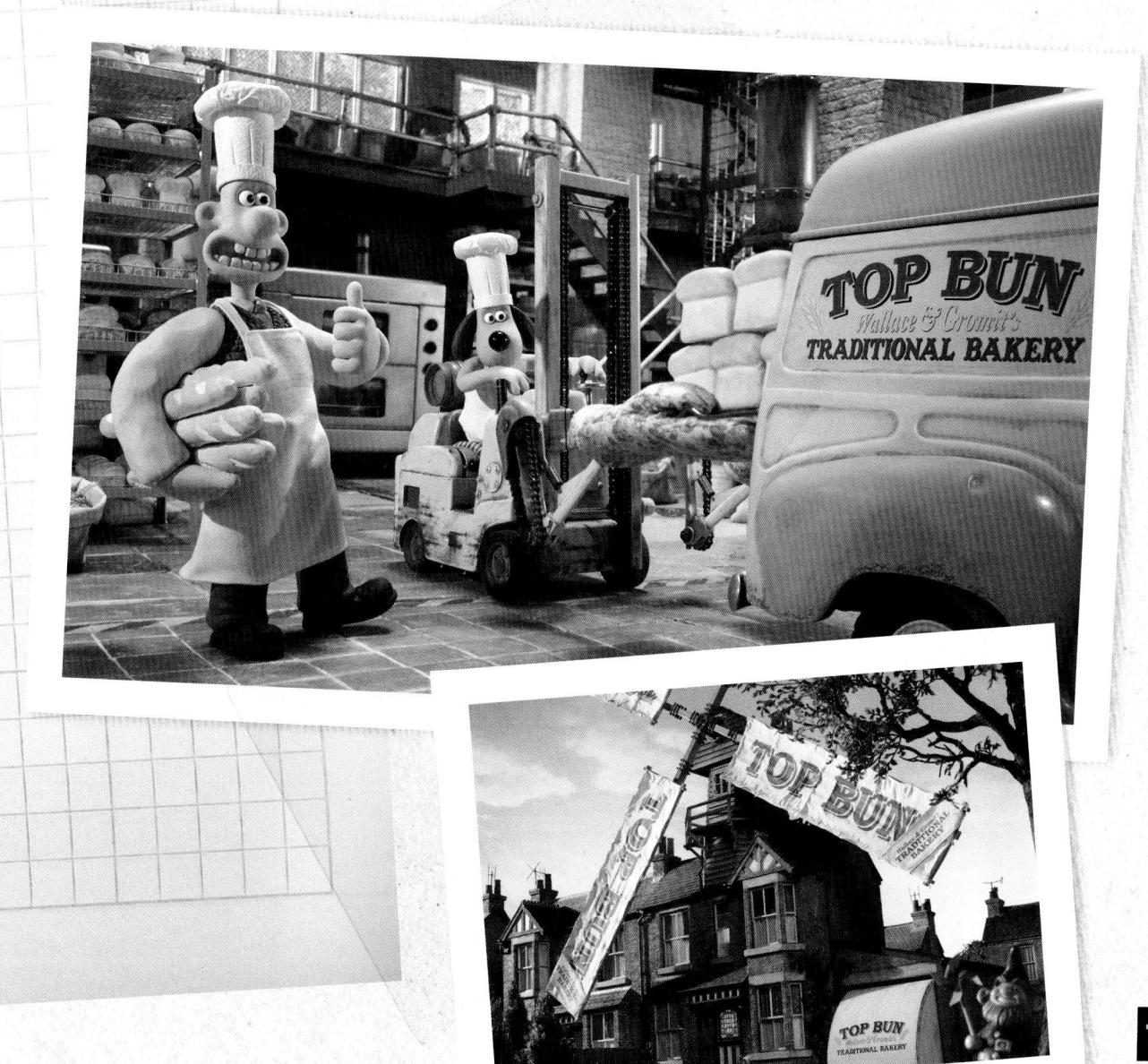

AUTOCHEF

Contents

General description	72
Autochef cutaway	

General description

The Autochef is a fully mobile, remote-controlled robot chef, designed to cook and serve breakfast at the push of a button. It is one of Wallace's ongoing projects and – it is fair to say – still in development.

While the prototype Autochef is undergoing testing, the remote control is configured with a basic 'menu', which includes eggs, served either scrambled or fried, and a choice of tea or coffee, with or without sugar. Further functions, and a more extensive menu, are planned for the future.

Internally, the Autochef can be divided into roughly two halves. The bottom half contains the wheels, drive motor and associated gearing that enable the robot to move independently between the kitchen and the dining room. At the bottom of the casing is a water tank with an integral heating element, which supplies hot water for tea and coffee. The tank is refilled via a funnel, which is accessed when the lid of the Autochef is opened.

Mounted above the water tank, on a pair of scissor lifts, is the hot drinks platter. This contains all the necessary ingredients (apart from the hot water) to prepare and serve tea and coffee. Hot water is supplied from the tank via an

electric pump to the tea and coffee pots; milk and sugar can be added at this stage if required. Once ready, the platter is raised up through the body of the Autochef to the 'neck' and the drinks are served through spouts which extend from the tea and coffee pots and through a hole in the 'face'.

The top part of the casing contains a frying pan, which is hinged at one side, allowing it to swing down to a vertical position when the tea and coffee platter is in the raised position. The frying pan can also swing up in order to serve cooked food, and this requires that the lid of the Autochef (also hinged) is opened first. Below the frying pan is a hinged heating ring, which swings into a horizontal position underneath the frying pan for the cooking of eggs.

At the top of Autochef's 'head' is a food measuring and mixing jug with integrated high-speed blending blades. The 'face' contains a mixer speed dial, a multi-function timer dial and a temperature gauge, while control circuitry and wiring is mounted behind on the inside of the casing.

Operation of the Autochef is straightforward although, unfortunately, it is still somewhat unreliable.

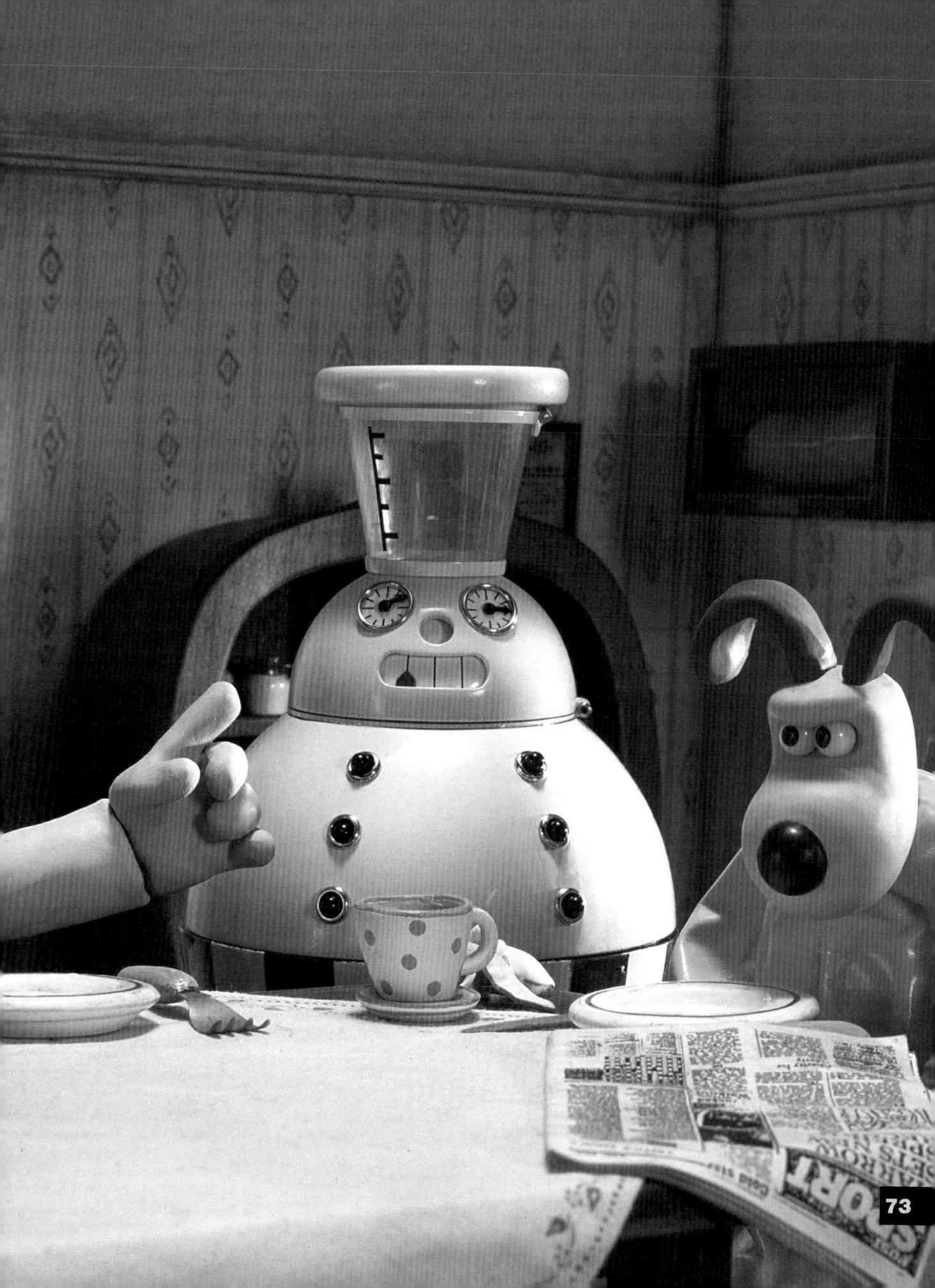

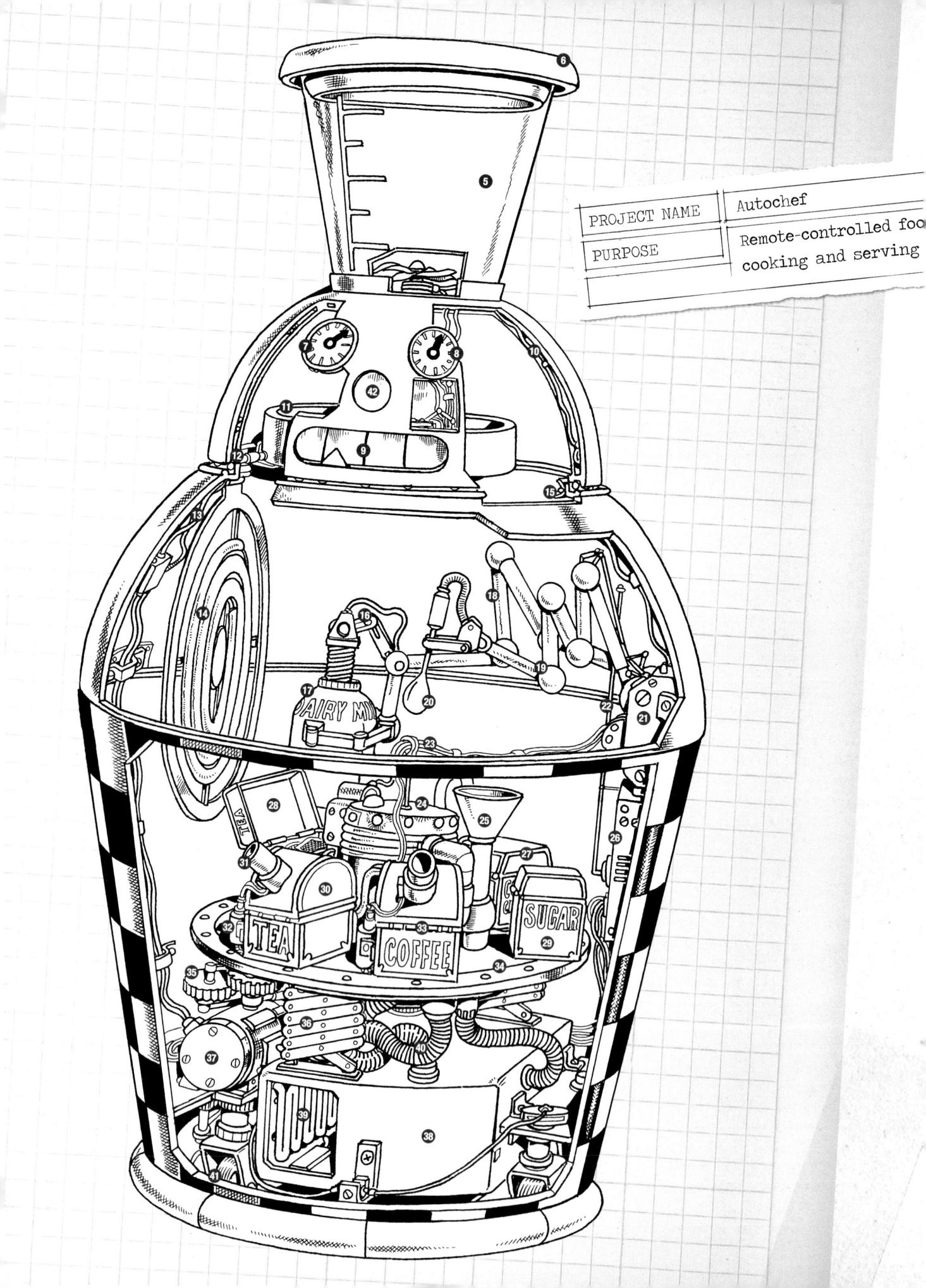

Autochef cutaway

- Autochef activation buttons
- 2 Remote-control antenna
- Temperature slider control
- 4 Timer control dial
- Food mixer bowl
- 6 Food mixer bowl lid
- Food mixer speed dial
- Multi-function timer dial
- Temperature gauge
- Tood mixer/dials wiring
- Frying pan (in horizontal position for normal use)
- Prying pan hinge
- Heating ring wiring
- Heating ring (swings down when not in use)
- Lid hinge allows access for maintenance and refilling
- Autograb unscrews milk bottle lid
- The Refillable milk bottle
- Milk pouring arm (also used to place teabags in pot)
- Sugar deployment and stirring arm
- Sugar/coffee spoon
- Arm control motors
- Remote-control antenna
- Control systems wiring
- ② Electric pump circulates hot water from tank to tea and coffee pots
- Water tank refill funnel
- Remote-control transceiver
- Coffee caddy
- Teabag caddy
- Sugar caddy
- 1 Teapot
- Telescopic spout on both tea and coffee pots
- Telescopic spout motor
- 3 Hinged lids on tea and coffee pots
- Revolving platter positions tea and coffee pots behind pouring hole
- Platter rotation gearing
- Platter scissor lift
- @ Electric motor for platter scissor lift
- Water tank
- Water tank heating element
- Flexible piping connects water tank to refill funnel and pump
- Steering caster wheels
- Pouring hole (also acts as a vent when Autochef is in cooking mode)

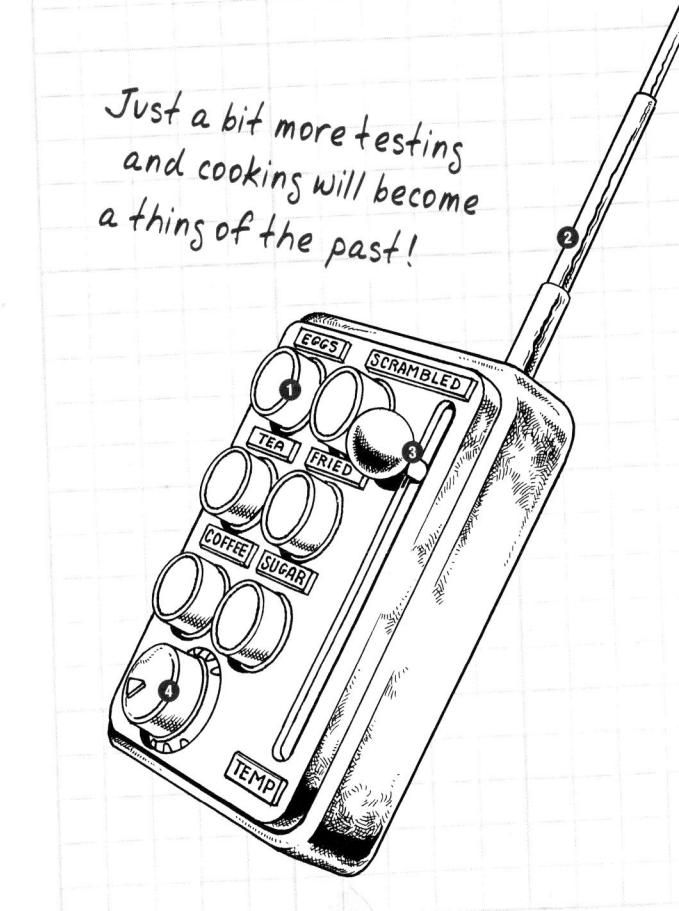

BULLY-PROOF VEST

Contents

General description	70
Bully-Proof Vest cutaway	78

General description

o the casual observer the Bully-Proof Vest appears to be a relatively harmless piece of personal body protection. It is constructed from a lightweight armoured material (composition unknown) and reinforced with riveted steel banding. This is arranged in a diamond pattern, which not only provides maximum strength but also coordinates with many popular styles of knitwear.

Mounted to the front of the garment is a small rectangular box, and it is this that houses the Bully-Proof Vest's secret weapon. When threatened, the wearer pushes a large red button on top of the

box, and this releases a long, high-tension spring on the end of which is a boxing glove. The boxing glove is flattened while stored in its housing but resumes its normal size and shape the moment it is deployed. Attackers should beware as this simple device is devastatingly effective.

Once deployed, the hightension spring and boxing
glove are retrieved using
a hand-operated cable
winder mounted on the
right-hand side of the
housing. As the cable is
wound in, it recompresses
the spring and returns
the boxing glove to its
housing, ready for the next
unwitting assailant.

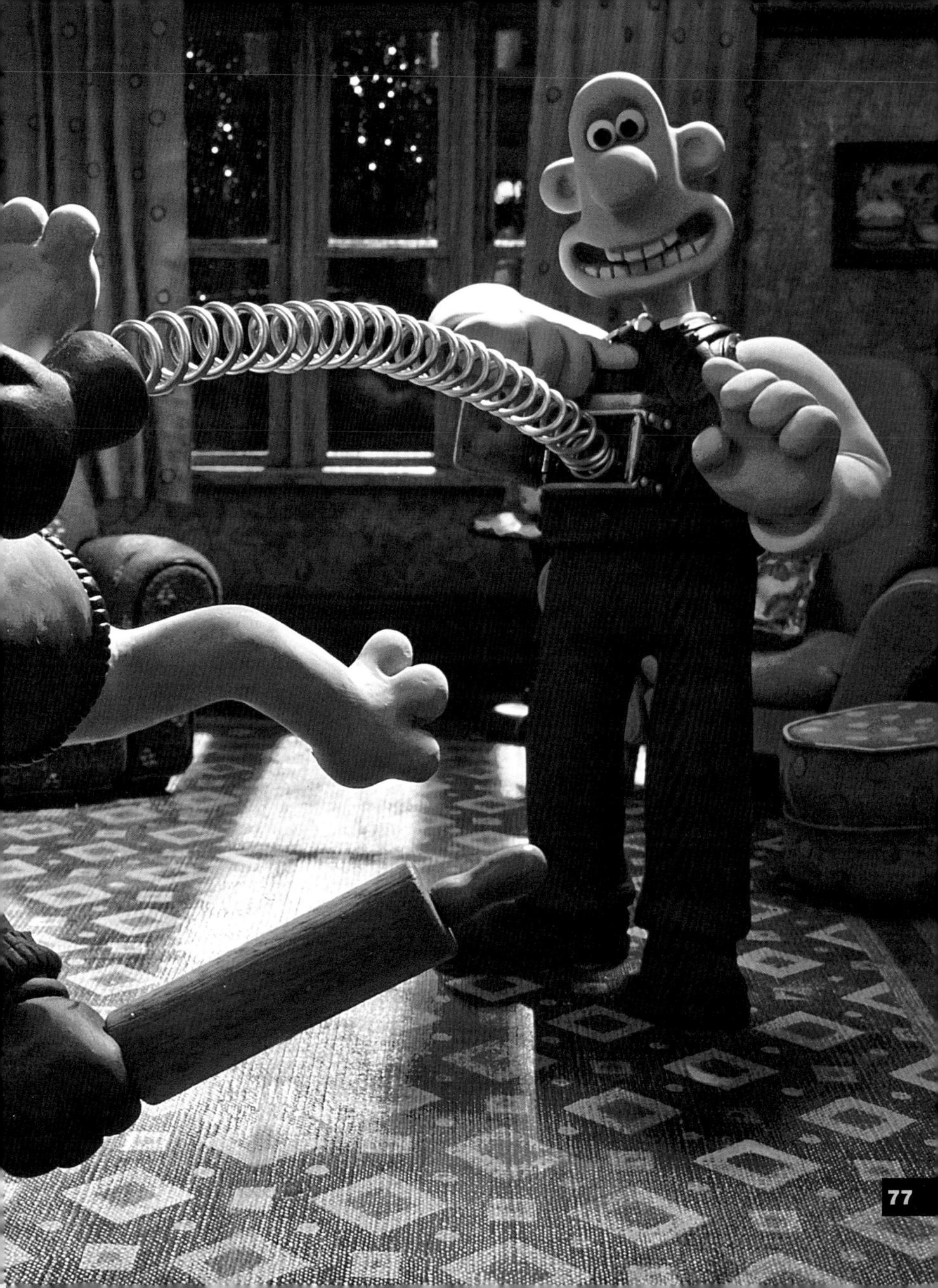

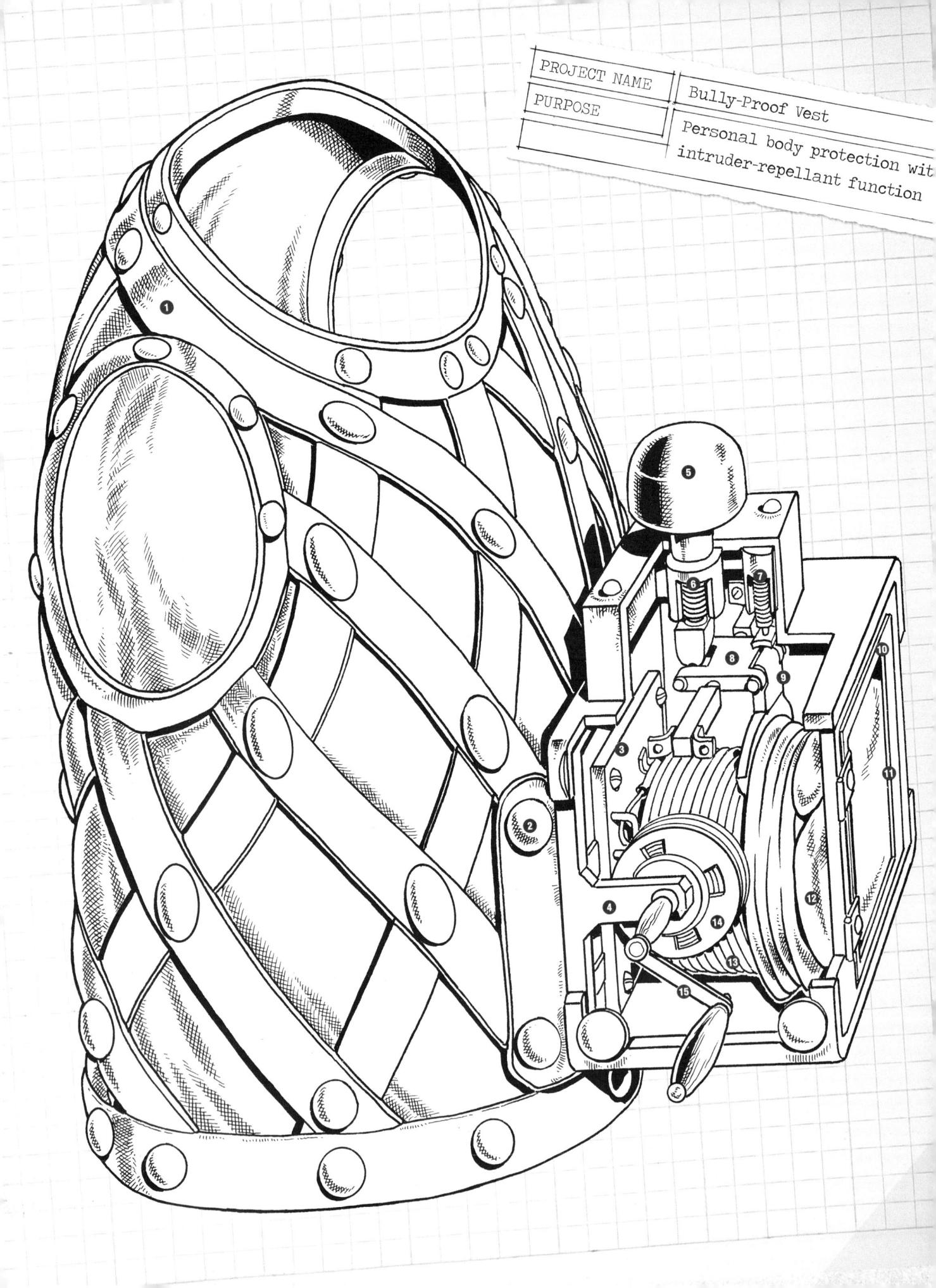

Bully-Proof Vest cutaway

- Armoured vest affords wearer protection and provides support for the boxing glove box
- Extra strong buttons to support the weight of the boxing glove box
- 3 Shock-absorbing plate
- Boxing glove deployment box
- Boxing glove activation button (large and easy to reach in emergency situations)
- 6 Activation button return spring
- Hook release cantilever
- 8 Cantilever repositioning spring
- Spring release hook
- Boxing glove box door
- Magnetic catch keeps door shut when not in use but opens easily when boxing glove is deployed
- Boxing glove is stored compressed behind the the box door. As it is deployed it regains its proper shape for maximum impact
- B High-tension glove deployment spring.
- Boxing glove retrieval cable reel
- Boxing glove retrieval winder

Fully tested with Gromit actins the Grant of danserous part of danserous intruder.

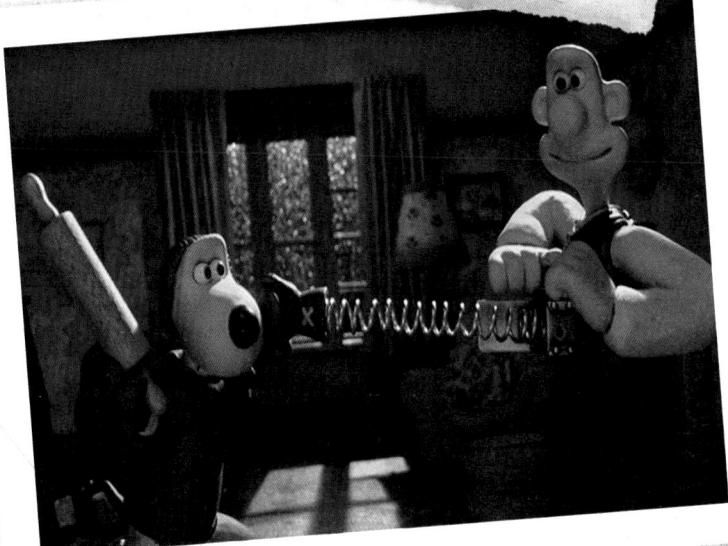

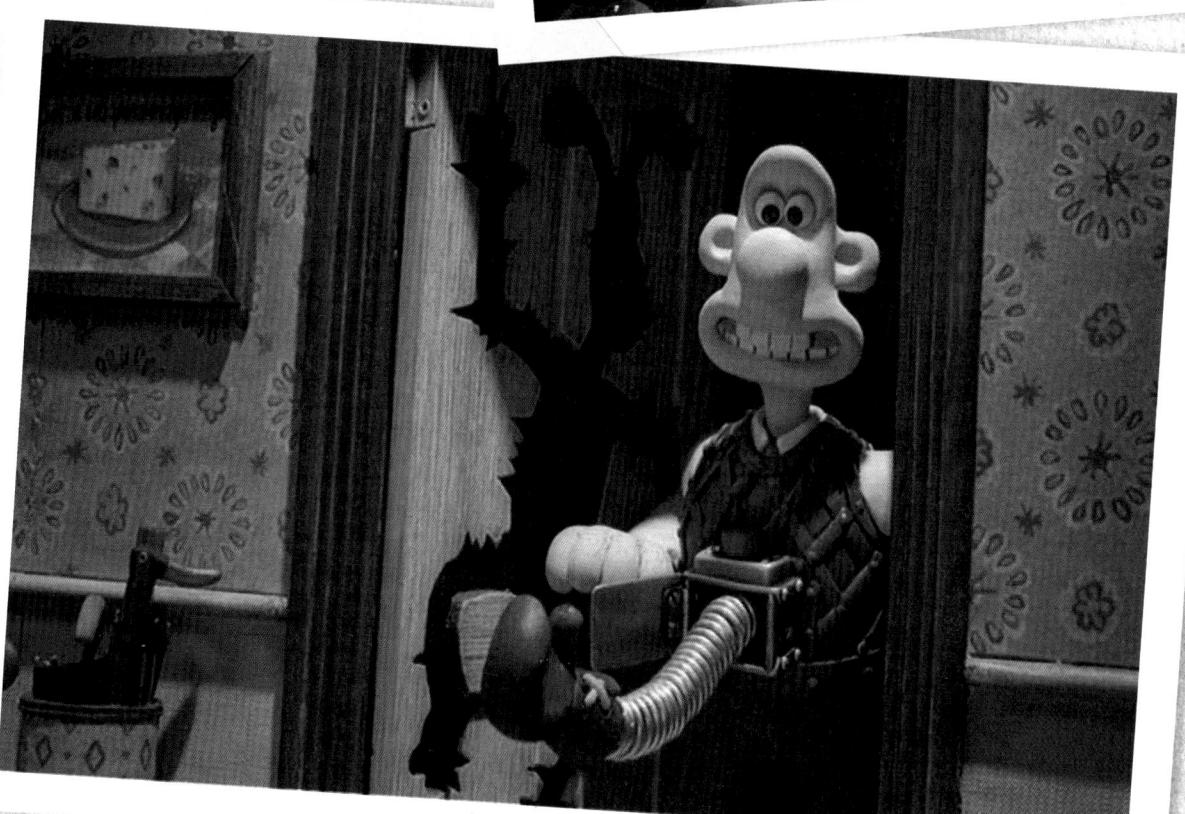

CHRISTMAS CARD-O-MATIC

Contents

General description	80
Christmas Card-O-Matic cutaway	82

I've attached a picture of our new, improved, travelling compact version

General description

Why buy Christmas cards when you can manufacture them at home? Wallace's Christmas Card-O-Matic takes a series of photographs, which are developed and then used to create a range of bespoke Christmas cards, and all from the comfort of the dining room. Our cutaway drawing shows the full-size early prototype of the Christmas Card-O-Matic, but Wallace has since developed a more compact 'portable' version. However, although scaled down the principle of operation is the same.

The camera used is of the 4x5in large-format variety and is loaded with sheet film, which is supplied from an automatic film-loading cartridge. After exposure, each film is removed from the camera and taken by the conveyor (in the dark) to the developing unit where it is developed, fixed and rinsed before being dried and passed to the printer unit. The conveyor then returns to the camera, running in a continuous loop.

Special heat-activated, self-adhesive photographic paper is used, and this is automatically loaded into and removed from the printer by an articulated grabber arm. The used films are discarded and the prints are dropped down a chute to a conveyor belt where glue and glitter are added for extra sparkle (optional).

The final stage of the process sees the printed photos applied to prescored cards, which are held by a vacuum holding plate, and heated to activate the adhesive backing. The finished card is then folded and placed on the exit conveyor, which carries it to a collection basket.

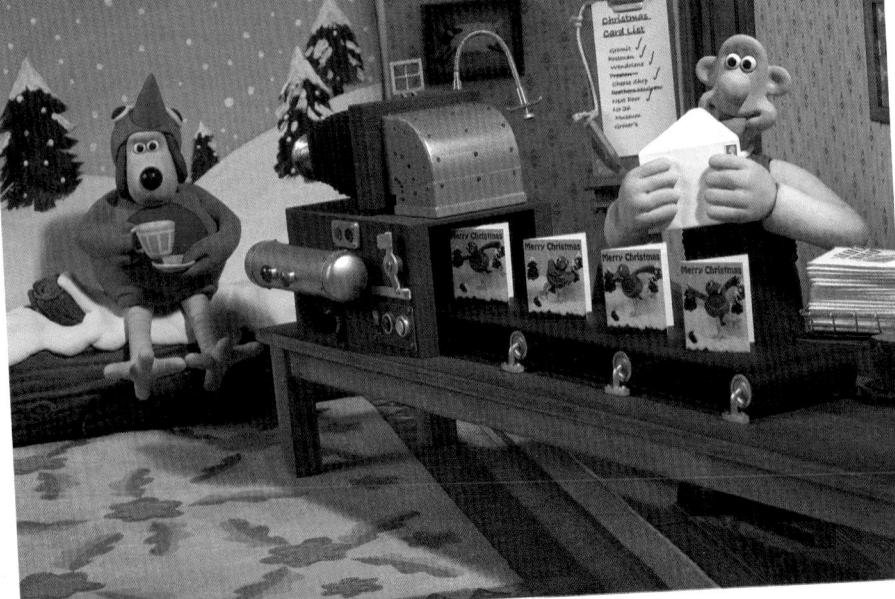

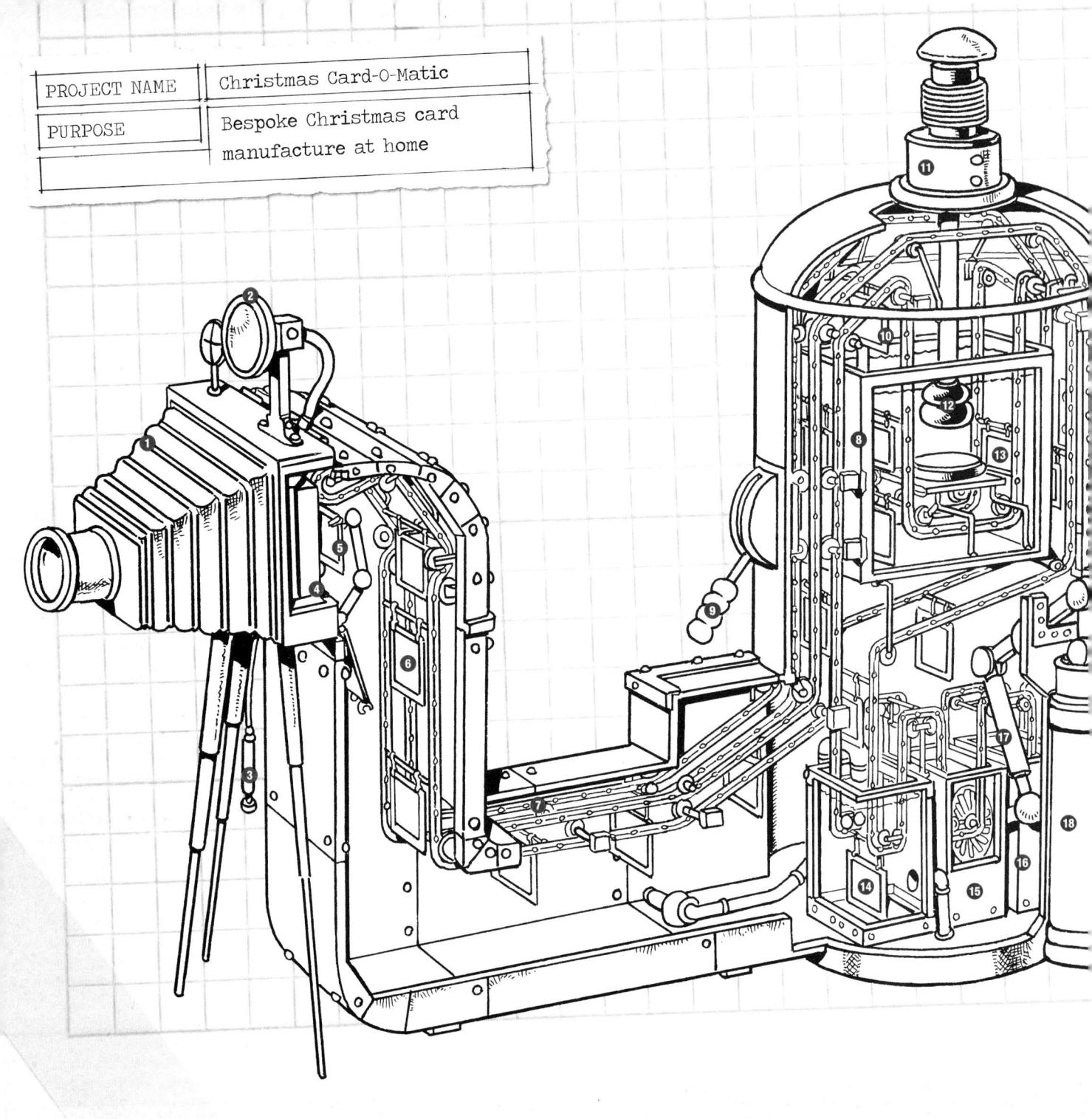

Christmas Card-O-Matic cutaway

- 1 Photograph is taken using 4x5in film
- Plash gun
- 3 Cable release for camera
- Automatic film-loading cartridge
- Exposed film is removed from camera by grabbers as new film is loaded
- In the dark, the films are hung on a conveyor and taken to the developer tank
- Top conveyor returns to camera
- O Developer tank
- 9 Film activation lever
- Films are dipped into developing tank
- 1 Pump circulates the developer

- Developer circulation paddle
- Conveyor removes films from developer tank and takes them to the water tank
- Developer is rinsed off the films in circulated water tank
- Films are dipped into fixer tank
- Films are rinsed again in second water tank
- Tixer circulation pump
- Fixer storage tank
- 1 Timer
- @ Drying fan

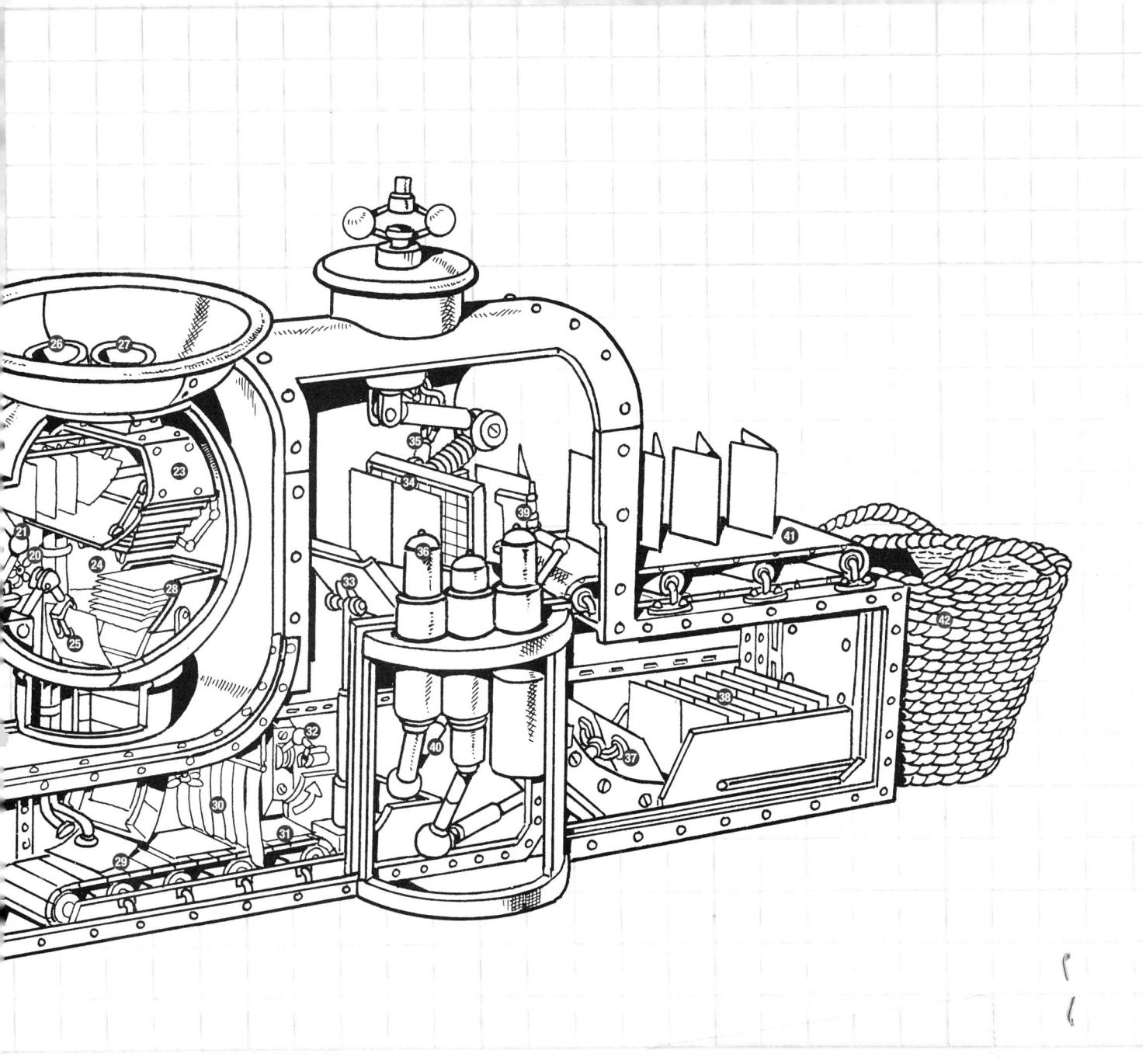

- Film grabbers
- Films are dried on moving rack and then placed in the printer
- Film printer
- Photo paper loading access panel
- Grabber removes used films then places prints in chute
- Glue chute used to apply glitter (optional)
- @ Glitter chute
- Pre-loaded heat-activated self-adhesive photo paper

- Prints slide down chute where optional glitter is added
- Light-shielding curtain
- Trints are conveyed to card-assembly unit
- @ Grabber turns print over
- Prints are lifted, turned over and pressed against heated card-holding vacuum plate
- Card holding plate holds card in place while photo print is glued to right-hand side
- Heating conduit

- 6 Grabber hydraulics
- Grabbers lift each sheet of pre-scored card up to the vacuum plate
- Pre-loaded and pre-scored cards
- Once photo has been glued to card, it is folded and placed on the exit conveyor
- Card-folding hydraulics
- Exit conveyor
- Collection basket

525 CRACKER VAC

Contents

General description	84
525 Cracker Vac cutaway	86

General description

allace describes the 525
Cracker Vac as an 'auto
cleaner' with a built-in
cracker sensor. It is designed
to accurately locate and
vacuum up stray cracker
crumbs - a constant problem
at 62 West Wallaby Street.

The device is based upon a traditional cylinder vacuum cleaner but with the addition of several special features, including trolley wheels with rear-wheel drive, modifications to the cleaning head and the aforementioned cracker sensor, which is a binocular visual sensing device that enables the Crackervac to locate cracker crumbs with extreme accuracy.

The 525 Cracker vac is powered by an uprated electric motor that also drives the rear wheels. This motor is powered by a rechargeable battery, allowing the cleaner complete freedom of movement around the house. The suction impeller (fan) creates a vacuum in the dust bag compartment, drawing in air (and cracker crumbs) through the cleaning head via a flexible hose. Special motordriven teeth in the cleaning head ensure that larger pieces of cracker are broken up to prevent them getting wedged in the hose.

Unfortunately, a bug in the Cracker Vac's programming means that it is unable to distinguish between genuine dropped cracker crumbs and a half-eaten packet of crackers, a fault that is potentially hazardous to unsuspecting cracker eaters.

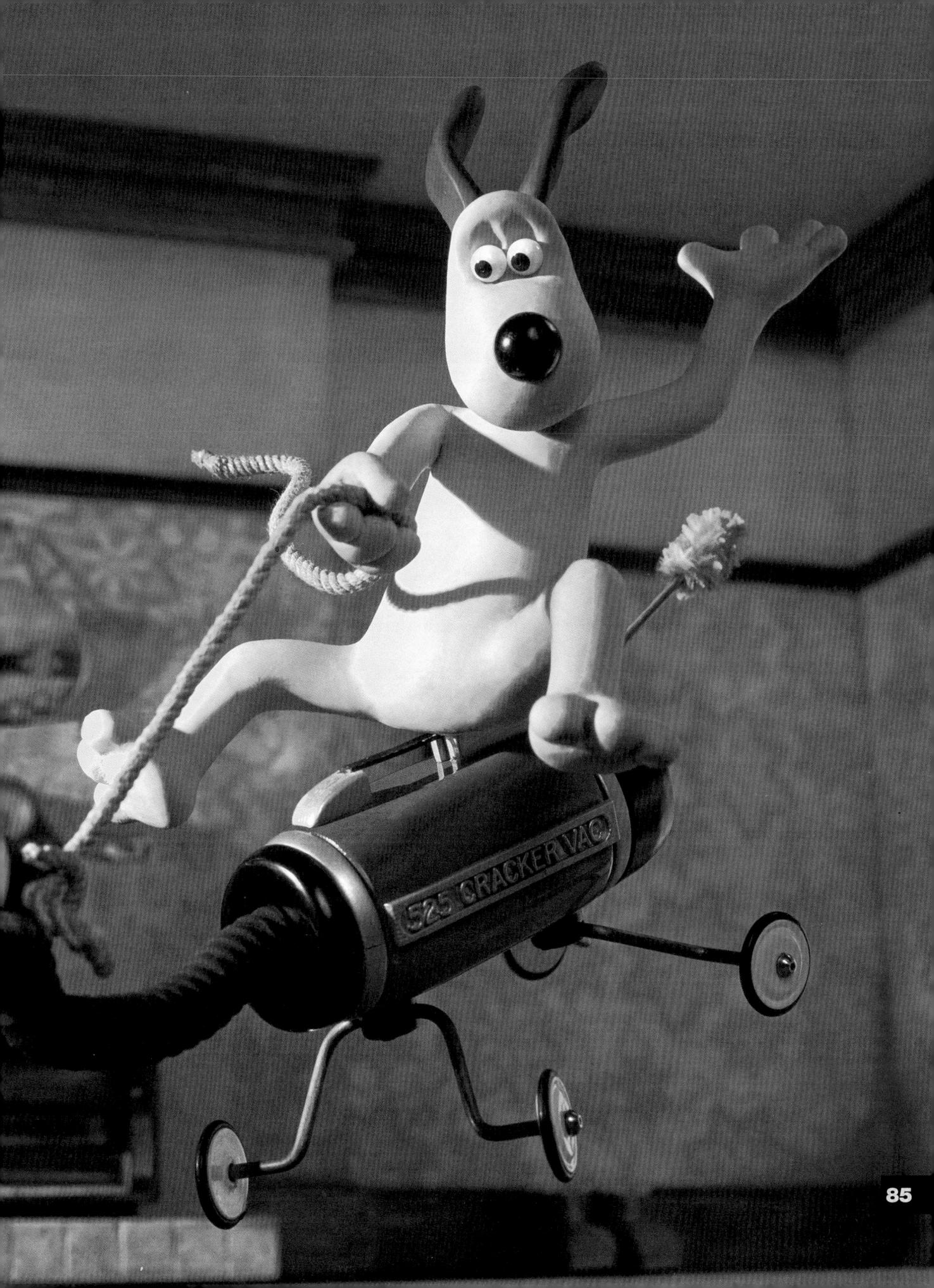

I think the next
version should
version should
perhaps be a little
perhaps be a little
less'automatic

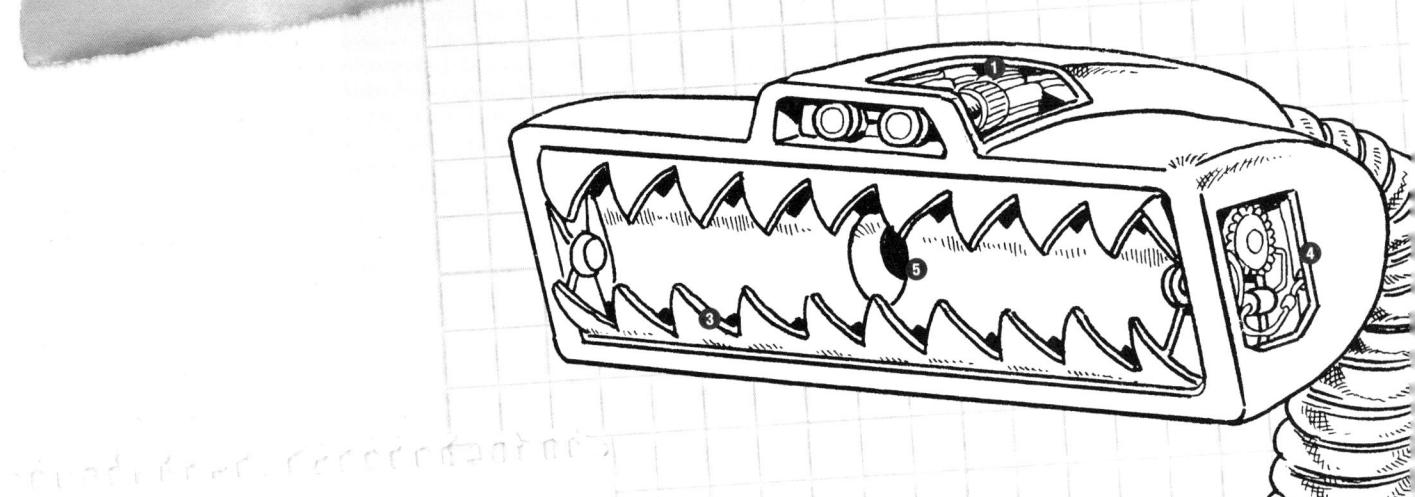

The 525 Crackervac cutaway

- Binocular cracker sensor for accurate sighting of cracker crumbs.
- ② Hose contains cable conduits linking cracker sensor to computer
- Teeth grip and crush larger pieces of cracker before being vacuumed.
- 4 Motor and gearing for teeth
- 6 Vacuum suction duct
- @ Dust bag securing clip
- Front housing can be unscrewed to empty the dust bag when full.
- Dust bag
- @ Primary filter
- ® Suction impeller
- (1) Secondary filter
- © Electric motor powers suction impeller and the rear-wheel drive
- ® Rear-wheel gearing provides maximum freedom of movement, allowing the cleaner to vacuum in awkward places

- @ Carrying handle
- © Computer and visual processing cortex enable the 525 Cracker Vac to locate cracker crumbs using data from cracker sensor
- @ Remote-control transceiver.
- ③ Remote-control antenna, with optional duster function
- ® Battery
- Accessible Service Section (A.S.S.) can be removed to allow maintenance of motor and electronics

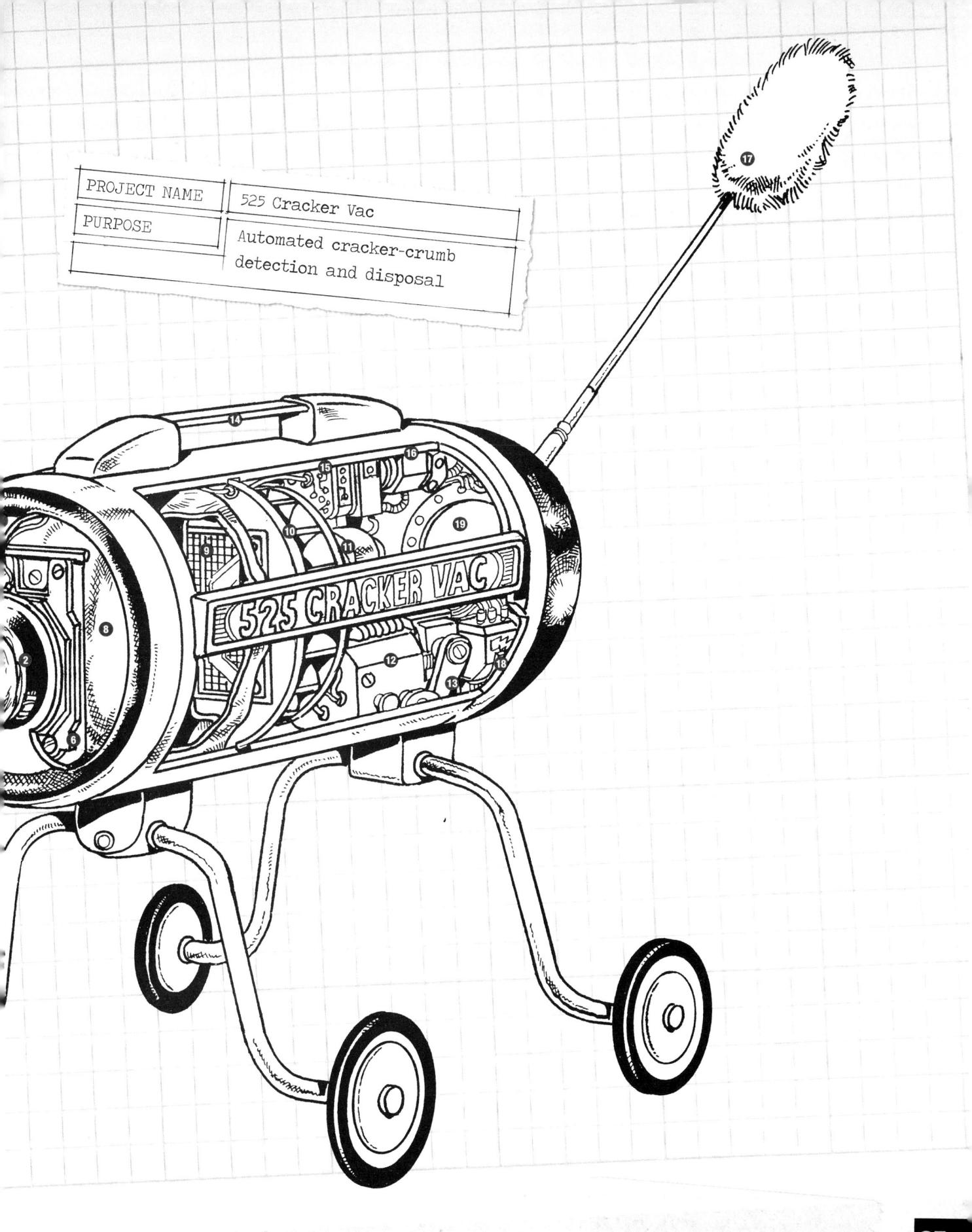

SHOPPER 13

Contents

General description	88
Shopper 13 cutaway	90

It's a long loaf but I thought we might just make it

General description

Wallace's 'Shopper' is a remote-controlled, automated shopping device comprising a conventional shopping trolley to which has been added a motor driving the two rear wheels, a front wheel for steering, a video camera, two articulated arms and associated control components and wiring. The model shown here is 'Shopper 13', this being the device's 13th trip to the shops.

Shortly after the Shopper sets out on a trip (or 'mission'), compressed air expressed through nozzles is used to jettison a panel on either side of the main compartment. This allows for the deployment of two fully articulated arms and hands, which are controlled through a set of gears, pulleys and actuators on either side.

Overall navigation and command is performed by remote from 'mission control' (the cellar of 62 West Wallaby Street). On arrival at the shops, Shopper 13's mission is to locate and retrieve the 'big cheese', and this is achieved using the on-board video camera (for target identification) and the articulated arms and hands. Once safely grasped, the cheese is stowed

in the main trolley compartment for the return journey.

Unfortunately, during the mission not everything goes according to plan. The cheese (a large edam) proves too heavy; the Shopper's frame starts to buckle under the load and one of the rear driving wheels falls off. The one remaining driving wheel causes the Shopper to circle helplessly in the middle of the shopping aisle. However, following some quick thinking back at mission control, a quickly extended arm grabs a nearby French stick, and uses it to stabilise the Shopper. The mission is able to continue with the Shopper using the French stick as a crutch in place of the missing wheel.

After hobbling back to West Wallaby Street, 're-entry' appears to be successful, but while scaling the doorstep to the house the Shopper becomes unstable and falls over, causing the cheese to roll out of the main trolley compartment and back down the path towards the gate.

With the edam now stranded, Wallace (as mission director) has one last option and he launches the 'probe' to try and retrieve it.

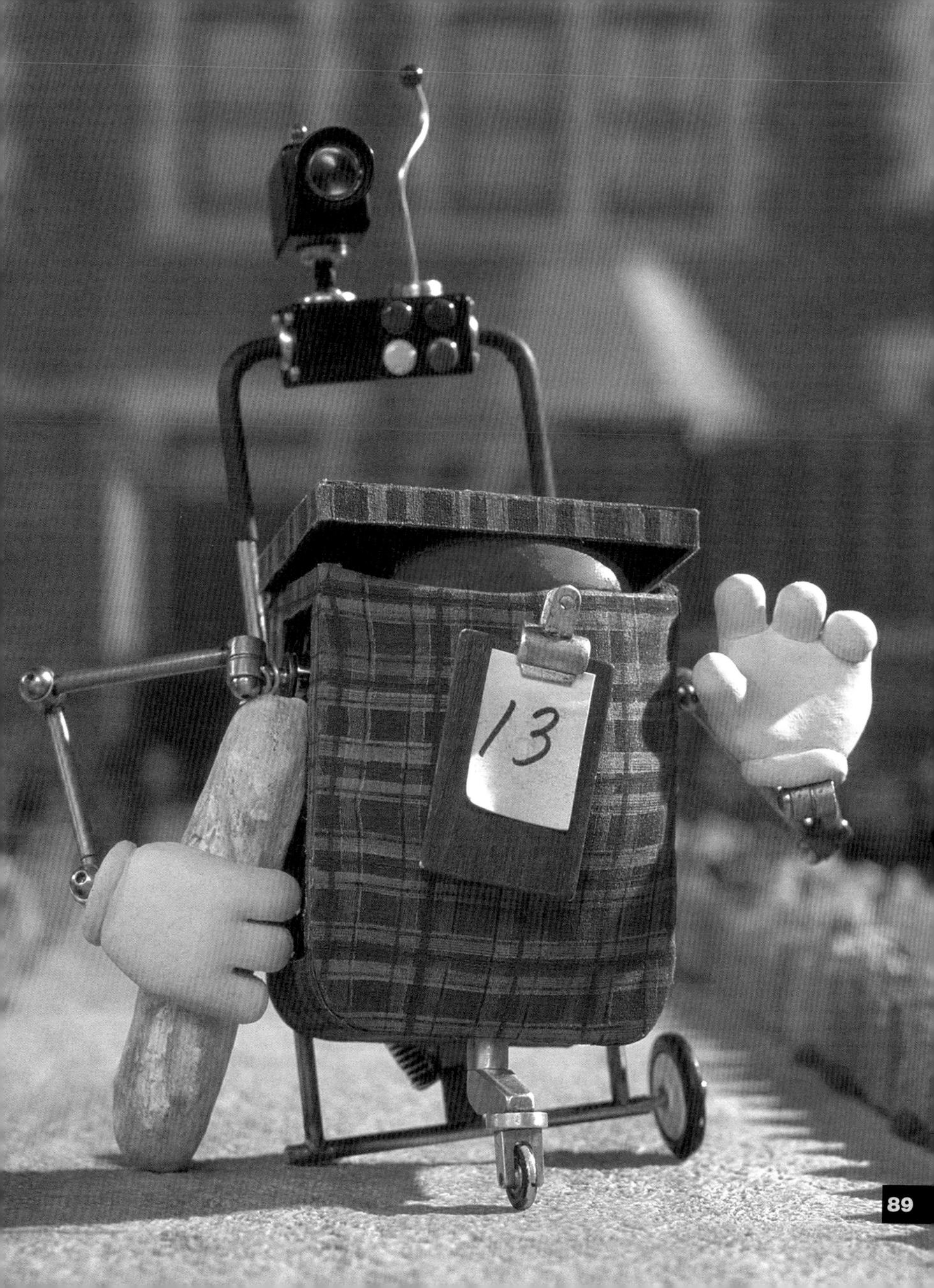

Shopper 13 cutaway

- 1 Lens
- **2** Iris
- Focus lens
- O Charge-coupled device
- 6 Remote-control command reception antenna
- 6 Control systems computer and command transceiver
- Camera and programming

- Arm motor box
- Ompressed air cylinder
- O Gas jet nozzle
- 1 Left side panel (jettisoned after launch)
- P Right side panel (jettisoned after launch)
- Exhaust pipe
- **1** Motor

- Battery cover
- Torward steering wheel
- Left arm gearing, pulleys and control actuators
- Trolley lid
- Olipboard for mission number

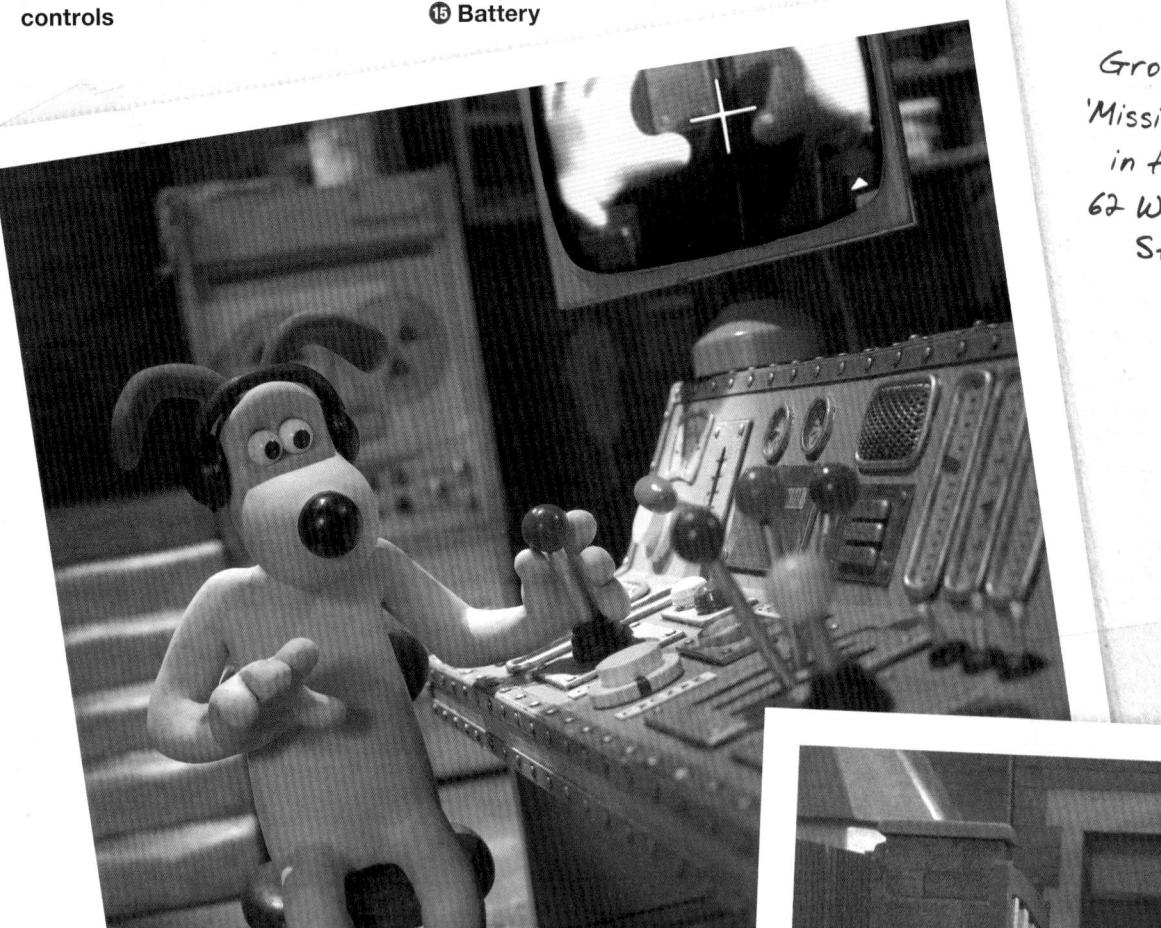

If only the 'probe' had been more reliable

Gromit at 'Mission Control' in the cellar of 62 West Wallaby Street

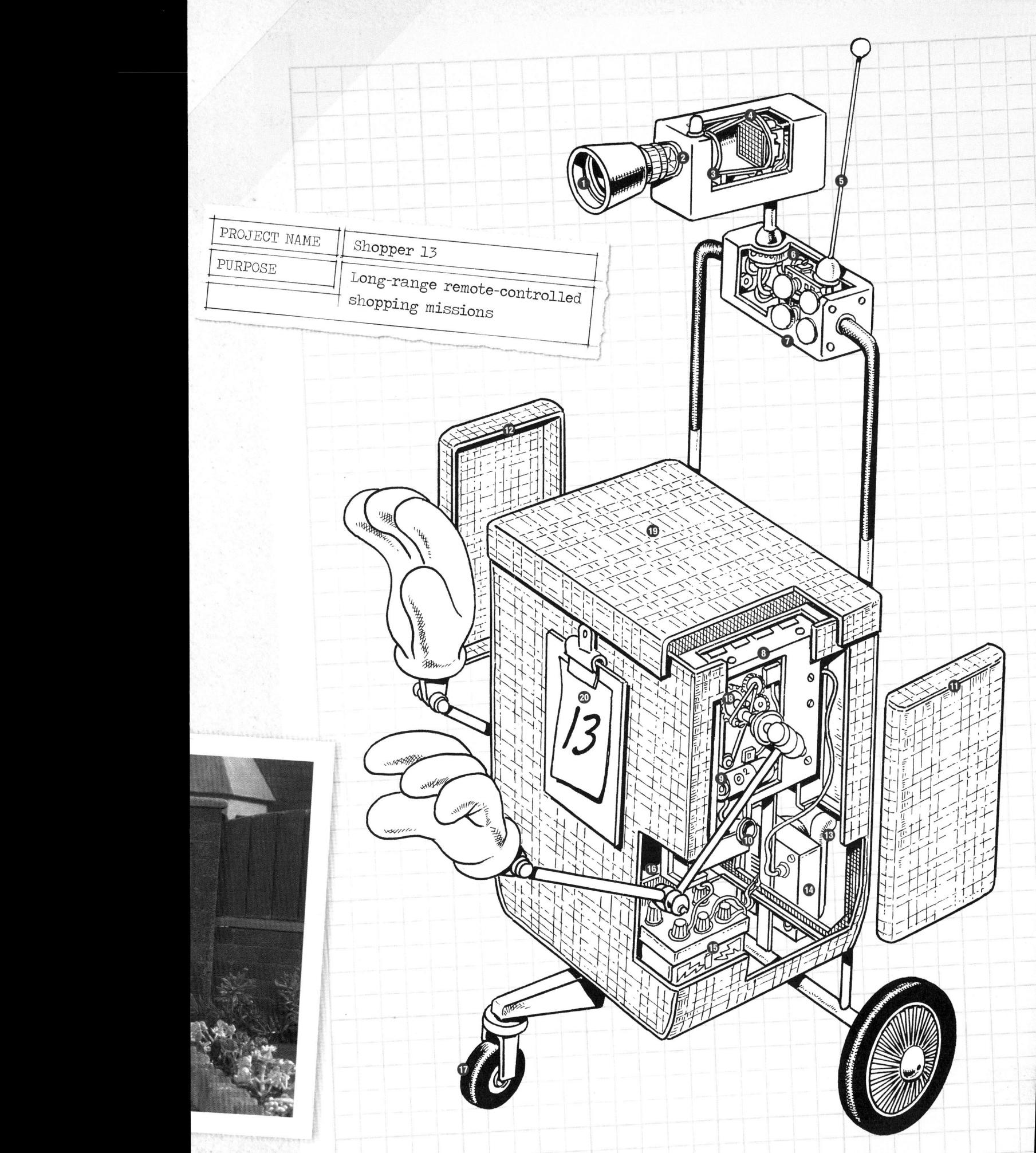

SNOOZATRON

Contents

General description	92
Snoozatron cutaway	94

General description

t's three o'clock in the morning and Wallace just can't get to sleep – what can he do? Well, perhaps this is the perfect chance to try out his new Snoozatron invention: a fully featured sleep-inducing machine with guaranteed results.

Wallace activates the system by pulling a single large lever on the control box next to his bed. This sets off the Snoozatron alarm and flashing alert in Gromit's bedroom, which wakes him up so that he can go downstairs and get changed. With the exception of Gromit's role (see below), the rest of the system is completely automated and follows a pre-set program of operation.

Automatic tucking-in devices, which are mounted on articulated arms and powered by electric motors, extend through hatches in the floor on either side of Wallace's bed to tuck in the bed sheets. At the same time, motorised plumpers, mounted on hydraulic rams, descend through hatches in the ceiling, and plump Wallace's pillow from either side.

Now that the bed has been made more comfortable, a self-heating hotwater bottle and emergency teddy bear are deployed by extendable arms, again through the ceiling hatches, while a gramophone slides out on rails through a hatch in the wall to play a well-chosen selection of soothing lullabies.

With Wallace now feeling sleepy at last, Gromit is downstairs and ready for action wearing his sheep costume. From the dining room below, he is launched by the auto-return sheep-counting spring straight up and through a hatch in Wallace's bedroom floor. Wallace counts each time he sees Gromit appear at the foot of the bed, but as he eventually drifts off to sleep the counting is continued by an automatic sheep counting device attached to the top of the Snoozatron control box.

In the unlikely event that Wallace does not fall asleep then he can pull the lever to activate the Snoozatron a second time. Again the automatic tucking-in arms, pillow-plumpers and gramophone operate, and they can be activated repeatedly until sleep eventually comes. However, so far repeated activation of the system has not been necessary.

The only apparent drawback to using the Snoozatron is that Gromit must be woken up for it to operate.

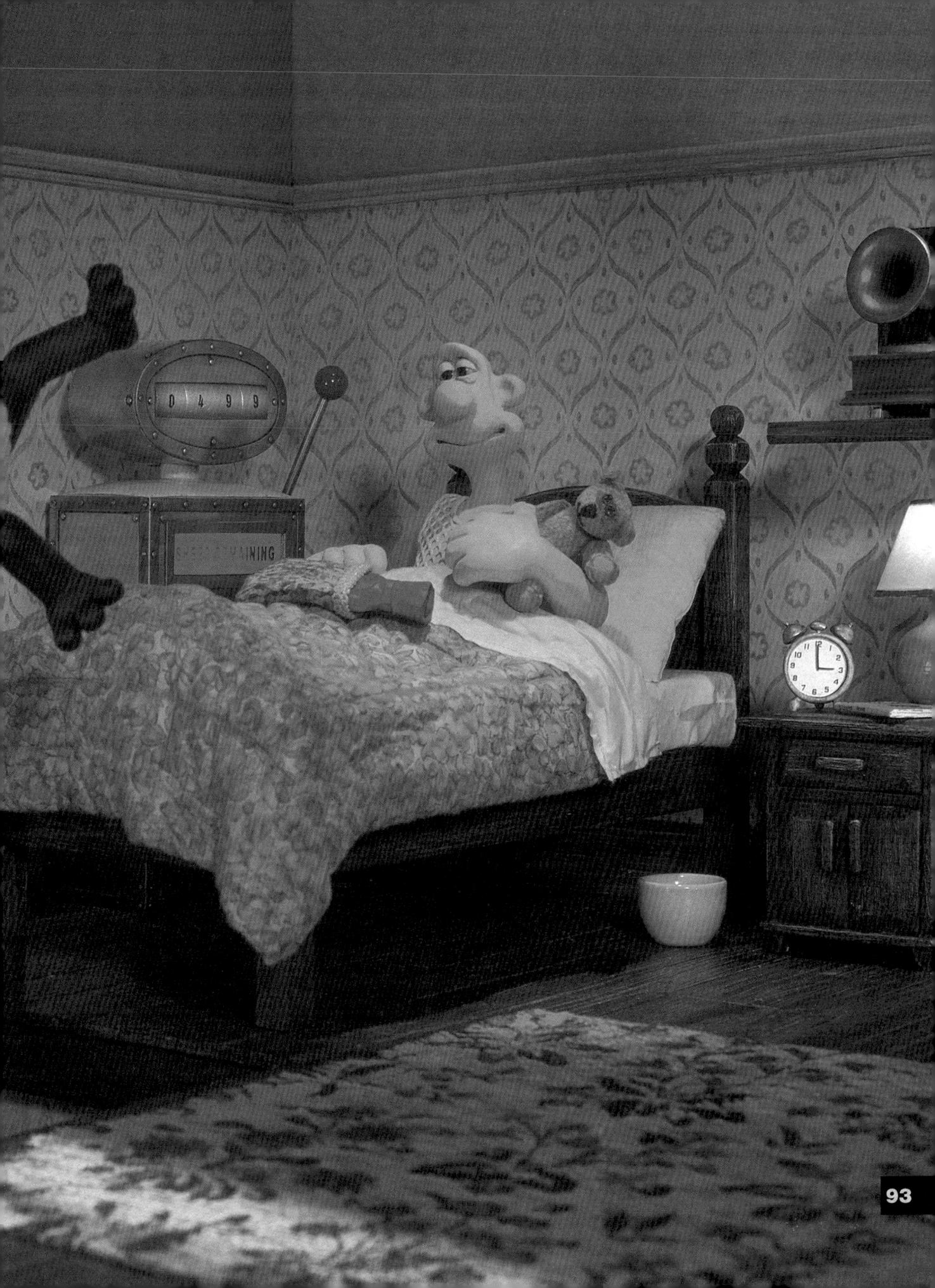

Snoozatron cutaway

- Snoozatron start lever
- 2 Light-up auto display
- Sheep counter
- Cables linked to Gromit's bedroom alarm and electricity ring main
- Primary electric motor and master control circuits
- 6 System wiring junction box
- Floor of loft
- Pillow plumping telescopic arm
- 9 Hot water bottle deployment arm
- Pillow plumper control arm

- 1 Control arm hydraulic ram
- Return spring
- (B) Hydraulic control unit
- Padded pillow plumper
- (B) Electric pillow plumping motor
- © Emergency teddy deployment arm mechanism
- The Emergency teddy deployment arm
- ® Emergency teddy
- (1) Gramophone
- @ Gramophone speaker
- 4 Lullaby record

- @ Gramophone deployment rail
- Bedside lamp
- Alarm clock
- 4 Left-hand tucking-in device
- Tucking-in device arm control electric motor
- Tloor hatch electric motor
- Auto-return sheep-counting spring used by Gromit when on Snoozatron duty (sheep costume not shown)
- Self-heating hot-water bottle
- Favourite slippers

Sheep counting continues automatically after Wallace falls asleep

PROJECT NAME Snoozatron

PURPOSE Automated, multi-function sleep-inducing system

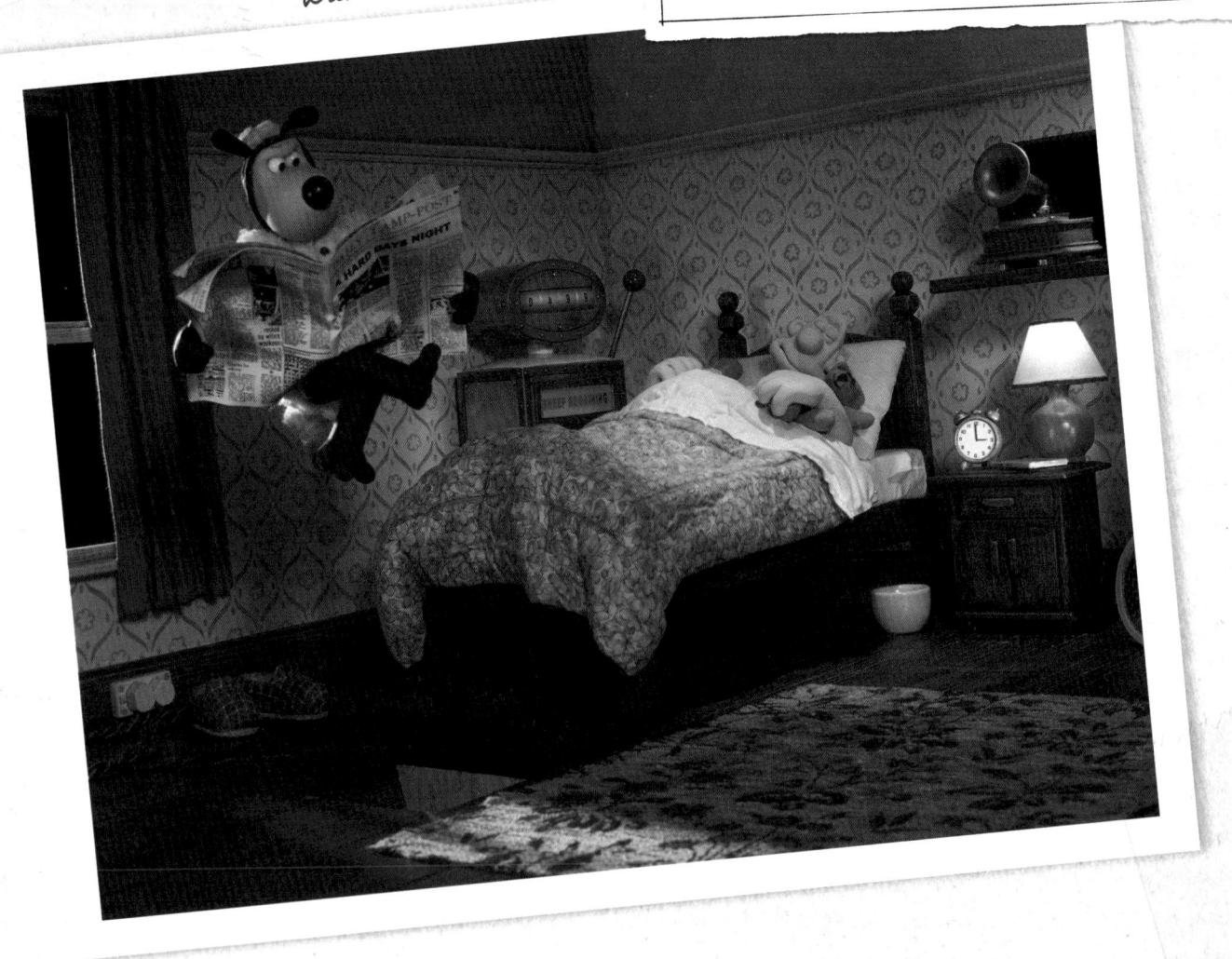

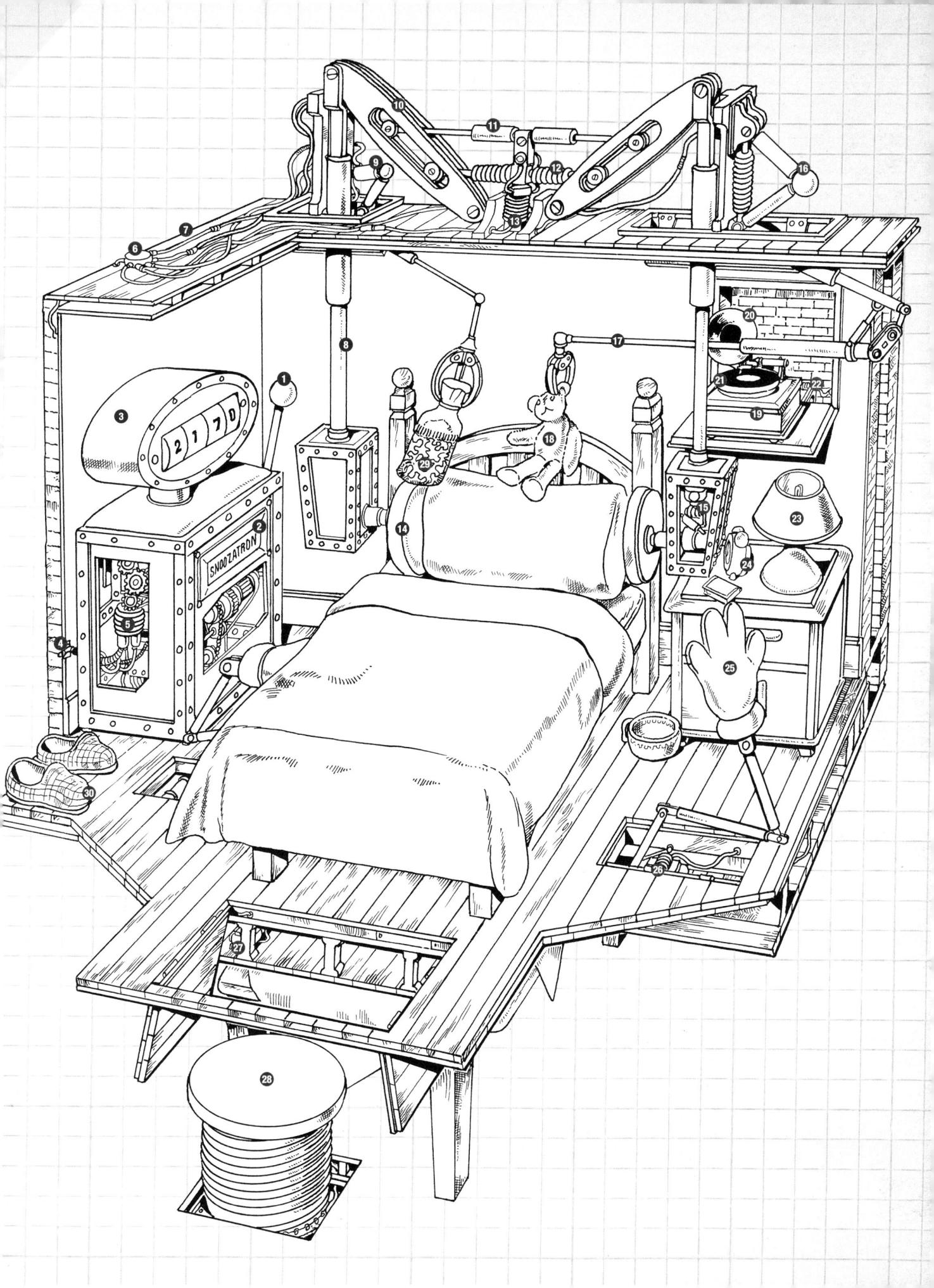

SOCCAMATIC

Contents

General description	96
Soccamatic cutaway	

too much wasted space. We thought it needed more explaining

General description

When Wallace and Gromit's weekly 'beat the goalie' football shoot-outs at the local park prove to be a little too energetic (and unsuccessful) for Wallace, he invents a true labour-saving contraption in an effort to up his game.

The Soccamatic is a fully automated, motor-driven penalty-kicking machine. Once manoeuvred into position, it can launch footballs at the goal with great speed, incredible accuracy and alarming frequency.

Several footballs are stored in the primary storage tube and are ready for immediate launch via the deployment chute. A hydraulically operated pumpaction mechanism ejects the balls one at a time from the bottom of the primary storage tube and down the deployment chute to four football boots mounted on a rotor. The rotor is synchronised with the pump-action mechanism, so as each ball exits the deployment chute it is kicked by one of the four boots. The rotor turns and the next ball is kicked by the next boot, and so on. The speed of delivery can be varied with no loss of accuracy, and the whole system is driven by a 400cc, two-cylinder petrol engine via a series of chains and associated gearing.

Once the balls in the primary storage tube are depleted, a secondary system can be brought into play. Five high-mounted storage cylinders rotate on a shaft, which is driven by an electric stepper motor. As the cylinders rotate around the shaft, they deliver further footballs to the primary storage tube via a capture bowl. Balls are delivered two at a time from each cylinder in turn as the mechanism rotates. This ensures consistent deployment even at high operating speeds. The height and angle of the secondary storage cylinders are adjustable and can be controlled by the operator, who also has control of ball-launch speed and trajectory as well as overall movement of the Soccamatic around the pitch.

The whole machine is mounted on four wheels, the rear two of which are driven by the engine. The front wheels are steerable, allowing the Soccamatic to be moved into the desired position.

A padded seat is provided for the operator, who can control the machine while watching the action in comfort.

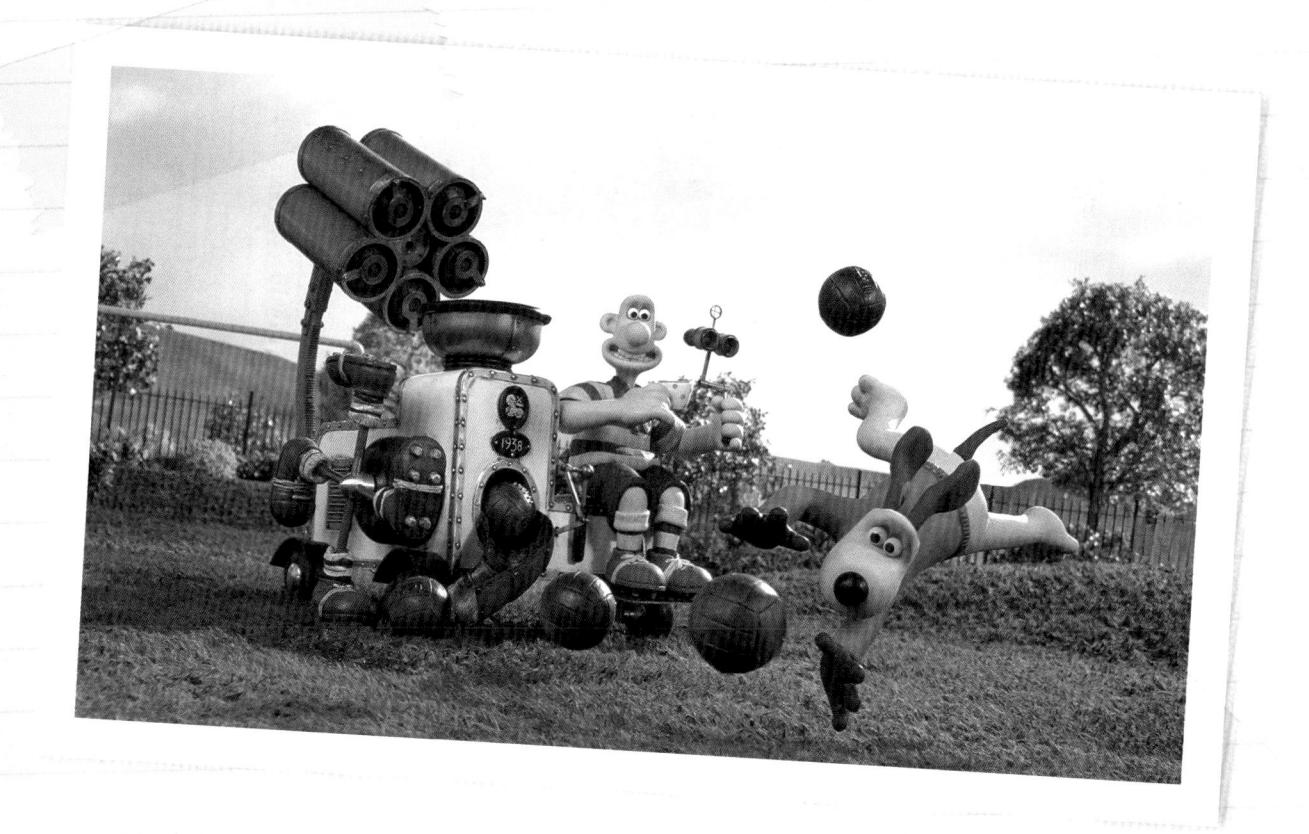

The Soccamatic cutaway

- ① Rotating football boot launch rotor.
- ② Launch rotor gearing.
- 3 Launch rotor chain drive.
- Chain drive and gear housing.
- ⑤ 400cc two-cylinder engine.
- 6 Fuel tank.
- ne Engine cooling fan.
- ® Football deployment chute.
- @ Football deployment spring.
- ⑤ Football deployment pump action mechanism (synchronised to launch system).
- ① Pump action mechanism hydraulics.
- ® Primary football storage tube.
- Secondary football storage cylinders.
- Storage cylinder rotation shaft.

- © Cylinder rotation electric motor.
- © Football stop, geared to cylinder rotation to ensure balls are deployed quickly and evenly.
- ③ Football capture bowl.
- Storage cylinder adjustable height support.
- Storage cylinder height support gearing.
- Multi-function control lever.
- (a) Control lever linkage.
- @ Operator's seat.
- Footplate.

PROJECT NAME	Motorised 'beat the goalie' football-kicking machine
	the second secon

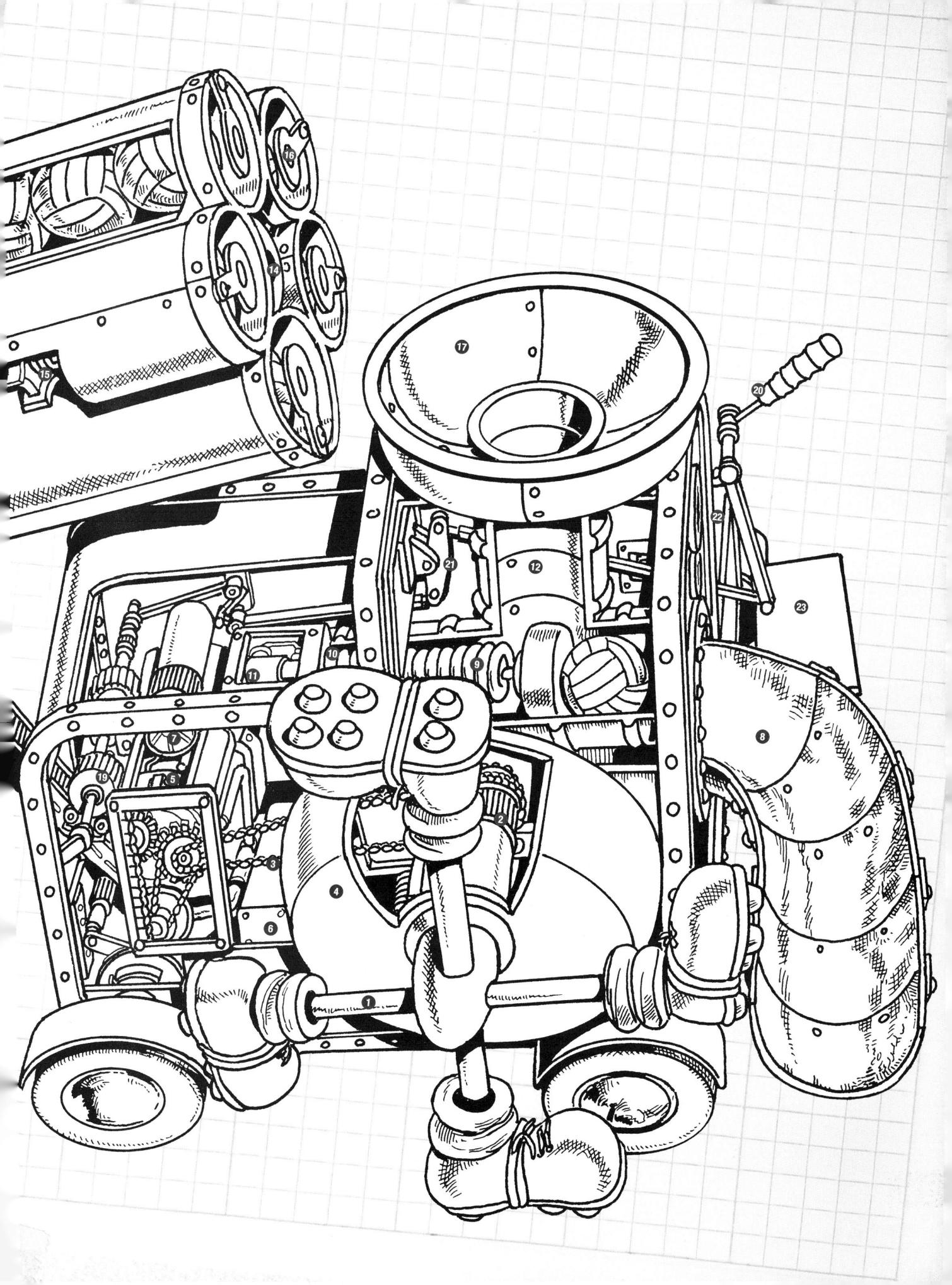

SNOWMANOTRON

Contents

General description	100
Snowmanotron cutaway	102

General description

It's time for the annual Grand Snowman Competition and Gromit is sculpting a fine snow statue of Wallace in 'The Thinker' pose. Meanwhile, Wallace is determined to take first prize using his new Snowmanotron invention.

As the machine is driven forward, the large front scoop fills with snow. This is then lifted up by hydraulics and loaded into a collection bowl on top of the machine behind the operator. The handbrake is applied and the machine is activated by a stop/start button on the dashboard. The articulated topside snow ram arm compacts the snow in the collection bowl and pushes it down into the snowman-making compartment, which is a heavily modified 'Smug' refrigerator. Once inside, the snow is compressed further by the topside snow ram.

Two further mechanical arms, one mounted on each side of the machine, enter the snowman-making compartment. The hands on the arms are fitted with highly articulated finger actuators, which are covered with woolly gloves to give an authentic finish.

When sculpting is complete, the operator pulls the 'eject' lever, which releases the door of the fridge and lowers the snowman deployment ramp

at the rear of the machine. Finally, the completed snowman is pushed out of the fridge and down the ramp by an ejection spring and pad.

The Snowmanotron is powered by a two-cylinder four-stroke petrol engine of 648cc capacity. The engine is enclosed in a compartment located below the main snowman-making apparatus and is cooled by air forced over it by a fan, which is also driven by the engine. The air-cooled engine is light and compact if a little noisy, and drives the axle between the two rear wheels of the Snowmanotron via a chain. A second pair of wheels are positioned forward of the rear wheels but are not driven, being purely loadbearing. A single wheel at the front of the machine provides steering and additional stability.

A main battery powers the electric motor for the refrigerated snowman-making compartment, as well as the snow ram and sculpting arms, hydraulics and all electrical systems. The battery is charged by a generator, which is driven by a toothed belt from the engine.

The cockpit of the Snowmanotron is open and so operators are advised to wear suitable cold-weather clothing.

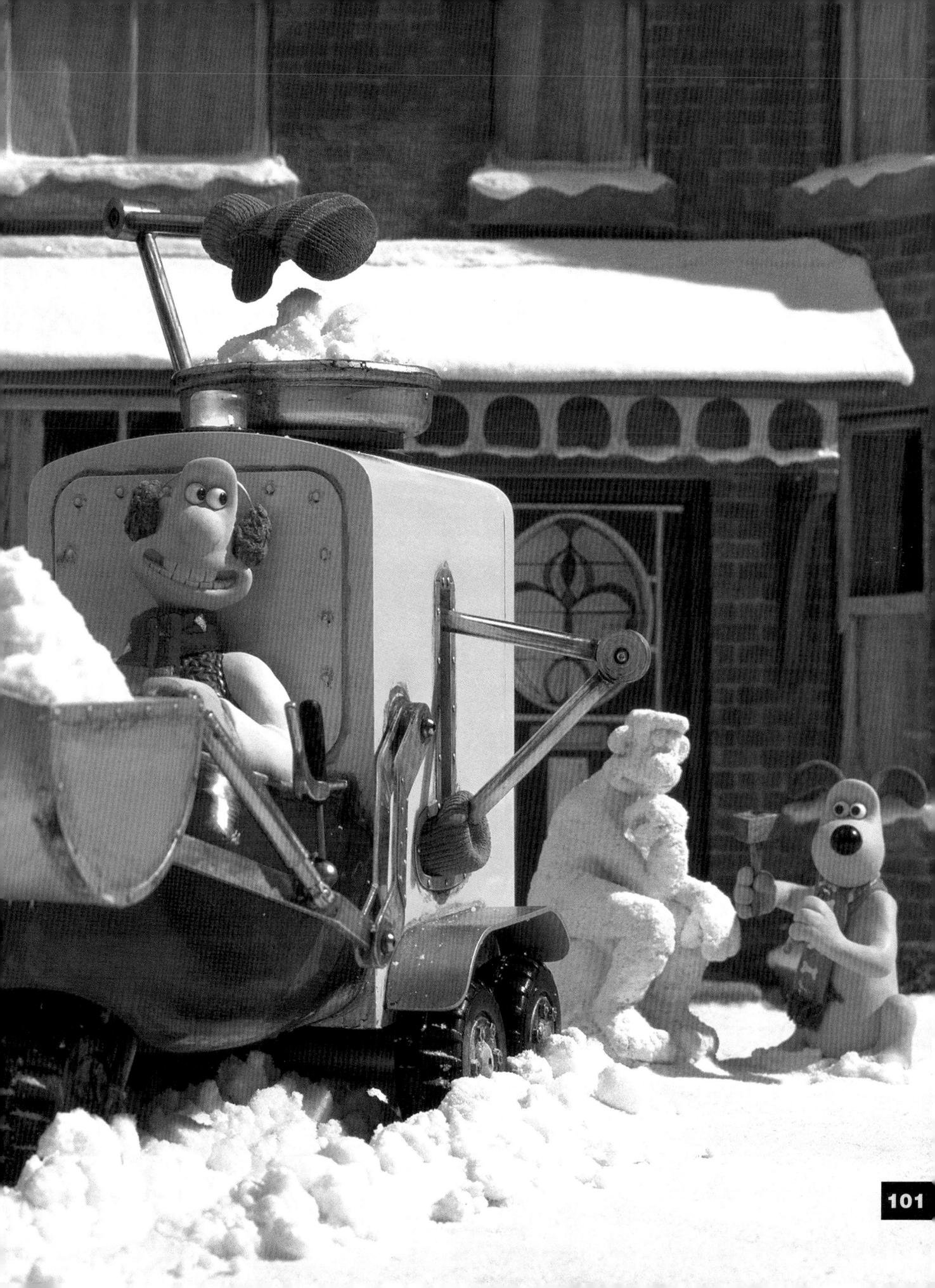

Snowmanotron cutaway

- Snow scoop/loader bucket
- Scoop lifting ram
- Scoop support beam
- 4 Left-hand loader bucket hydraulic lift
- 6 Hydraulic lift ram
- 6 Handbrake
- Topside snow ram start/stop button
- 8 Finished snowman eject lever
- Temperature gauge
- Speedometer
- 1 Dashboard electrics
- Topside snow ram pushes snow into fridge compartment for processing
- Finger actuators beneath outer glove ensure sculptural finesse
- Snow compression and sculpting arms
- Snow collection and first-stage compression chamber
- Customised and adapted 'Smug' fridge
- Fridge compartment keeps snow cool during sculpting
- Expansion chamber
- © Evaporator coils
- Refrigerant gas under pressure in condenser coils
- Metal vanes
- Pridge maintenance access cover
- Fridge door handle
- Pridge door seal
- Flashing warning light
- Heavy-duty temperature control curtain
- Sculpting arm electronic control processors
- 8 Fridge electric motor
- Fridge ventilation grille
- Capillary tube
- 1 Engine cooling air fan
- 2 650cc twin-cylinder two-stroke engine
- Chain drive to rear axle
- Coil ignition for each cylinder
- Finished snowman ejection mechanism
- Snowman ejection ramp (shown in raised position)

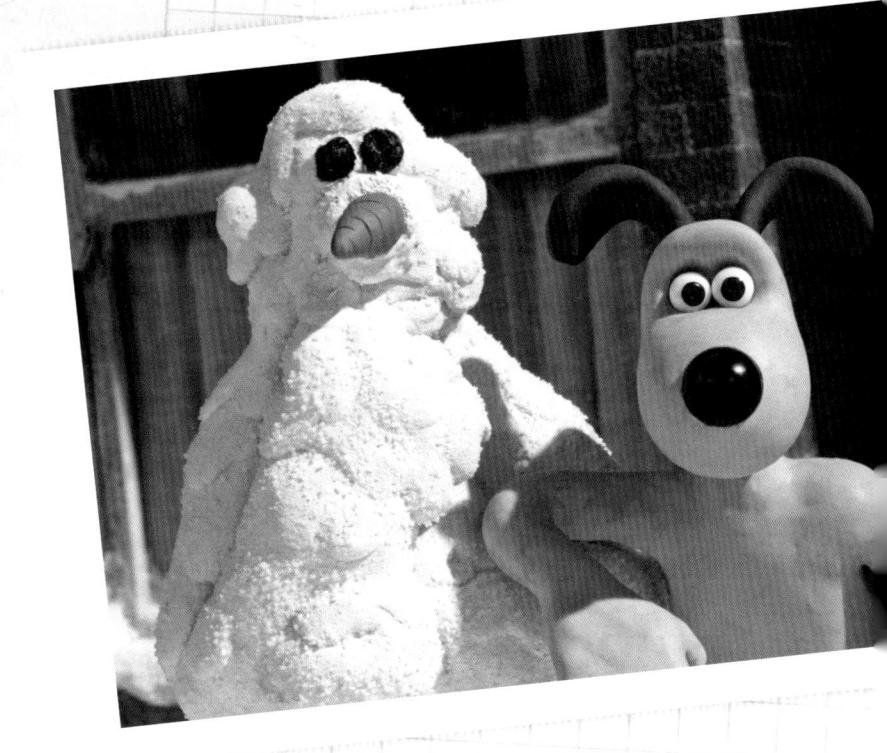

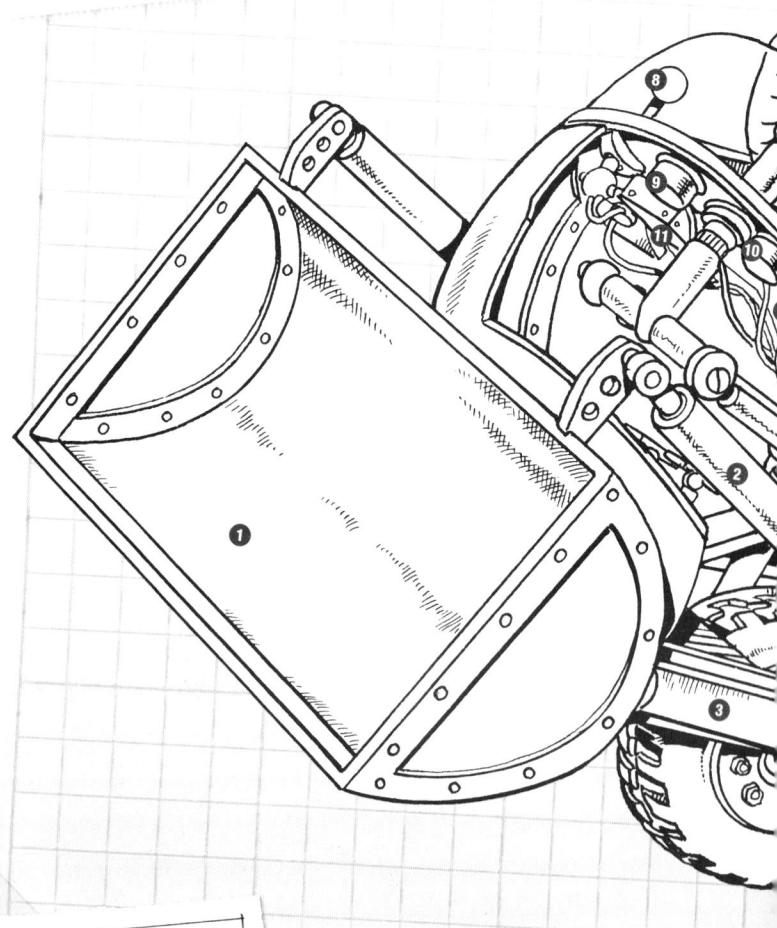

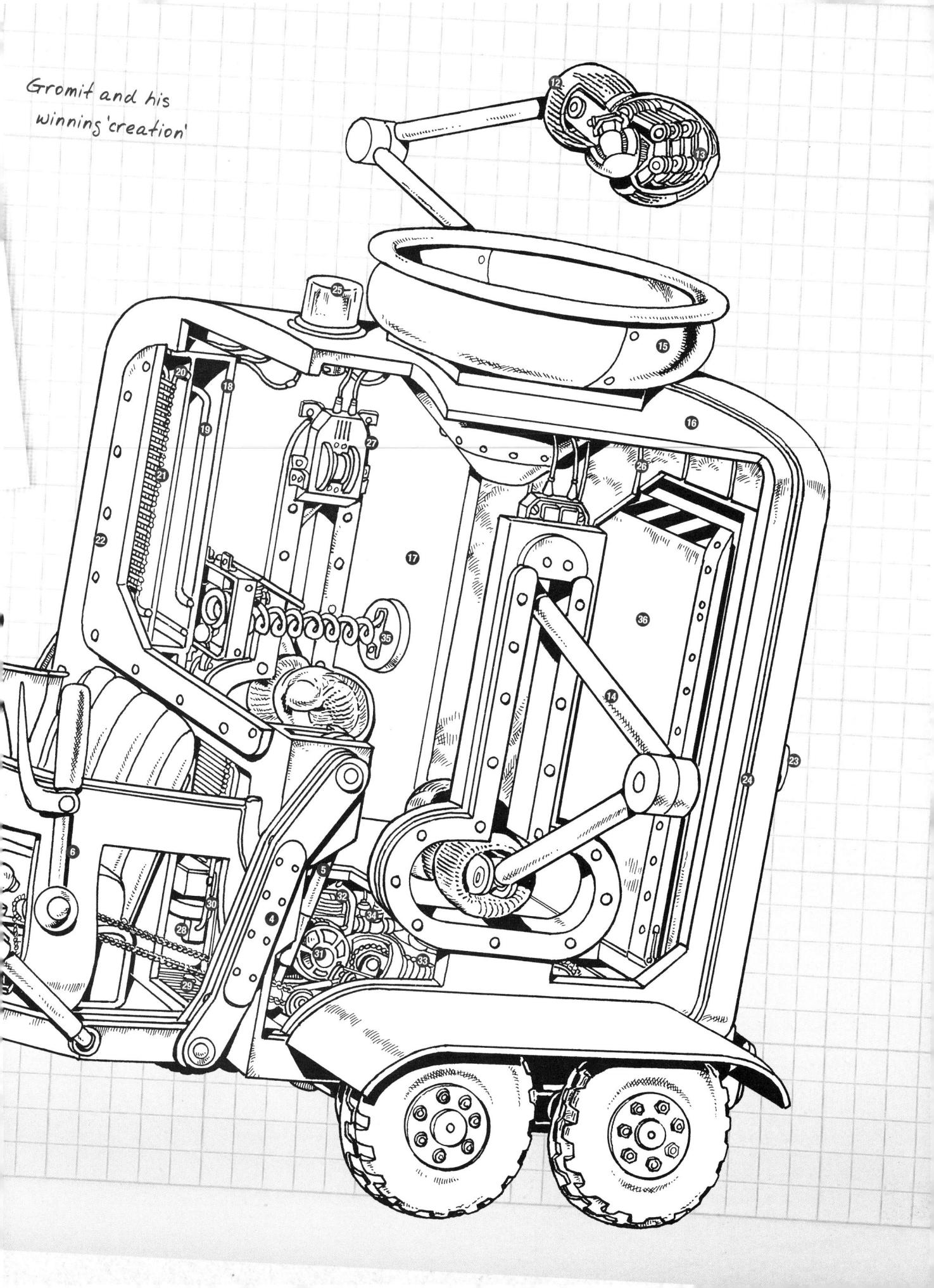

TELLYSCOPE

Contents

General description	104
Tellyscope cutaway	106

General description

When Wallace wants to change television channels, he doesn't need to bother with the remote control when he can use his new 'Tellyscope' contraption instead.

At the touch of a button, a flap opens in the arm of the chair and up springs a gloved catapult, which Wallace loads with a tennis ball. The catapult is then pulled back and released, sending the ball flying across the lounge and through a hole in a picture on the wall above the television. Once it has passed through the hole in the wall, the ball bounces off a target pad and rolls down a straight chute, and then down a helical chute, at the end of which is another straight chute.

The ball drops from the end of the second straight chute and lands in a bucket, one of several mounted on a vertical carousel, which is turned by a motor and assisted by a counterweight. When the carousel has rotated through 180 degrees, a boot on the end of a lever kicks the ball from the bucket and into a retrieval bowl. A final chute carries the ball from the retrieval bowl down to a gloved lever, which finally activates the Tellyscope positioning beams.

The positioning beams are toothed and driven through a series of gears by an electric motor. The beams pass through holes in the wall into the lounge on the other side where they are fixed to the rear of the television, which is pushed out into the room on wheels. The otherwisestandard television is fitted with a telescopic rear casing, which shrouds the positioning beams as they extend from the wall and push the television towards the operator. An extra-long power cord ensures that the plug is not pulled from its socket as the Tellyscope extends.

With the television now within easy reach, Wallace is able to change channel or adjust the volume as required. Finally, the mechanism is reversed automatically and the Tellyscope retracts, returning the television to its usual position against the lounge wall.

The Tellyscope's only shortcoming seems to be its need for a ready supply of tennis balls, as Wallace discovers when a channel-changing emergency develops and he attempts to activate the system by catapulting the television's usual remote control instead.

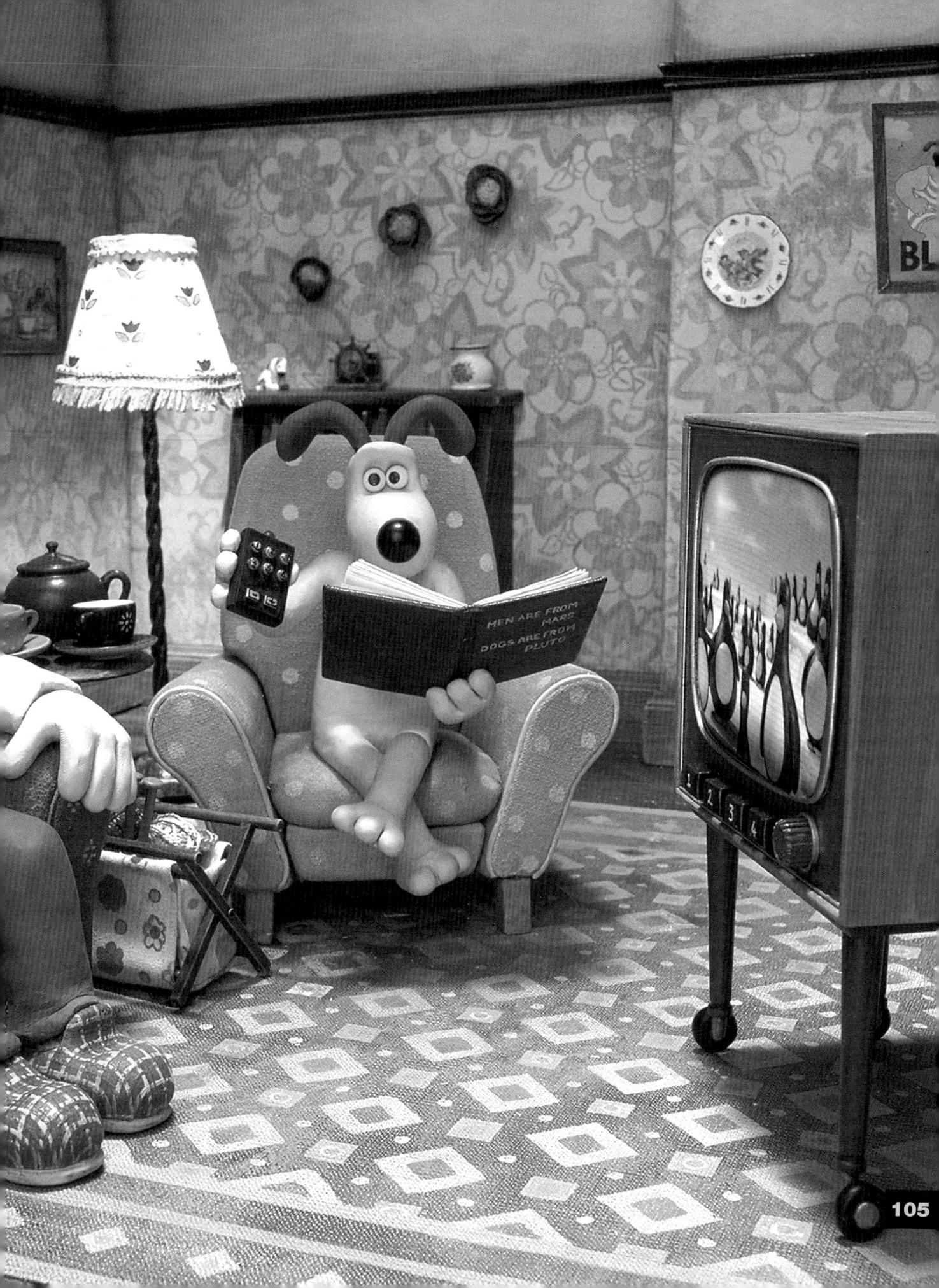

Tellyscope cutaway

- Wallace's armchair
- @ Gromit's armchair
- Spring-loaded catapult
- Telescopic television 'Tellyscope'
- Extra-long power cord
- 6 Tellyscope positioning beams
- Positioning beams activation level
- 8 Positioning beam gearing
- Gearing for carousel and boot
- Carousel counterweight
- Carousel
- Retrieval bucket

Sequence of operation

- Tennis ball is catapulted from Wallace's armchair
- 2 The ball flies through the hole in the picture on the lounge wall
- 3 The ball bounces off the target ...
- 4 ... and down the chute ...
- ... where it lands in one of the buckets; the carousel rotates, assisted by the counterweight
- 6 The ball is kicked from the carousel bucket ...
- … into the retrieval bowl …
- 3 ... and down a second chute to ...
- ... the Tellyscope positioning beam activation lever
- The lever activates the motor and gearing which drive the positioning beams forward into the lounge
- The Tellyscope extends into the lounge, allowing Wallace to change channel from the comfort of his armchair

PROJECT NAME

television from armchair

PURPOSE

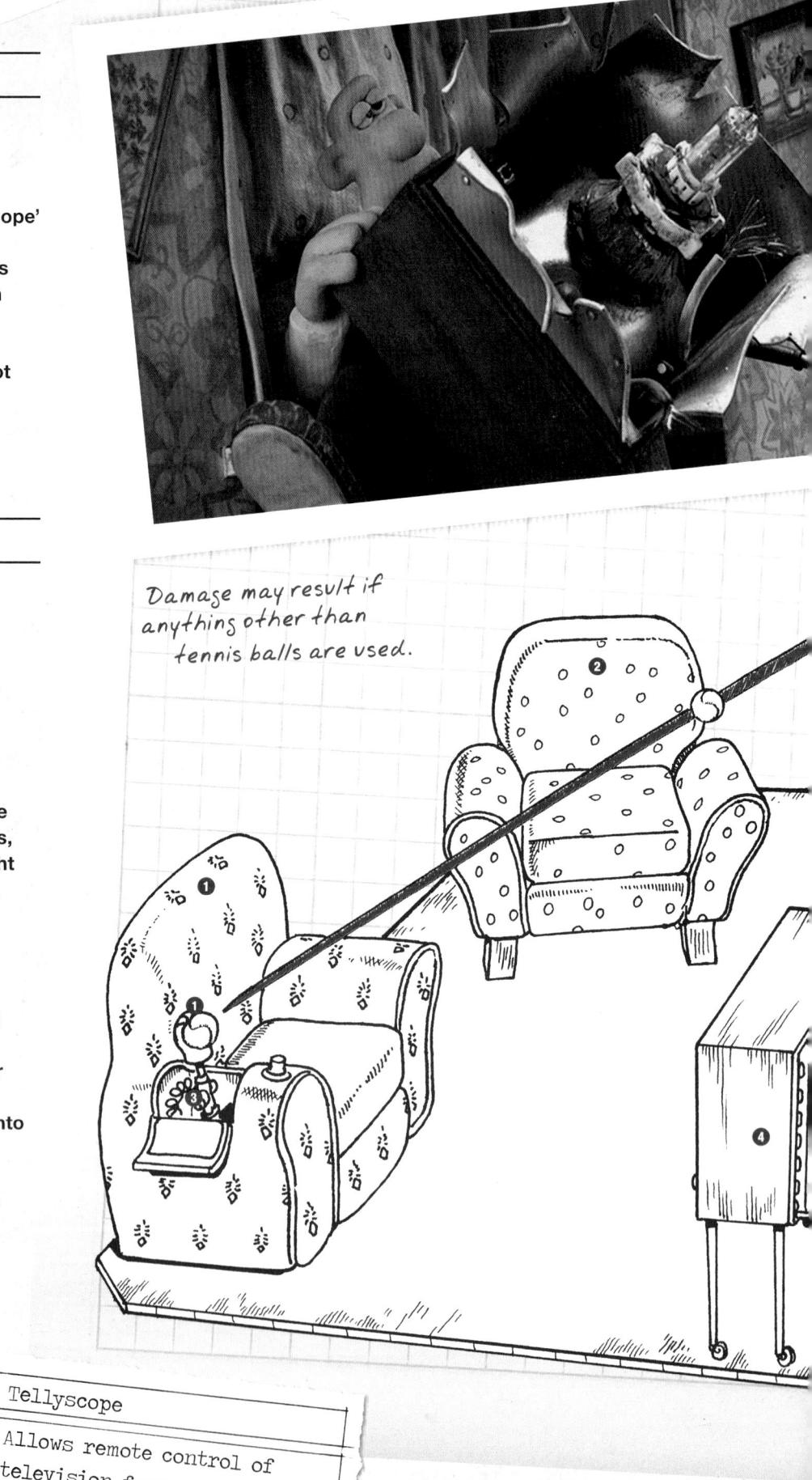

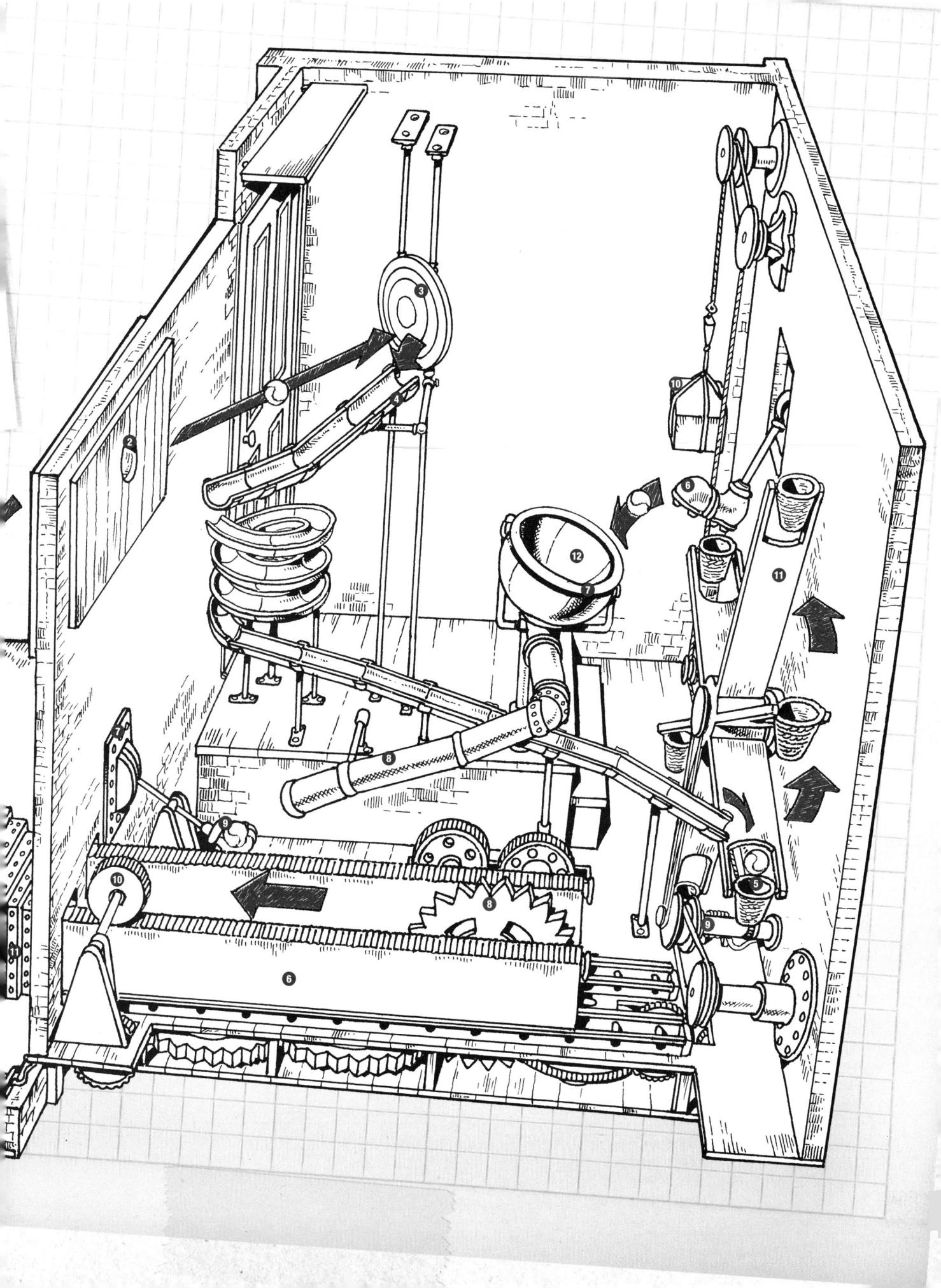

TURBO DINER

Contents

General description	
Turbo Diner cutaway	

General description

The Turbo Diner is a complete, automated dining system, designed to speed up the entire process of clearing and laying the table, cooking a full dinner and clearing up afterwards.

Before activating the device, it is necessary to insert coins into a dedicated electricity meter. This activates the Turbo Diner, and it only remains for diners to take a seat and relax while the machine does all the work. However, before the system activates, arm and leg clamps fitted to the chairs secure and immobilise diners both for their own safety and also to prevent them interfering with the food preparation process.

The Clutter Clearance System consists of a large rectangular hood, which is lowered through a hatch in the ceiling to a position just above the dining table. Clutter is sucked up by a large-diameter vacuum hose, * attached to the top of the hood, and removed to the kitchen for sorting. Once the table is clear, the Clutter Clearance System retracts into the ceiling cavity, and slides to one side on rails to allow the main part of the Turbo Diner to be lowered through the ceiling hatch.

A second hood is lowered on to the dining table. This contains all the mechanisms, crockery, cutlery and ingredients necessary to prepare and serve a full roast chicken dinner (or other pre-programmed meal). Since speed is of the utmost importance, all food is cooked using an integrated, high-power microwave unit. The food is removed from the microwave and positioned on the table by a system of automated serving arms, which also lay the table with plates, cutlery and condiments.

Finally, the finishing touch to any dining occasion, a candelabra is lowered on to the table and lit automatically by a gas-powered flame-thrower (needs attention).

If there is one drawback to the Turbo Diner then it is the vast amount of power it consumes during operation.

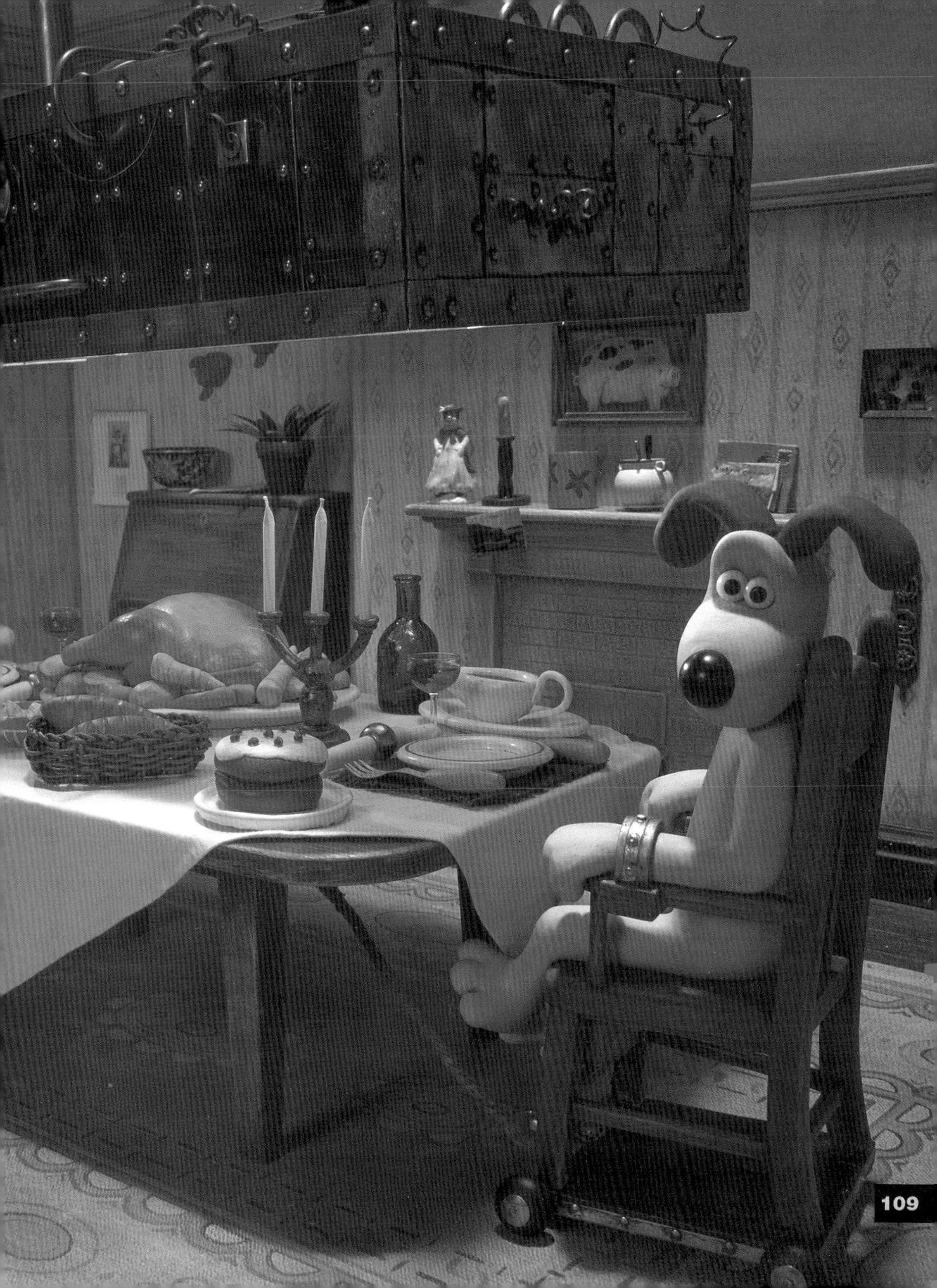

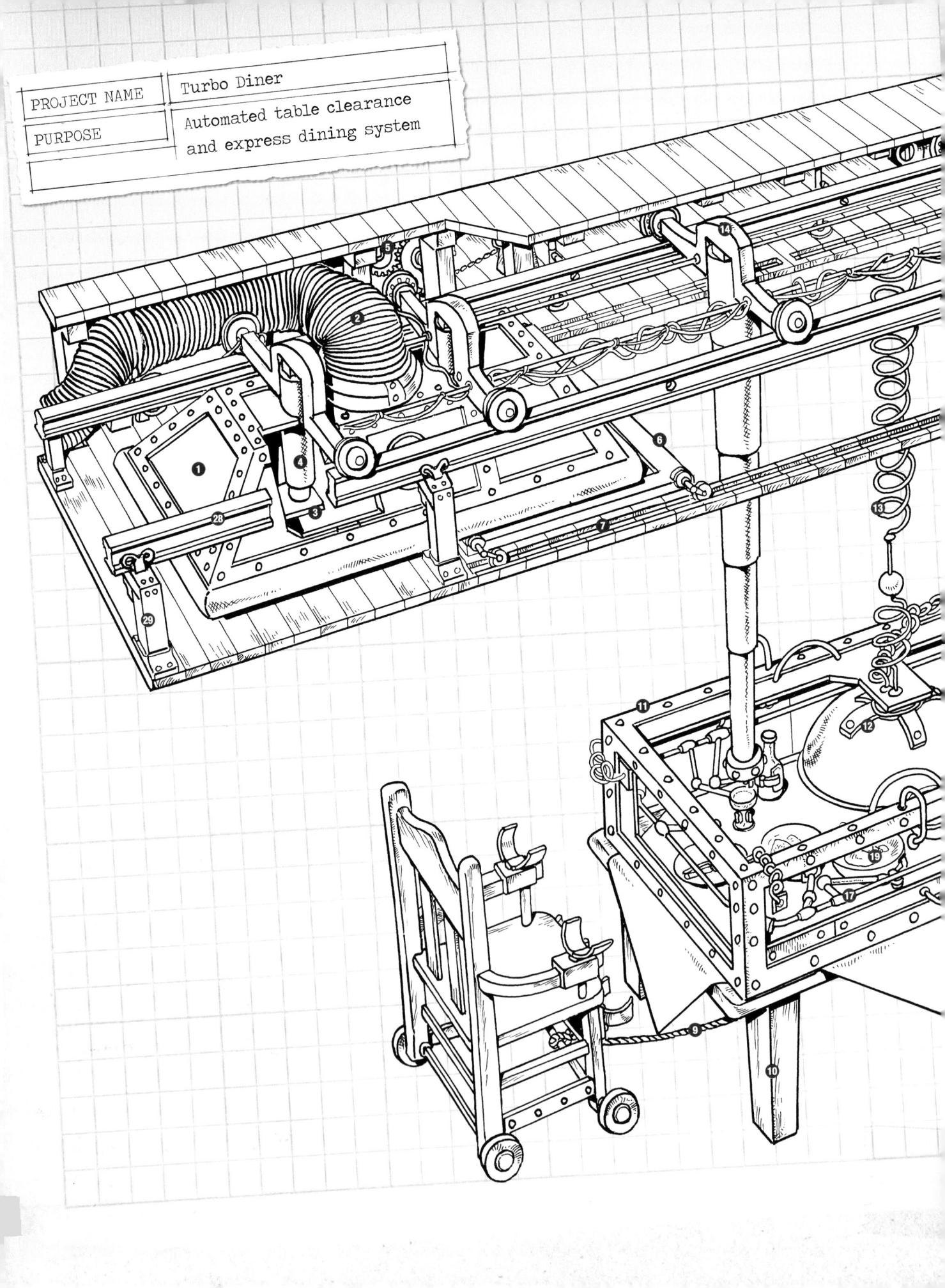

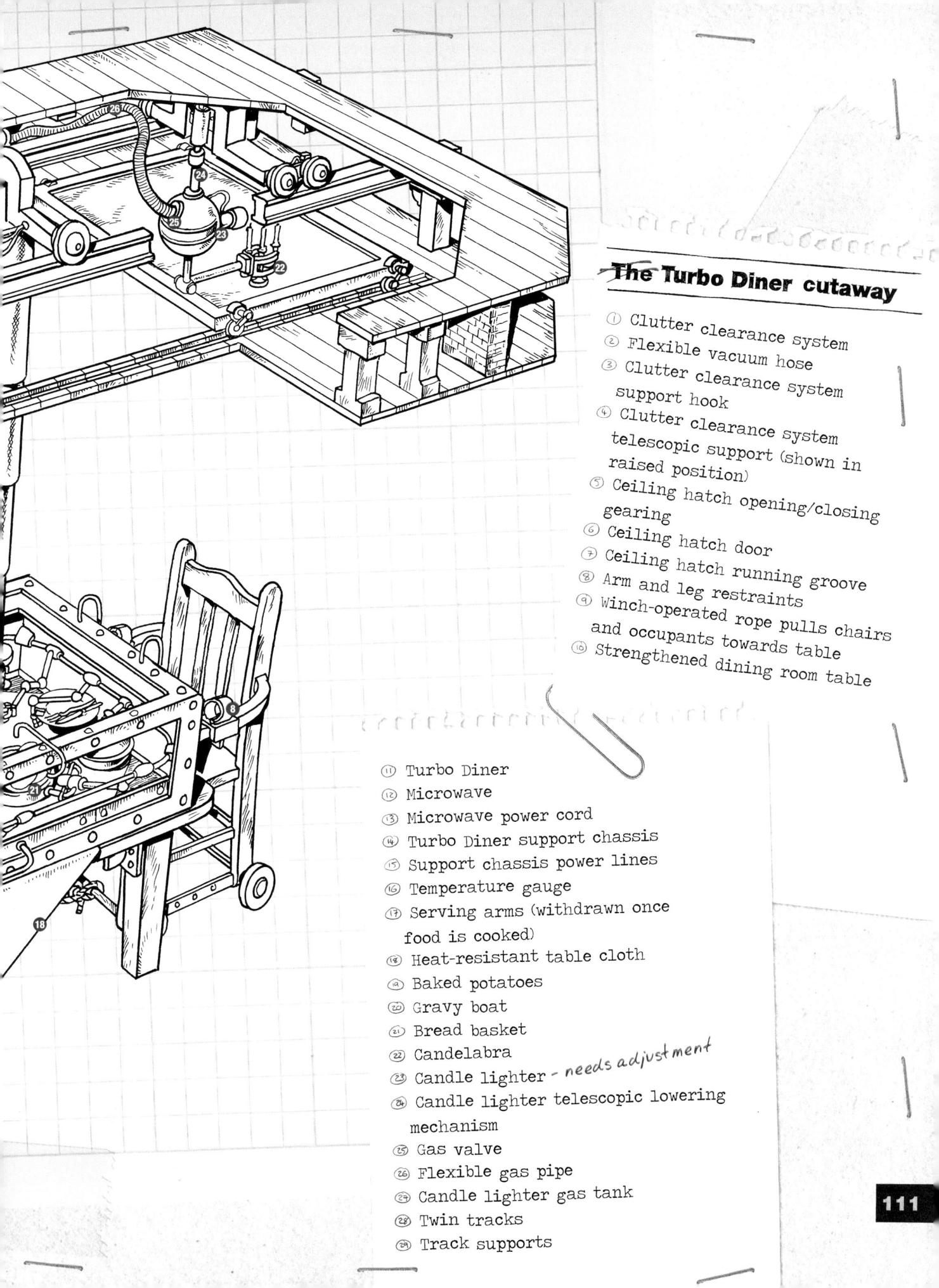

Wallace & Gromit

62 West Wallaby St, Up North, England

The Editor Haynes Publishing Ltd Sparkford Somerset BA22 7JJ

Dear Editor.

I'm so glad that everyone enjoyed the first book, and I have to agree it's an absolutely cracking idea to do a second one to show off a few more of my inventions. I'm sure readers who, like Gromit and me, enjoy a modern lifestyle will find plenty here to keep them occupied.

Once again your people have done us proud. Thank you. I've had a quick look through and, like last time, the text only needed the odd nip 'n' tuck here and there on every single page from 1 to % inclusively. The inside back cover was

This time, however, I haven't sent back the proofs. This is because, after fine, by the way! consulting with my constant canine companion, I've decided to try this publishing lark for myself. So you'll be delighted to know that everyone at Stains Manuals can now put their feet up and have a cuppa - because I've finished the book for you and printed it using my own new 'PRONTO PRINT' device

In fact, you are holding in your hands the very first copy, hot off the press! (patent pending)!

Not only can Drains Publishing now do away with all its editors, designers (Please allow to cool before reading.) and printers, but you can run off as many copies of the finished book as you need - at the push of a button! I've taken the liberty of including a drawing of my latest labour-saving device and a few notes on the next page.

So enjoy the book ... and thanks again!

Yours ever,

1/allow

Wallace

P.S. You can expect the first 50,000 copies sometime tomorrow afternoon. Will 3pm be ok - and is there parking for the van?

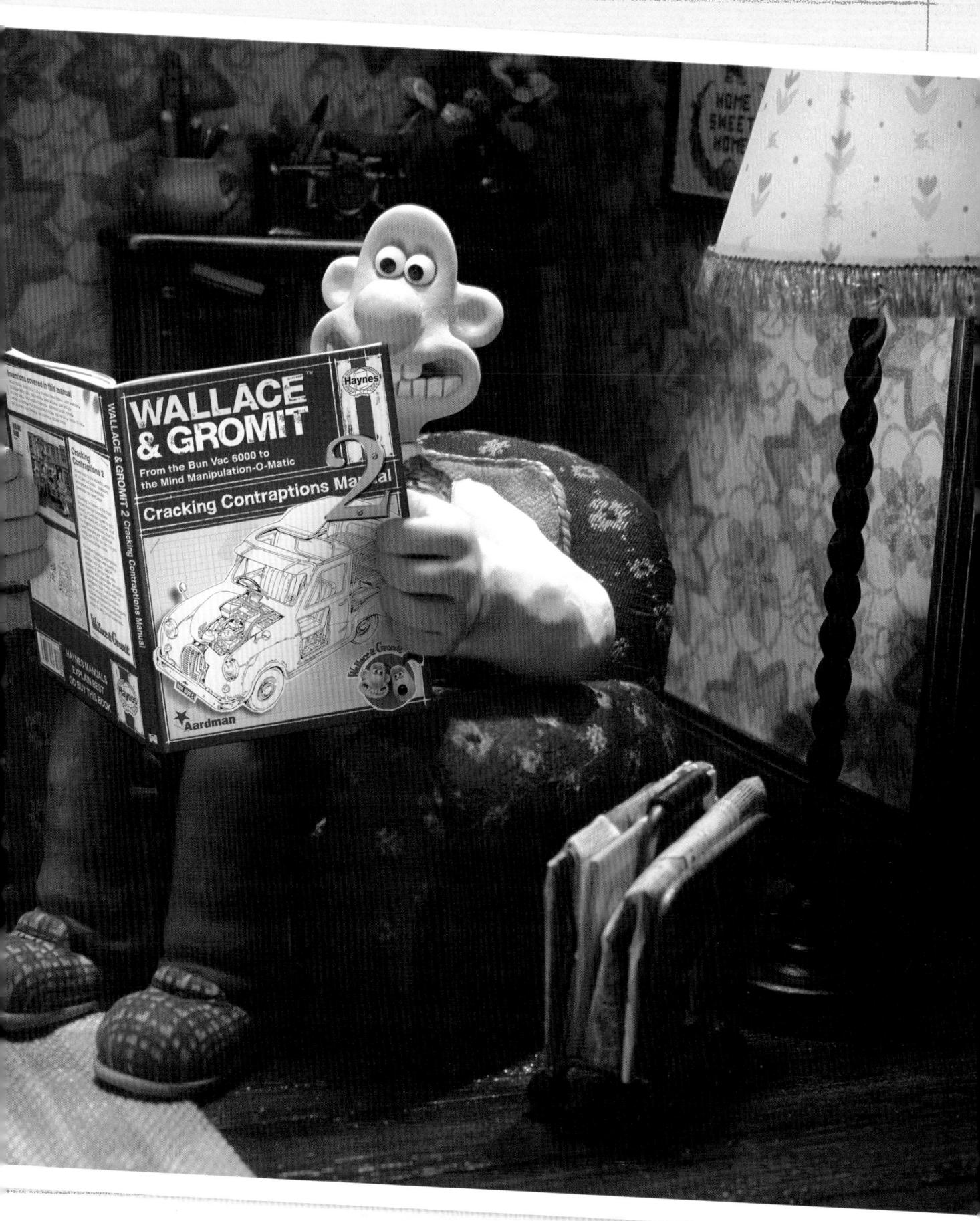

113 ×

Pronto Print

- 1 Editor's chair.
- 2 Manuscript holder.
- 1 Text input keyboard.
- Printed text, ready for conveying to process camera.
- 6 Editor's refreshments.
- Printed text is fed into process camera to finalise page layouts and add images.
- Flat-bed process camera adds photos and drawings to page layouts.
- Photo processing/enlarging/editing controls. Final page layouts are edited here.
- Oamera monitor screen.
- Photo and drawing insertion trays.
- 1 Process camera auto-focusing system.
- Paper reel.
- 1 Paper reel drum support frame.
- Paper reel drum carrying frame: an external crane (not shown) lifts the paper drum into position.
- 1 Paper feed controls.
- 16 Paper tension and speed control rollers.
- Four-colour printing ink containers (cyan, magenta, yellow and black).
- 1 Ink distribution valves.
- Gravure printing press enclosure.
- Ink supply dials.
- Ink regulator controls.
- 2 Ink drying heat chamber.
- Ink drying chamber cooling vent.
- 2 Printing ink heater controls.
- 3 Heat chamber temperature display.
- Paper and ink is cooled here before trimming and binding.
- @ Paper trimming guillotine (mind fingers!).
- @ Paper trimming conveyor and guillotine pad.
- @ Guillotine controls.
- 1 Chop counter.
- Over binding glue container and automated valve.
- Pre-printed card covers stacked in binding machine.
- 3 Cover binding placement grabs.
- Dages ready for binding.
- © Cover binding drum pages are stacked on the drum's upper angled edge while glue is applied.
- Drum swivels forward after each book is completed and bound, dropping the book down to the packing chute.
- Packing box for finished books, ready for dispatch.

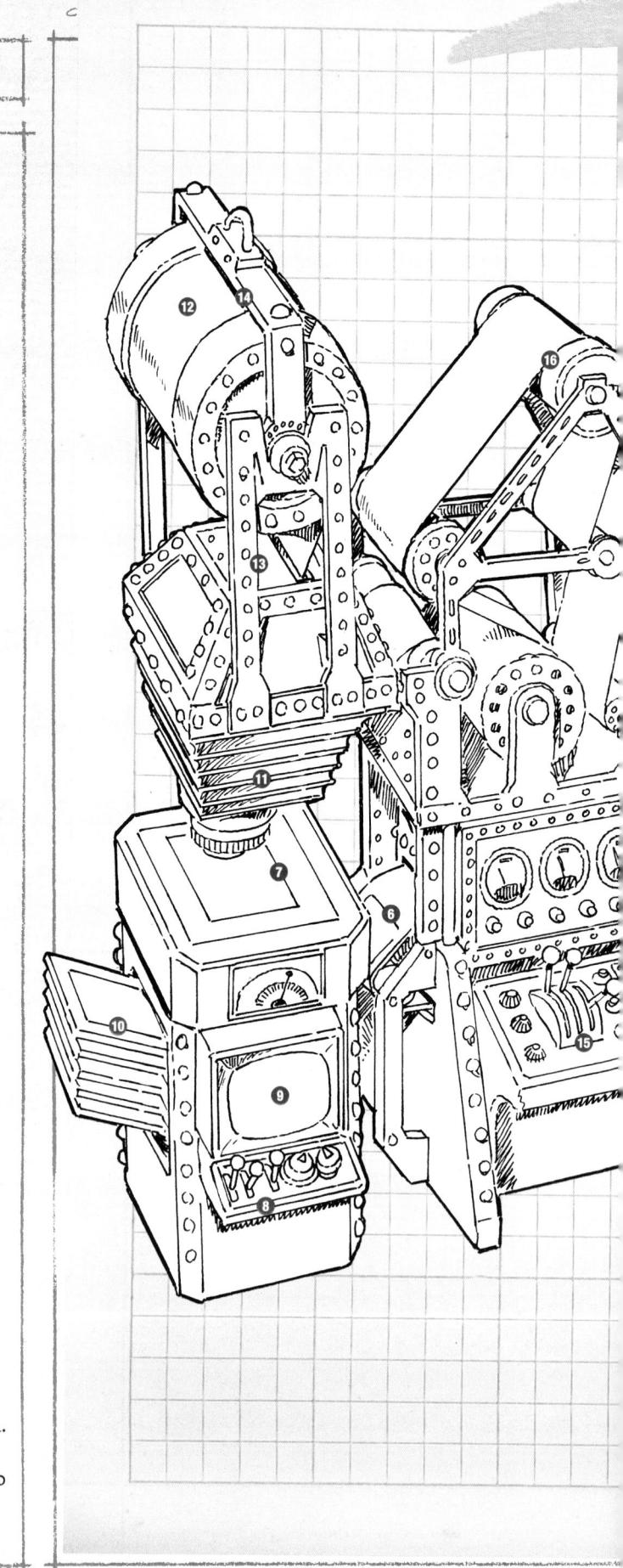

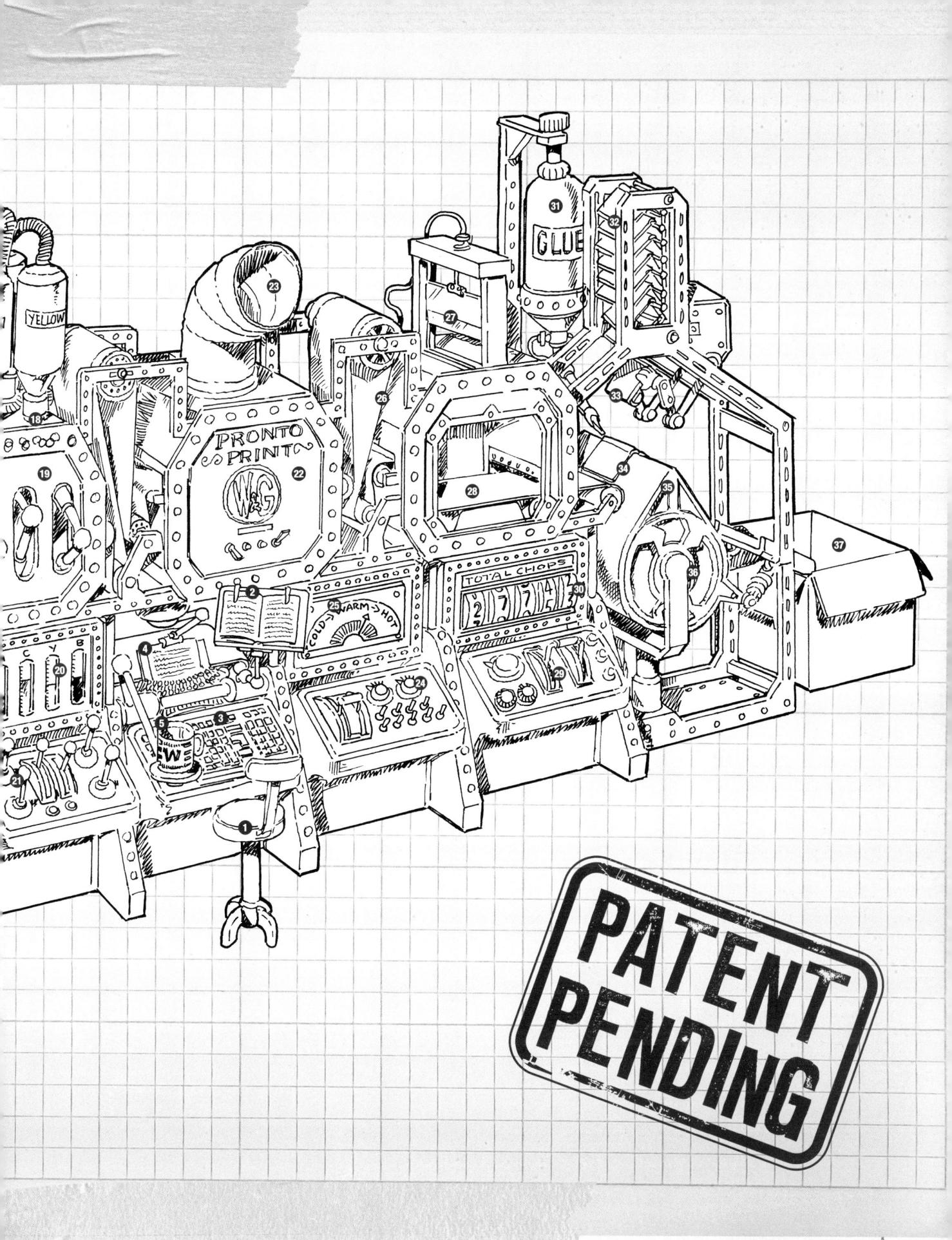

FO 115 X

SUB Contents

CONTENTS LIST

General description

Cellar Studio cutaway

General description

RODY COPY

hen Wallace is invited to host a new television programme about inventions, he decides that it would be handy to build the studio in the cellar of 62 West Wallaby Street so that he can demonstrate a few inventions of his own.

The centrepiece is Wallace's presenting workbench, and behind this is the 'World of Invention' main studio set backdrop, which features a rotating globe at its centre surrounded by a contrarotating series logo. The rotation of these is actuated by a series of large gears behind the backdrop, which are driven by an electric motor.

Studio lighting is suspended from an overhead rig, with additional lights mounted on tripods for ease of positioning. Three studio cameras are employed, which are mounted on dollies in order to follow Wallace around the studio as required. Each programme episode has a 'Curiosity Corner' section, which Wallace presents from an armchair (not shown).

Studio sound and vision mixing is performed by Gromit from a control desk positioned just off camera. Next to this is the programme editing and vision-mixing console, which enables Gromit to cue filmed reports of inventions from around the world. A cooker, grill and kettle are included as part of Gromit's control suite for the supply of tea and cakes during non-live sections of the programme.

On the other side of the studio is a second set backdrop. This conceals the 'Jumbo Generator' (see page 26 for full description), which provides a backup electricity supply in the event of a power cut as well as additional power on demand. Mounted in the centre of this backdrop is a television monitor used for the viewing of outside reports and archive footage. A mechanical hatch covers the screen and opens automatically to reveal it at the start of each film, closing again at the end.

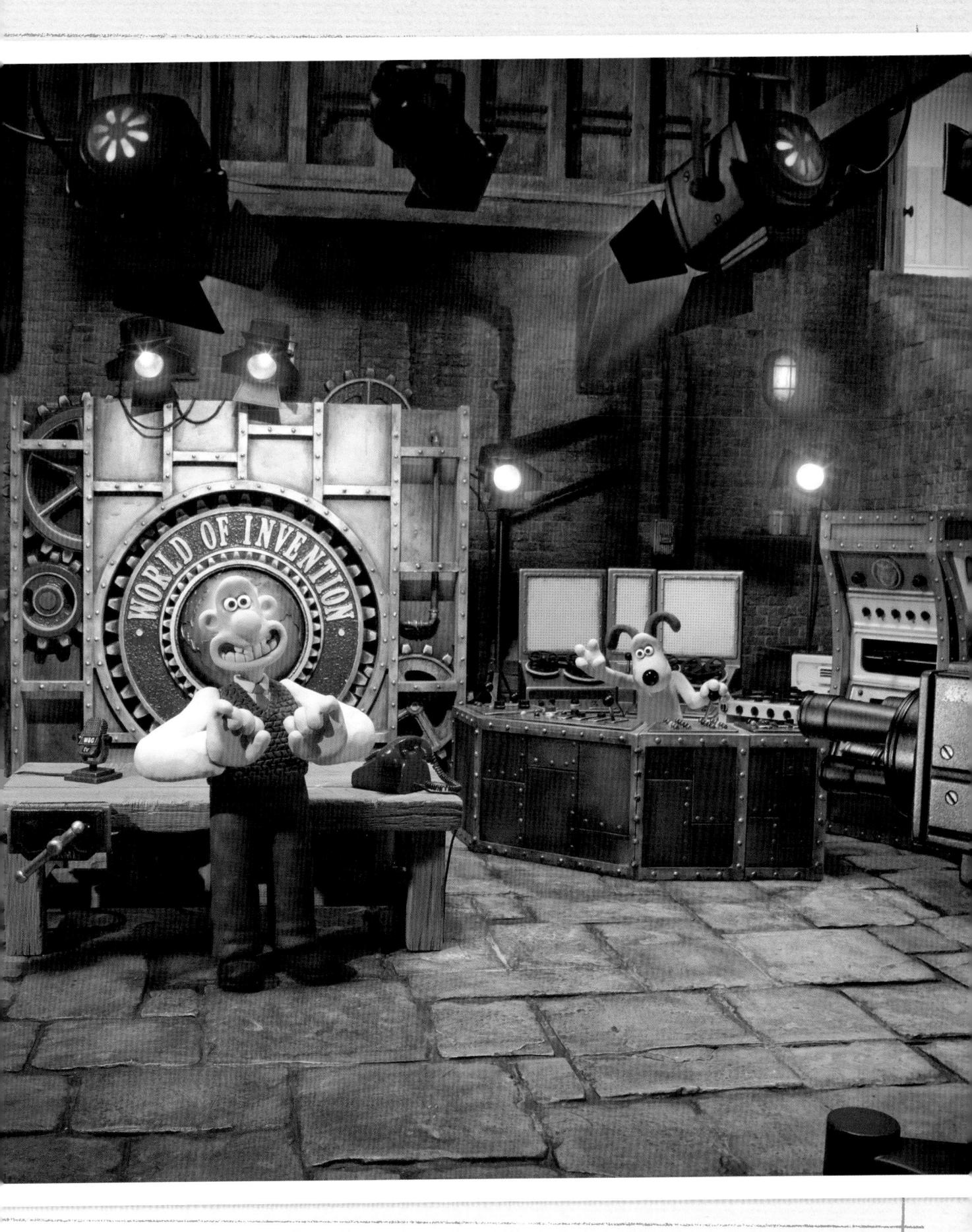

FOL 119 X

Cellar Studio

- BULET
- 1 Wallace's presenting chair.
- 2 Script.
- 3 Microphone.
- Telephone linked to outside broadcast units and hotline to programme commissioner.
- 5 Wallace's workbench.
- 6 Workbench vice, supplied by 'Miami'.
- 7 Rotating 'World of Invention' logo.
- Revolving globe.
- O Custom-built W&G TV automatic studio camera Mk-1.
- Telescopic and height-adjustable camera dolly.
- 1 Camera movement operating handles.
- 12 Rig-mounted standard studio light.
- 13 Rig-mounted multicolour light.

- 10 Spotlights used for studio backlighting.
- 15 Logo rotation gearing.
- 1 Studio backdrop.
- Tighting rig.
- 13 Studio sound and vision mixing control desk.
- 19 Remote camera controls.
- 20 Sound mixing control console.
- 3 Studio lighting controls.
- 22 Gromit's chair.
- 3 Studio monitor speakers.
- 2 Kettle.
- Cooker for snacks and in-studio cookery demonstrations.
- 26 Long-focus narrow-angle lens.
- 2 Short-focus wide-angle lens.
- 28 Medium/long focus lens.
- 29 Focusing dial.
- 1 Viewfinder.
- 3 Remote control antenna.

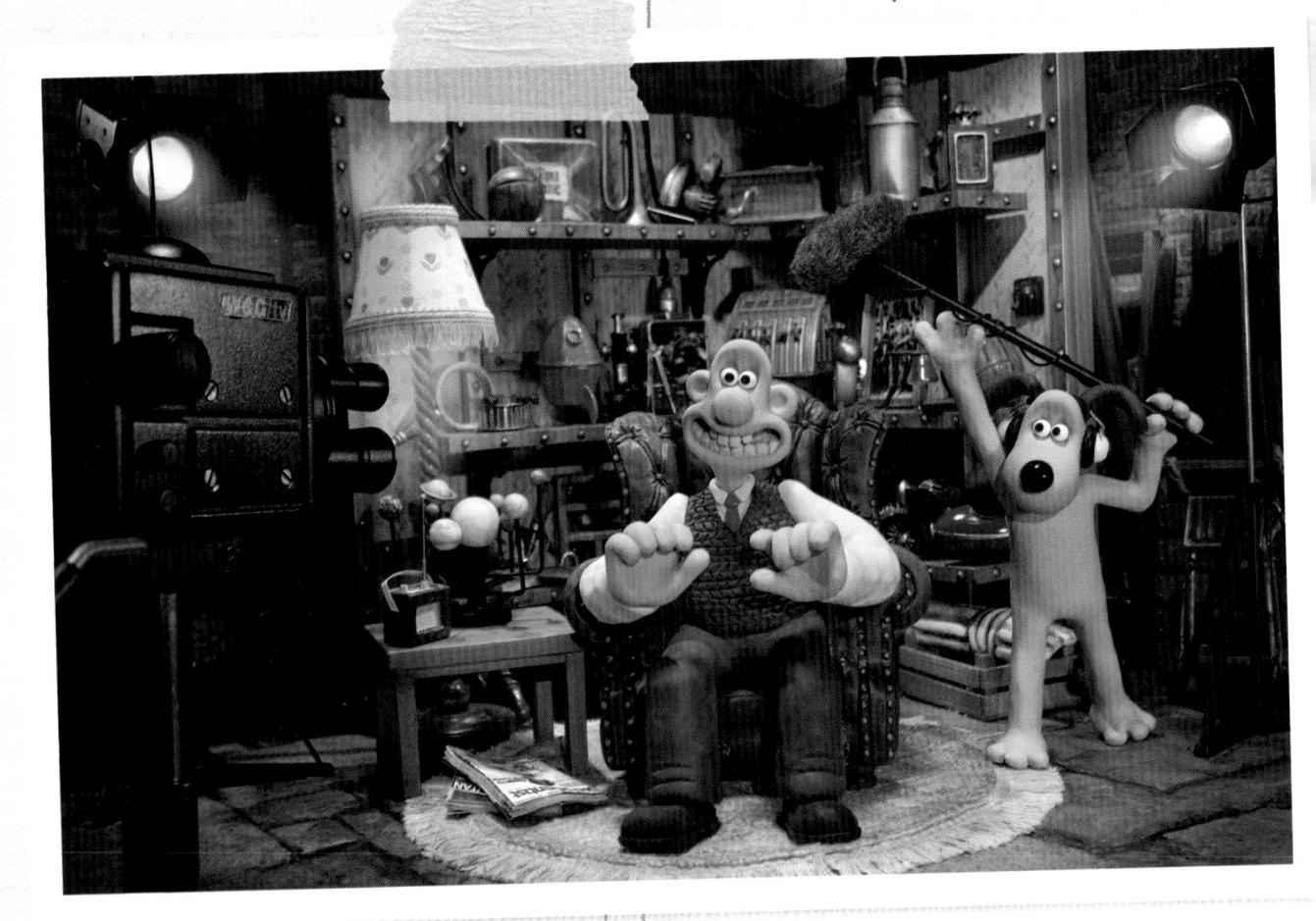

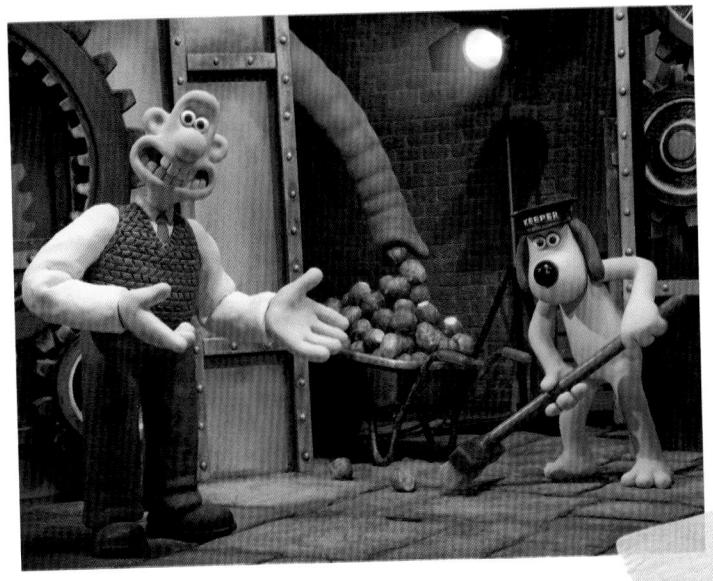

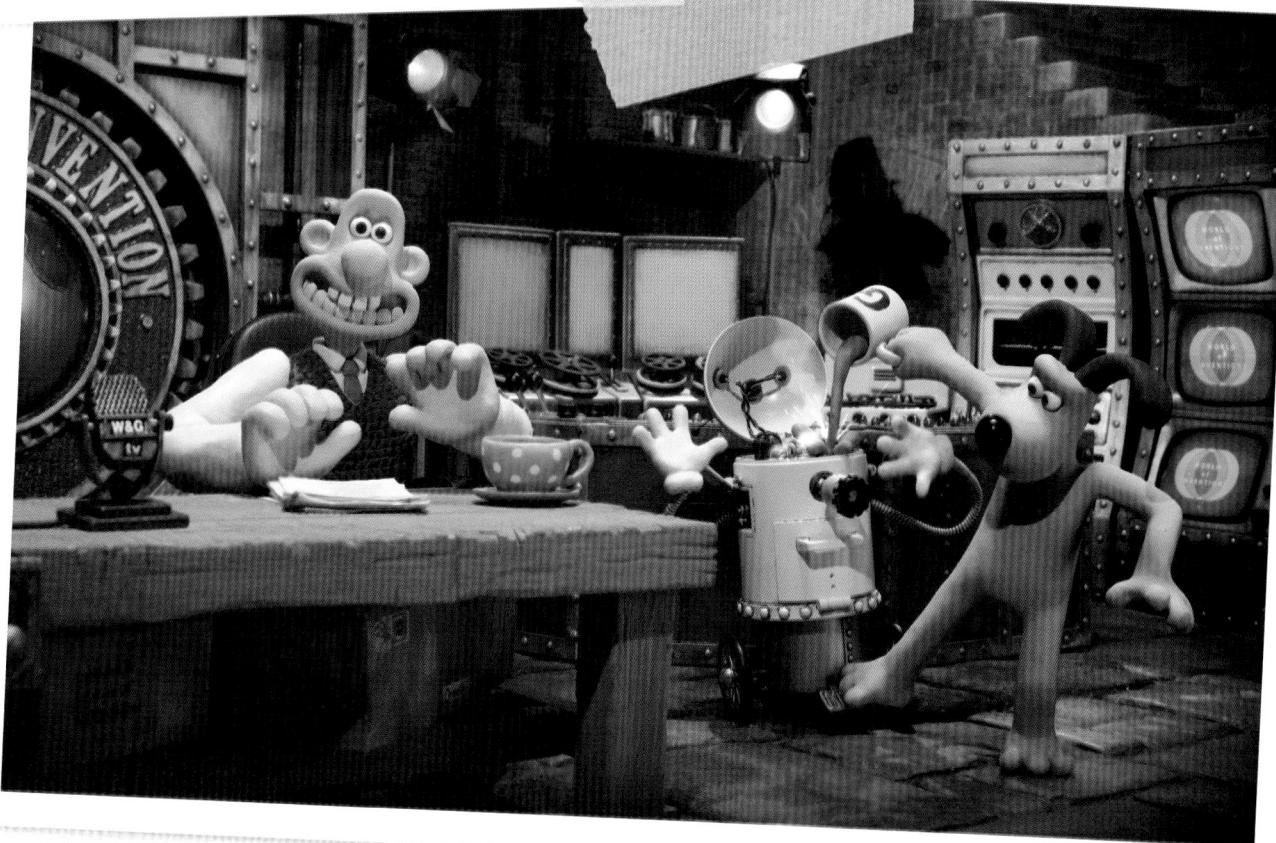

- ② Vision mixing console.
- 3 Monitor screens show output from studio cameras.
- 4 Programme editing console.
- 3 Grill.
- 35 Tripod-mounted studio light.
- 3 Stairs to ground floor of house.

- 3 Standard cellar light.
- 39 Methane-powered 'Jumbo Generator'.
- 40 Secondary studio set backdrop.
- Television monitor installed behind sliding hatch.
- @ Gearing for monitor hatch mechanism.

ROCKET 1/1/4-2

Contents Contents

CONTENTS LIST

General description.....

Rocket Mk-2 cutaway

122 1

3k

General description

BODY COPY

he moon rocket is one of Wallace's most ambitious inventions, and it remains one of his finest. So it is no surprise that he keeps it "spaceship shape and Bristol fashion". In fact, not only has the rocket been carefully looked after over the years but it has also undergone a substantial refit since its first lunar excursion.

The modifications have addressed several weaknesses in the original design, and include changes to the engine room and the additions of an auto-locking lower deck access hatch and a staircase linking the upper and lower decks. While the basic structure and outer hull of the rocket remain largely unchanged, slight modifications have been made to the three stabilising fins to improve flight control and comfort upon leaving and re-entering the Earth's atmosphere.

Communications systems have been significantly overhauled, and the original transistor radio has been replaced by an integrated audio-visual communications console, in order to maintain contact with 'mission control' at 62 West Wallaby Street. Flight and navigation controls are carried over from the previous model although a new state-of-the-art cheese detection device enables more accurate targeting of appropriate lunar landing sites.

For the crew, several important improvements have been made to the cabin on the upper deck, and particularly in respect of home comforts. Extra storage for tea, cheese and crackers was considered a priority, along with a larger (tea-making) water tank for extended journeys. Finally, cabin lighting has been upgraded from a single standard lamp to fixed wall lights with tasteful shades.

Although the rocket can be launched and controlled completely from the cabin as before, a remote-control system has been added. This allows the rocket and any occupants (willing or otherwise) to be launched into space at the push of a desk-mounted button.

Rocket Mk-2

- Stabilising fin (one of three) now incorporates aerodynamic points for extra stability in flight.
- 2 Lower deck access ladder in stowed position.
- 3 Folding step ladder on lower deck, used for access to upper deck from ground level.
- 4 Pressurised lower deck access hatch.
- 6 Rocket engine.
- 6 Engine manual controls.
- Water tank.
- 6 Cabin air tanks.
- Access staircase between upper and lower decks.
- 10 Access hatch between upper and lower decks.
- 10 Observation porthole.
- @ Acceleration/relaxation chair.
- 1 Cabin lighting.
- 1 Upper deck exit hatch.
- 15 Hull support stanchion.
- ® Radio telephone communications console.
- T Video communications controls.
- 1 Video communications camera.
- 19 Video and audio connecting cables.

- 20 Video communications CRT monitor.
- Video and radio communications antenna (compact indoor type).
- 2 Kettle and teapot.
- 3 Cheese dish and cheese supply.
- 2 Cheese crackers supply.
- 25 Wallace's tea mug.
- 26 Cheese detection device antenna.
- Otherse detection device, used to verify types of cheese on lunar excursions.
- Flight control console systems monitor screen.
- 29 Control systems console seat.
- 3 Rocket control systems console.
- 3 Gromit's tea mug.
- @ Control system mechanics.
- 3 Tea supplies storage.
- 3 Engine room light switch.
- 3 First-aid box.
- 3 Fuel feed pipe.
- 3 Fuel tank.
- 3 Fuel distribution/regulation valve.
- § Fly by wire/elastic band control systems.

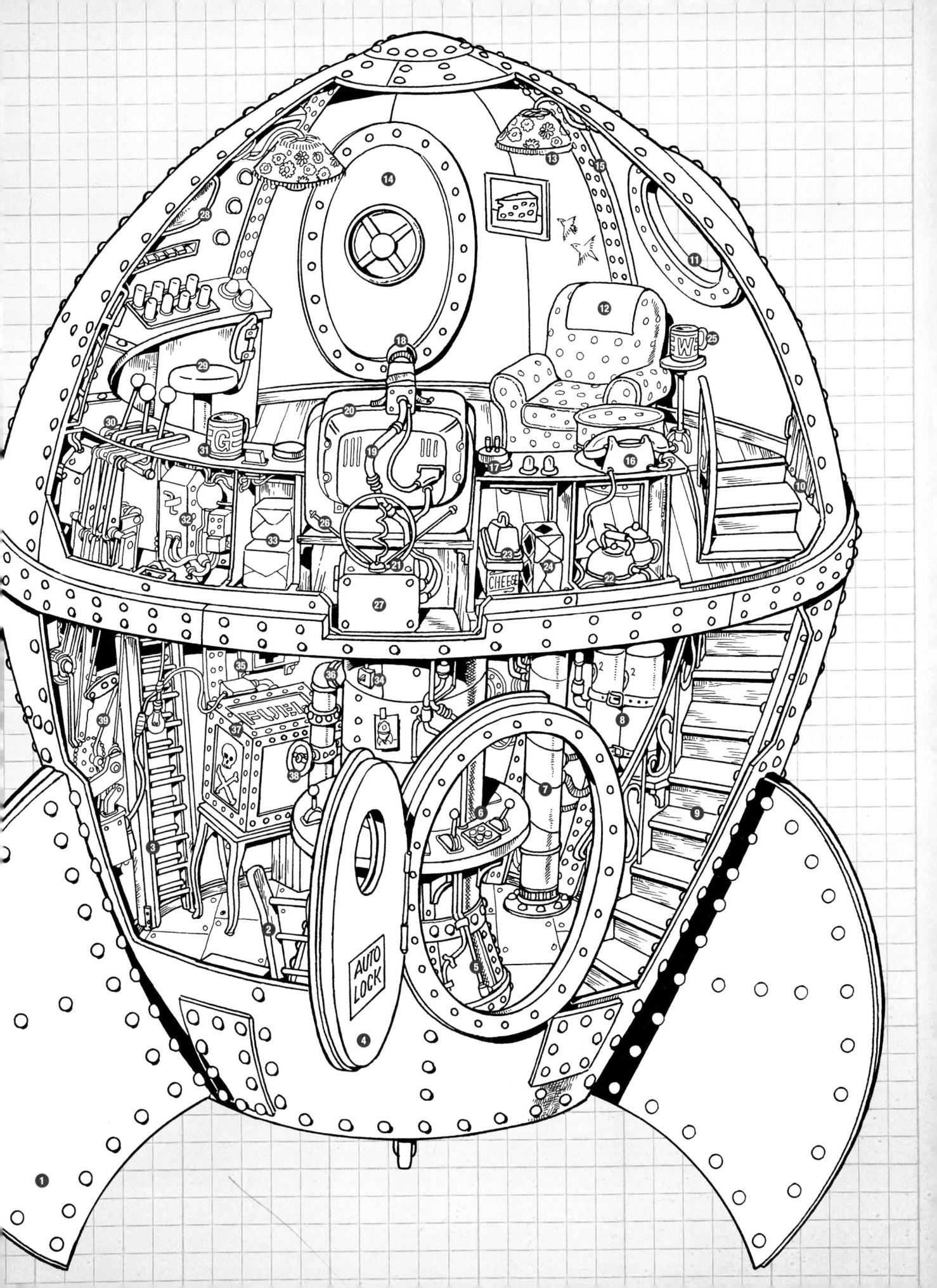

Contents

CONTENTS LIST

, PAGE NO

General description.....

126 38

L.A.D. cutaway

28 20

SUB HEADING

General description

BODY COPY

any inventors imagine a future where robots carry out all the household chores while we enjoy a life of leisure.

Wallace's contribution to this dream is the Labour Assisting Device or L.A.D., which was built to perform various duties around the studio during the filming of the 'World of Invention'

television series.

L.A.D.'s basic construction comprises a short, cylindrical body with a domed top. It is able to move around freely using two large drive wheels, one on each side, with a smaller, rear-mounted wheel for balance. Each drive wheel is mounted on a half axle and driven from the main motor via speed control gearing. This enables L.A.D. to move forwards and backwards, and make turns of any radius, even turning on the spot if required.

Three hatches (one each side plus one at the front) open to allow the deployment of five separate articulated arms. Two arms are deployed from each side hatch and one from the front hatch. Each arm is carried and stowed on a deployment reel, and can be extended fully or partially as necessary. At the end of each arm is a gloved hand featuring four articulated fingers for grasping.

Protruding from the front of L.A.D.'s upper casing is an articulated and telescopic visual processing camera lens. This captures all visual information and supplies it to the primary functions circuit boards (the 'brain'), which are linked directly to the memory bank and processing circuits.

All mechanical functions are driven by a single motor, and a complex arrangement of gears and clutches supply drive to individual components, such as the drive wheels and the arm deployment reels.

L.A.D. operates independently for the most part but can be programmed to perform specific tasks using a hand-held remote control. Maintenance is carried out via any of the three arm hatches, or by opening the entire domed top section using a footoperated pedal at the front of the device. However, care must be exercised when working on the sensitive circuits in the domed top section, which are susceptible to damage by moisture in particular.

19

LAD.

BULET

- Antenna linking Wallace's remote to the L.A.D. Primary functions.
- 2 Memory bank and program processing circuits.
- 3 Indicator light power cables.
- 4 Power indicator lights.
- 5 Transformer coils.
- Fully articulated visual processing autofocus camera lens.
- 7 Visual processing conduits.
- ① L.A.D. Primary functions circuit boards controlling arm movement and speed/direction functions (linked to remote via antenna).
- 9 Left arm hatch.
- 10 Lower left arm deployed.
- Hands fitted with white butler gloves for clean service.
- Upper left arm in stowed position inside deployment reel.
- 13 Arm reel deployment gearing.
- Right arm hatch also provides maintenance access to L.A.D.'s upper section.
- 15 Deployed upper right arm.
- 16 Arm movement control wiring.

- HERE
- 1 Lower right arm in stowed position.
- 1 Left side battery.
- Pright side battery.
- Torward arm deployment reel.
- 3 Forward arm deployment reel rotation gearing.
- 2 Finger manipulation and control actuators.
- 3 Foot-operated upper dome hatch pedal.
- 2 Dome hatch pedal linkage.
- ☼ Upper dome section hinge: dome opens to allow access to L.A.D. control circuitry.
- Forward hatch in lowered position allows forward arm deployment and maintenance access.
- Electric motor drives all mechanical functions.
- 3 Speed control gearing.
- 2 Rear-mounted balancing wheel.

L.A.D. Remote Control

- 1 L.A.D. rotary function selector and programming dial.
- 2 Emergency programming override switch.
- Opper and lower right manipulation arm control on/ off switches.
- Upper and lower left manipulation arm control on/off switches.
- 6 L.A.D. main power switch.
- 6 Telescopic remote control command antenna.
- 7 Antenna safety tip.

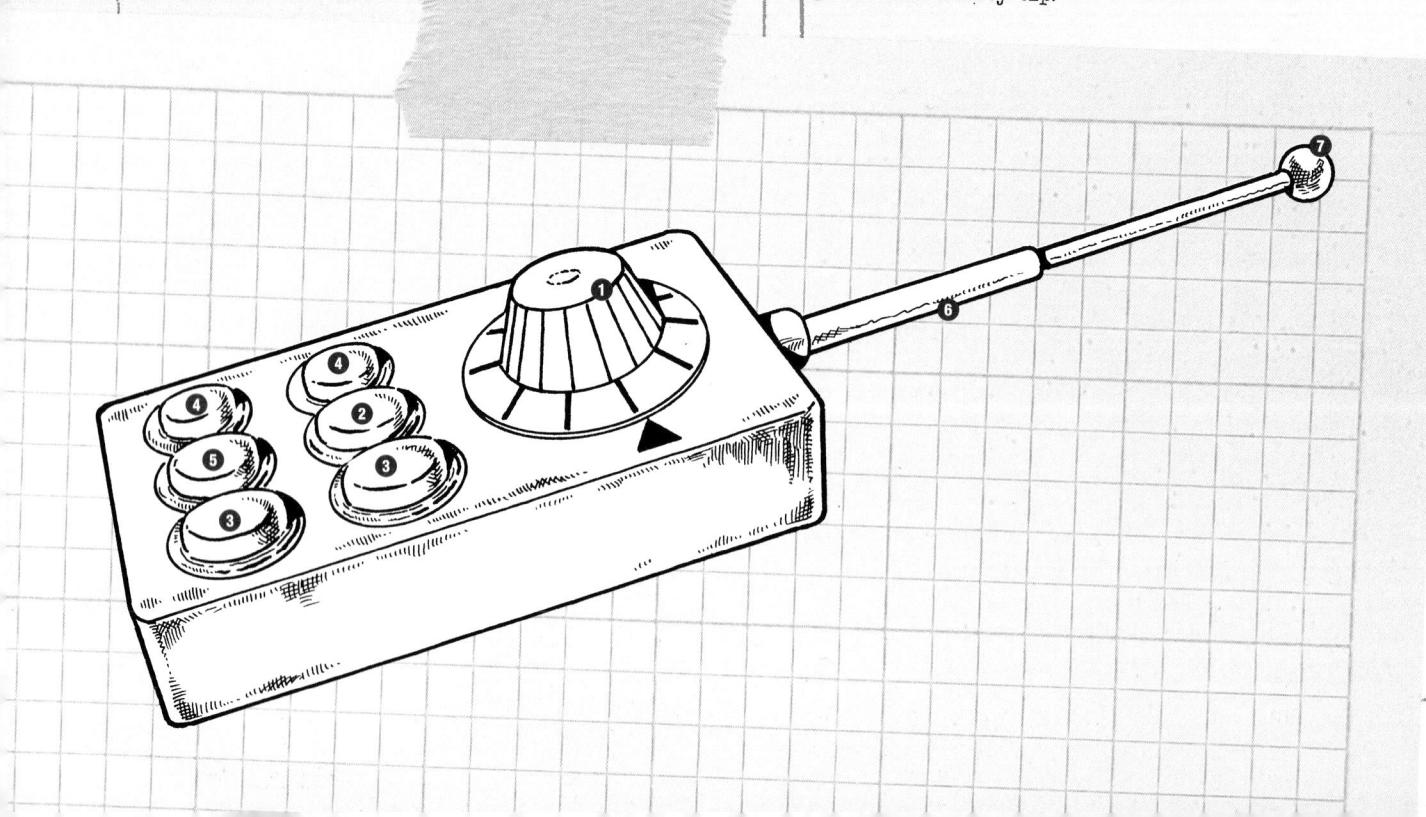

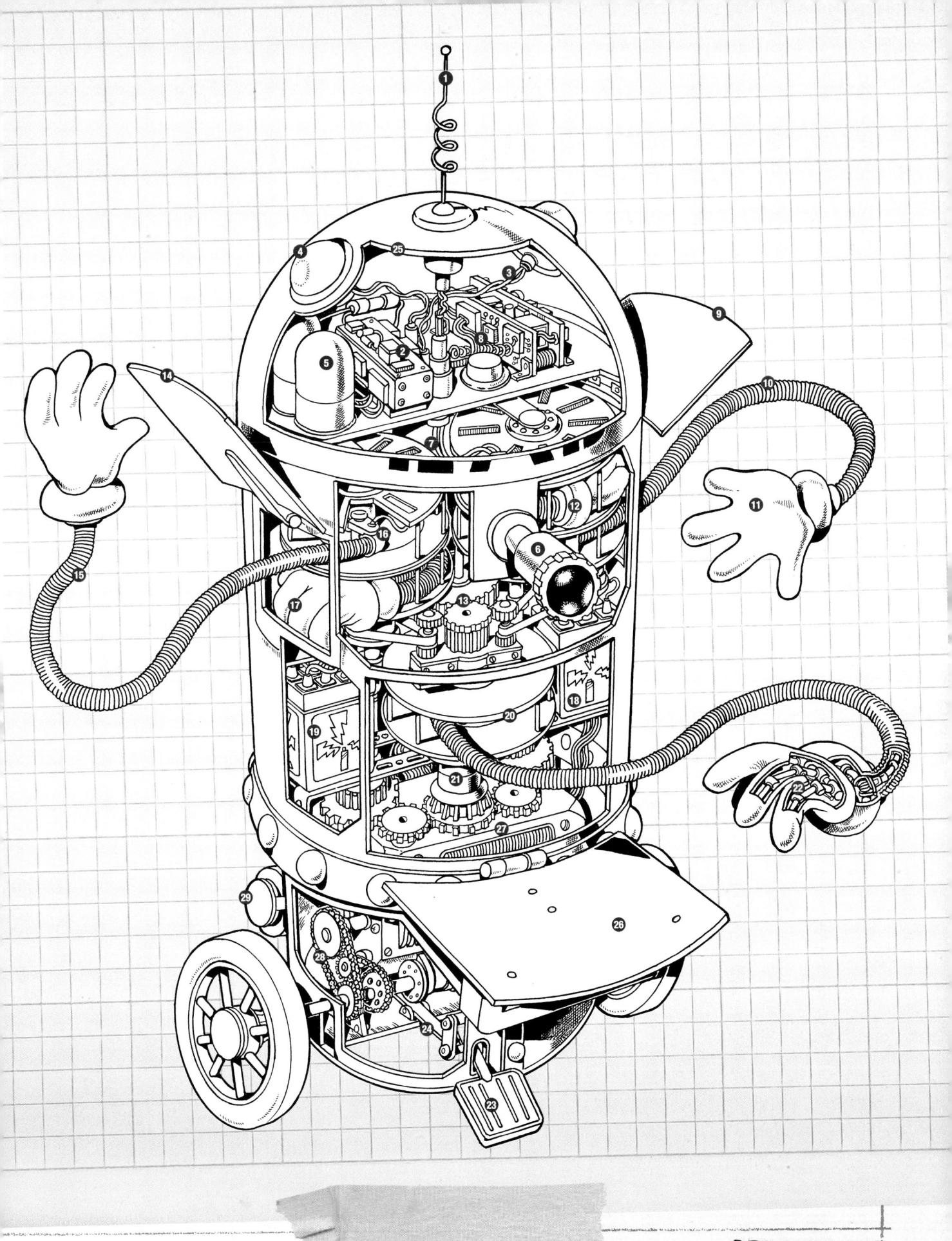

RUNABOUT SIEAMGHAIR

HEADING

Contents

CONTENTS LIST

, PAGE NO.

General description.....

13022

Runabout Steam Chair cutaway.....

32 24

SUB HEADING

General description

BODY COPY

DROP

he Runabout Steam Chair is Wallace's prototype for personal motorised transport. It is compact, manoeuvrable and easy to operate although reliability can be an issue. Because it is designed to carry one person, who controls all functions from a seat at the front of the machine, an assistant is also required to act as fireman, keeping the fire stoked and fuelled with coal.

The general principle of operation can be compared to any conventional steam engine. Water is turned into superheated steam by the boiler and fed via pipes to the piston cylinders, which are mounted either side of the vehicle. The amount of steam entering each cylinder is independently controlled by the operator using two regulator handles at the front of the vehicle. The steam enters each cylinder through a reciprocating valve assembly, forcing the piston and connecting rod to move, which in turn causes the front wheel to rotate. On its return stroke, the piston forces the steam back out of the cylinder, through the valve, and up the exhaust blast pipe. The cycle is then repeated until the supply of steam is cut off.

when both regulator handles are moved to the same position, the same amount of steam is allowed into each cylinder causing both front wheels to move by the same amount. Hence, the vehicle is propelled forward in a straight line. Turns are effected by reducing the amount of steam entering one cylinder, thereby slowing the rotation of the wheel on that side. The resulting speed differential between the wheels causes the vehicle to turn. A hand-operated brake lever is fitted to each regulator handle, which provides instantaneous steam cut-off for sudden stops. The rear end of the vehicle is supported by a single pivoted castor wheel, which allows very tight turning circles.

The operator's seat is padded and heat-resistant for comfort, and it can be raised on a vertically mounted steam piston to provide access to high shelves around the home or workshop.

Runabout Steam Chair

- 1 Steam dome.
- 2 Superheater tubes.
- 3 Steam pipes to cylinders.
- 4 Superheater header.
- 5 Exhaust blast pipe from cylinders.
- 6 Chimney cowl.
- Rear-mounted valve tap provides boiling water for essentials like tea.
- 3 Firebox (also good for fry-up).
- 9 Piston valve housing.
- 10 Piston cylinder.

- Water tank.
- 12 Connecting rod to drive wheels.
- Large front-mounted fixed wheels provide forward and reverse drive as well as steering.
- 1 Rear-mounted pivoted castor wheel.
- (b) Steam chair operator's padded, heat-resistant seat.
- 16 Padded, heat-resistant backrest.
- 1 Support frame.
- 18 Armrests for elbow support.
- 19 Independent steam regulator handles.
- 20 Braking handles.
- ② Footplate.

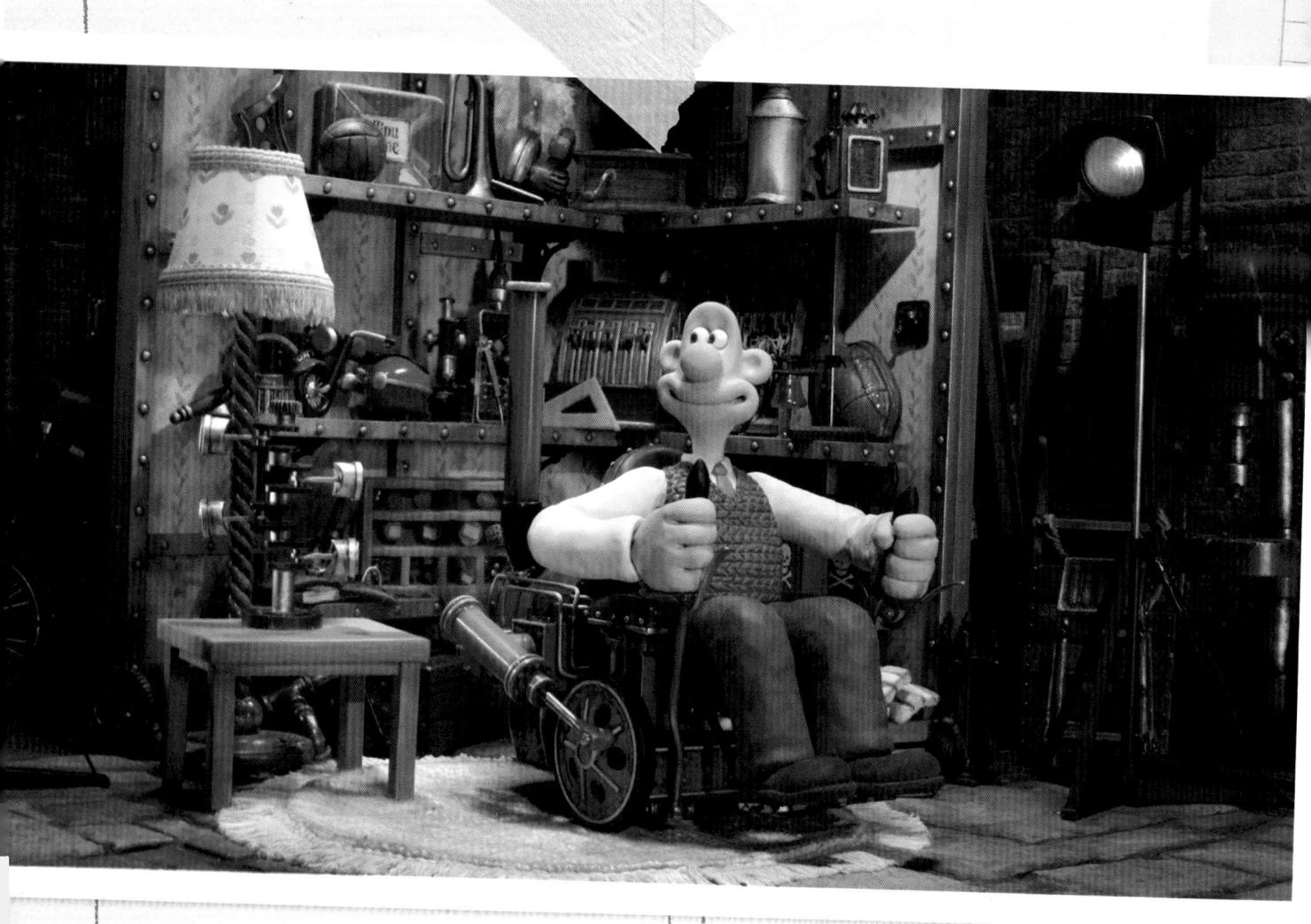

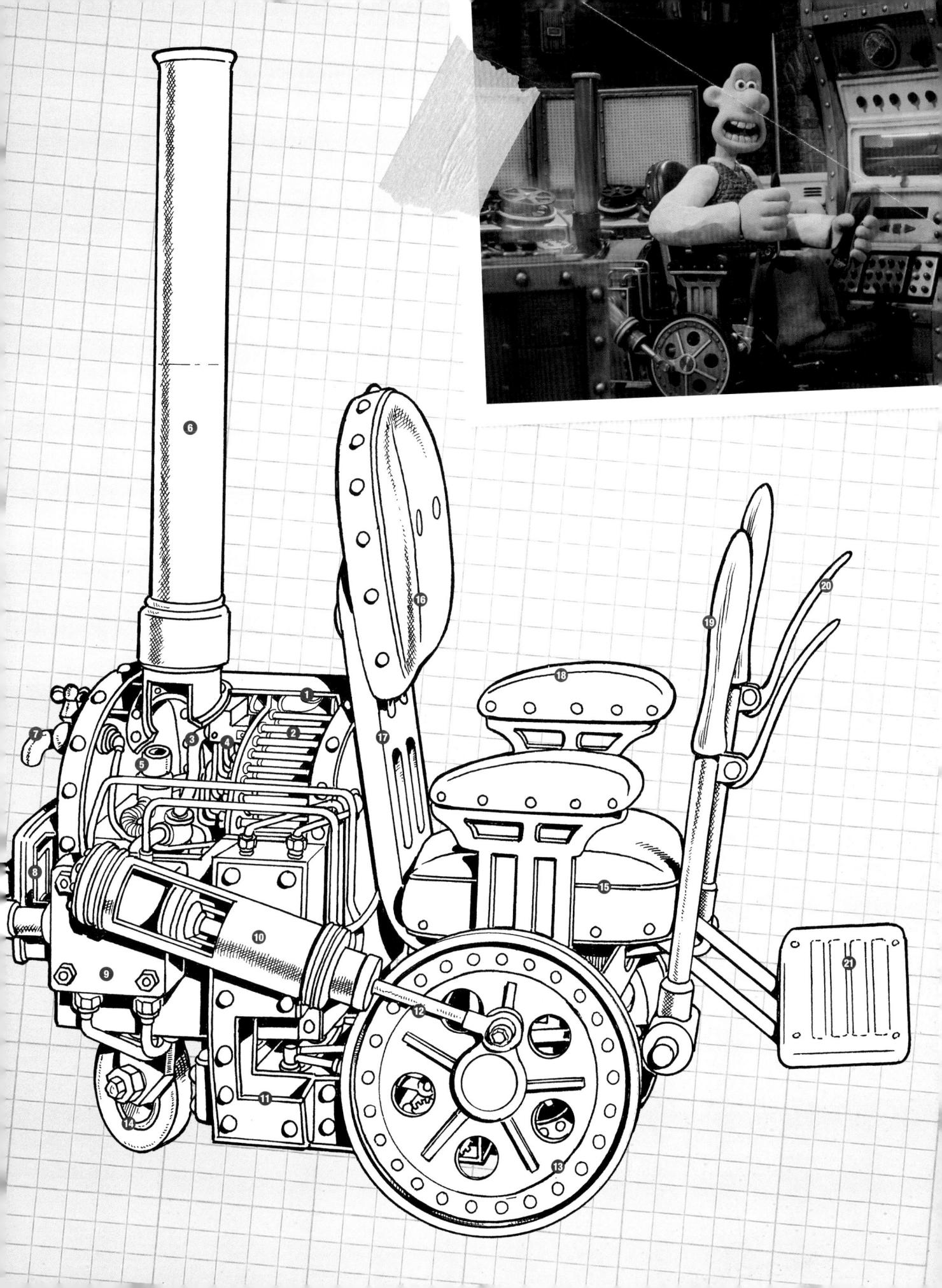

JUMBO GENERATOR

SUB HEADING

Contents

CONTENTS LIST

ents list page

HEADING

General description

BODY COPY

t is well documented how mammals can turn leafy vegetables into methane gas. Perhaps less well known is that the process is particularly efficient in the case of elephants. With the Jumbo Generator, Wallace created a remarkable, if somewhat unorthodox, solution to the huge power demands of the television studio in his cellar.

The structure of the machine consists of a large riveted steel frame, which is designed to hold the elephant (Kevin) in position via a spring-mounted adjustable neck collar. It is essential that this collar is fitted correctly, with enough slack to allow two adult arms to be inserted between it and the elephant's neck. At the rear end is a similarly sprung collection dome, which is shaped for maximum comfort and flexibility. A reinforced wooden platform provides a sturdy base for Kevin to stand on as well as protection for the studio cabling that runs beneath it. The front of the frame is covered to shield Kevin from view and forms part of Wallace's studio set. In the centre of the front wall a television monitor is mounted behind a twin-sliding-door hatch, which opens and closes as required.

Brussels sprouts are used as the 'input' fuel due to their convenience and high yield. The methane gas is collected in the collection dome and fed via a flexible hose to the generator. A pressure valve is fitted to regulate the supply of methane to the generator, which is driven by a reciprocating two-cylinder, air-cooled engine. A cranking handle is provided to start the engine by hand, after which it runs until the supply of methane is cut off. Electric power is created by the generator and fed via cables to the studio's main power distribution board. The entire engine/generator assembly is mounted on a trolley for ease of positioning.

Provided with a willing elephant and a ready supply of sprouts from the allotment, this simple yet effective device is able to cope with all of Wallace's energy needs.

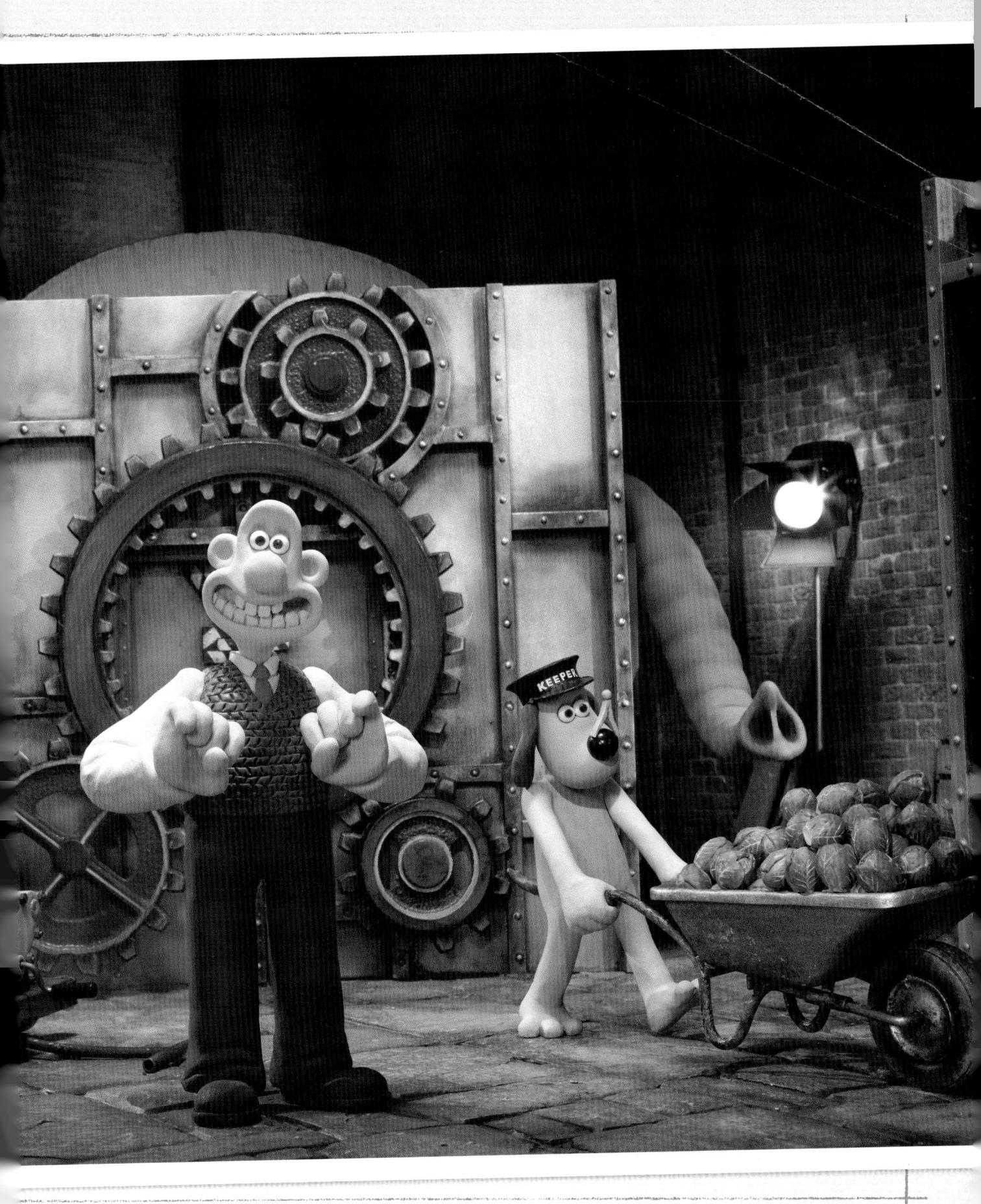

135 %

Jumbo Generator

- Adjustable collar maintain's Kevin's position on the Jumbo Generator. Fully sprung connectors provide comfort and flexibility during Kevin's generating duties.
- Rear frame supports the collar and methane gas collection dome.
- Sprouts and other vegetables provide Kevin with the raw materials to make methane gas.
- Wheelbarrow borrowed from Wallace and Gromit's allotment.
- 5 Reinforced platform.
- 6 Sprung collection dome connectors.
- Methane gas collection dome.
- 8 Flexible methane gas collection hose.
- Methane gas pressure valve.
- 10 Generator trolley.
- 1 Generator engine.
- @ Generator (driven by engine).
- 13 Starting handle.
- Underfloor cabling leading to studio's power supply.
- ⑤ Cog system powered by generator allows the television monitor hatch doors to slide open while providing visual interest to Wallace's viewers.
- 16 Television monitor.
- Television monitor connection cables.
- TV monitor hatch door slot (used when doors are open).
- 19 TV monitor hatch in closed position.
- 10 Hatch sliding cog mechanism.

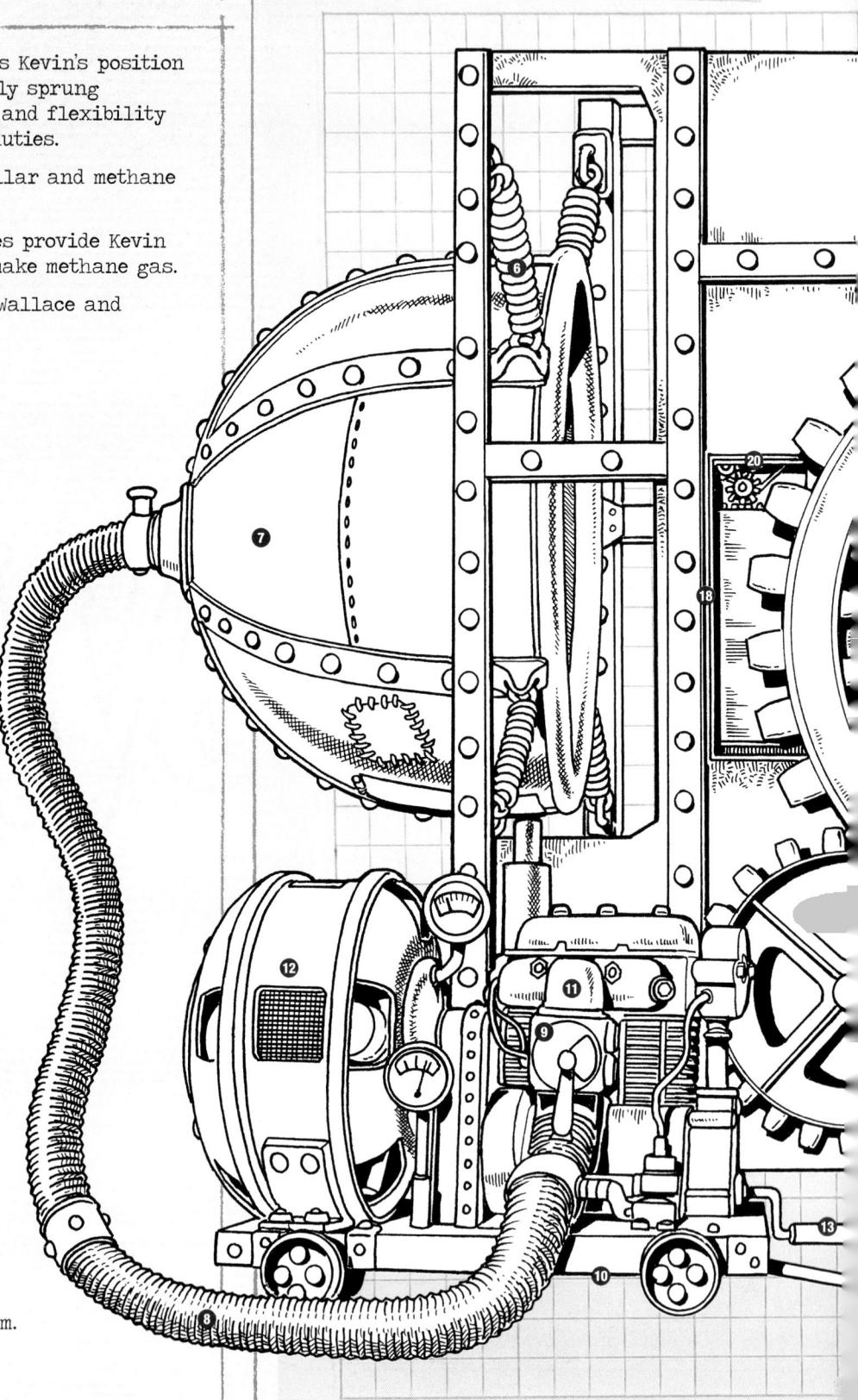

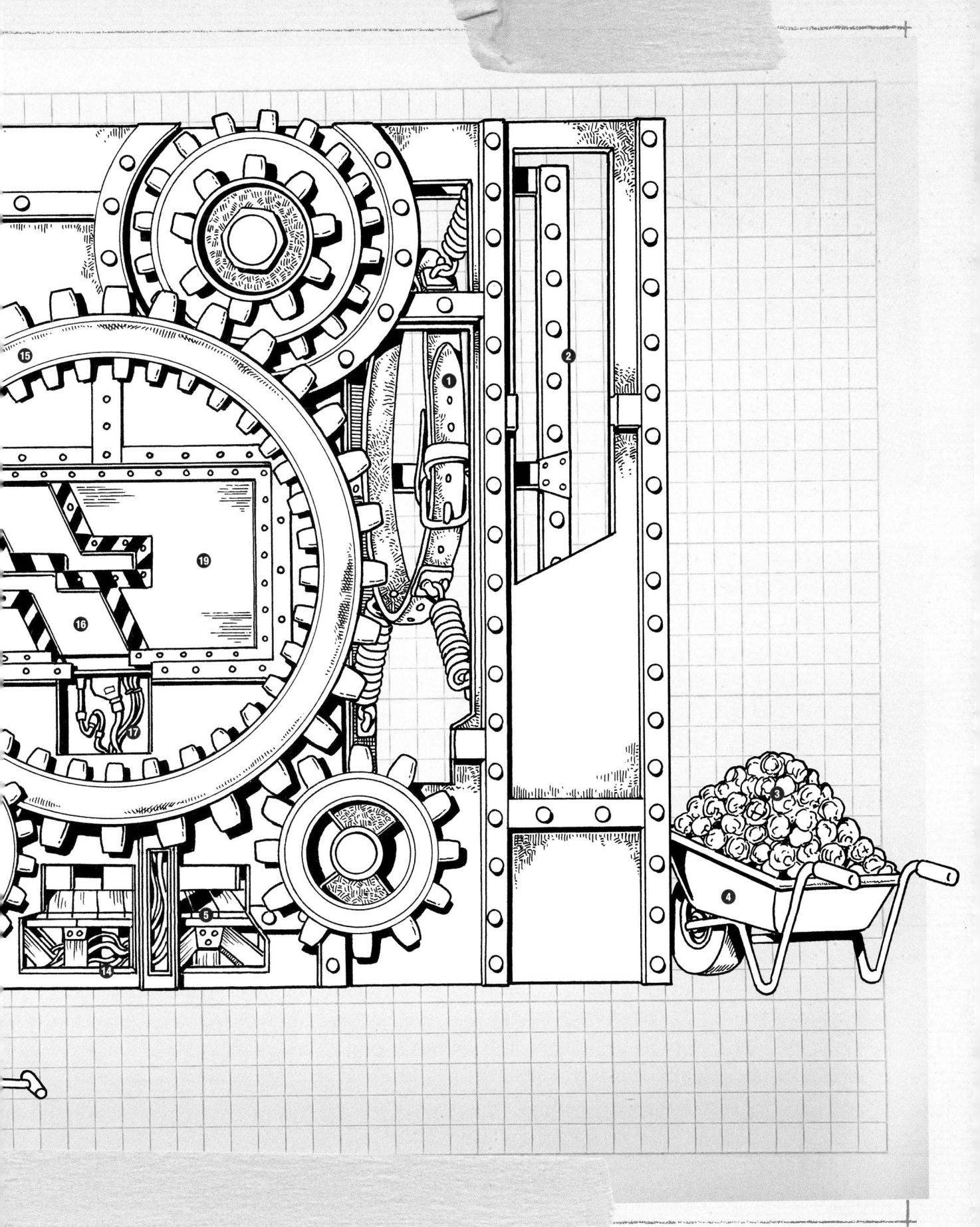

MFLATAS LE SAFETY SULT

HEADING

Contents

CONTENTS LIST

I PAGE NO.

MAIN PICTURE

General description.....

3838

Inflatable Safety Suit cutaway.....

SUB HEADING

General description

BODY COPY

he "total protection hazard-free safety suit" represents a new leap forward in personal accident avoidance. Following a single, sharp tug on the activation cord, the wearer is

rendered "instantly impervious to harm".

The suit itself is constructed in one piece from gusseted elasticated fabric, which is based on underwear technology. All joins are supported by carefully designed 'anti-chafe' flexible rubber ribs, which serve to maintain the shape of the suit and provide additional strength and protection upon deployment.

Activation is by means of the aforementioned activation cord, and this is easily located thanks to its bright red triangular hand grip. Pulling the cord activates the igniter. This causes separately stored compounds of sodium azide and potassium nitrate to combine (IMPORTANT: SEE BELOW). The resulting chemical reaction releases a vast amount of nitrogen gas, which inflates the safety suit, encompassing the wearer in an all-round 'air cushion'. Total deployment time is practically instantaneous at around one tenth of a second or less, after which the wearer is fully protected by the inflated suit.

The suit remains inflated indefinitely. Leakage at the neck, wrists and ankles is prevented by tight-fitting anti-deflation gussets, which stretch as the suit expands. For maximum operator comfort, both before and after activation, the wearing of only a

string vest under the suit is recommended.

On the whole, the safety suit is simple, ingenious and almost completely successful. The one weakness is the hazard posed to it (and the wearer) by sharp objects, with discarded drawing pins proving to be particularly troublesome, as Wallace discovers when demonstrating the suit during an episode of his 'World of Invention' television show.

(IMPORTANT SAFETY NOTE: DO NOT TRY THIS AT HOME! On no account should readers attempt to recreate the igniter reaction employed by the safety suit.)

1393×

Inflatable Safety Suit

BULET

- 1 Activation cord.
- 2 Igniter.
- 3 Sodium azide compound.
- 4 Potassium nitrate compound.
- 5 Anti-deflation flexible rubber neck gusset.
- 6 Anti-deflation wrist gusset.
- 7 Anti-deflation ankle gusset.
- 8 Anti-chafe flexible rubber suit ribbing.
- Easy-inflate balloon fabric based on underwear technology.
- Wallace's boots.

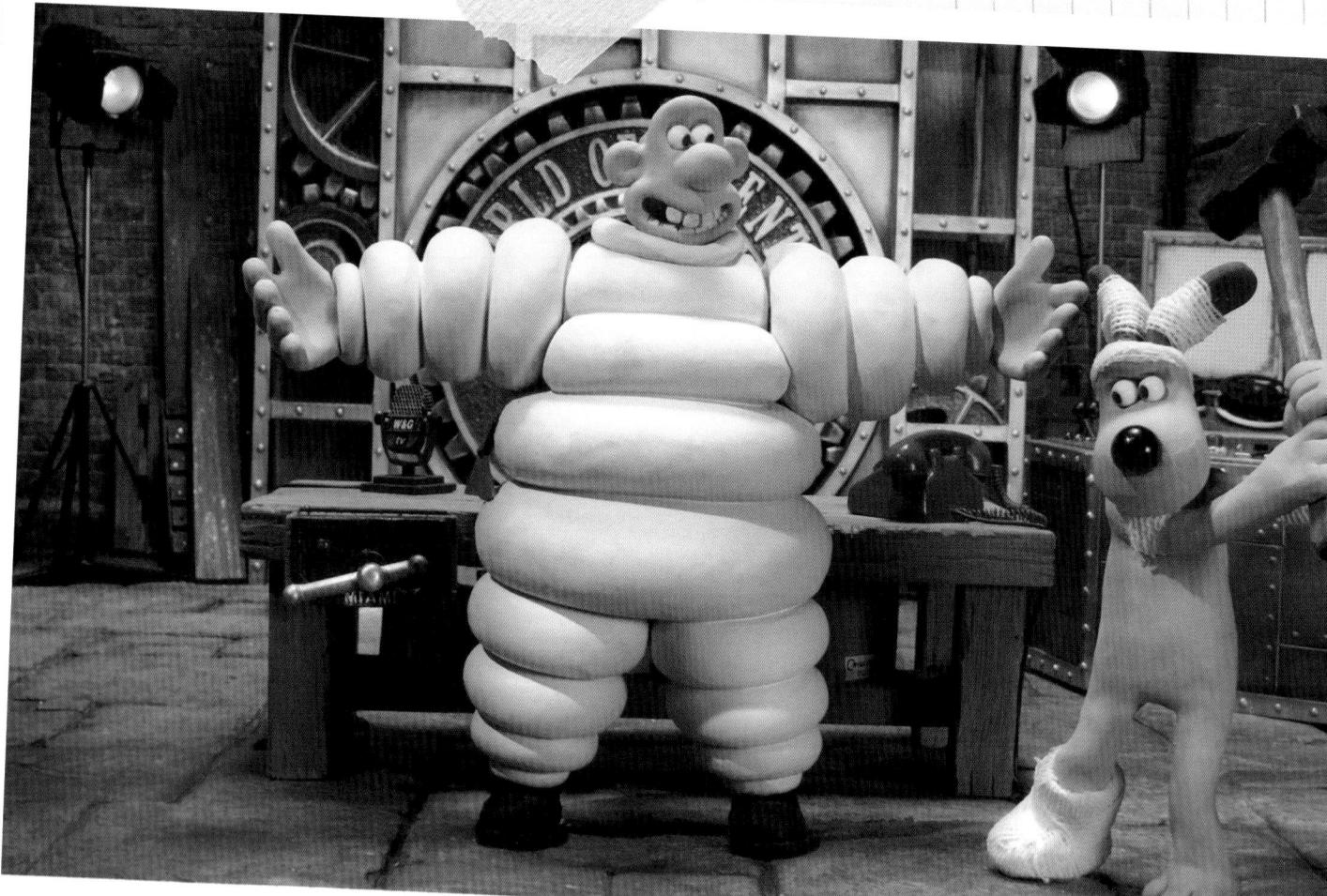
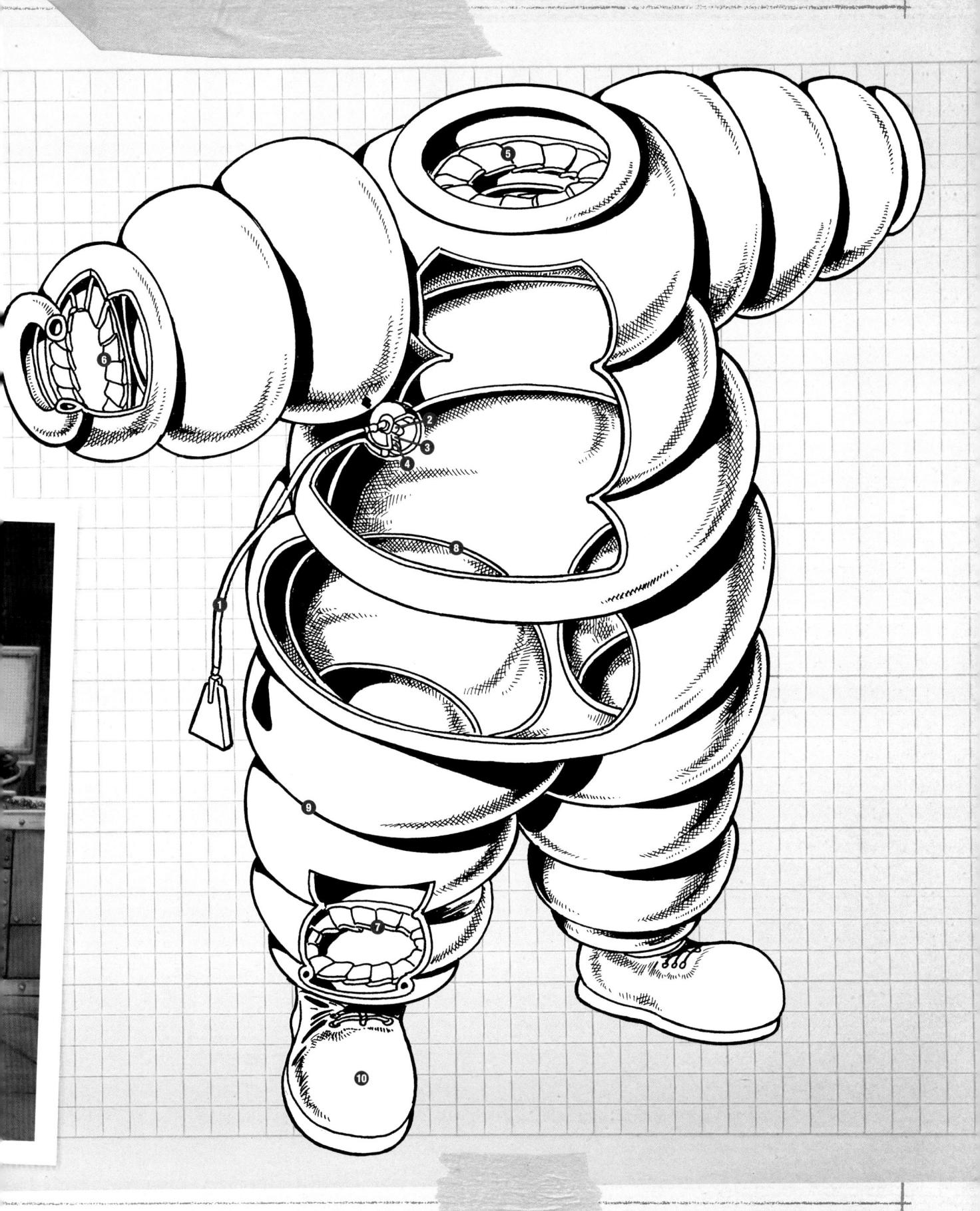

Fat | 41 ×83

BUML-U-MATIG

Contents Contents

CONTENTSLIST

General description

Bowl-O-Matic cutaway

SUB

General description

BODY COPY

he Bowl-O-Matic is a fully integrated, shoulder-mounted cricket ball launcher, and is intended to take the strain out of bowling for cricketers at all levels. At the same time, ball delivery is improved and, hopefully, more wickets taken. Its functional design is based on the principles of speed, accuracy and ease of use, making it equally at home on the club pitch or village green.

The chassis of the Bowl-O-Matic is a hollow wooden beam on top of which is mounted the main catapult apparatus, trajectory upper control rod and targeting array. Inside the beam is the trigger mechanism, the main components of which are a trigger, trigger tension spring, lower control rod and a launch activation hook and pivot.

The type of ball delivery is pre-set using the ball trajectory control dial, which is linked to the trigger mechanism via the upper control rod. The settings available are Leg break, Off break, Yorker and Googly. As the trigger is pulled, the launch activation hook is released via the lower control rod according to geometry determined by the position of the upper control rod. In short, the system fine tunes the point at which the catapult is released, which in turn determines the type of ball delivery.

Upon release, the launch arm is catapulted forward, relieving the tension in the catapult spring and releasing the ball at the optimum angle.

The Bowl-O-Matic comes equipped with a fixed magnification targeting array, which is mounted at the front of the device. This enables the appropriate bowling style to be determined in relation to the batsman and prevailing conditions.

The substantial trigger hand grip and padded shoulder rest act as braces against the recoil of the device, which can be vigorous. Even so, some discomfort may still be caused after prolonged use.

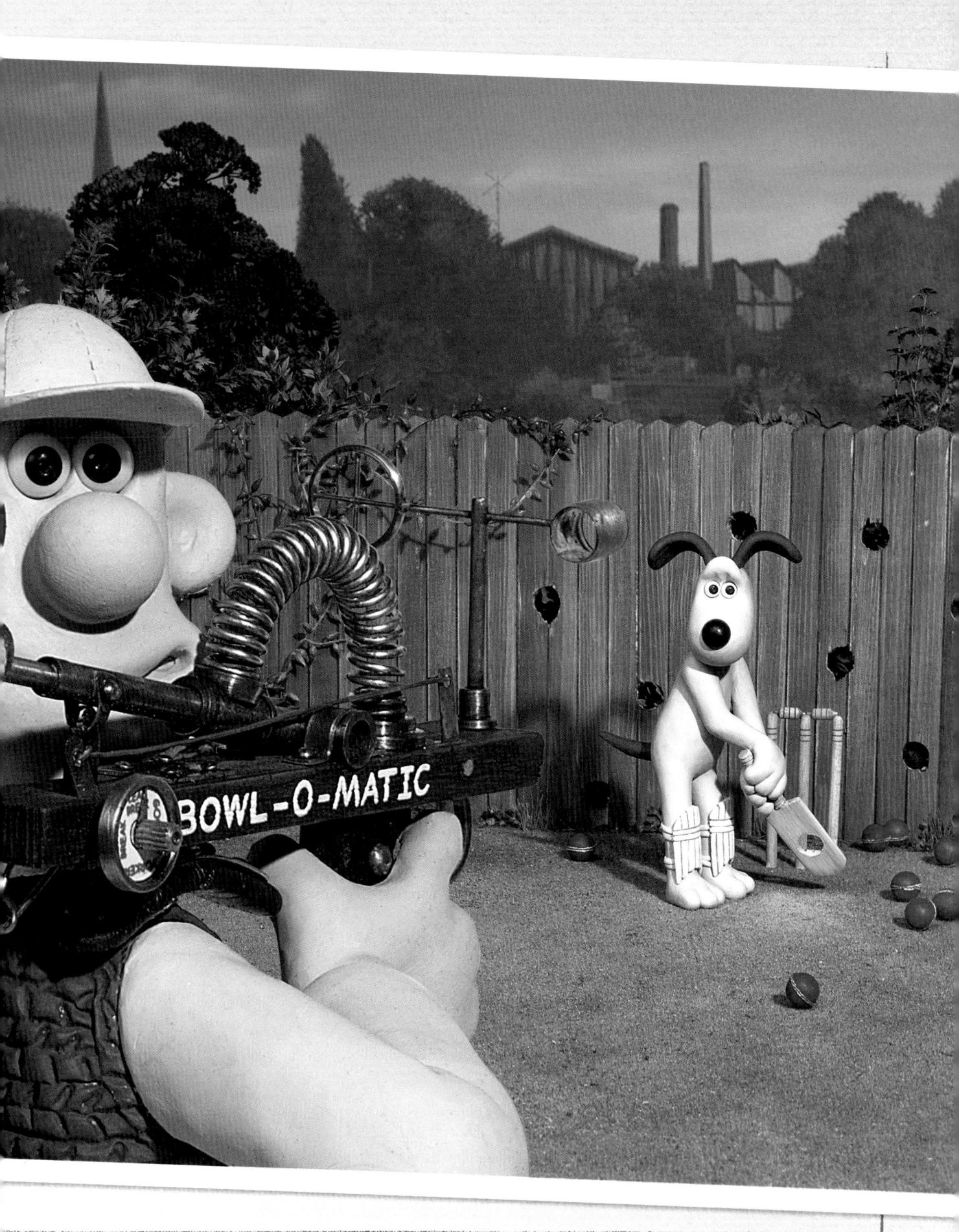

Bowl-0-Matic

- Cricket stump targeting array swivels to provide magnified viewfinder if desired.
- 2 Twin-lens fixed magnification target finder.
- 3 Bowl-0-Matic bodywork constructed from hollowedout wooden beam.
- 4 Cricket ball.
- 6 Super-efficient cricket ball catapult grip designed to replicate a bowler's hand.
- 6 Catapult cricket ball launch arm.
- O Catapult spring.
- 3 Trigger.
- 9 Trigger tension spring.
- Forward pivoted rod control lever.
- Trigger-activated upper control rod determines the style of bowling via the ball trajectory control dial.
- Rear pivoted rod control lever.
- 13 Launch activation hook pivot.
- 14 Launch activtion hook.
- 15 Lever tension spring.
- Trigger-activated lower control rod located inside the Bowl-O-Matic operates the launch activation hook, which in turn releases the catapult arm.
- To Ball trajectory control dial.
- 13 Control dial programming knob.
- 19 Padded shoulder rest.
- Reinforced hand grip enables operator to brace for recoil.

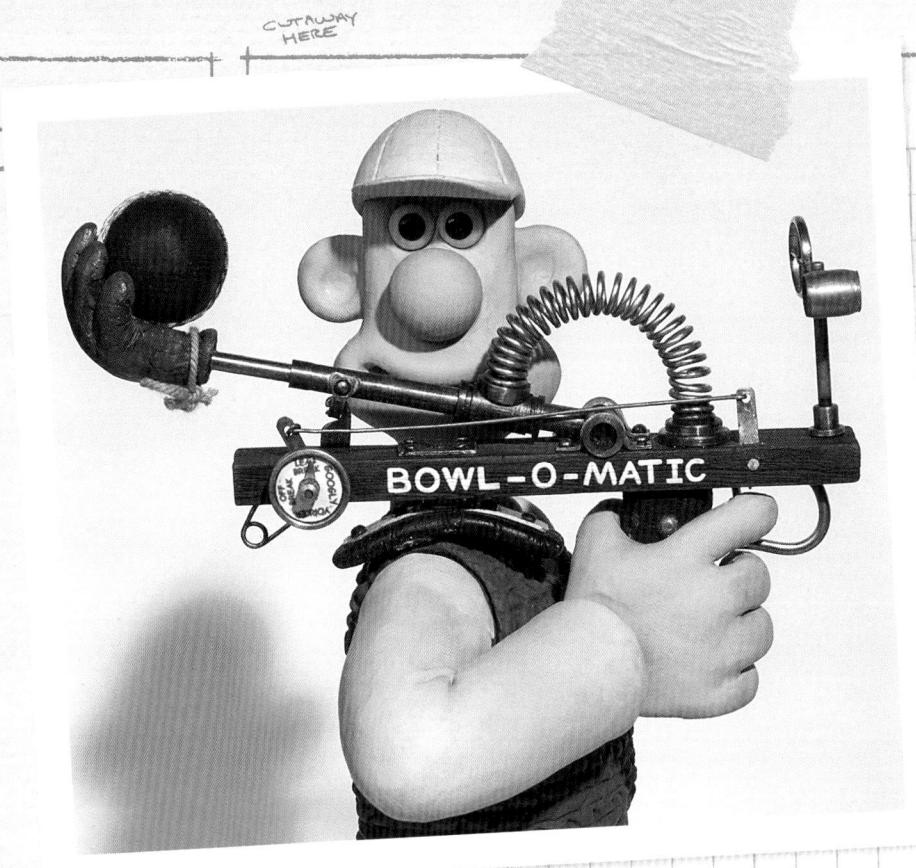

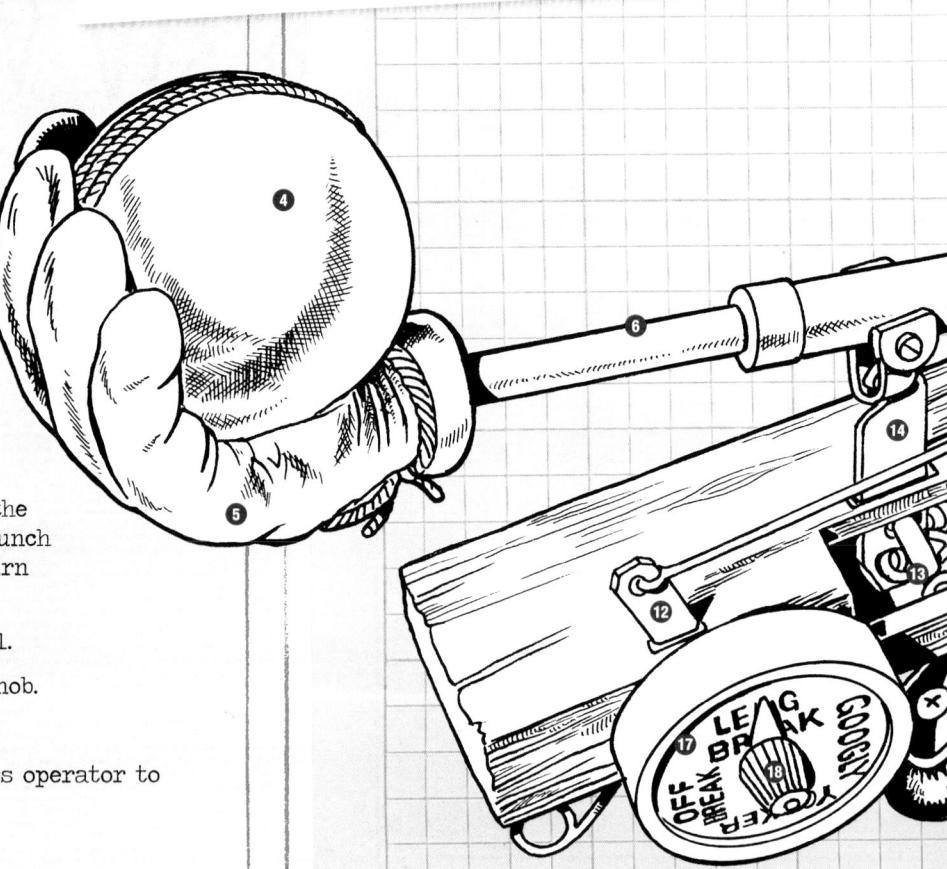

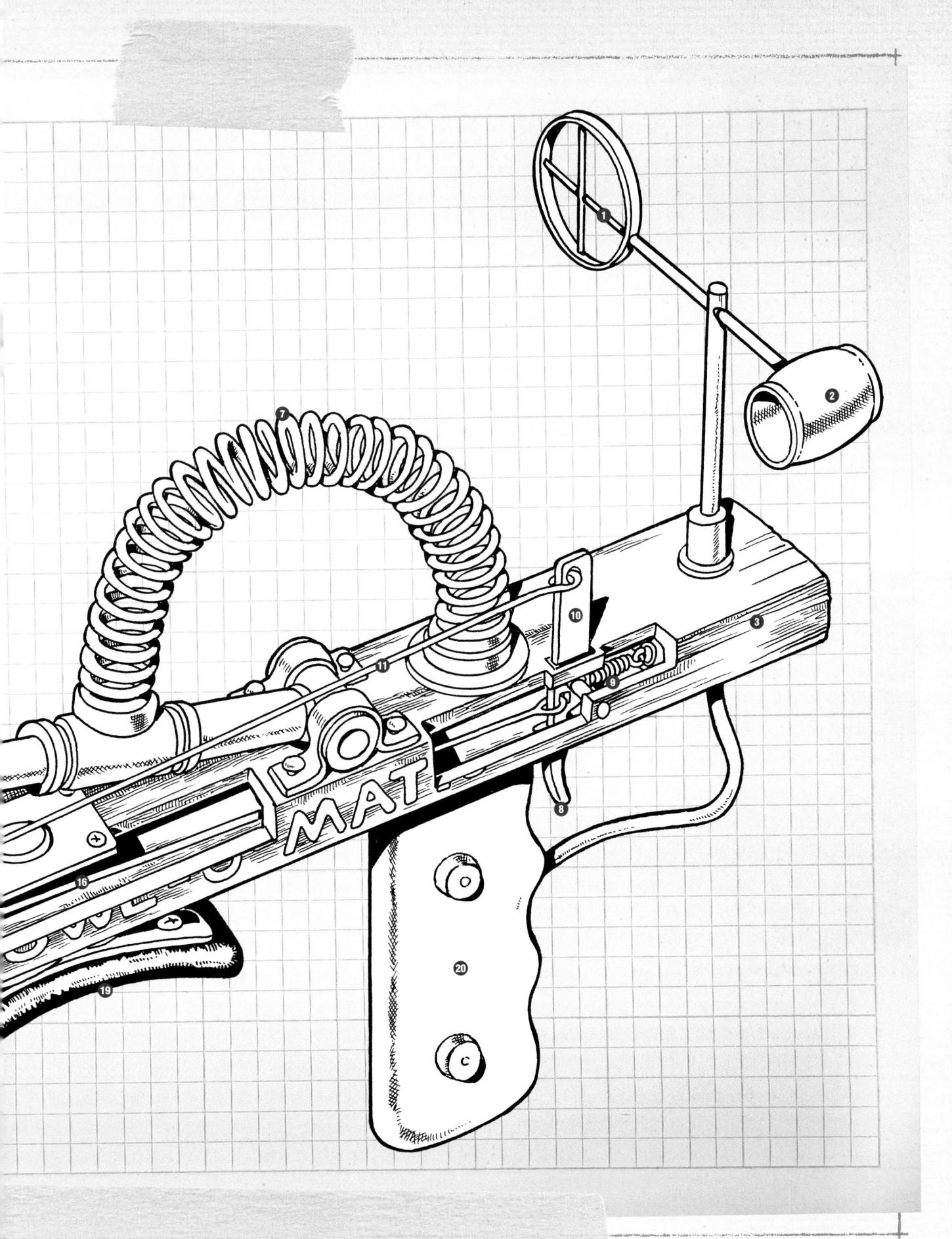

Contents

CONTENTS LIST

General description Hover Wellies cutaway

General description

hether employed as a safety device for use when encountering deep puddles, or as general transport across land, water, snow and ice, the Hover Wellies are an elegant addition to every inventor's wardrobe.

Each Hover Welly is an oversized Wellington boot onto which is fitted a substantial air intake above the toe section. Inside the intake housing is an electric motor, which is powered by a battery. The motor drives a four-bladed fan, mounted horizontally inside the intake housing on a support spanning its diameter. The fan sucks air in through a safety grille on top of the intake housing and forces it into a pair of curved ducts running either side of the wearer's foot. The forced air passes through the ducts and down through holes in the sole of the boot where it fills a compartmentalised air bag. Holes between the compartments ensure that the air bag is filled evenly so that it becomes rigid while remaining flexible over rough surfaces. Slits in the base of the air bag permit the air to escape under high pressure, thus creating a cushion of air, which lifts the boot just clear of the ground. The wearer of the Hover Wellies is now free to move around on any surface.

Forward propulsion is provided by a three-bladed propeller on each boot, driven by an electric motor, which is enclosed in a nacelle and mounted on a support at the rear of the boot. On top of each nacelle is a master on/off switch controlling both the lift fan and the rear propeller.

Internal padding and a fleece lining ensure a snug fit and comfort for the user in all weather conditions. A battery is housed in a compartment at the rear of each boot and is accessed from the inside via a padded flap. Therefore, battery replacement requires boot removal.

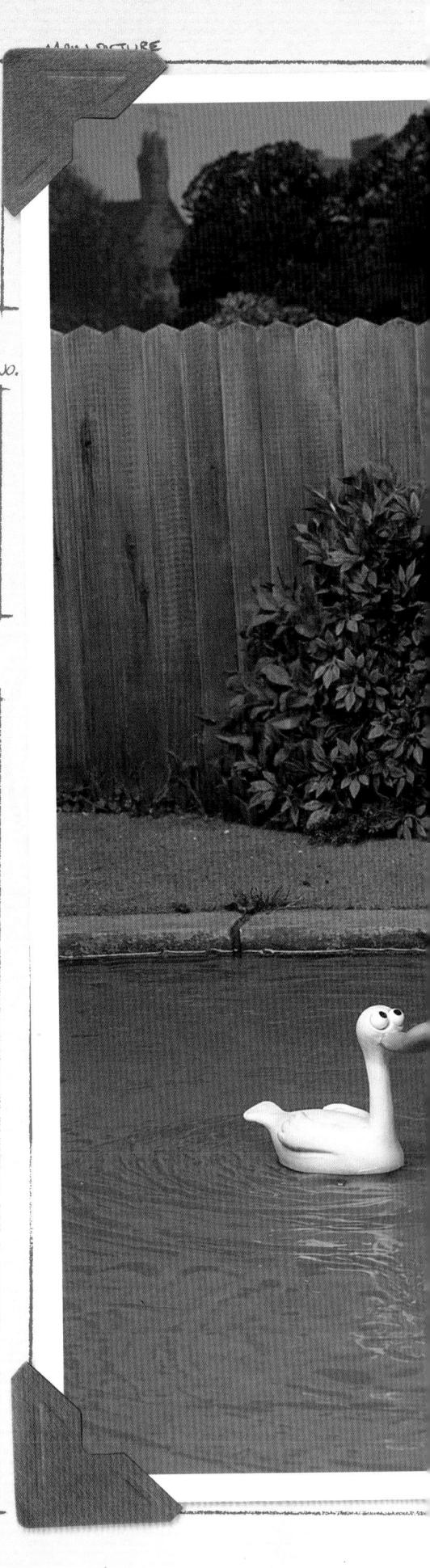

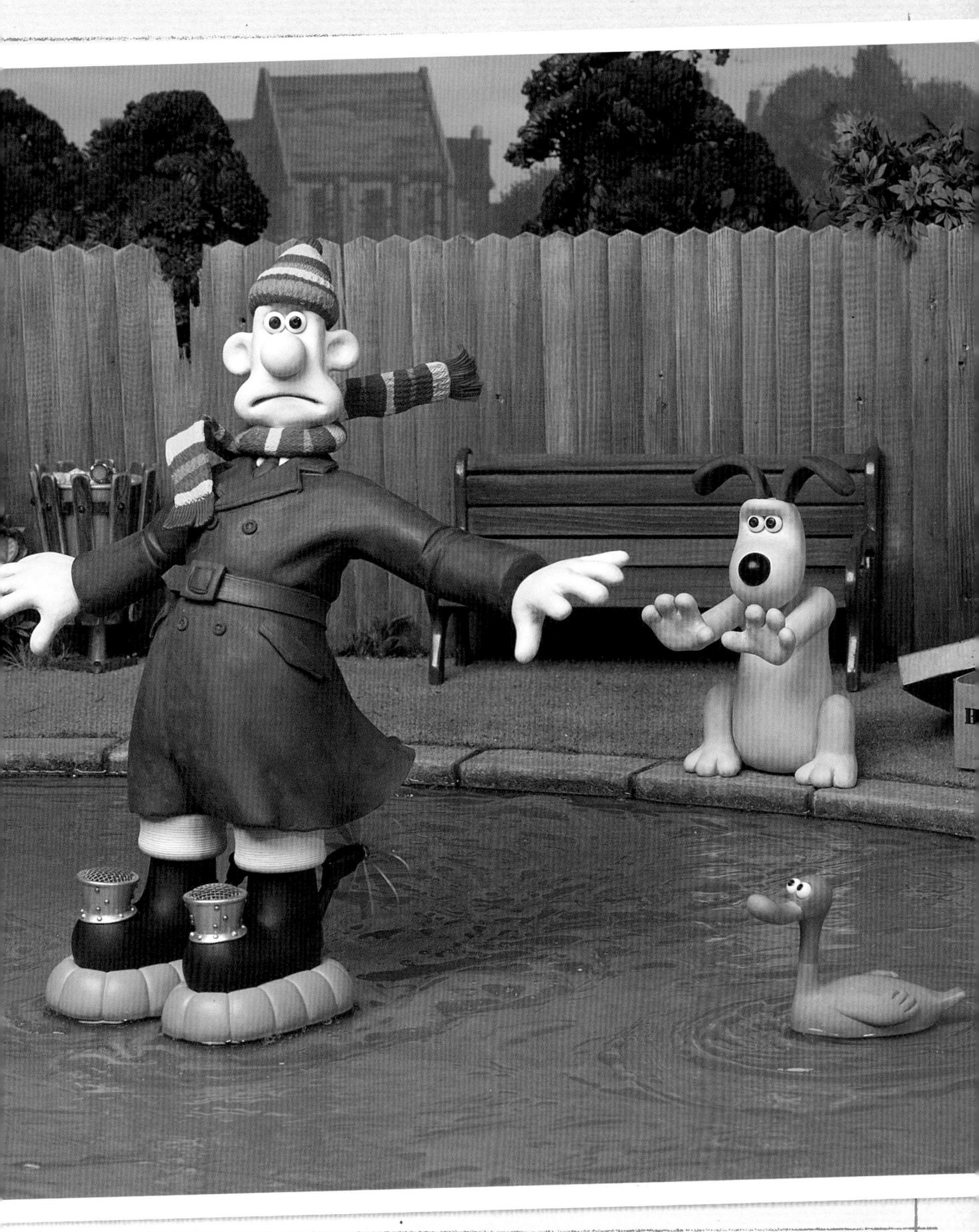

≈147 ×89

Hover Wellies

- 1 Air intake and fan housing.
- 2 Air intake safety grille prevents large items being sucked into fan housing.
- 3 Four-bladed fan provides lift.
- 4 Fan electric motor.
- 3 Power cable linking fan motor to battery.
- 6 Air ducts connecting fan housing to air bag below each boot. The operator's toes fit snuggly between each pair of ducts.
- Ocompartmentalised air bag provides strength and stability when in use on all surfaces.
- 3 Slits in the base of each air bag create an air cushion for lift.
- 9 Battery flap button.
- Battery in shoe heel provides power for both lift fan and rear propeller.
- Propeller assembly mounting plate and battery housing.
- Power cable linking propeller motor to battery.
- 13 Propeller electric motor.
- Rear-mounted propeller provides forward propulsion.
- 1 On/off switch built into top of propeller nacelle.

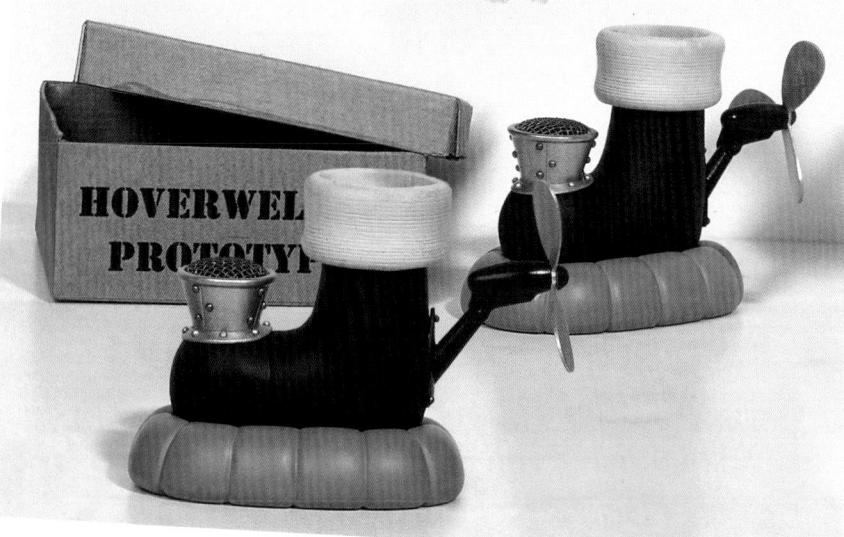

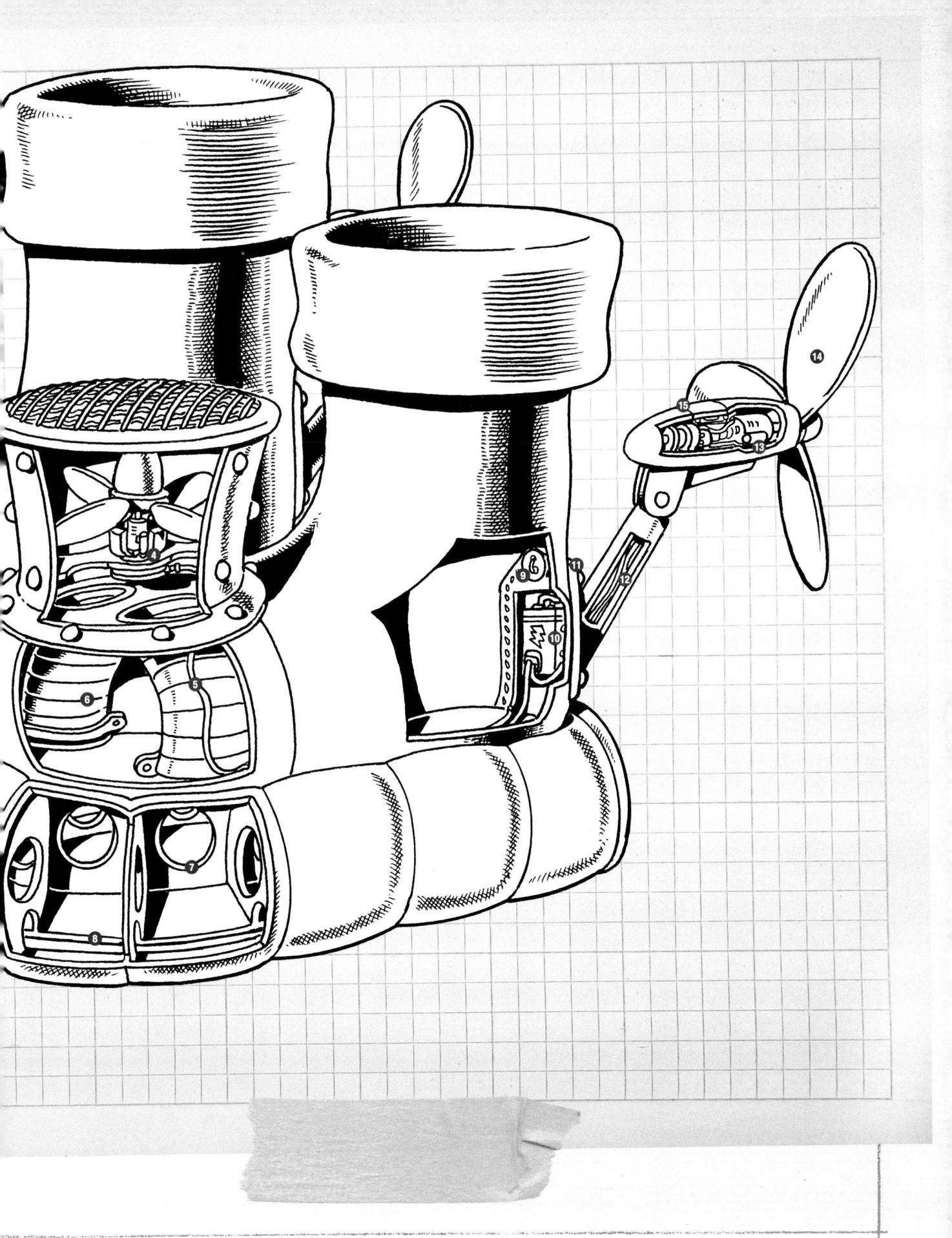

149 ×1

GYRO BROLLY

Contents

CONTENTSLIST

PAGE NO.

General description.....

Giyo Brolly cutaway

150 42

HEADING

General description

BODY COPY

DEOP

he Gyro Brolly is designed to satisfy the needs of today's busy commuter as well as the more casual umbrella user. It provides not only a degree of protection from bad weather but also, and ingeniously, a means of motorised personal air transport.

when not in use, the device may be carried discreetly, appearing to unknowing passers-by much like any folded umbrella, albeit a bulky one. Also, like any full-size umbrella, it can function as a walking stick and as a pointer for drawing people's attention to points of interest while strolling.

However, upon deployment, it becomes clear that this is no ordinary umbrella. The Gyro Brolly features a distinctive spiral hood, shaped to deflect rain and wind away from the user during inclement weather conditions. The design of the hood incorporates a number of features that prevent it from being blown inside out in high winds. These features alone render the Gyro Brolly instantly superior to its conventional counterpart.

Once the hood is unfolded, the second feature of the device is revealed. A small yet extremely powerful electric motor is fitted into a lightweight hub casing just above the curved handle. The battery-operated motor powers a driveshaft, which runs through the telescopic support column at the centre of the Gyro Brolly's hood. The driveshaft causes the hood to rotate and, by virtue of its unique helical design, acts as an 'air screw', thus lifting the entire assembly, and its user, into the air. The motor hub remains stationary relative to the rotating driveshaft, as does the umbrella handle and the user.

A few simple controls on the motor hub allow the user to start and stop the motor and control ascent and descent as required. Directional control is, however, a little more unpredictable, particularly so in high wind conditions. Should the motor stop working, or the battery become discharged, the device enters failsafe mode whereby the user simply 'parachutes' to the ground, hopefully landing somewhere near a bus stop.

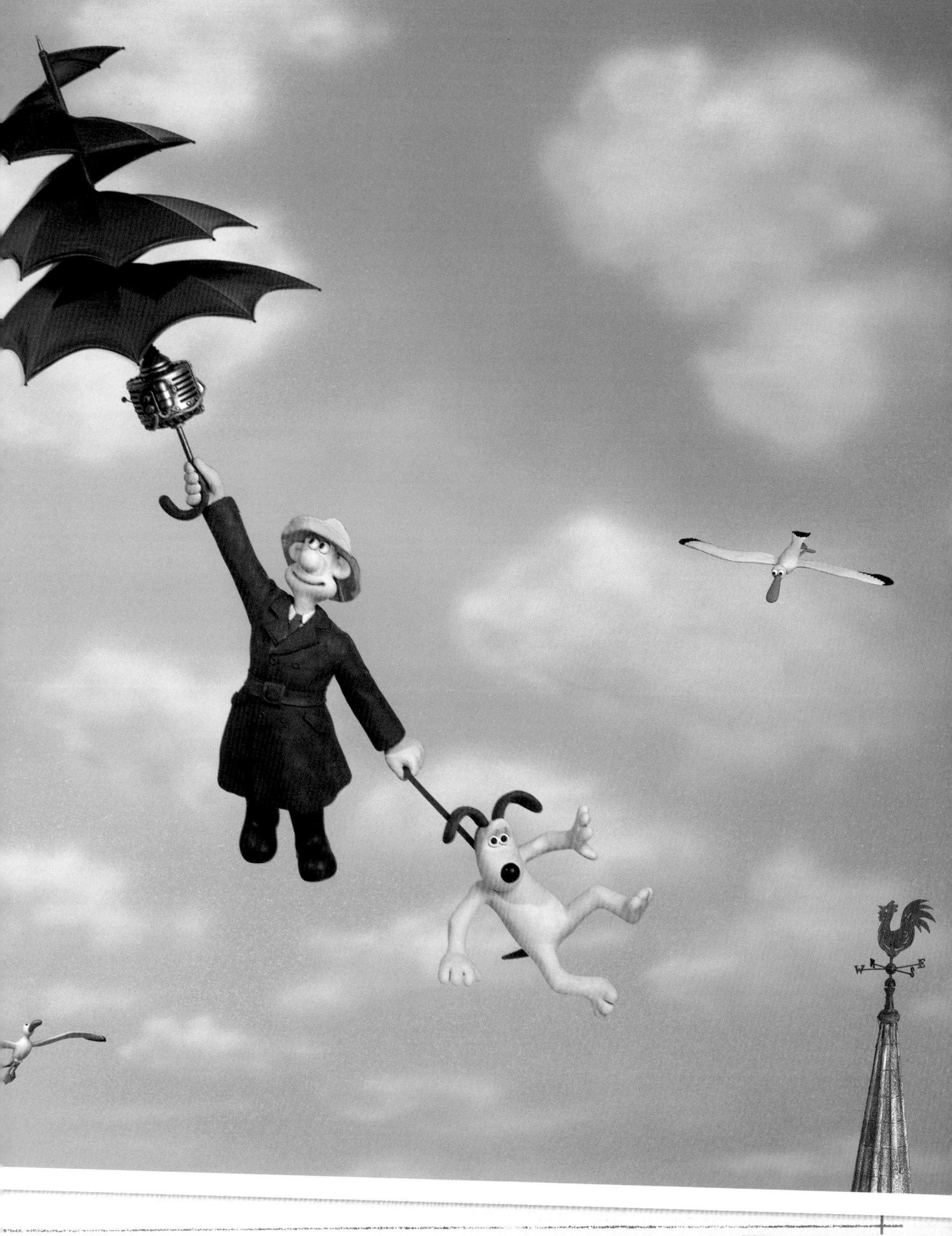

48

Gyro Brolly

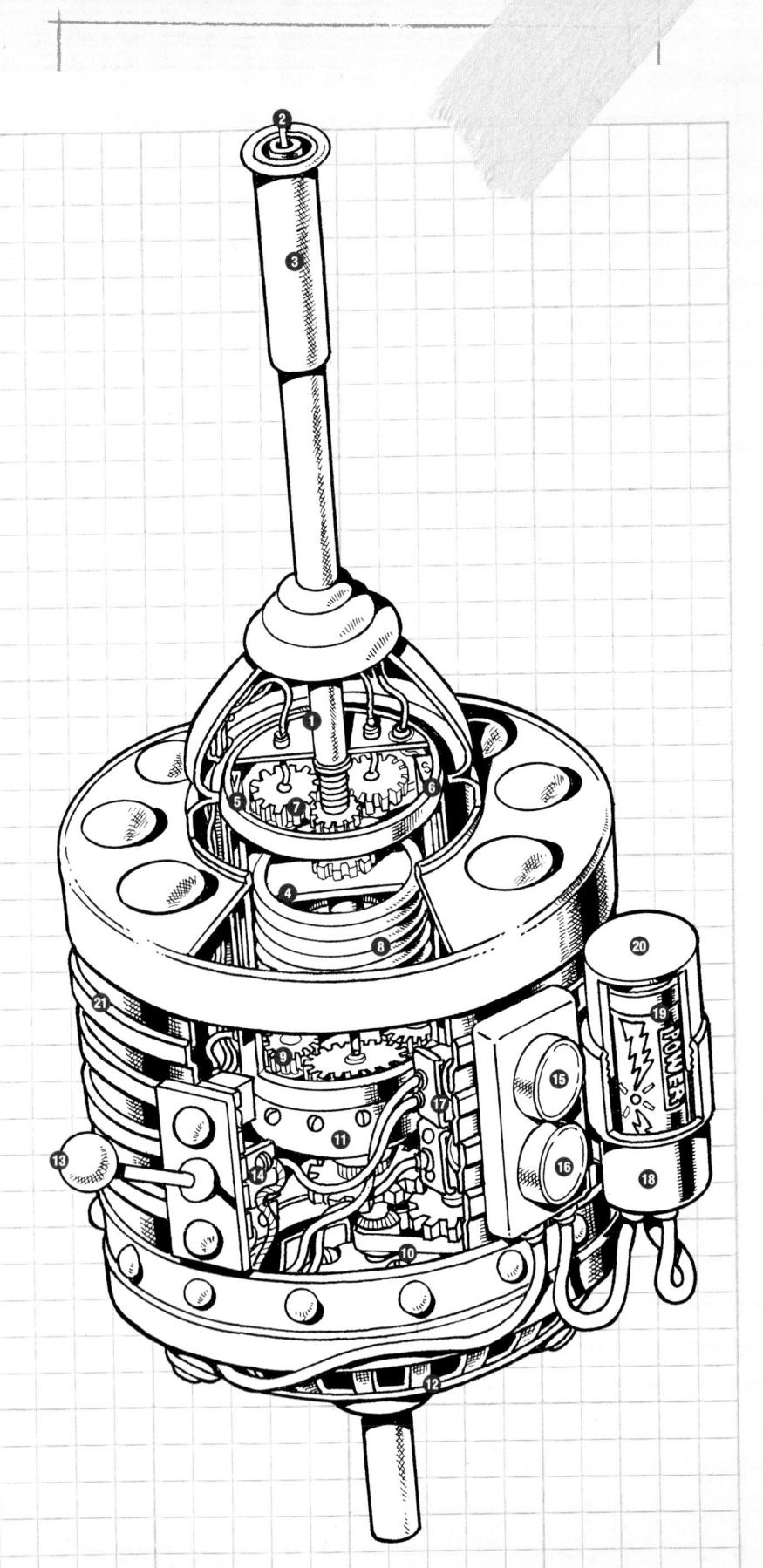

- 1 Umbrella internal deployment rod.
- 2 Deployment rod control line.
- 3 Drive shaft.
- 4 Wire coil support armature.
- 5 Stator permanent magnet.
- 6 Reversed stator permanent magnet.
- 1 Armature control gearing.
- 8 Armature wire coil.
- O Drive shaft speed control gearing.
- Speed control gearing belt drive.
- 1 Cooling fan enclosure.
- Cooling fan lower heat outlet grille.
- © Controlled ascent/descent lever.
- 1 Switching circuitry.
- 19 On/off power switch.
- 1 Umbrella deployment switch.
- To Switching circuitry.
- 18 Battery compartment.
- 1 Long-life battery.
- ② Screw-top battery compartment lid.
- Motor heat dissipation grille.
- 2 Dual-purpose umbrella hood prevents the user getting wet in inclement conditions and provides lift for flight when rotated.
- Aerodynamically shaped spar tips for balanced flight.
- 2 Telescopic hood support column.
- Powerful electric motor controls umbrella 'blade' rotation speed.
- 3 Super-grip umbrella handle.

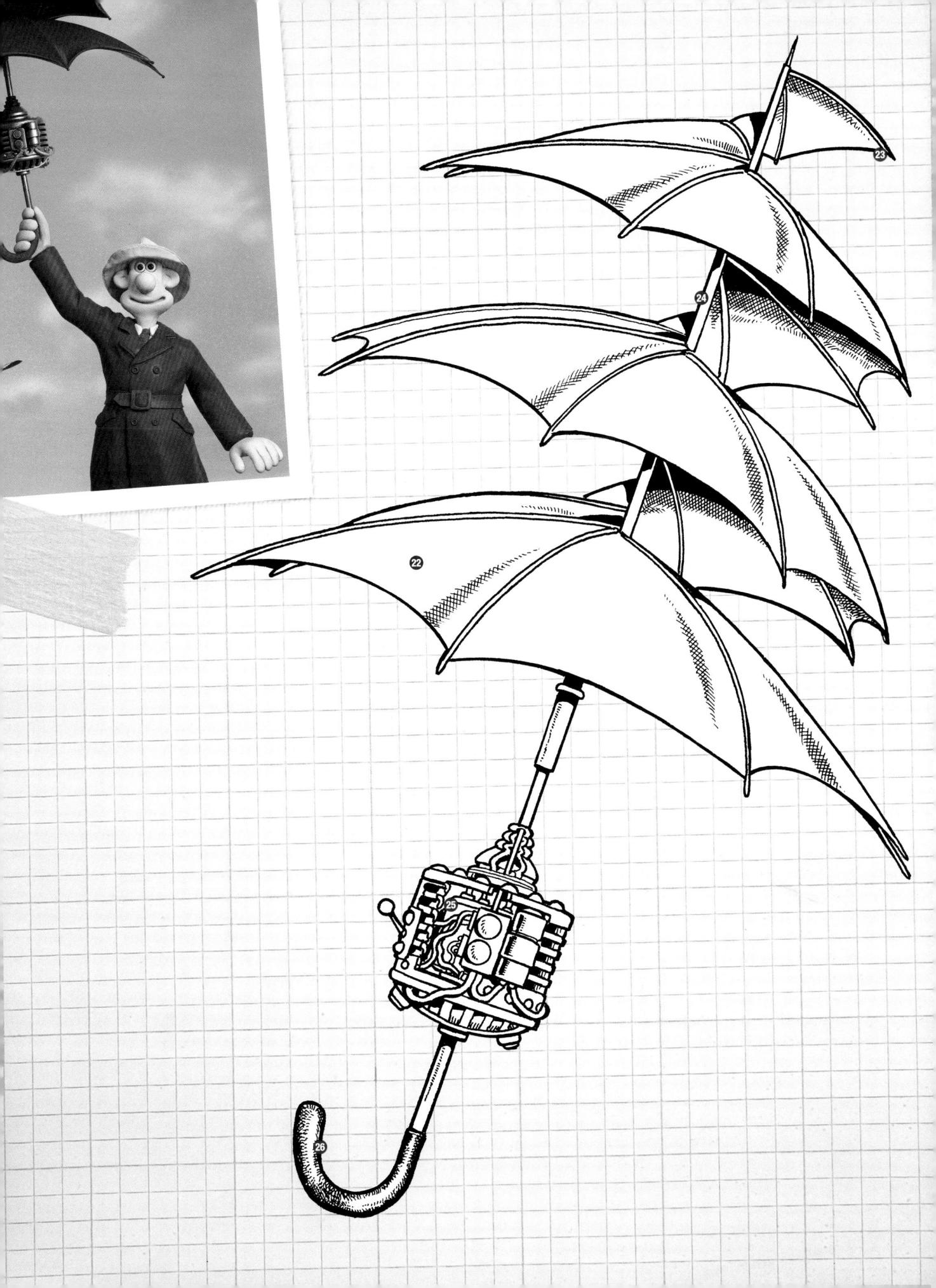

MK-I EASY IRON

Contents

CONTENTS LIST

, PAGE NO.

General description

54 46

Mk-l Easy Iron cutaway.....

156 48

SUB HEADING

General description

BODY COPY

he Mk-1 Easy Iron is designed to partially automate and greatly speed up the arduous task of ironing shirts, trousers and tank tops (the device could also be used to iron a full range of other garments, subject to further testing).

The main apparatus consists of a heat-resistant conveyor belt (the ironing board), which is driven by an operator (Wallace) by pedal power through a system of chains and gears. The ironing part is performed by two irons, which are strapped to the feet of an assistant (Gromit). The pedal operator selects the speed of the conveyor, depending on the type of garment to be ironed. He then places the garment on the conveyor, which carries it towards the ironing assistant, who then 'skates' over it with the irons strapped to his feet.

The irons themselves are attached to the assistant's feet by adjustable leather straps. They are connected to standard household power sockets by extra-long, flexible cables, which are coiled to take up any slack during use.

whereas a temperature dial is used to control the heat setting of a conventional iron, the Mk-l Easy Iron relies on the speed that the garment travels along the conveyor and hence the amount of time it spends in contact with the irons, which are held at a constant temperature by a fixed thermostat control. Cotton shirts require a slow speed setting to allow time for the assistant to iron out all creases, not forgetting collars and cuffs, while woollen tank tops and silk ties require a fast speed setting to minimise contact time with the irons and, hence, the chances of burning.

The Mk-l Easy Iron is not recommended for garments that traditionally require a very low heat setting (for example, nylon and acetate) unless the operator is prepared to pedal extremely quickly using the top speed setting.

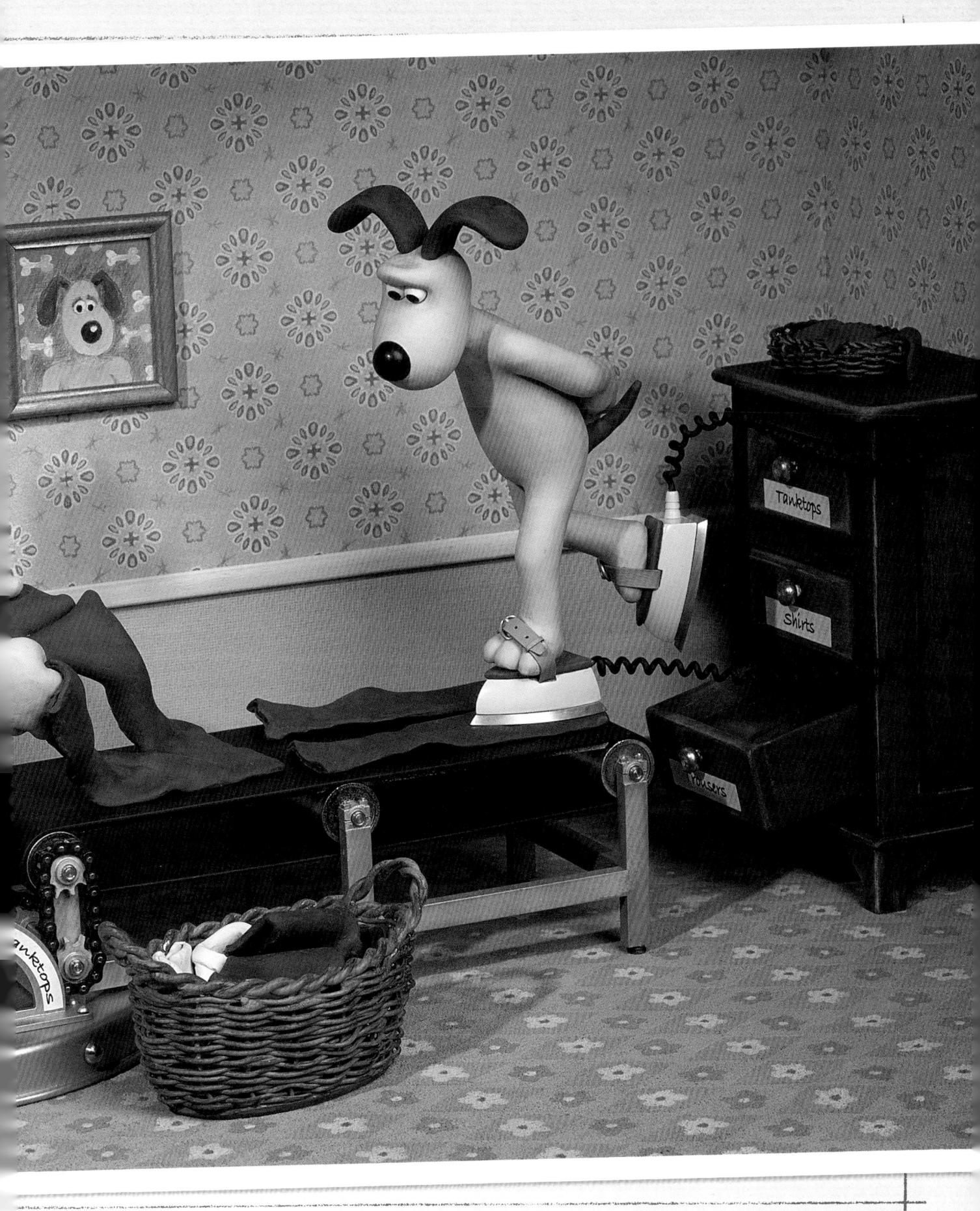

~155 ¥1

Mk-1

Easy Iron

BULLE

- Heat-resistant ironing conveyor belt.
- 2 Conveyor frame strengthened to take Gromit's weight.
- 3 Chain drive wheel.
- 4 Foot pedals.
- 5 Ironing speed control gearing.
- 6 Ironing speed chain drive linked to pedal system.
- 7 Pedal operator's saddle.
- Garment ironing selection lever is linked to chain drive and alters control gearing.
- 9 Iron.
- Meat-resistant and cushioned foot pad prevents Gromit's feet from overheating.
- 1 Adjustable foot strap.
- Plexible and insulated power cable.
- 1 Power points.
- 1 Ironing basket.
- Three-drawer cabinet stores ironed tank tops, trousers and shirts.
- 16 Wicker basket for ties.

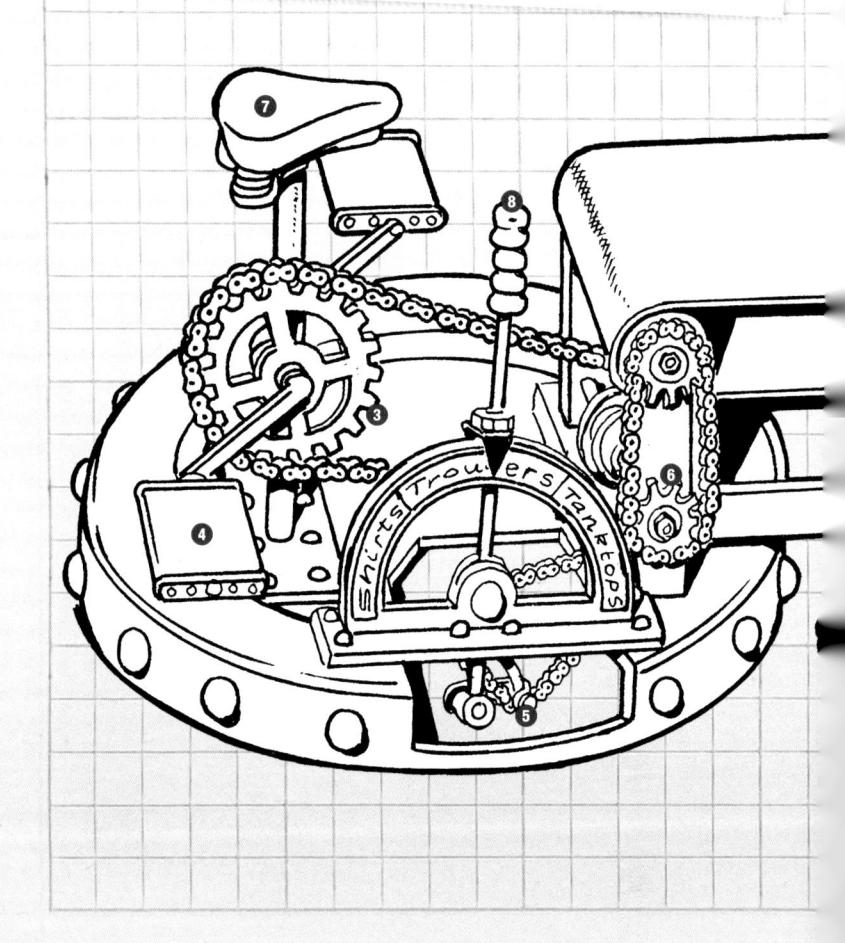

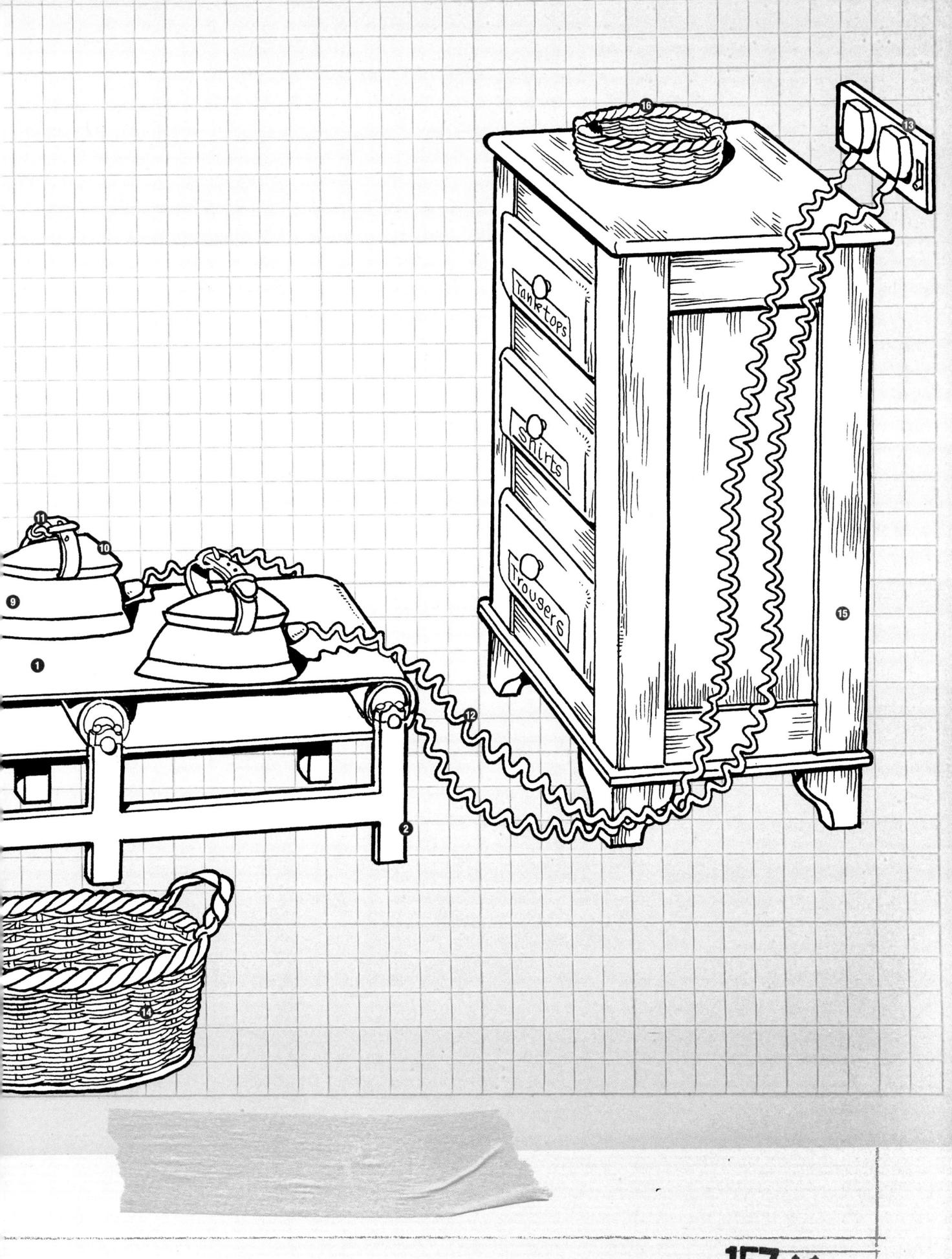

FUEL & DRIVKS DISPENSER

HEADING

Contents

CONTENTSLIST

, PAGE NO.

General description

5850

Fuel & Drinks Dispenser cutaway.....

160 52

HEADING

General description

BODY COPY

he fuel and drinks dispenser pump used in Wallace and Gromit's Top Bun bakery business is one of those ideas that makes you wonder why no one has thought of it before. It is a compact and elegant solution to the refuelling needs of vehicles and staff in and around the workplace.

Based on a standard forecourt petrol pump, the device serves four-star and unleaded petrol plus diesel, which are all drawn from underground storage tanks by an impeller pump and passed through an air separator unit in the base of the unit. The type of fuel is pre-selected by pressing the appropriate button on the front panel of the machine. This activates a selection valve that determines the correct underground storage tank to draw from.

In the top of the unit three thermo-insulated containers are filled with tea, coffee and milk. These are connected via flexible tubes to a drink dispenser pump and selection valve, with selection again activated by buttons on the front of the machine. From here, the selected beverage (tea or coffee, with milk to taste) is pumped via the fuel meter before delivery.

The delivery volume of the selected fuel/beverage is measured by a two-piston meter and displayed on a fuel quantity indicator on the front panel of the machine. The fuel/beverage is then dispensed via the fuel hose and nozzle in the normal manner.

The nozzle is fitted with a hand-operated trigger and an automatic cut-off mechanism to prevent overfilling of fuel tank or mug. A display 'blimp' is mounted on top of the machine and illuminated when fuel and drinks are available.

≈159 ¥

Fuel & Drinks Dispenser

- 1 Fuel selection buttons.
- 2 Backlit fuel selection indicators.
- 3 Fuel indicator backlighting bulb and wiring.
- 4 Fuel volume indicator.
- Nozzle for van fuel tank or appropriate tea/coffee mug.
- Starting handle for pump motor and fuel volume indicator motor.
- Hand-operated compression trigger controls flow of fuel. Automatic cut-off prevents overfilling.
- 8 Fuel hose.

- Two-piston meter makes four revolutions for each gallon of fuel delivered.
- 10 Pump draws fuel from underground tanks.
- 1 Pump impeller.
- 12 Fuel selection valve.
- B Air separator.
- 10 Diesel pipe.
- 1 4 Star petrol pipe.
- 16 Unleaded petrol pipe.
- The Hose connects drinks dispenser pump and selection valve to main fuel system.
- Heating element maintains temperature of tea or coffee.
- 19 Drinks dispenser pump and selection valve.
- Thermo-insulated containers pre-filled each evening for use the next morning.
- 1 Drink refill caps.
- 2 Rear-mounted hose outlet.
- Front panel hinges forward allowing maintenance access.
- Wires to fuel pump display blimp internal lighting.
- 5 Fuel pump display blimp.

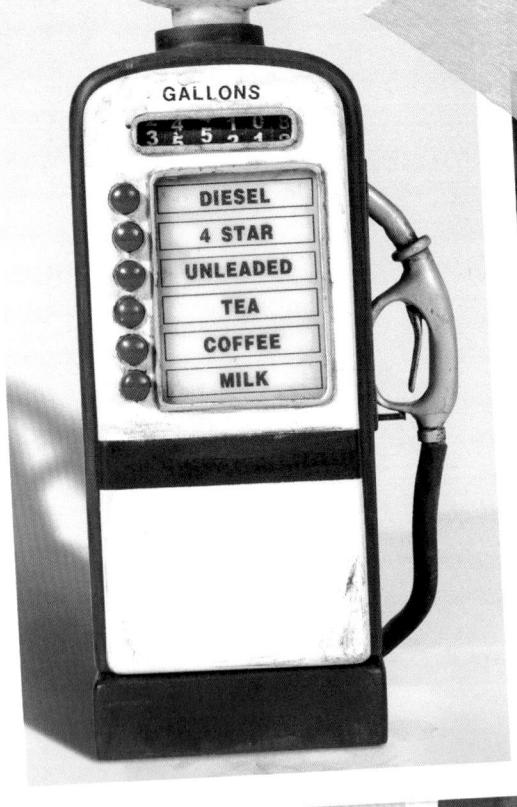

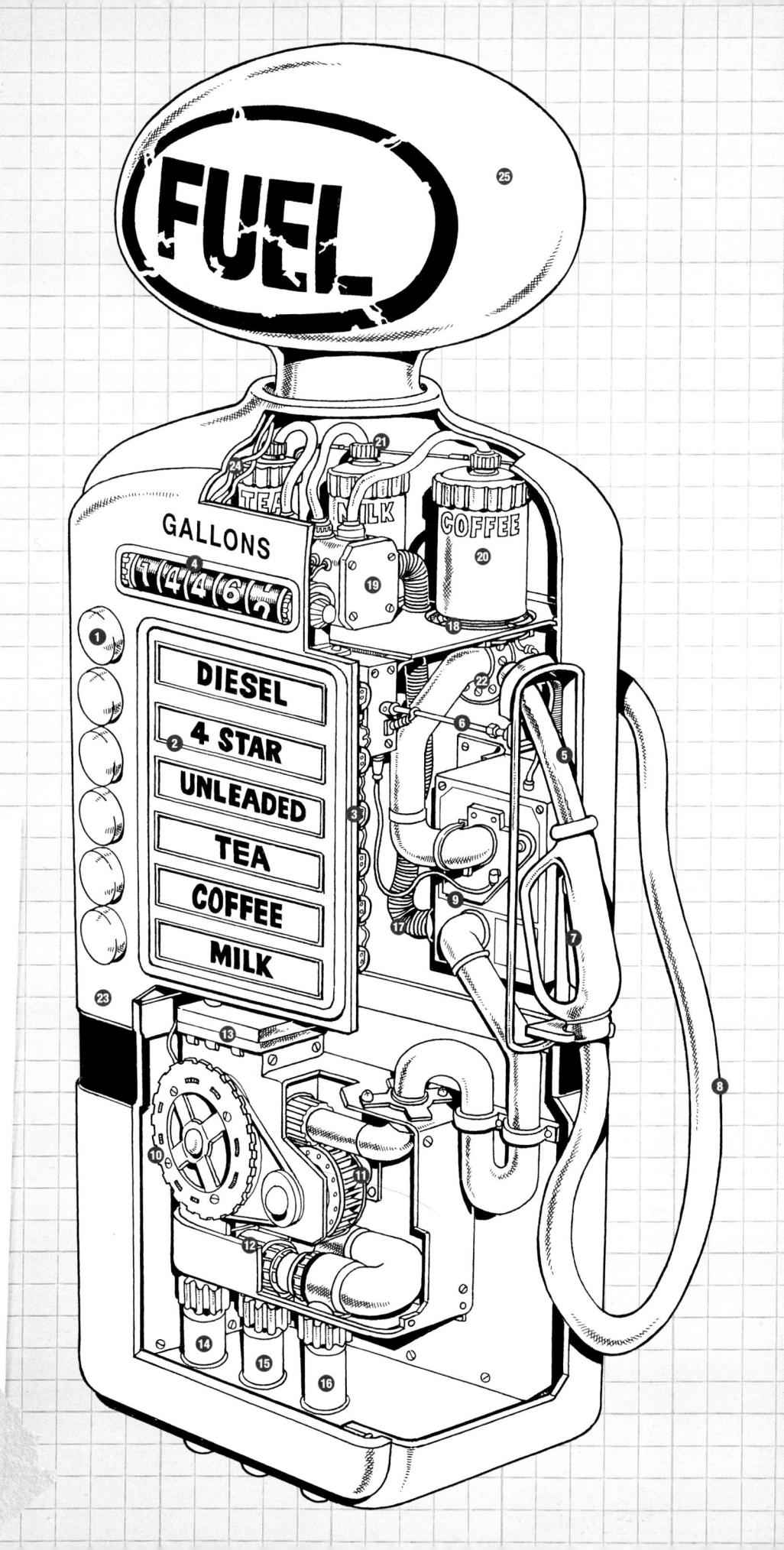

ANTI-PESIO LAUNCH SYSTEM

HEADING

Contents

CONTENTS LIST

, PAGE NO.

General description.....

62 3

Anti-Pesto Launch System cutaways...

6456

HEADING

General description

BODY COPY

ne of Wallace and Gromit's more adventurous business schemes is 'Anti-Pesto', specialising in high-tech pest-control. The company offers a range of tailor-made services to deal with pests such as rabbits, rats and insects (but particularly rabbits), which threaten vegetable gardens and allotments, and cause torment for their nervous owners. The Anti-Pesto team (Wallace and Gromit) are especially skilled in the humane capture of rabbits, and they have developed a number of ingenious contraptions to lure, bait and trap them without harm. Many of these are simple and effective while some are considerably more elaborate. One such device is the 'Bun Vac 6000', which is covered in detail later in the book.

As the annual vegetable competition at Tottington Hall draws closer, local residents are becoming extremely anxious, and many are willing to go to great lengths to protect their potential prize-winning vegetables from vermin and unscrupulous rivals alike. The stakes are high and Anti-Pesto's services are in huge demand.

The Anti-Pesto 'Special Wardrobe and Tools' (SWAT) team is an elite pest-control operations unit, which is ready to respond quickly at any time to any pest emergency that arises. The gardens and greenhouses of Anti-Pesto's clients are protected by sophisticated intruder alarms and early-warning systems. Infrared and sonic motion sensors and expertly concealed surveillance cameras are just some of the devices employed to provide the ultimate in vegetable protection. These systems are all linked directly to Anti-Pesto's headquarters at 62 West Wallaby Street. Not only do they alert the SWAT team instantly of pest activity in the area but they also trigger the automatic launch system that can scramble the team within two minutes even in the middle of the night.

The following pages describe the various elements of the launch system in step-by-step detail.

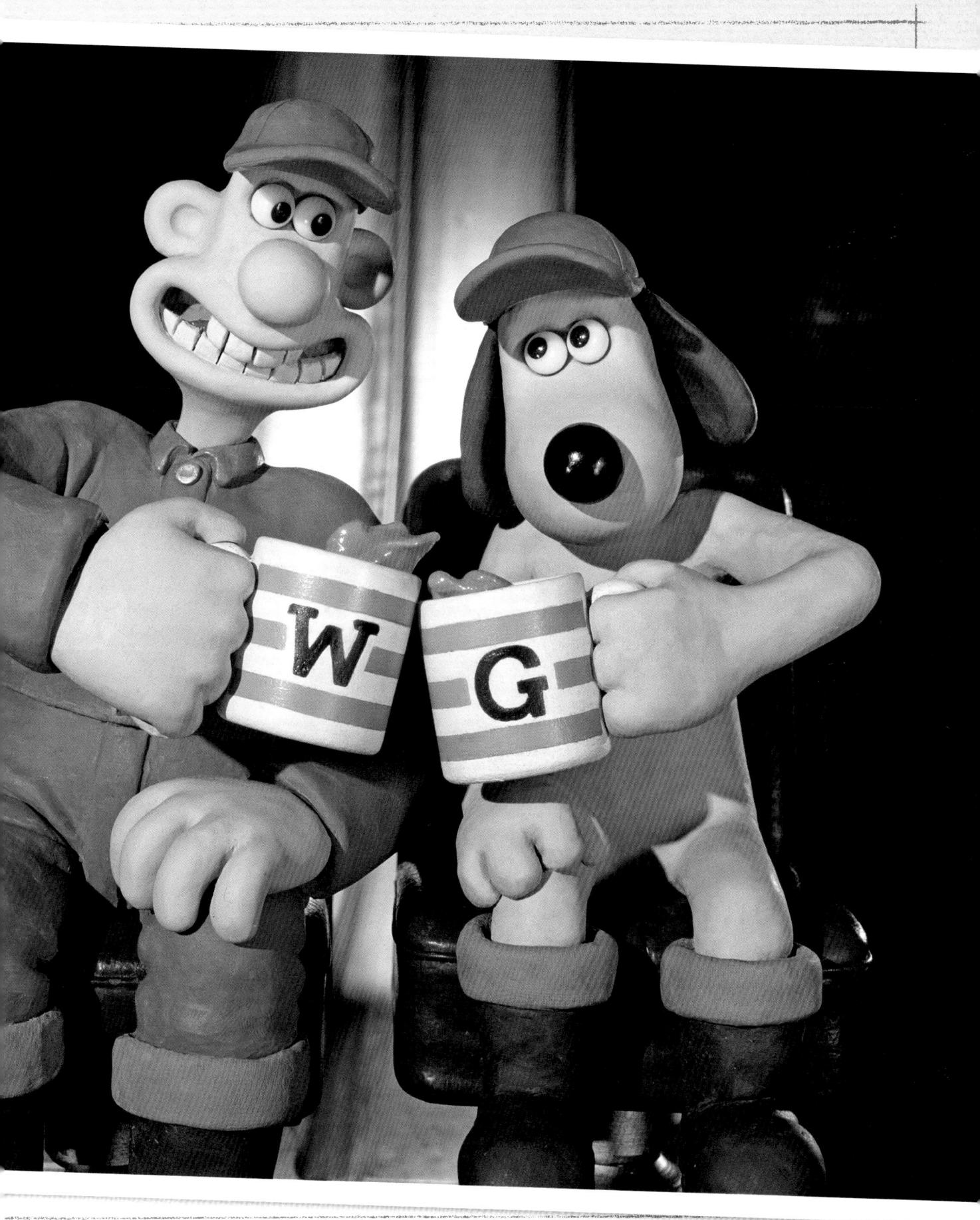

163 54

Anti-Pesto Launch System

- A boiling kettle on the timer-controlled cooker begins the launch sequence.
- Steam from the kettle turns the wall-mounted turbine.
- The turbine is connected to a pulley and rocker, which activates the wake-up pole.
- 4. The wake-up pole wakes Gromit, just in time for phase two. ...
- 5. The beds tip backwards through sliding panels in Wallace and Gromit's respective bedrooms.
- Wallace and Gromit slide down the chutes, coming to rest head first. Their night caps are discarded by the impact.
- 7. Wallace and Gromit's caps are automatically \neg fitted to their heads.
- The bottom of the chute tips downwards, allowing Wallace and Gromit to continue their journey feet first.
- Wallace and Gromit continue their journey down towards the catapult at the bottom of the cellar.
- 10. Once they 'land' in their waiting boots, cups of tea are supplied by the automated dispensers.
- 11. The catapult then swings round, ready for phase four. ...
 - ♠ Shoulder restraints prevent Wallace and cromit from sliding any further.
 - 15 Auto-cap deployment arms.
 - 16 Chute direction auto-changer.
 - @ Extractor fan.
 - © Cellar air-conditioning system.
 - 19 Foul-air extraction pipes.
 - Top of launch system power plant
 - 1 Launch system power plant.
 - ② Catapult activation arms, retracted into cellar/sub-basement floor space.
 - 3 Catapult mechanics.
 - 2 Tea maker One.
 - Tea maker Two.
 - 3 Boots.

- 12. Once the catapult has swung round, activation grips pull the lower end towards the floor.
- 13. The grips are released, launching Wallace and Gromit into a double piked somersault as they approach the final section of the launch chute.
- Wallace's downward motion allows him to don his overalls.
- 15. They continue their journey on the final section of the launch chute.
- 16. Wallace and Gromit come to rest on the folded down seats of the A35 Van at the bottom of the chute.
- 17. The seats and occupants are lifted on hydraulic rams up towards the waiting van in the garage above.
- 18. A hatch in the floor of the garage opens up to allow Wallace and Gromit to enter the van from below.
- 19. The seats enter the van via hatches in the floor and are secured in position by the seating support stanchions (see page 80) before the hydraulic rams retract and the two sets of hatches close.
- 20. The now-empty tea mugs are placed on retractable trays, and the van is ready to begin the 'Autostart' procedure using the crank handle (see page 80).

- Gas cooker with built-in timer switch (can also be activated by garden gnome alarm systems).
- 2 Kettle.
- 3 Wall-mounted steam turbine.
- 4 Pulley and sprung rocker.
- 6 Wake-up pole.
- Geared lifting mechanism pushes up through bedroom floor to tip bed backwards.
- @ Gromit's bed.
- Bed tipping hinge.
- 1 'Stinking Bishop' cheese.
- 10 Cheese deployment arm.
- Wallace's bed in upright 'Go' position.
- 1 Bed lifting mechanism.
- 1 Chute support beams.

- 2 Power plant.
- 23 Catapult.
- 29 Catapult activation grips.
- 30 Wallace's overalls.
- (1) Chute leading to subbasement beneath garage.
- 32 Sub-basement.
- Van seats lie flat with the backs horizontal at the end of the chute so that Wallace and Gromit can slide directly onto them.
- Retracted seating support stanchions.
- 35 Retractable tea mug trays.
- Tea mug tray retraction arm power unit.
- 3 Back wall of garage.

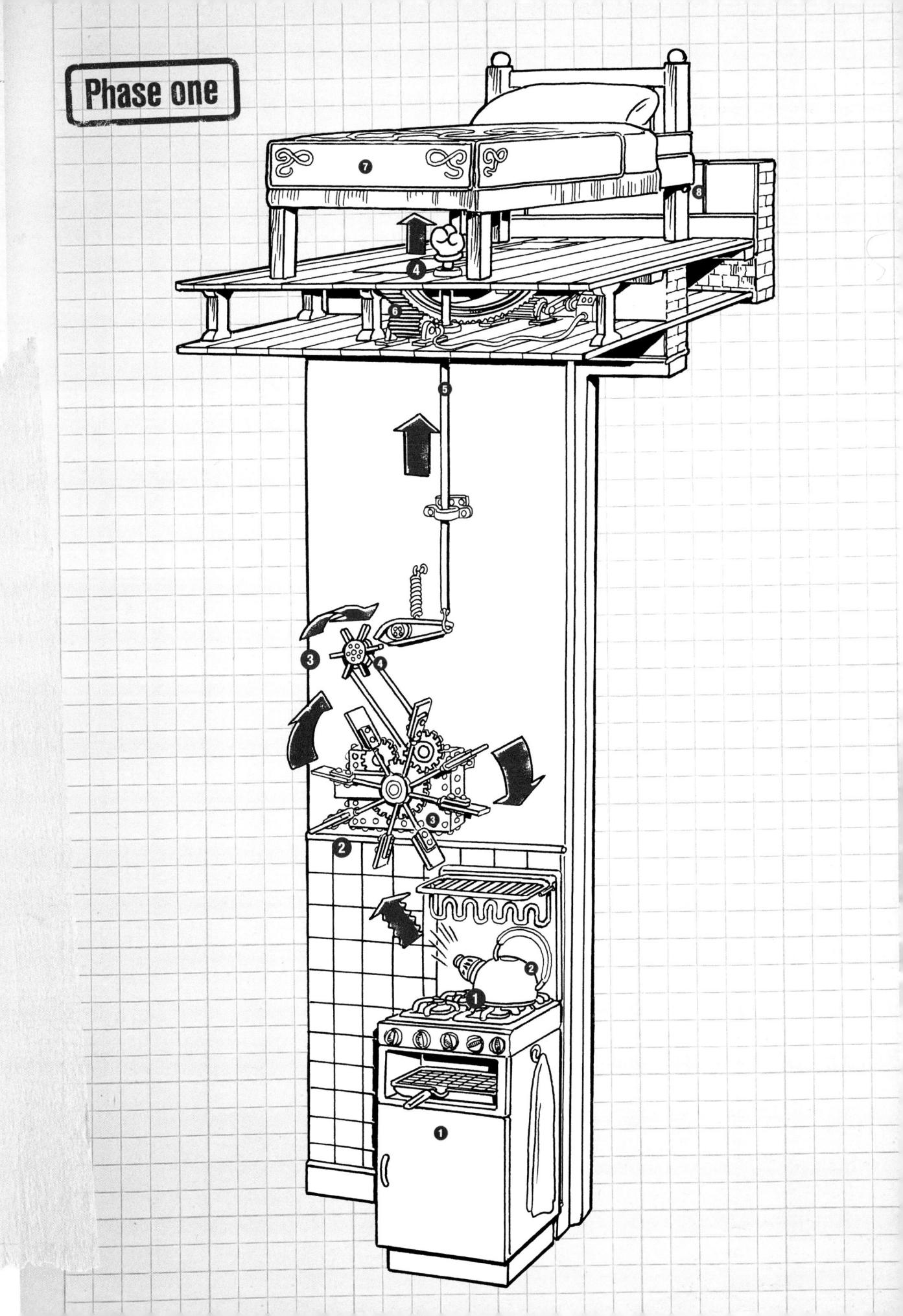

Anti-pesto launch system

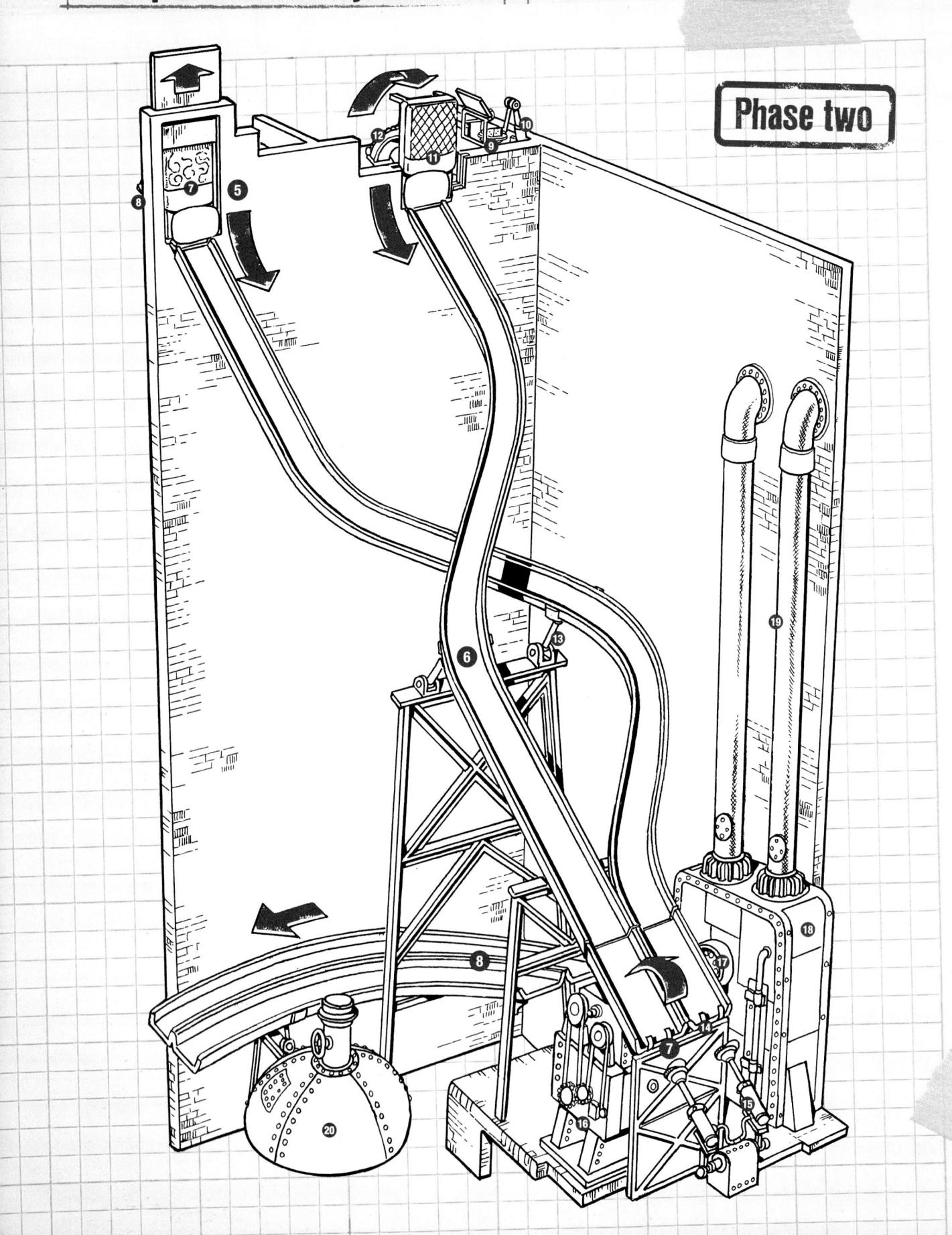

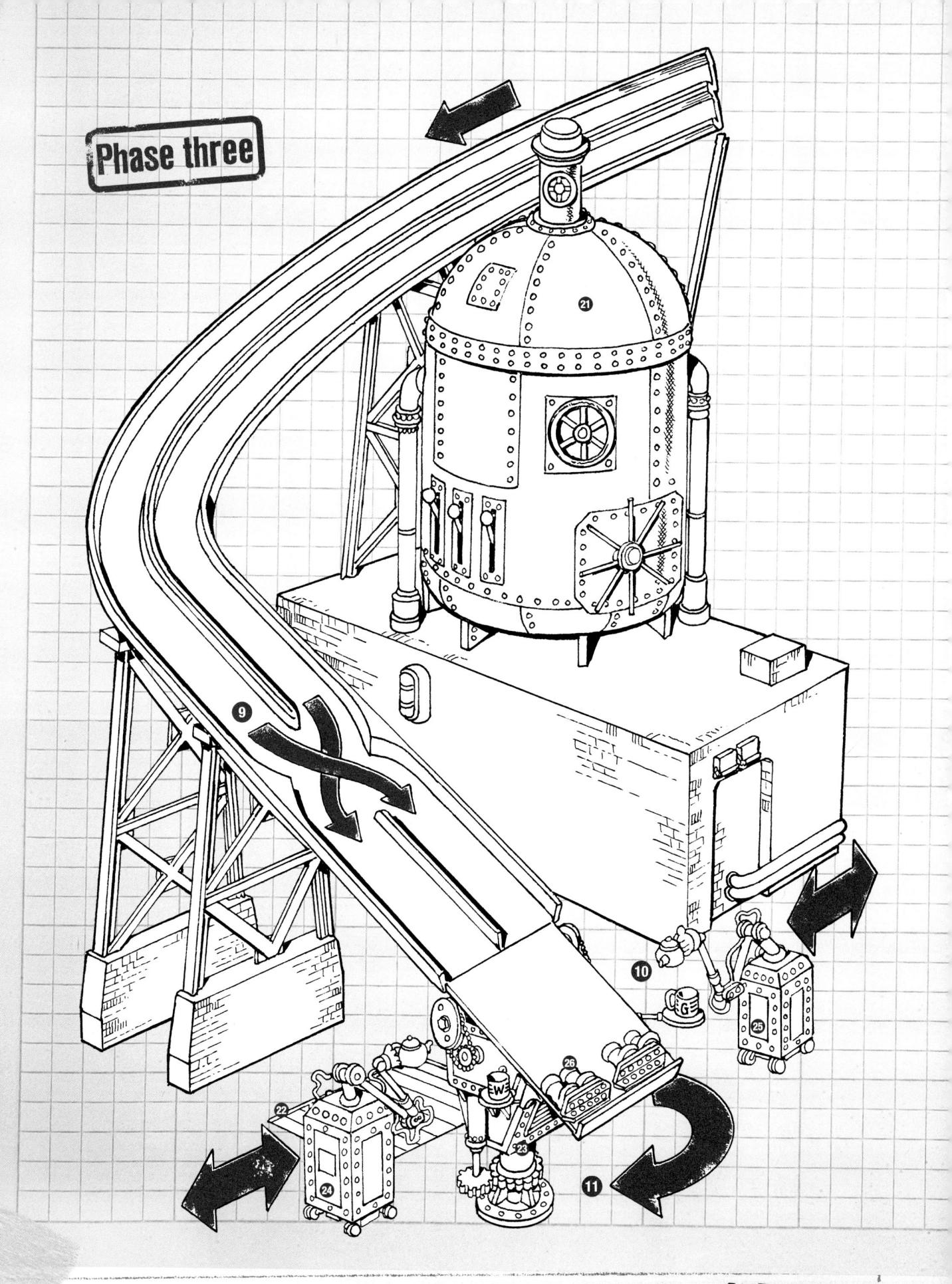

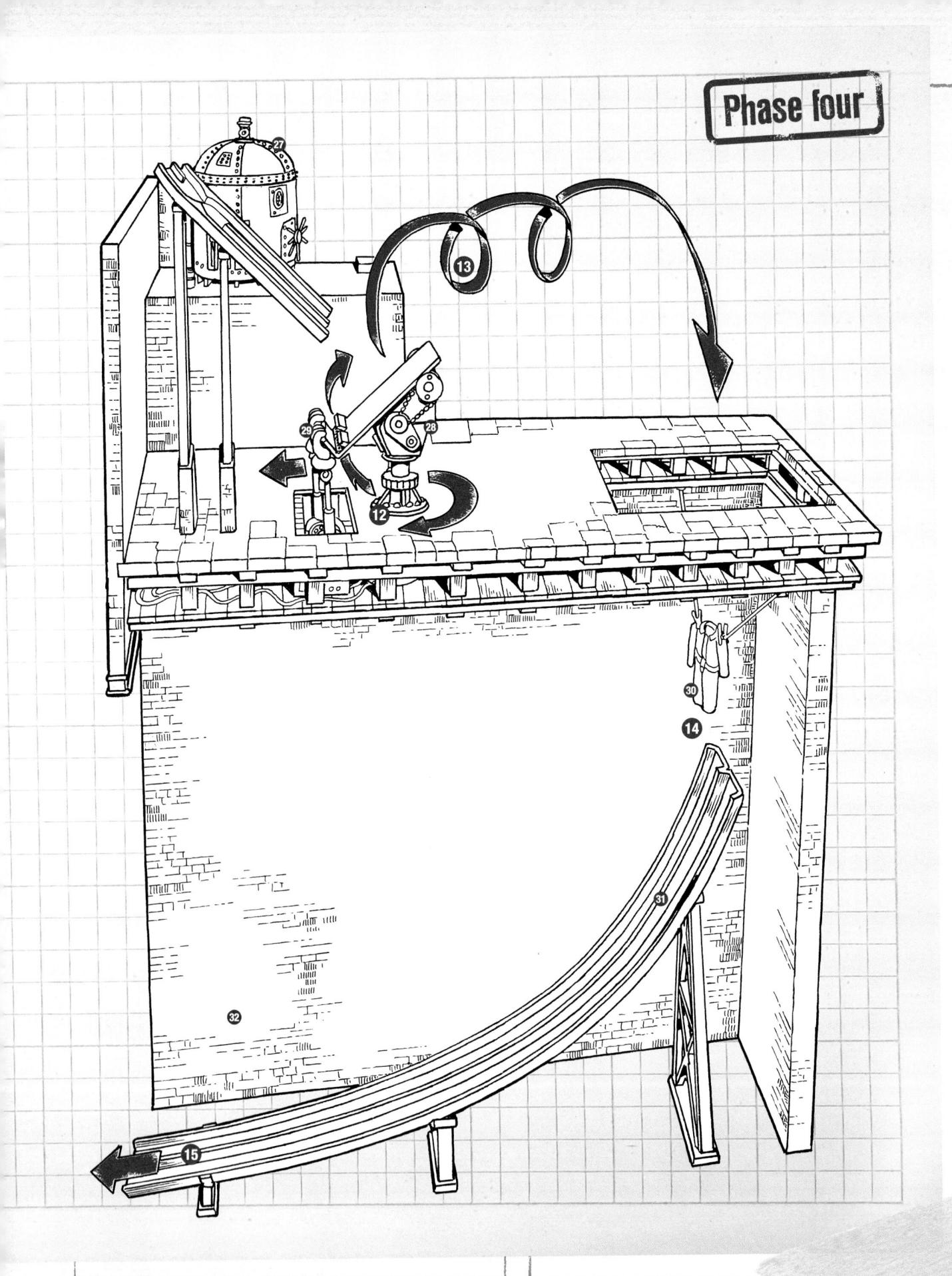

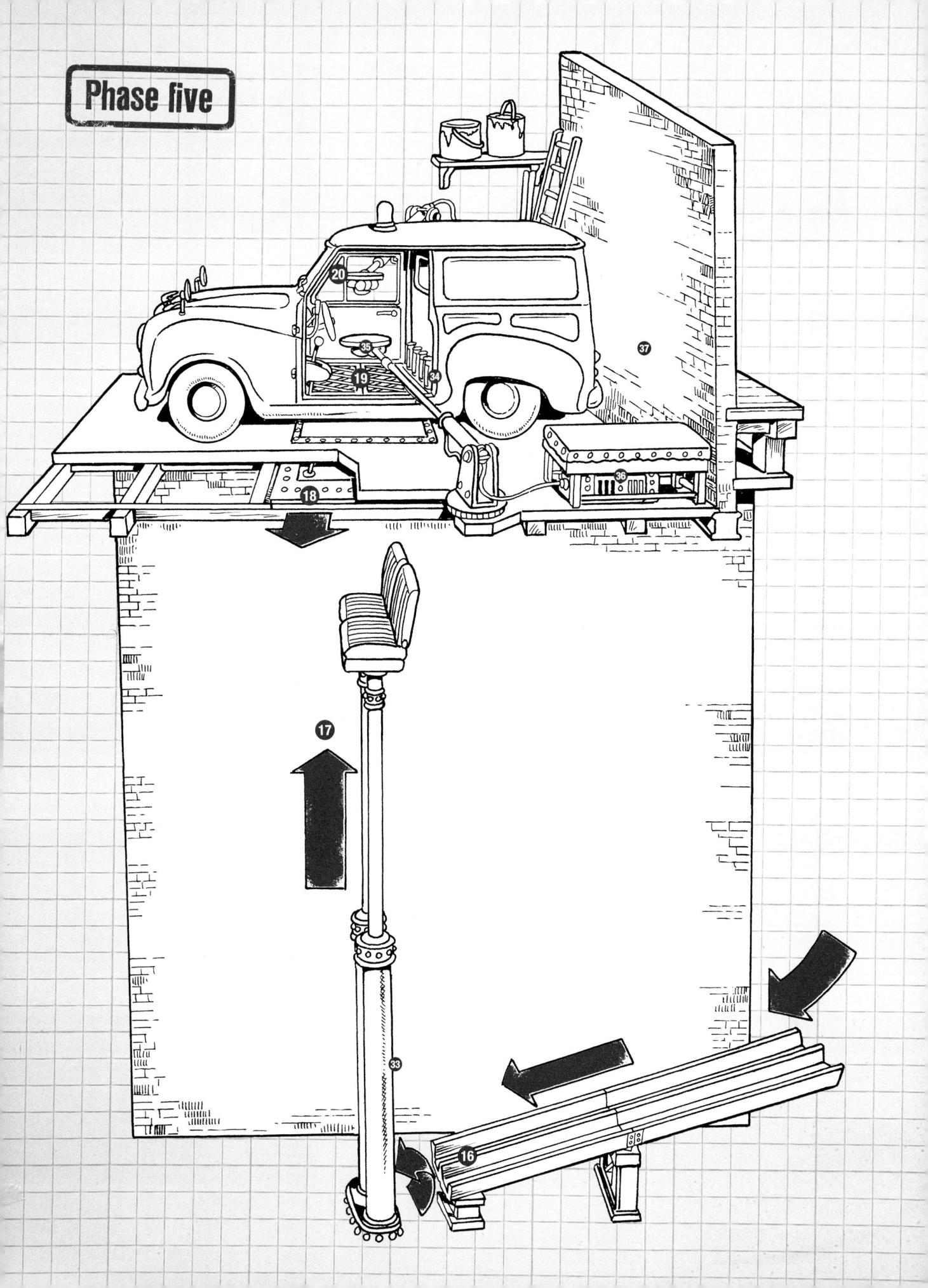

Contents

CONTENTS LIST

General description

Garden Exit System cutaway......

General description

allace and Gromit's various enterprises have often required the use of a vehicle, most notably either the motorbike and sidecar or the Austin A35 Van. On many occasions, a quick getaway is called for, whether to dash to an urgent window-cleaning assignment, respond to a pest-control emergency, or make the early-morning bread delivery run. Time is of the essence, and Wallace and Gromit have devised many elaborate contraptions to get them from the house, into their vehicle and ready to go in the shortest time possible. It is essential therefore that not a moment is lost as the vehicle finally leaves the garage.

Upon exiting the garage the vehicle passes over a discreet pressure pad, which is built into, and disguised as part of, the garden path. The load pushes down on a pressure switch beneath, which activates several mechanisms hidden below the ground. The first is the garden pond plinth, which is rotated through 180 degrees to reveal a continuation of the driveway on the underside. The plinth rotates on a hardened steel axle, the movement being actuated by a high-torque electric motor and transfer pulley and gears.

Having passed over the pond, all that now lies between the van and the road is the garden wall and fence. A complex system of ropes, pulleys, flywheels and counterweights, driven by further electric motors and servomechanisms contained in a single housing, act to lower the garden wall into the ground (leaving the coping stones flush with the path) and raise the fence out of the way, allowing the van to pass. The mechanism to raise the fence panel is contained within one of the garden wall columns and actuated from beneath.

The entire 'basement' below the garden path is accessible via a door from the cellar of the house, enabling maintenance work to be carried out as required.

Once the van has cleared the garden wall, the mechanisms are reversed, and the garden returns to normal.

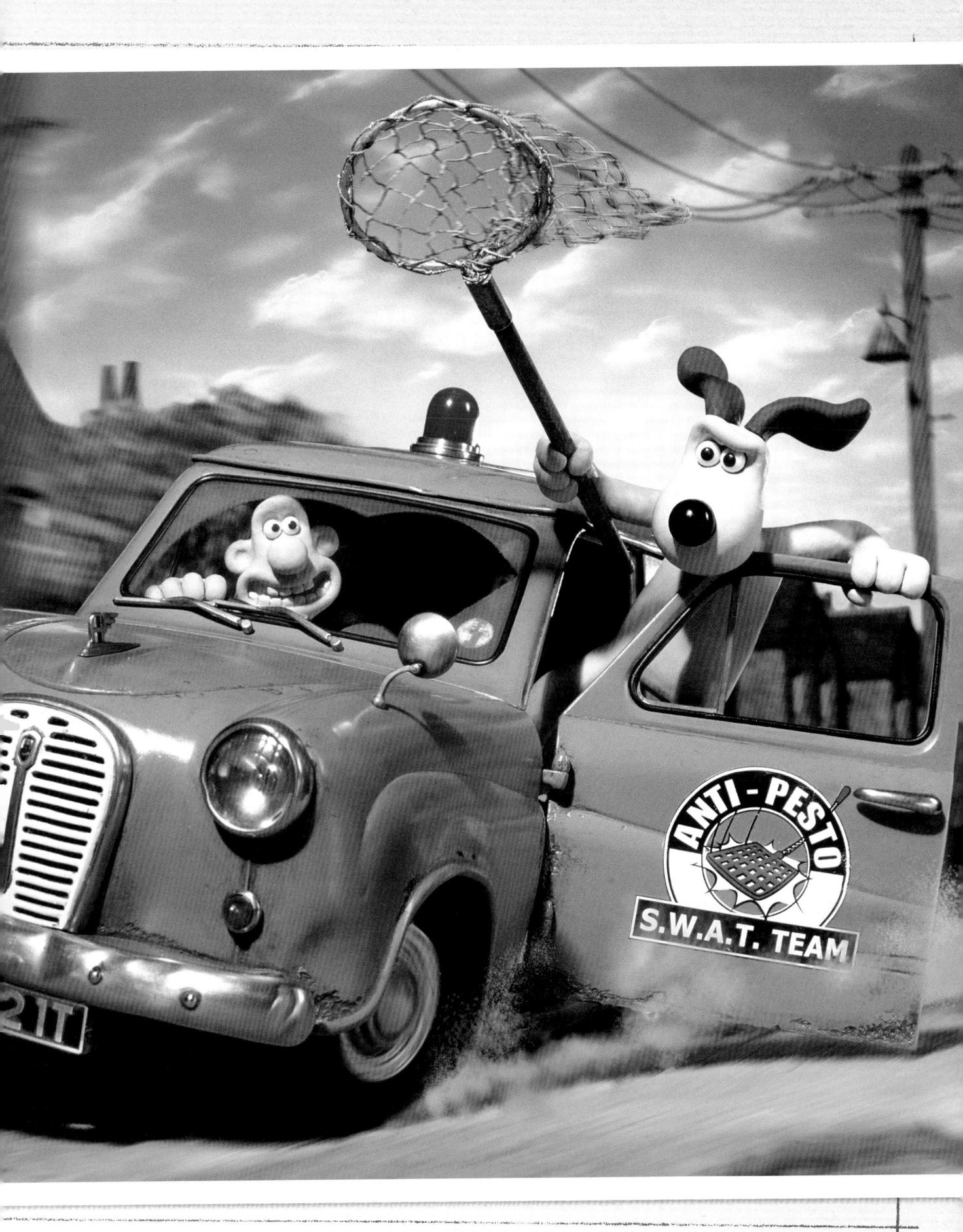

FO10 71 08

Garden Exit System

- Garden gadget activation pressure pad. As the van drives towards the pond, the paving lowers slightly and activates a pressure switch controlling the pond, wall and fence mechanisms.
- 2 Pressure switch.
- 3 Control box.

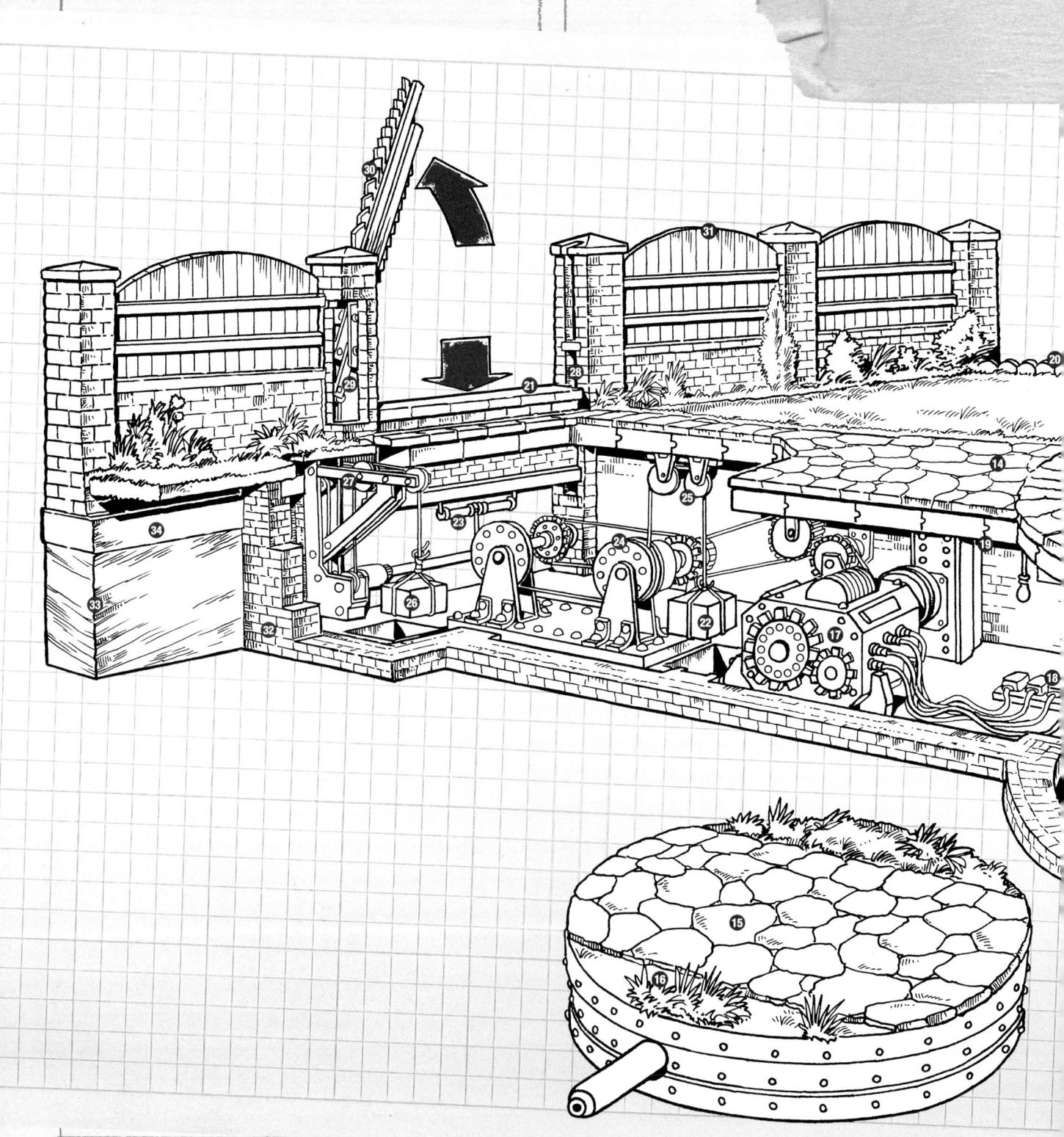

- 4 Door to basement from garage and cellar.
- 6 Well-kept lawn.
- 6 Steel-bonded plinth rotates to reveal a continuation of the driveway on the underside, immediately before the van passes over it.
- The gnome's fishing rod is connected to the plinth and rotates with it.
- ® Pond statue.

- Top side of 'pond' is covered in clear resin, creating a water-like effect.
- Garden gnome sitting on the pond's paved surround maintains its position as the plinth rotates.
- 1 Hardened-steel pond rotation axle.
- 1 Plinth rotation gearing.
- 13 Plinth rotation clearance pit.
 - Crazy-paving driveway.
 - Underside of plinth is designed to match the crazy paving of the driveway leading from the garage to the disguised garden wall exit.
 - 6 Artificial plants.
 - 1 Electric motors.
 - 18 Power distribution board.
 - Interlocking concrete driveway base supports.
 - 20 Edge of garden footpath.
 - Wall lowers to ground level allowing van to drive through.
 - 2 Wall-lowering counterweight.
 - 3 Wall underside lowering hook.
 - ② Flywheel system simultaneously controls fence raising and walllowering mechanisms.
 - © Counterweight flywheel pulley system.
 - 3 Fence-raising counterweight.
 - @ Fence-raising mechanism.
 - 29 Fence wall slots.
 - 49 Hollow garden wall column houses fence beam mechanism.
 - Wooden fence is raised at the same time as the wall is lowered.
 - wall and fence facing onto West Wallaby Street.
 - Brick retaining wall of basement.
 - 3 Subsoil.
 - 3 Base of garden wall.

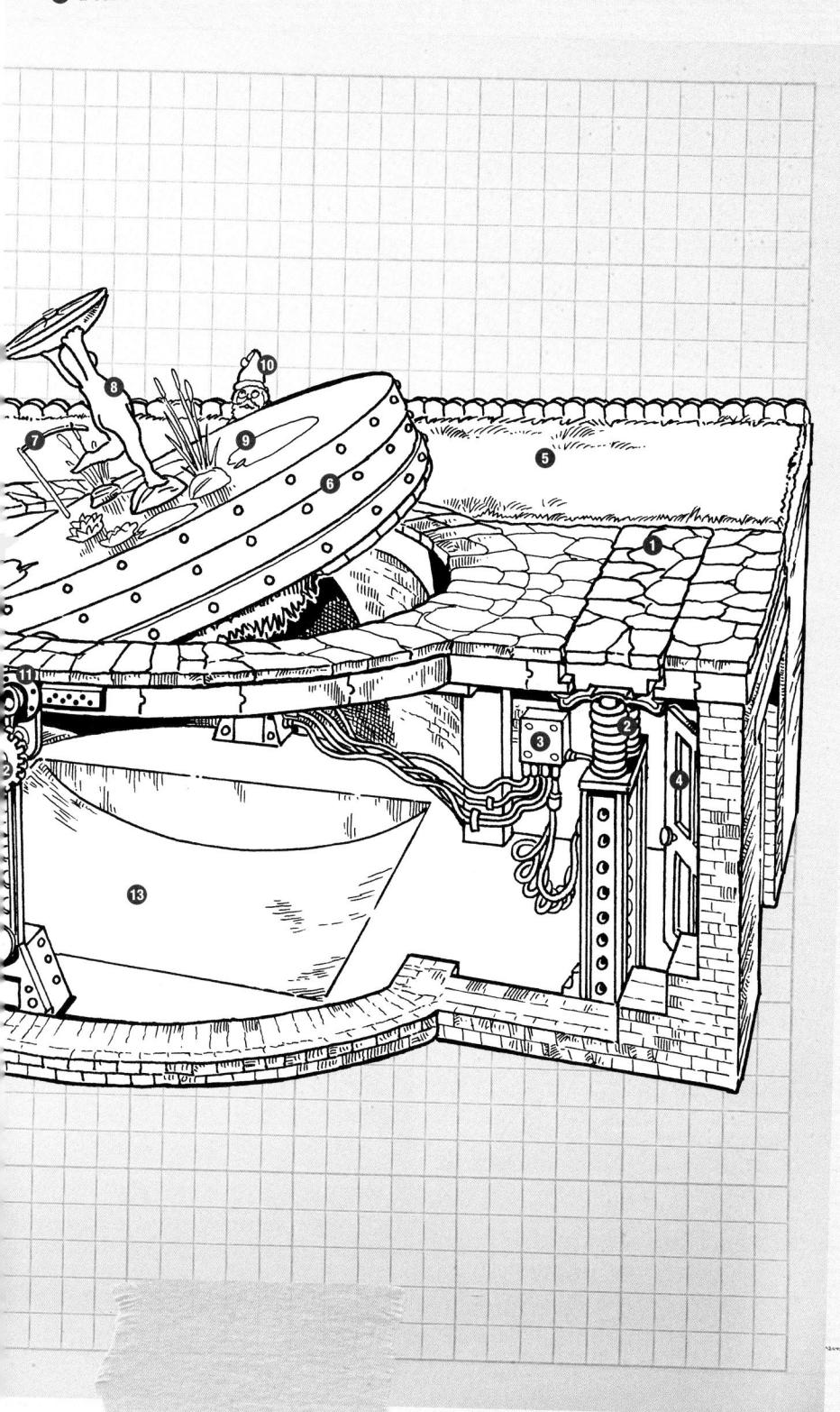

BUN VAC 6000

HEADING

Contents

CONTENTS LIST

, PAGE NO.

General description....

174 80

Bun Vac 6000 (deployment) cutaway

176 68 70 70

Bun Vac 6000 (fully deployed) cutaway ...

SUB HEADING

General description

BODY COPY

DROP

nti-Pesto has developed the very latest in humane pestcontrol technology, and the Bun Vac 6000 is the ultimate solution when it comes to large-scale rabbit infestations.

Although a large and complex device when in use, the Bun Vac 6000 compacts neatly into a 'pod', which replaces the rear section of the Austin A35 Van. While in transit the pod makes the Anti-Pesto van appear completely normal from the outside. Upon arrival at the scene of the rabbit infestation, Bun Vac deployment is initiated by a button in the cab.

First, hydraulic support legs are extended from each side of the vehicle to provide stability when the Bun Vac is in use. The sides and back of the 'pod' fold down in three sections, after which they are completely removed by hand. This reveals the Bun Vac in its compact stowed state, and full deployment commences immediately as various hydraulically actuated components are extended and slotted into place to form the lower bodywork of the device.

The main section of the Bun Vac comprises upper and lower cylinders, which are formed from glass panels and supported by four stanchions positioned around the lower cylinder. The resulting structure is a large vacuum cylinder, which is airtight. The steel cylinder cap comprises a vacuum pipe attachment valve and filter, to which a series of vacuum pipes can be fitted.

Finally, a control panel and operator's seat attach to the top rim of the lower cylinder

A large suction fan is fitted into the centre of the base of the cylinder. During operation, this draws air out of the cylinder, thus creating a high vacuum inside. As a result, air is sucked into the top of the cylinder through the valve inlet and the various vacuum pipes. The last pipe ends with the 'bunny retrieval attachment' and this is placed over a convenient rabbit hole in the ground, thus extending the suction of the vacuum throughout the entire warren.

Rabbits are sucked up the vacuum pipe and deposited in the glass cylinder where they remain safely trapped but completely unharmed before being removed via an airtight retrieval hatch in the lower cylinder.

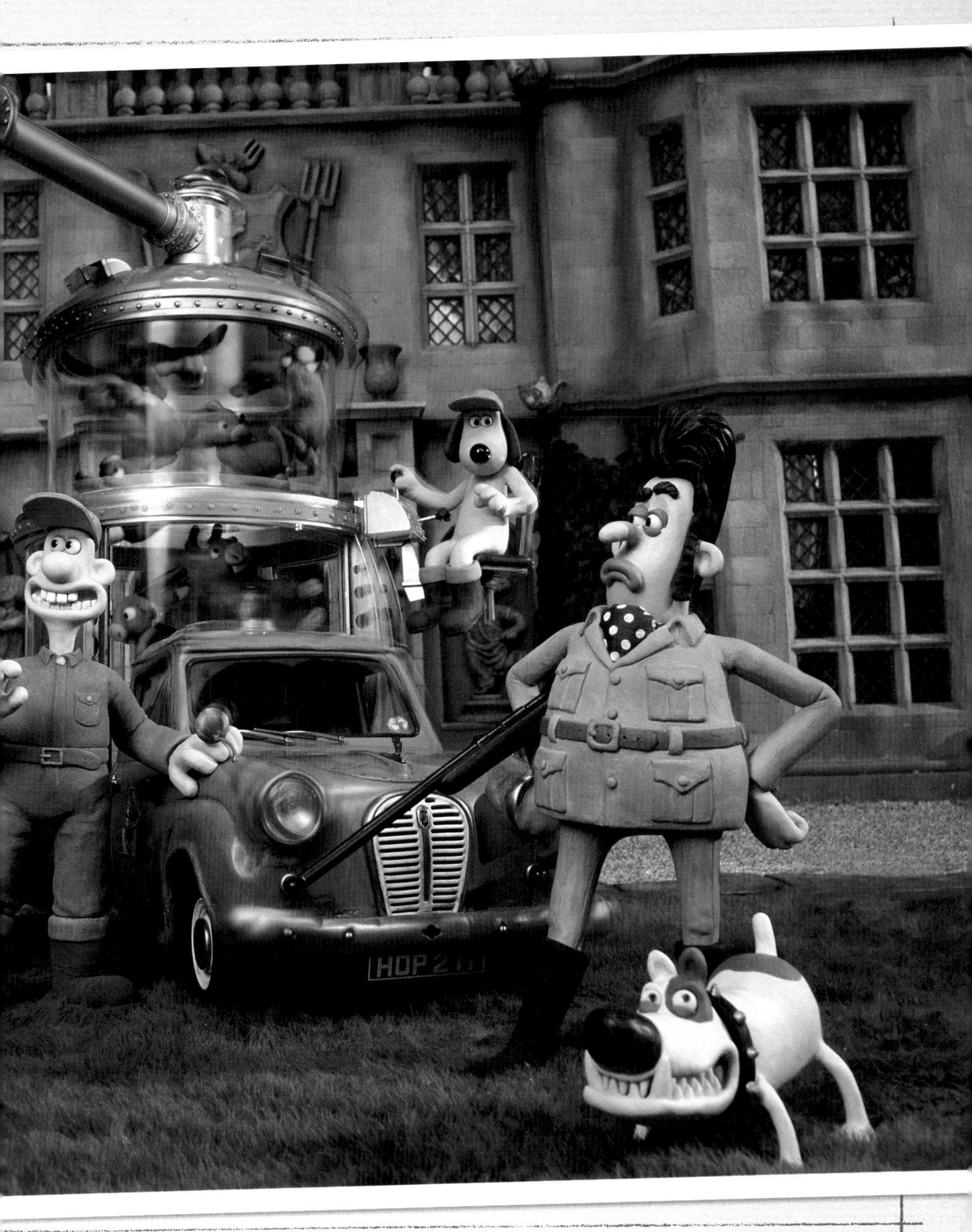

≈175 **8**7

Bun Vac 6000 (deployment)

- 1 Wing mirror.
- @ Gear lever.
- 3 Speedometer.
- 4 Van de-ice, de-mist and de-mud control panel.
- 5 Bun Vac 6000 activation button.
- Hydraulic vehicle support leg (deployed when Bun Vac is in use).
- 7 Chassis reinforcement panel for support leg.
- Four lower cylinder glass panels deploy outwards and around to form an airtight seal as upper cylinder is raised.
- Hydraulic arm lifts upper cylinder into position (retracts before lower cylinder panels slide into place).
- One of four lower cylinder support stanchions making an airtight seal when in fully deployed position.
- 1 Upper cylinder glass panel.
- Passenger side rear van wall and roof deployed (before manual detachment).
- 13 Driver's side rear van panel and roof deployed (before manual detachment).
- W Bun Vac lower bodywork stowed horizontally in segments beneath lower cylinder filter and deployed into vertical position to form an airtight skirt.
- 1 Bun Vac lower bodywork deployment ram.
- 16 Stowed vehicle support leg.
- The Heat ventilation grille in stowed position.
- 18 Heat ventilation grille in deployed position.
- Each cooling fan tips forward and drops into adjacent slots in the Bun Vac's lower bodywork.
- 20 Cooling fan positioning slots.
- 3 Suction fan drive chain.
- 2 Suction fan reversible gearing.
- 2 Lower cylinder segment positioning ram.
- 2 Suction fan.
- 29 Position-adjustable lower cylinder filter.
- © Cooling fan in stowed position.
- @ Rear light wiring.
- 2 Electric motor.
- 2 Upper cylinder filter.
- 30 Adjustable valve airtight inner tube.

- HERE
- Attachment valve height adjustment gear (valve stowed inside upper cylinder for transit).
- ② Attachment valve pressure control handle.
- 3 Vacuum pipe attachment valve in raised position.
- Wacuum pipes stowed each side of the cylinder and attached manually.
- 3 Vacuum pipe observation window.
- 3 Bunny retrieval attachment.
- Bun Vac control panel mounts onto rim of lower cylinder.
- 3 Padded operator's seat.
- 39 Control panel attachment bolts.
- @ Control panel wiring.
- 4 Safety warning light.

FOUTT 68

Bun Vac 6000 (fully deployed)

- 1 Bunny retrieval attachment.
- 2 Ground seal.
- 3 Vacuum pipe contents observation window.
- Vacuum pipes in manually deployed position.
- 5 Bun Vac control panel.
- 6 Control panel operator's seat.
- 1 Upper vacuum cylinder in raised position.
- Airtight seals and lower cylinder support stanchions.
- 9 Airtight rabbit retrieval hatch.
- 10 Heat ventilation grille.
- 1 Cooling fans.
- 12 Hydraulic vehicle support leg.

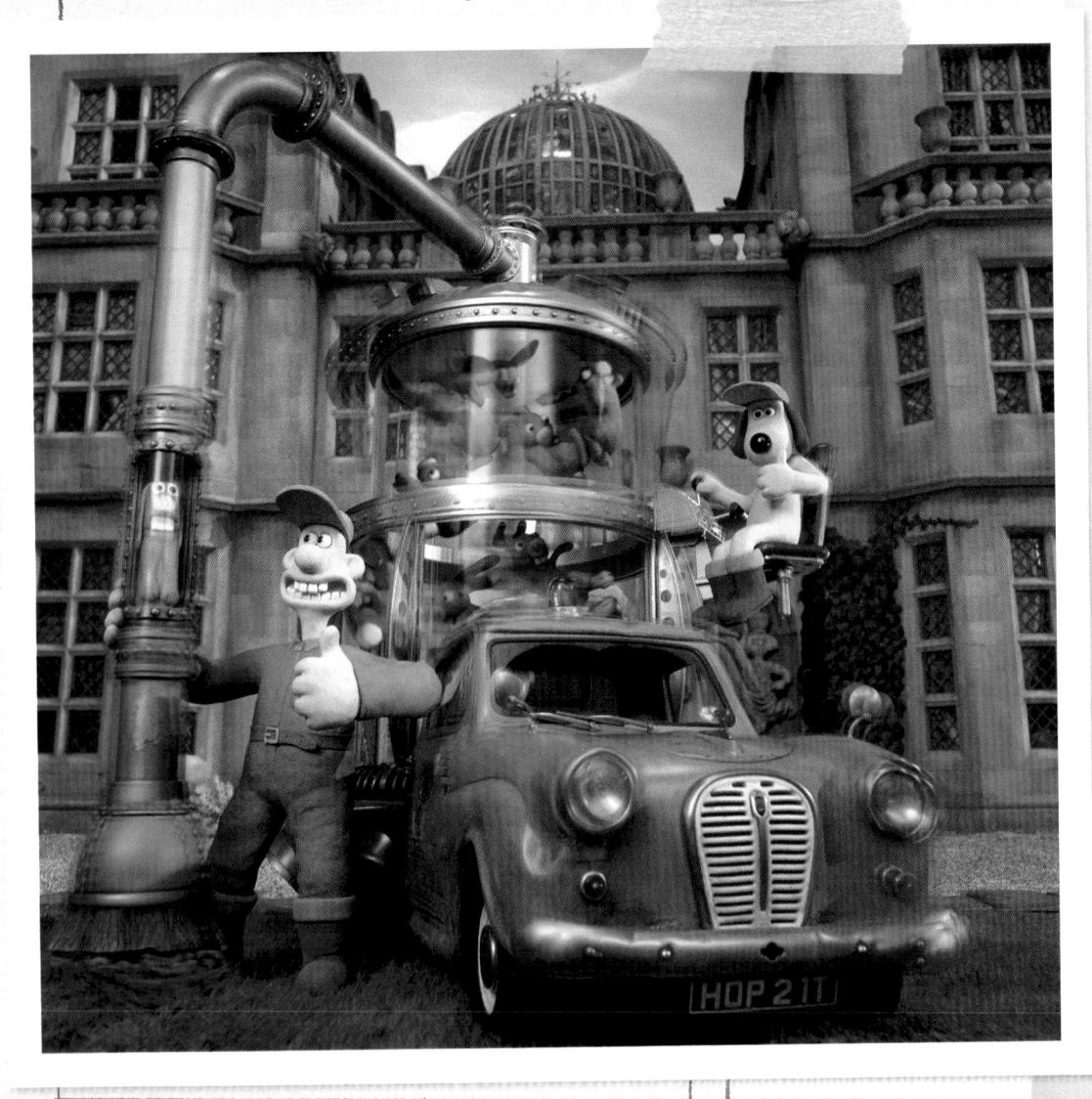

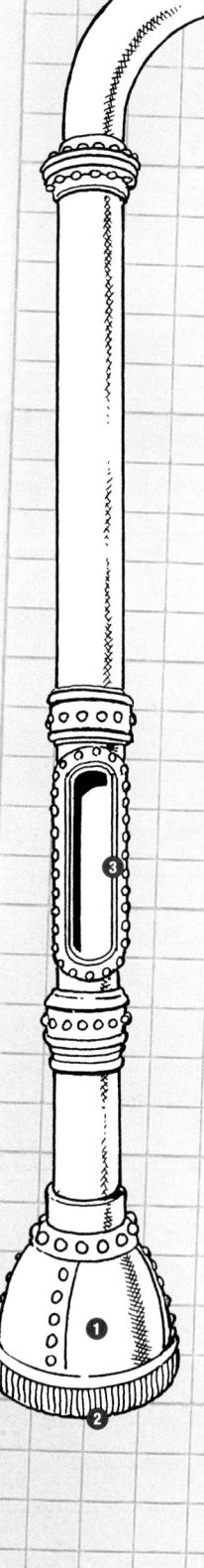

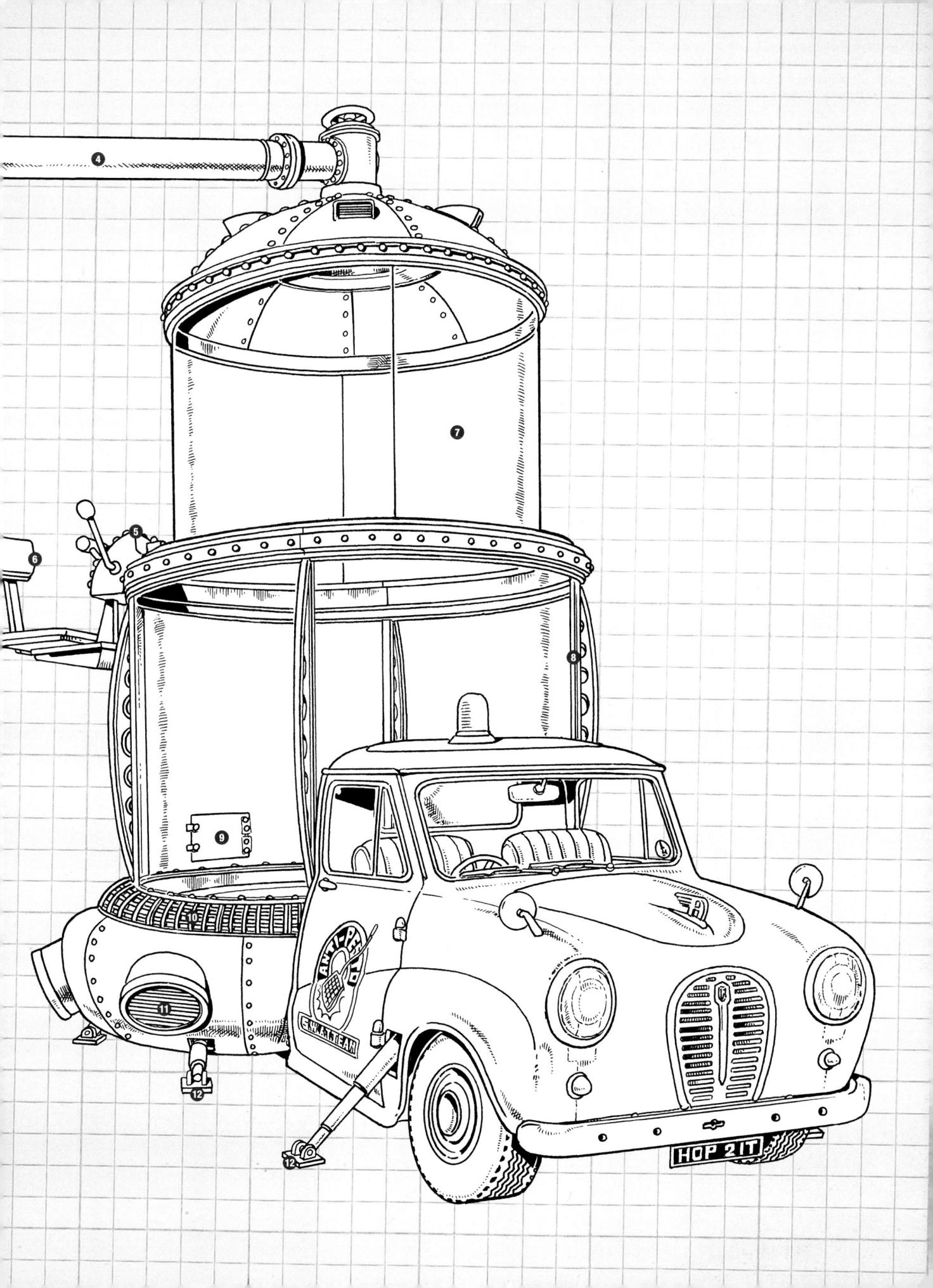

Contents

CONTENTS LIST

Mind Manipulation-O-Matic (dining room version) cutawa

Mind Manipulation-O-Matic (cellar version) cutaway..

SUB HEADING

General description

General description.....

RODY COPY

hile most of Wallace's inventions are designed as time- and labour-saving devices, occasionally one comes along with a far more subtle and sophisticated purpose. One such invention is the Mind Manipulation-O-Matic, which is a machine for the removal of unwanted thoughts and desires.

The main part of the Mind Manipulation-O-Matic comprises a glass thought-collection dome mounted on a pair of cantilevered positioning arms. This apparatus is stored in a cabinet in Wallace's bedroom and deployed through hatches in the floor of the bedroom and the ceiling of the dining room below. Horizontal positioning is accomplished by the aforementioned cantilevered arms while vertical positioning is achieved by a telescopic section and flexible conduit. The thought-collection dome is anatomically shaped and fitted with an adjustable forehead clamp. During use, thoughts are collected by two sensor probes and signalled by an indicator bulb on each probe.

This first prototype is activated by a discreet condiment switch (pepper pot), located on the dining room table, which opens a place-mat panel to reveal a control console, which rises up from beneath the table top. From here, the main apparatus can be deployed, programmed and controlled completely. Wallace tries this first prototype out to help him lose weight using the power of the mind, but with limited success.

A second prototype is built into the cellar of 62 West Wallaby Street. Featuring a more permanent structure, this lacks the deployment and positioning apparatus of the dining-room version but features a pair of moonshine lunar panels, which provide additional power during the thought transference process. An armchair, with integrated control console and handy magazine rack, are provided for the user's comfort during extended thoughtcontrol sessions.

with a large number of recently captured rabbits to relocate, Wallace wonders if the Mind Manipulation-O-Matic can be used to clear their minds of all vegetable desires. He hastily connects his new invention to the suction pipe of the Bun Vac 6000 and attempts to brainwash the bunnies, but a malfunction results in a 'mind-meld' between Wallace and one of the rabbits, which brings unforeseen consequences.

Mind Manipulation—O—Matic © Retra

- 1 Fork.
- 2 Knife.
- 3 Salt cellar.
- 4 Control console activation condiment switch (pepper).
- 6 Control console deployment mechanism.
- 6 Place mat in lowered position.
- 7 Mind Manipulation-O-Matic control console in raised position.
- 3 Dining room table and tablecloth.
- 9 Nest of tables.
- 1 Decorative doily.
- 1 Aspidistra.
- 12 Padded high-impact dining room chair seat.
- 13 Unwanted thought and desire collection sphere.
- 1 Collection sphere special glass blown by Jones the Glass.
- 15 Thought collection sensors.

- 16 Retractable longlife thought extraction indicator bulbs.
- Theight adjustment grips in deployed position.
- 13 Height adjustment cords.
- 19 Mind Manipulation-O-Matic vertical deployment motor.
- 20 Upper cantilevered positioning arm.
- 2 Lower cantilevered positioning arm.
- 2 Sliding ceiling hatch.
- 23 Hatch cord winch electric motor.
- 20 Mind Manipulation-O-Matic horizontal deployment motor.
- 25 Electronics and control box.
- 36 Mind Manipulation-O-Matic storage cabinet in Wallace's bedroom.
- 2 Floor hatch pulley and cord.
- 28 Floor hatch.
- 29 Ceiling joists.
- @ Ceiling hatch pulley and cord.
- 3 Dining room ceiling.
- 3 Floor hatch winch wheel.

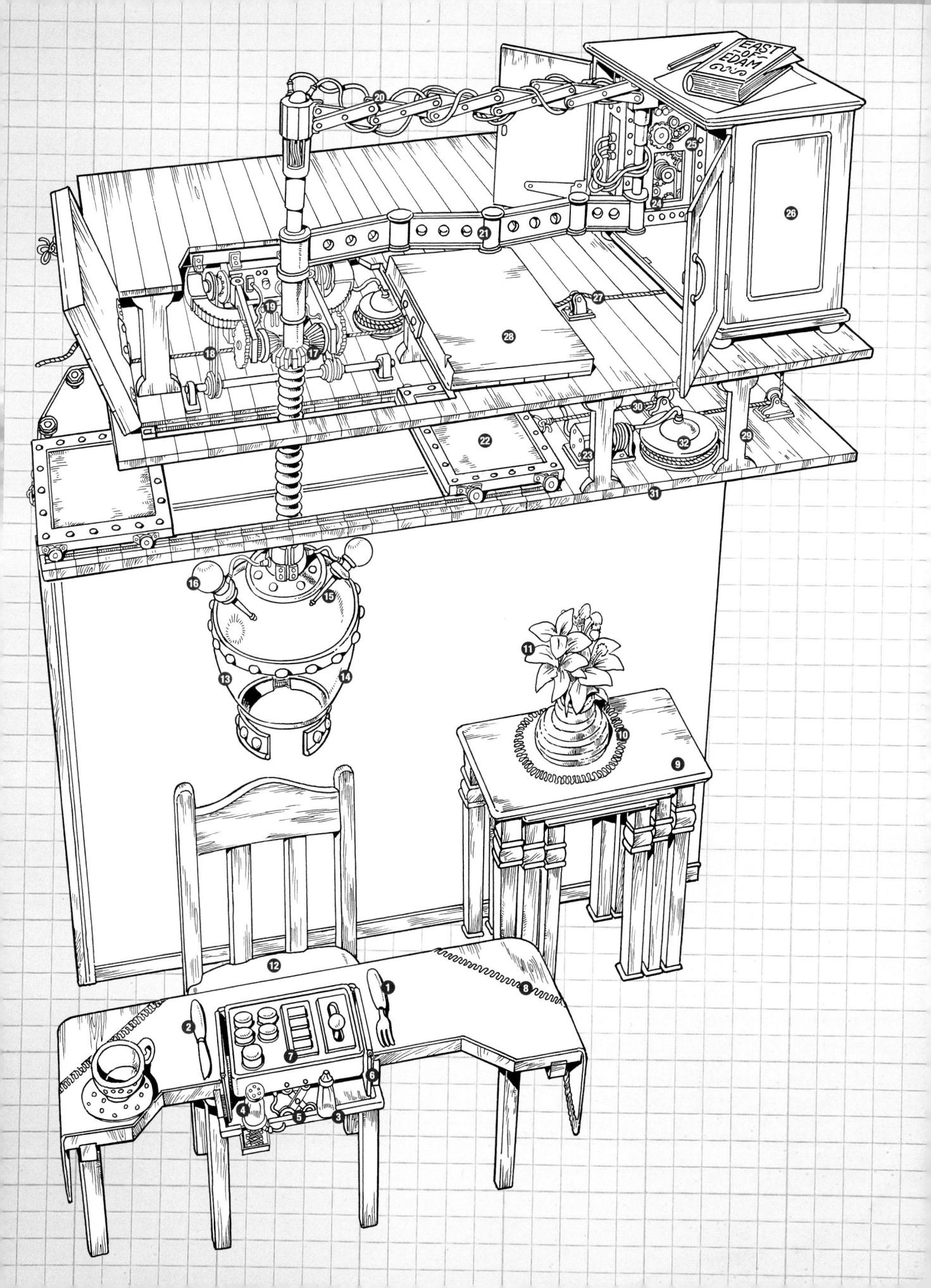

(cellar version)

Mind Manipulation-O-Matic

- 1 Blow 'n' suck control lever.
- 2 Relocated Bun Vac control panel.
- 3 Extended cabling for relocated control panel.
- Toolbox, used to relocate control panel and provide a seat for the operator.
- 5 Electric motor.
- 6 Drive chain.
- 7 Suction fan control gearing.
- 8 Bodywork positioning ram.
- Positioning ram control box.
- Cooling fan.
- 1 Heat ventilation grille.
- 12 Suction fan.
- 13 Rabbit retrieval hatch.
- 10 Lower cylinder support stanchion.
- 15 Airtight rim seal.
- Upper cylinder in raised and airtight position.
- 1 Upper cylinder filter.
- 18 Adjustable valve airtight inner tube.
- 19 Vacuum pipe/thought transfer tube attachment valve.
- Attachment valve height adjustment gearing (retracted).
- a Attachment valve pressure control handle.
- Thought transmitter and release mechanism for brainwashing.
- 3 Thought transfer tube.
- 24 Thought collection sensors.
- 3 Unwanted thought and desire collection sphere.
- 3 Longlife thought extraction indicator bulb.
- 7 Forehead clamp.
- Moonshine lunar panels provide additional power to enhance mind waves during the thought transfer process.
- Multi-angle lunar panel adjustment and support arms. Panels fold up and are stored in upright position when not in use.
- Mind Manipulation-O-Matic support column incorporates wiring to control box behind chair.
- 3 Comfy chair.
- 2 Mind Manipulation-O-Matic control console.
- 3 Magazine rack.

AUSTIN A35 VAN

HEADING

Contents

CONTENTS LIST

, PAGE 1

General description

86 76

Austin A35 Van cutaway.....

88 88

SUB HEADING

General description

BODY COPY

allace and Gromit's faithful Austin A35 Van has undergone many modifications over the years, and here it is shown adapted for use in their Anti-Pesto pest-control business.

As a crucial part of the Anti-Pesto SWAT team rapid-response launch system, the van is fitted with access hatches below the driver and passenger seats. When open, these allow the van seats, carrying Wallace and Gromit, to pass up through hatches in the garage floor and into the cab, where they are secured automatically by self-extending support stanchions. The hatches close, and the engine Autostarter operates. This consists of a telescopic arm, which extends through the front of the engine bay, on the end of which is a mechanical hand grip and engine cranking handle.

The engine bay also houses an automatic lasso system and gearing for the special 'de-mud' mechanism, which rocks the van vigorously from side to side to shake off loose mud after callouts to fields and allotments.

The rear of the van is fitted out with a comprehensive range of pest-control equipment, including grabbers, a net, binoculars, a spade, wire cutters and a ladder.

Occasionally, certain pest problems call for special equipment, and one such example is the giant lady rabbit puppet, which Wallace and Gromit devise as a lure to catch the were-rabbit. The puppet is very large to make it visible from a distance, and very alluring in order to attract the male were-rabbit. It is mounted on the roof of the van by means of a flexible support column, which extends through the full height of the puppet. The legs and arms can be moved independently via a system of sprung linkages and control cords. The controls are operated from inside the rear of the van by Gromit who is seated on a saddle and restrained by a harness in case of tactical manoeuvres.

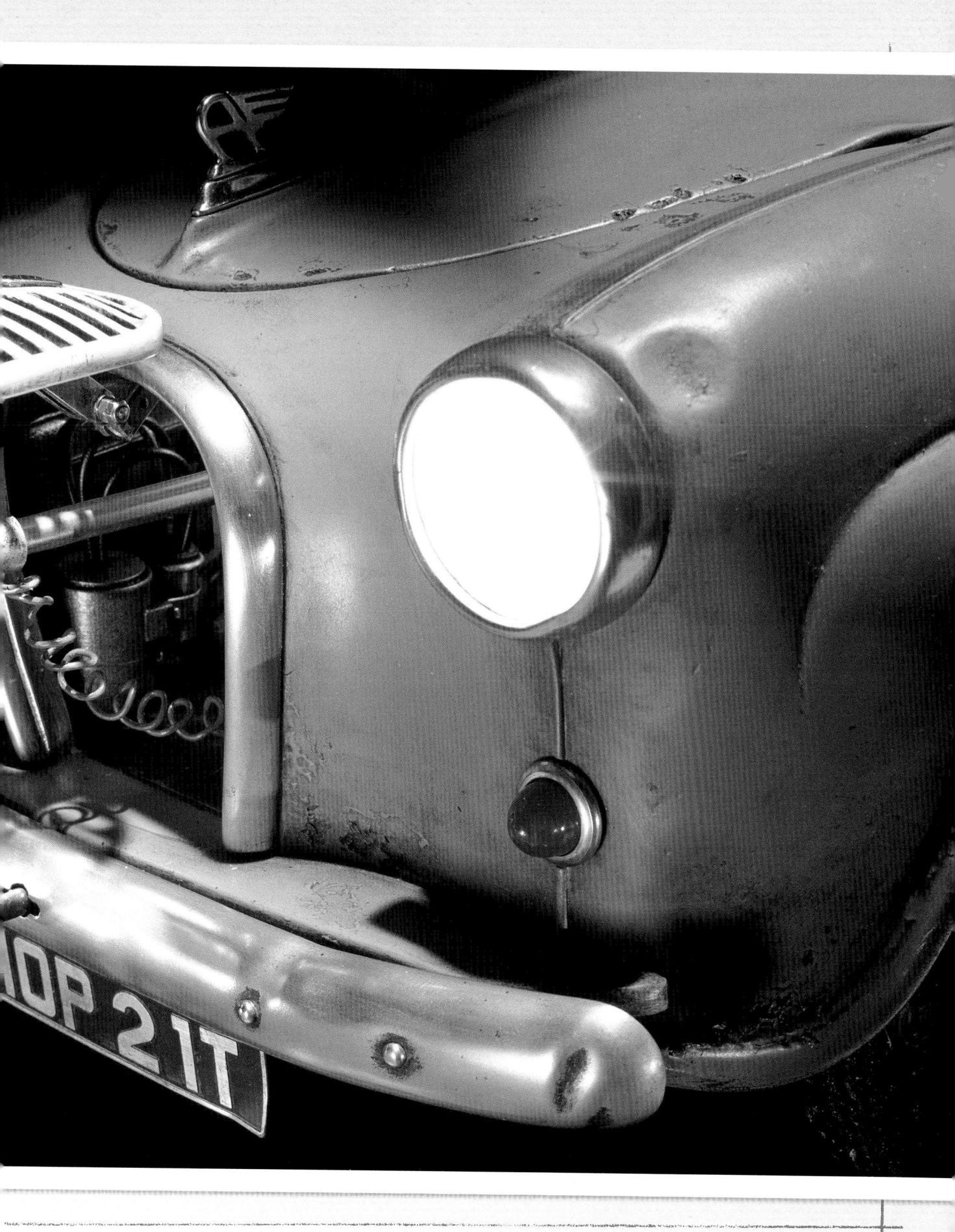

Austin A35 Van

- Multi-jointed and telescopic Autostarter control arm.
- 2 Radiator grille in raised position to allow Autostarter to pass through.
- 3 Cranking handle grip.
- 4 Engine cranking handle.
- 5 Retracted cooling fan.
- Radiator swings back allowing Autostarter to pass through.
- 7 Radiator hose leading to engine.
- 1 Telescopic lasso rope deployment arm.
- 9 Lasso electric motor.
- 10 Lasso arm control linkage.
- 1 Lasso rope control and retrieval winch.
- ② Austin bonnet badge swings 90 degrees and descends allowing lasso system to operate.
- 13 Lasso operator's control handle.
- 1 Steering column.
- 1 Battery.
- 6 Passenger side van support leg (retracted).
- 10 Mud removal control gearing (see page 74, no. 4).
- @ Gear lever.
- Passenger seat support stanchions (shown folded back to allow seat to ascend through floor access hatch (see page 61).
- Driver's seat support stanchions shown in deployed position.
- 2 Floor access hatch.
- 2 Safety warning light.
- 23 Humane mice knockout gas cylinder.
- 24 'Operation clean-up' bucket.
- 25 Shears.
- 26 Rabbit grabber.
- 2 Binoculars.
- 23 Hammer.
- 2 Sink plunger.
- 30 Pest-catching net.
- a End of step ladder (stowed on left side of van compartment).
- 3 Humane rat knockout gas cylinder.
- 3 Wire cutters.
- 3 Spade.
- 3 Puppet operator's control harness.

- 36 Puppet operator's saddle.
- 3 Right arm control cord.
- 3 Left arm control cord.
- 3 Right foot control cord.
- 40 Left foot control cord.
- 4 Eyebrow control pedal.
- @ Flexible puppet support column.
- High-strength puppet subframe wrapped in chicken wire.
- 4 Fully sprung leg movement linkage.
- 6 Central control column (through which eyebrow control cord is fed).
- 46 Heavy-duty elastic bands.
- 4 Chicken wire upper body.
- 49 Fake fur for extra rabbit authenticity.
- Body curvature specially designed to attract the were-rabbit.
- 50 Bow for feminine touch.
- **5** Fully sprung arm movement linkage.
- © Colourful female rabbit lip gloss.
- Plastic balls painted to resemble pearls for added allure.
- Left winking eyebrow controlled via cord from foot pedal.

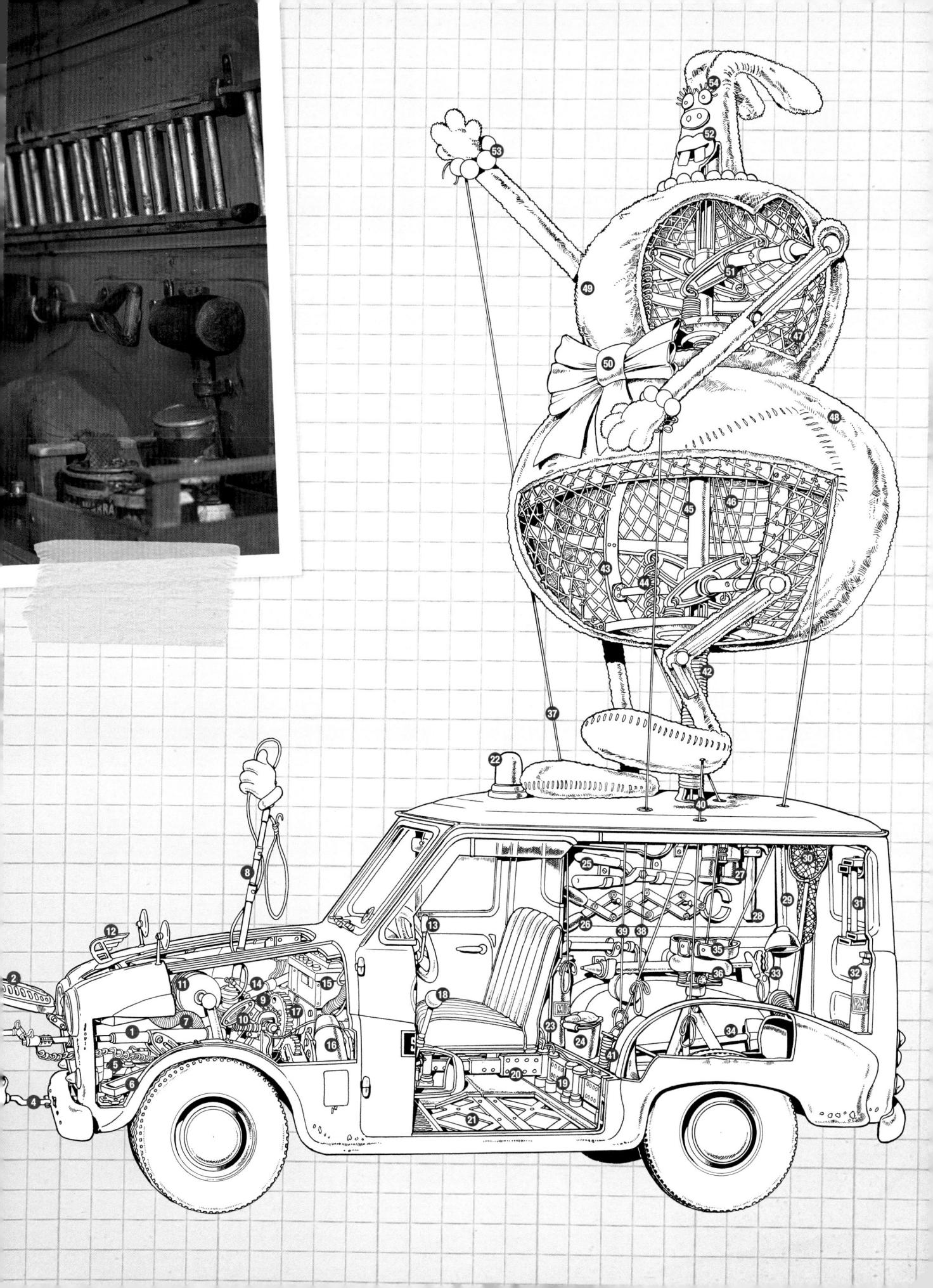

BED LAUNCHER & AUTODRESSER

4UB HEADING

Contents

CONTENTS LIST

PAGE NO.

General description.....

19082

Bed Launcher & Auto Dresser cutaways ...

9284

HEADING

General description

BODY COPY

DROP

ven the most successful inventions require occasional tweaking and modification to make them better still, and two such devices are Wallace's trusty Bed Launcher and Auto Dresser.

The Bed Launcher is activated by a push-button on the bedside control panel. This starts a winch motor, located above the bedroom ceiling, which, assisted by a large counterweight, lifts the head end of the mattress causing Wallace to slide out of the foot end of the bed. At the same time, an under-floor motor winches open a two-door hatch via a system of pulleys and cords, allowing Wallace to slide neatly through to the dining room below. If Wallace should get stuck part way through the floor hatch (perhaps due to his expanding waistline) then extra assistance may be called upon. The Activated Assistance mechanism consists of a single lever, which is mounted on the wall of the dining room and operated by Gromit. This opens the doors of the wardrobe in Wallace's bedroom and releases a large softwood mallet from within. The force of the mallet 'assists' Wallace through the hatch before being automatically wound back up into the wardrobe ready for the next use.

Once safely though the hatch from the bedroom above, Wallace lands on a dining chair at the breakfast table, and the Auto Dresser system is immediately activated. Trousers are pulled over Wallace's legs by the Auto Dresser's arms, which extend forward either side of the chair, while slippers are deployed by a separate device located on the underside of the table. The Auto Dresser then pulls Wallace's tank top, complete with shirt body and tie, over his head before two ceiling-mounted articulated arms attach the shirt sleeves to complete his outfit.

- 1. Wallace presses the launch activation button on the bedside control panel.
- 2. The bed tips up and Wallace slides down to the floor hatch.
- 3. The floor hatch doors have opened to let Wallace through.
- 4. If Wallace gets stuck, Gromit throws the Activated Assistance Lever (see page 86).
- 5. The lever activates the drop mechanism of the large mallet in the bedroom wardrobe.
- 1 Bedside call system control box.
- 2 Mattress lift winch motor.
- 3 Mattress lift counterweight.
- 4 Strengthened bed mattress.
- 5 Floor hatch pulley and cord.
- 6 Bedside table.
- Tray of cheese and crackers.
- 8 Cabinet containing Mind Manipulation-O-Matic (see page 72)
- 9 Hatch cord winch motor.
- 10 Hatch cord winch reel.
- 1 Sliding ceiling hatch.
- @ Ceiling joists.
- 13 Clothes rail and hanging clothes.
- 1 Side panels of wardrobe used to store clothes.
- 15 Mallet drop release mechanism.
- 16 Softwood mallet head.
- 1 Drop mechanism gearing cogs and rewind mechanism.

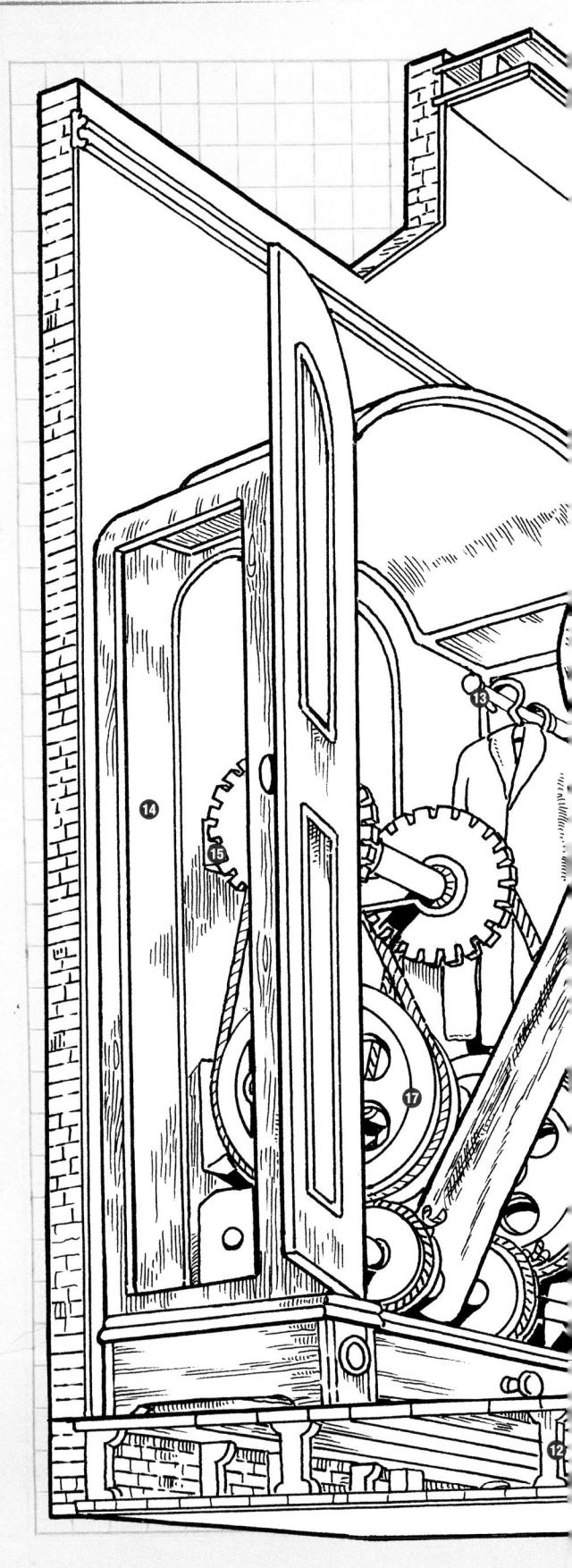

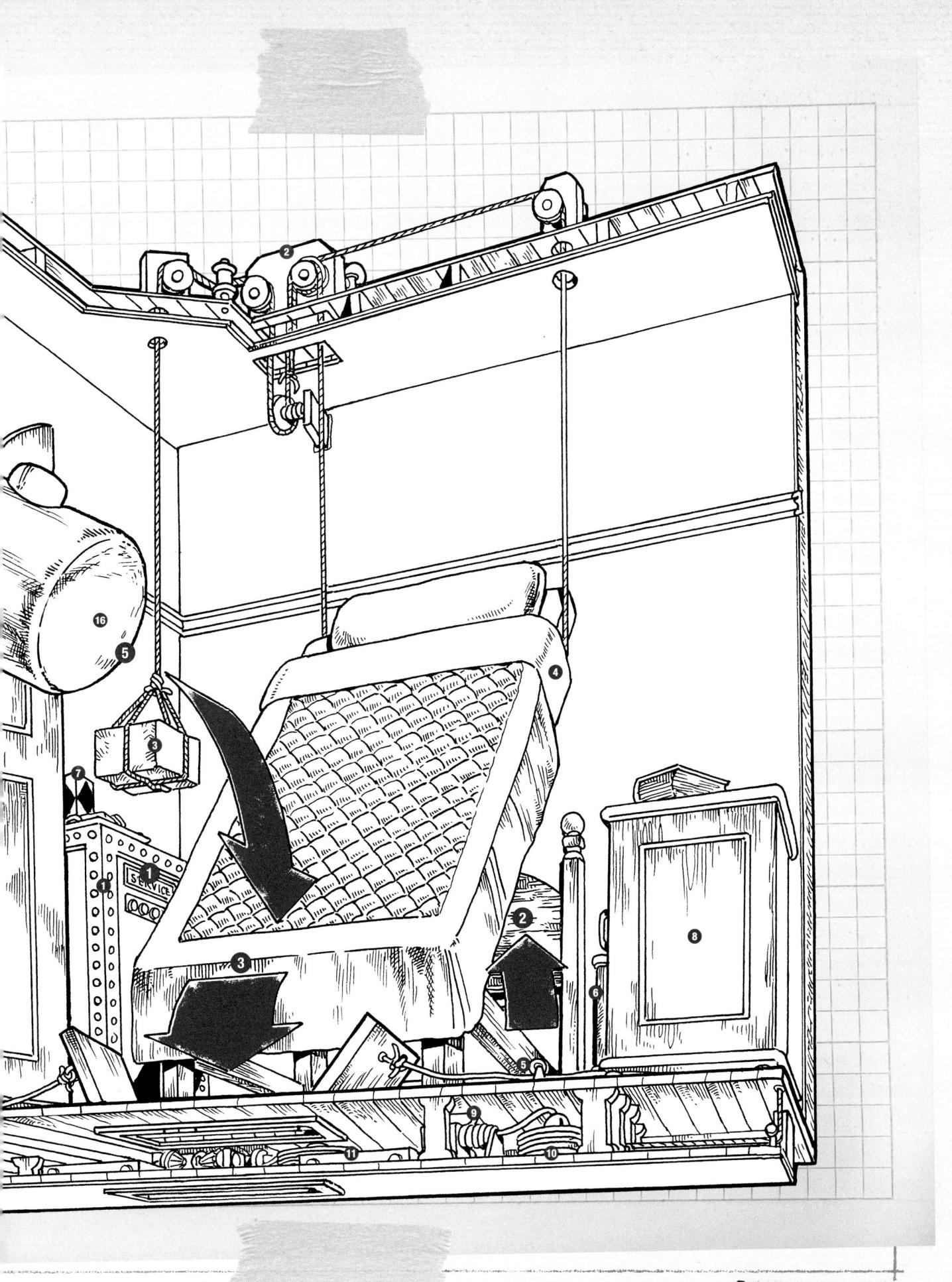

Auto Dresser

- The mallet 'assists' wallace through the floor hatch and he lands on a chair at the dining table below.
- 7. The slipper deployment device puts Wallace's slippers on his feet.
- 8. The Autodresser puts on Wallace's trousers, followed by his tank top.
- Finally, Wallace's shirt sleeves are put on by the ceiling-mounted overhead auto-dressing device.
- ① Activated Assistance Lever.
- 2 Dining room table and tablecloth.
- 3 Slipper deployment device.
- 4 Hydraulic slipper deployment rams.
- 5 Slipper deployment motor.
- 6 Auto slipper placement grabs.
- Trouser holder bows place trousers over Wallace's legs.
- 8 Auto Dresser.
- 9 Auto Dresser control box.
- Shirt sleeve deployment grabs.
- Fully articulated dressing arms.
- ② Auto-dressing positioning rams.
- 13 Overhead auto-dressing device.
- Mind Manipulation-O-Matic control console (concealed below table top).
- 15 Nest of tables and plant.
- 1 Door to kitchen.

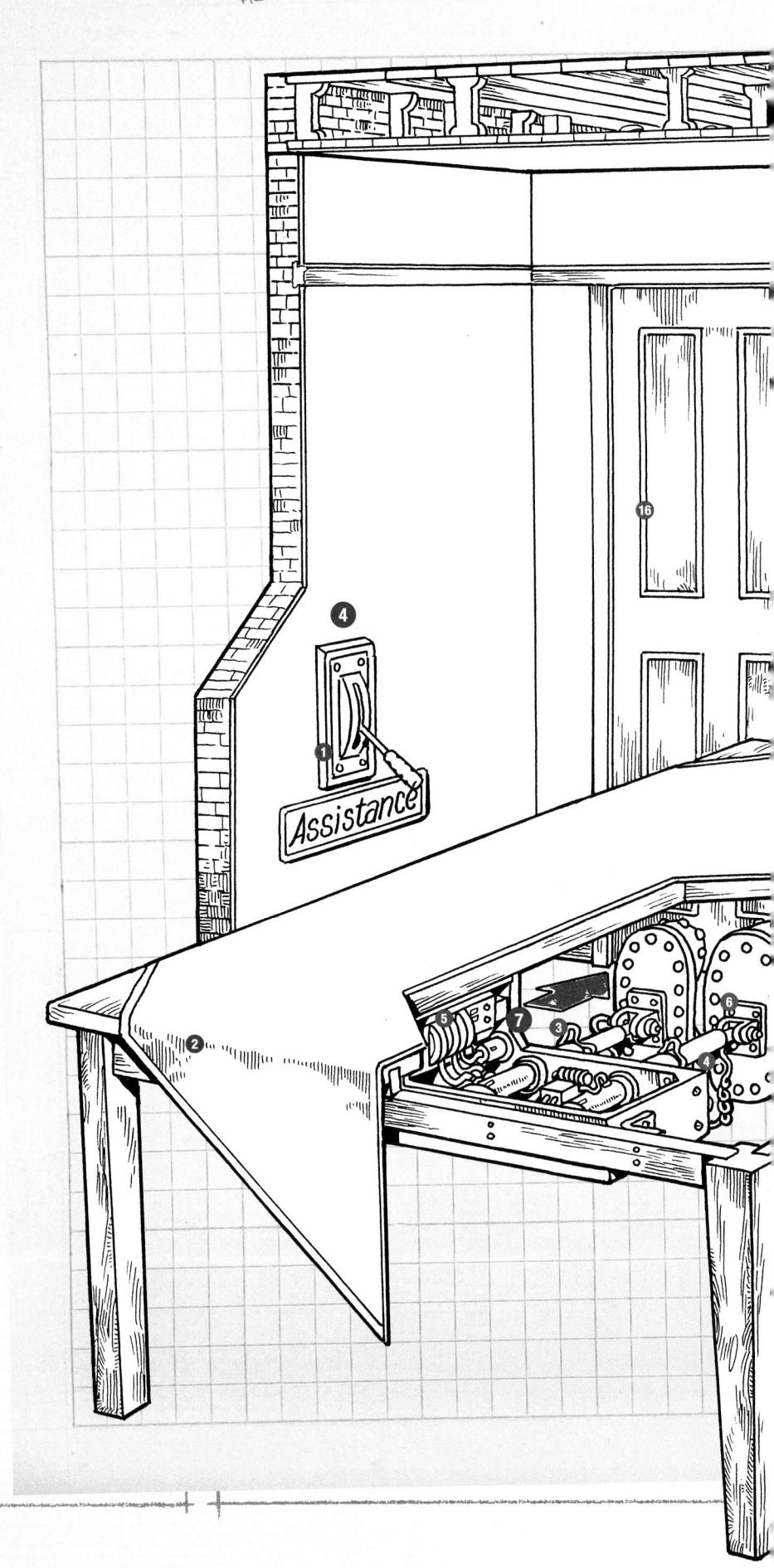

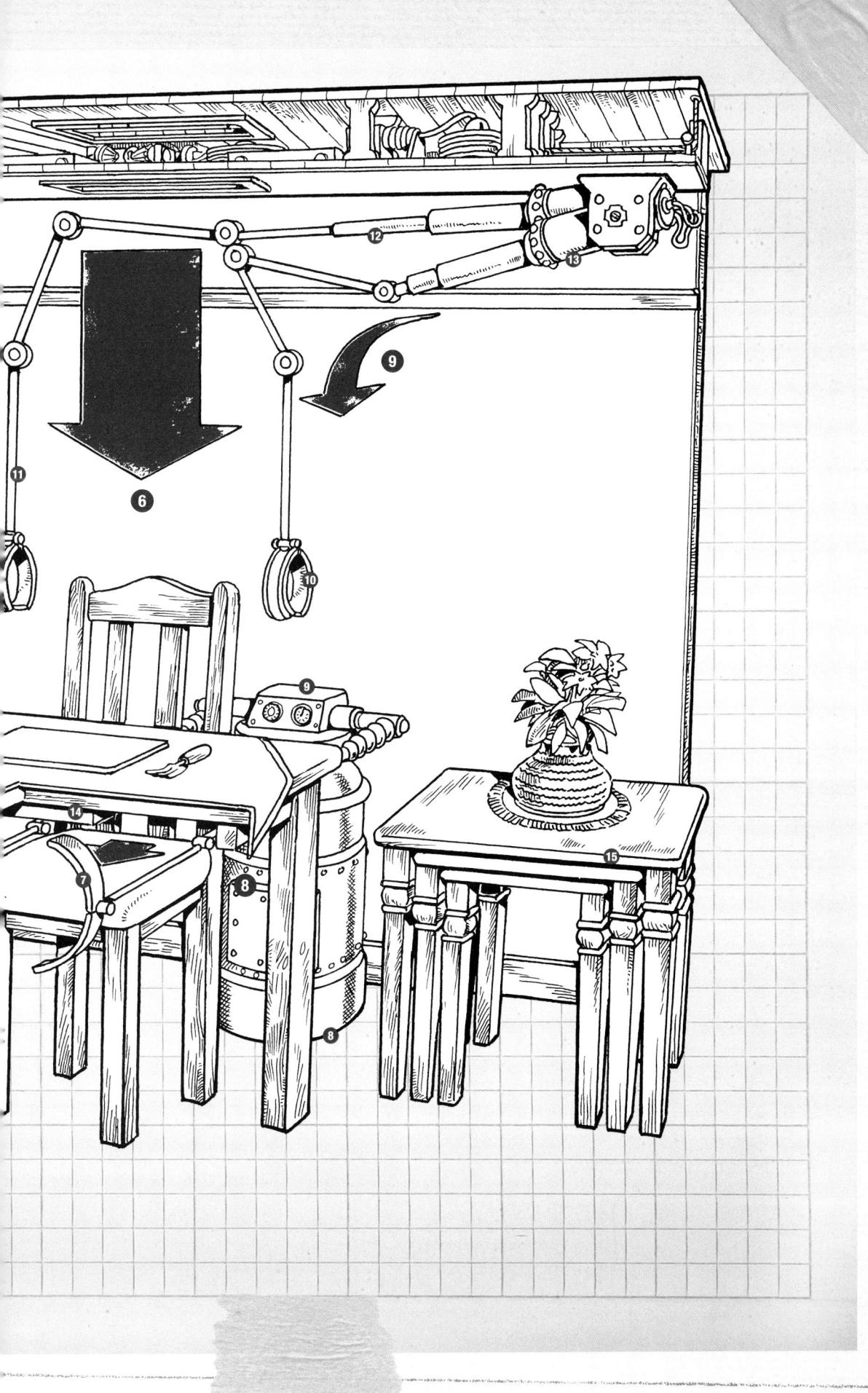

PELAUNCHER

Contents

CONTENTS LIST

General description.....

Pie Launcher cutaway

PAGE 100

96 88

General description

RODY COPY

allace and Gromit's latest venture, WAG's Pies Ltd is doing a roaring trade, supplying hot pies to hungry football supporters. So much so, in fact, that Wallace decides to mobilise his latest invention: the Pie Launcher.

Hot pies from the WAG's Pies stall are loaded into two vertical stacking frames by an automated pincer mechanism. The frames are then lowered via telescopic arms to a position just above the Pie Launcher, which rises from the floor on elevation-adjusting supports into the firing position.

The Pie Launcher itself consists of a domed turret, inside of which is a sophisticated auto-fire pie-launching mechanism and associated targeting apparatus. The operator's seat is carried to the turret on a telescopic arm, entering via a hinged access hatch. Once the operator and seat are in position, the telescopic arm retracts, the access hatch closes and firing can commence.

Pies are released from the stacking frames and loaded into the barrel, one at a time, via two loading slides (one on each side of the turret). Before the pie enters the barrel, its foil dish is removed ready for discharge through one of two outlets located either side of the barrel. Firing is by means of a coil spring and shaped plunger, which propel the pie up and out of the barrel towards its target customer. The barrel is reloaded automatically from each loading slide alternately.

A range-finding telescopic gunsight is mounted on a tubular support beam fixed behind the operator. Targeting angle and elevation are controlled by the operator via a system of gears and chains, and actuated by a mains-powered electric motor installed behind the operator's seat.

Unfortunately, the auto-firing mechanism is liable to sticking, resulting in the rapid discharge of the entire supply of pies in both stacking frames.

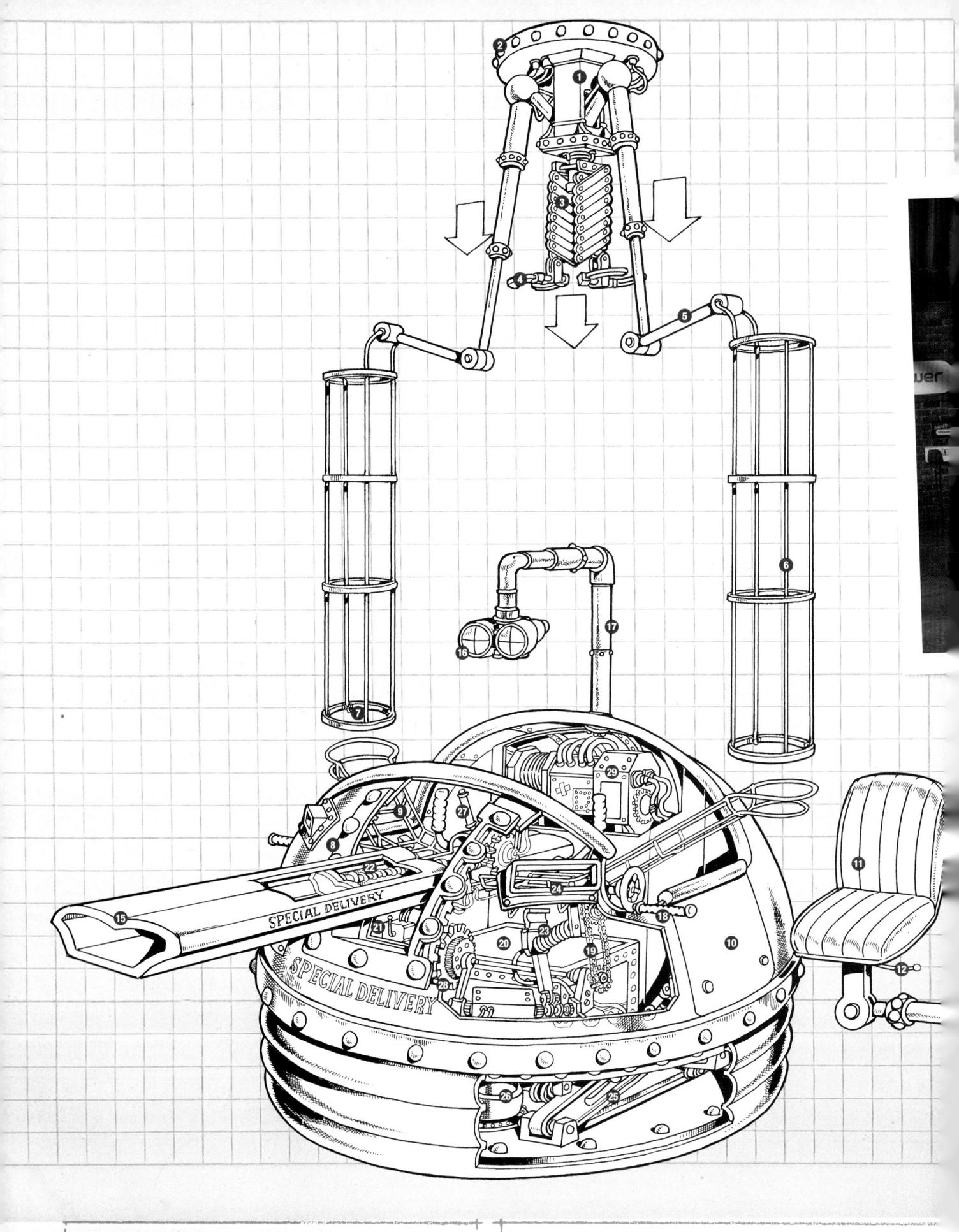

Pie Launcher

- 1 Pie-stacking frame motor enclosure and release timer.
- 2 Roof attachment plate.
- 3 Pie-loading scissor arms.
- 4 Pie-loading pincers.
- Pie-stacking frame telescopic positioning arms.
- 6 Pie-stacking frame (maximum capacity 18 pies).
- Pie-release hooks, connected to release timer.
- 8 Pie Launcher turret.
- 1 Pie loading slide.
- 10 Gun turret access hatch.
- 1 Pie Launcher operator's seat.
- Under-seat starting handle begins Wallace's entry to turret.
- 13 Telescopic access arm.
- 1 Access arm motor.
- 15 Pie-shaped discharge gun barrel.
- 16 Range-finding telescopic gunsight.
- To Gunsight tubular support beam.
- 18 Gun barrel elevation control handle.
- Gun barrel elevation control gearing chains.
- 20 Operator's seat platform.
- 2 Pie barrel loading regulator and timer.
- 2 Pie launching coil spring.
- ② Spring-operated foil dish removal device.
- 2 Foil dish discharge outlet.
- 25 Turret elevation-adjusting supports.
- Turret rotation gearing and telescopic central support column.
- 2 Pie firing trigger (with automatic reload).
- 28 Pie Launcher elevation gears.
- 29 Mains-powered motor controls all functions.

WALLAGE VISION

Contents

CONTENTS LIST

20092

General description

General description

ere is an invention that heralds a new dawn in home entertainment and one that might soon be seen in living rooms up and down the country. The Wallace Vision combines many television sets and video monitors (31 in total) to form a single tall and wide 'TV wall'. The resulting 'wide-screen' viewing experience is very large, very loud and totally immersive for the viewer.

While the sheer bulk of the Wallace Vision is impressive, the true ingenuity is found in the video signal distribution box, which, although large itself, fits snugly behind the TV wall. This is the heart of the machine and is responsible for receiving the primary broadcast signal (via the primary broadcast receiving antenna) and distributing it to all 31 TVs and video monitors. The video signal distribution box can either send different channels to individual screens, the same channel to all 31 screens, or take one channel and 'tile' it across the entire TV wall. The result created by this tiling effect is truly magnificent to behold, and even a little intimidating for novice users.

One of the key features of the TV wall is its modularity. If a particular TV set or monitor develops a fault, it can be simply replaced by another (of the same size, smaller or larger). Small screens can be upgraded to larger ones over time, and the TV wall can be expanded by adding further screens and connecting them to unused aerial lead outputs on the video signal distribution box.

If there is one drawback of the Wallace Vision then it is that the 31 television sets and monitors (some of them quite old and inefficient) together with the video signal distribution box consume a vast amount of power. Therefore, electricity is provided by a dedicated generator, which is positioned behind the TV wall, and built into the base of the generator is a necessarily large heat sink and cooling fan.

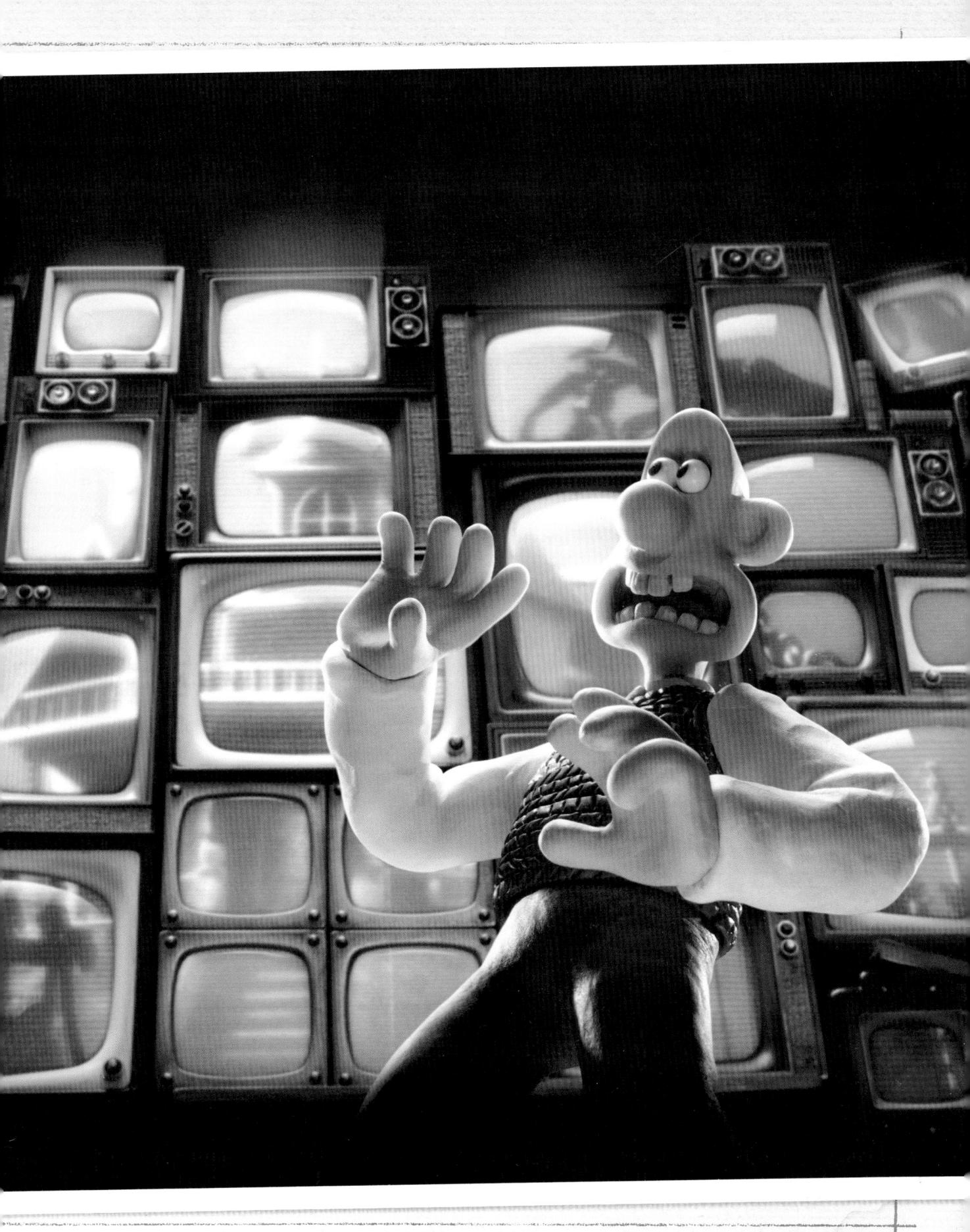

~201 98

Wallace Vision

- 1 Video signal distribution box.
- ② One of three multi-plug power distribution points linking television sets to generator.
- 3 Primary broadcast receiving antenna.
- 4 Aerial lead connectors.
- Electricity generator provides ample power for all 31 television sets.
- 6 Generator cooling fan.
- Individual TV antennae enable some televisions to display channels different to the main video feed from the video signal distribution box.
- 8 More aerial lead connectors.
- 9 Upside-down TV for better fitting.
- 10 Television support crook.
- Books provide handy additional support in awkward gaps between television sets.
- Strengthened coffee table provides support for seven televisions and four video monitors.
- 13 Set of four video monitors.
- M Anode.
- 13 Cathode.
- 6 Steering coils create magnetic fields to which the electron gun responds.
- Telectron gun.
- 18 Conductive tube coating.
- 19 Shadow mask.
- 20 Phosphor-coated screen.
- 4 Glass screen.
- 2 Cathode ray tube (CRT).
- 23 TV control electronics.